Digital Wedding Photography: Capturing Beautiful Memories

Digital Wedding Photography: Capturing Beautiful Memories

Glen Johnson

WILEY

Wiley Publishing, Inc.

Digital Wedding Photography: Capturing Beautiful Memories

Published by
Wiley Publishing, Inc.
111 River Street
Hoboken, N.J. 07030
www.wiley.com

Copyright © 2006 by Wiley Publishing, Inc., Indianapolis, Indiana

Published by Wiley Publishing, Inc., Indianapolis, Indiana

Published simultaneously in Canada

ISBN-10: 0-471-79017-6

ISBN-13: 978-0-471-79017-4

Manufactured in the United States of America

10 9 8 7 6 5 4 3

1K/RZ/QX/QW/IN

For general information on our other products and services or to obtain technical support, please contact our Customer Care Department within the U.S. at (800) 762-2974, outside the U.S. at (317) 572-3993 or fax (317) 572-4002.

Wiley also publishes its books in a variety of electronic formats. Some content that appears in print may not be available in electronic books.

Library of Congress Control Number: 2006923793

Trademarks: Wiley and the Wiley Publishing logo are trademarks or registered trademarks of John Wiley and Sons, Inc. and/or its affiliates. All other trademarks are the property of their respective owners. Wiley Publishing, Inc. is not associated with any product or vendor mentioned in this book.

WILEY is a trademark of Wiley Publishing, Inc.

About the Author

Glen Johnson is an acclaimed wedding photographer whose client list spans North America, the Caribbean, and Europe with more than 20 weddings outside the US in 2006. His Web site is located at www.aperturephotographics.com. Glen's wedding photography has been featured in the October 2003 issue of *Studio Photography and Design* and in a Nikon advertisement in the February 2004 issue of the same magazine. His work was also featured in the fall 2005 issue of *American Photo* magazine.

Credits

Acquisitions Editor
Michael Roney

Project Editor
Jade L. Williams

Technical Editor
Serge Timacheff

Copy Editor
Jerelind Charles

Editorial Manager
Robyn Siesky

Vice President & Group Executive Publisher
Richard Swadley

Vice President & Executive Publisher
Bob Ispen

Vice President & Publisher
Barry Pruett

Business Manager
Amy Knies

Project Coordinators
Adrienne Martinez
Erin Smith

Graphics and Production Specialists
Jennifer Click
Denny Hager
Clint Lahnen
Barry Offringa
Lynsey Osborn
Amanda Spagnuolo

Quality Control Technicians
Leeann Harney
Joe Niesen
Christy Pingleton

Permissions Editor
Laura Moss

Proofreading
Evelyn Still

Indexing
Kevin Broccoli

Special Help
Kim Heusel
Scott Tullis

This book is dedicated to Amy Lizotte.
Thank you for being my partner in life and photography.
Thank you for all the time you've spent taking care of my life,
my business and our children while I worked long hours on this book.
It wouldn't have been possible for me to do this without your help.

Preface

I was shooting a wedding in the Bahamas where the bride and groom purchased a "package" wedding from a large resort. The package came with a minister, a videographer, and all the other essentials except the photographer (me), which the couple arranged separately because they wanted more than what the typical hotel photographer provides. On the day of the wedding, I did my normal photojournalistic thing until just before the ceremony when the videographer arrived. This man stepped up with a loud voice and just took over the reins of that whole wedding. From then on, he and the minister ran the show completely, telling the bride and groom where to stand, when to move, where to put each hand, how to hold the pen, and even when to smile at the camera. They were arranging shots for me (which I didn't ask for) and then saying, "There you go Mr. Photographer! That's how we do it here in the Bahamas!"

When the first dance started, the videographer was at the bar but he came charging back with a drink in his hand and a napkin flying in the air behind him. He was waving his hands and motioning across his throat at the DJ to cut the music. The DJ was ignoring him so he finally just yelled, "Stop!" which of course everyone did. Then he walked out on the dance floor and carefully placed the groom on one side, and the bride on the other, and then he grabbed his camera and motioned for the DJ to start the music up again.

Only a few weeks before this scene, I saw another bride in the Bahamas that stopped all that nonsense right in the beginning. She told them all how she wanted it to go, and if they didn't want to do it her way, they could just pack up! At first, the minister didn't want to comply, but when she told her father to ask him to leave, he changed his mind. She then proceeded to have a very quiet ceremony that went exactly her way, with no interruptions.

Those two very different experiences made me think about how those of us in the wedding business go about our business. Sometimes videographers, ministers, and we photographers forget to honor the sacredness of the wedding. We all see so many weddings that we forget this is the first and perhaps only time the bride and groom will ever experience it. Our familiarity makes us good at what we do, but it also wears away our perception of the sacredness of the event. Before long, each wedding is simply another day at work, and we are eventually tempted to herd our clients through the paces.

Thankfully, a change is swirling in the air around the wedding photography industry. The move towards photojournalism is bringing with it a change towards letting go of being in control — a change towards allowing the bride and groom to express their individuality by creating their own ceremony within the bounds of whatever religion they choose, without us "professionals" trying to force them into our own overworked perception of what a wedding should be.

We must remember that the bride and groom hire us to create a beautiful record of their wedding, not to create the wedding itself. We must also remember that the purpose of a wedding is to announce publicly the couple's agreement to be bound together as a family for the rest of their lives, and contrary to what some photographers seem to believe, a wedding is *not* a photo shoot.

In writing this book, my wish is that a new generation of photographers will continue the current trend of working in a more discreet fashion throughout the wedding day. I hope that the techniques and insights gained from this book help you to capture the beauty and emotion of the day without spoiling its uniqueness by trying to control it.

Is This Book for You?

Anyone interested in learning wedding photography, and particularly how to do it with digital equipment, will find *Digital Wedding Photography: Capturing Beautiful Moments* very useful. Seasoned wedding professionals looking to convert to a digital camera and digital workflow systems will also find it very useful. The specific information on how to create beautiful images at different parts of the wedding day, and the chapters dealing with the business of wedding photography will be useful to amateurs and professionals alike.

This book is designed to teach a person who already knows how to use a camera about how to be a digital wedding photographer — and make no mistake about it; there is a huge difference between being able to take good pictures and being a good wedding photographer.

This book is not designed as a beginning photography book. There is no information on f-stops, apertures, or operating a camera. If you need to learn beginning photography, this book is not the place to start. If you already feel comfortable with the basics of photography, and you want to learn how to apply those skills to shooting weddings, this is the book for you.

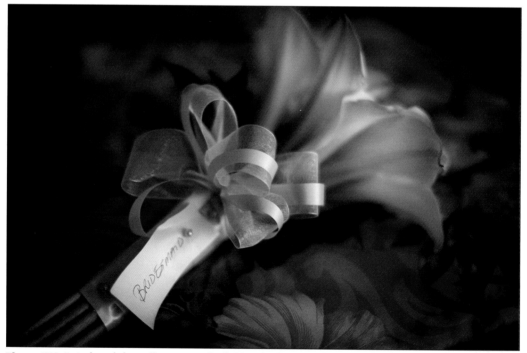

Figure FM-1: I placed these flowers on the bride's bed where the side lighting from a large window added just enough shadow to create some mood.
50mm, f1.4, 1/3000 ISO 400

What Does This Book Cover?

This book gives an in-depth look at the challenging and rewarding world of digital wedding photography. Whether you are an aspiring amateur, or a professional looking at converting to digital, this book provides valuable insights and information to assist you on your way to becoming a digital wedding photographer.

Part I: Understanding Digital Wedding Photography

This book is organized into three parts with 16 chapters. Part I is a general overview of styles, equipment, daily workflow, and some specifics about composing good wedding images.

Chapter 1 is a general overview of the world of wedding photography.

Chapter 2 discusses the three main stylistic approaches to wedding photography — photojournalistic, portrait journalism, and traditional. Topics include how your price structure dictates which style you use, a description of the methods used in each style, a look at how the images differ, and some thoughts on what clients want. The final section looks at factors to consider when deciding which style is right for you.

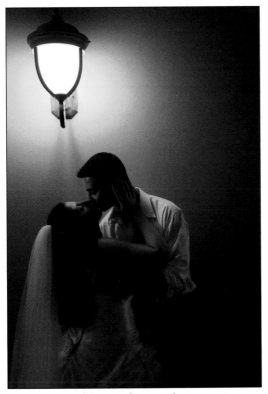

Figure FM-2: This posed romantic moment was shot at night right next to the dance floor after I noticed the beautiful light fixture and the way it cast light across the wall.
37mm, f4, 1/30th, 3200 ISO

Wedding photographers have a set of unique and specific equipment needs, as you discover in Chapter 3. Many equipment choices you make are simply a matter of personal preference, while others are dictated almost completely by the specific requirements of the job at hand. No matter how serious your business aspirations, this chapter can give you a long list of qualities to look for as you shop for that perfect camera system.

Chapter 4 covers the reality of day-to-day business as a photographer. Photographers must each develop an organized system that allows work to flow from one task to the next as each job progresses from beginning to end. The term *workflow* refers to the sequence of steps involved in taking one job from start to finish. The workflow information you gain in this chapter can help you to streamline your business so that it functions as efficiently as possible.

Chapter 5 discusses how the rules of good composition are simply guidelines that help to set you on your way towards creating great art. These guidelines are valuable to all artists, but the beginner stands to gain the most from learning and adhering to them. As you master the basics, you develop a *feel* for when you can bend or break the rules and still create images that work.

Part II: Shooting Weddings on Location

Part II looks at each type of location and each major aspect of wedding photography in its own chapter. Topics include shooting in the dressing rooms, indoor shooting, outdoor shooting, shooting candids, shooting the ceremony, creating romantic images, shooting at the reception, and finally, how to shoot a destination wedding.

Chapter 6 covers information on how to develop a comfortable relationship with people while shooting in the dressing rooms. Anyone getting started in wedding photography needs to know how to approach the dressing rooms so that your clients will trust you to capture great images while still respecting everyone's need for privacy. Other topics range from what sort of equipment is needed, what settings to use, dressing room etiquette, how to arrange the room, and how to create detail shots that capture the feeling of the day.

Chapter 7 covers general concepts and specific techniques that can help you deal with changing outdoor light conditions from the bright sun of a mid-day ceremony to the complete darkness you may encounter with a late evening event.

Shooting indoor weddings requires some specialized equipment as well as a lot of knowledge about how an indoor ceremony works. Chapter 8 covers everything from how to put out the candles, how to set up your lights, how to avoid reflections, and how to select a good background for family groups. Reflections are discussed in detail because they are a constant threat to your indoor images and you need to know why they happen and how to avoid them if you want to shoot indoors. The dark scenes you often encounter shooting indoors present a unique set of challenges — forcing you to make decisions about whether to set your ISO high and go for the natural light look or to use artificial light and lose the naturalness of the scene. Your personal shooting style dictates which type of images you choose to create.

The ceremony can easily be considered the pinnacle of every wedding day. Chapter 9 provides an in-depth look at this important time in the wedding day. Months of preparation lead up to this one moment and yet, when it actually happens, it seems to go by so fast that I often find myself standing there thinking, "Is that it? Is that all of it?" Thankfully, most weddings follow a very predictable sequence of events that seldom varies within the US. This predictability allows an experienced wedding photographer to stand in exactly the right spot at exactly the right time to catch the most important events. This chapter shares some insights and the thought processes that go into every movement that a professional photographer makes during those few fleeting moments of the ceremony.

Chapter 10 provides information on equipment to use as well as tips on capturing candids by learning how to see them coming. A good candid image is a snapshot that captures a spontaneous natural moment. Candids frequently tell a story, but more importantly, they simply capture people living their lives. The images are not contrived or posed. Candids catch rare and fleeting moments of reality — often achieving a "snapshot" look by trading perfect photographic technique for speed.

Chapter 11 describes a few of the techniques and thought processes that go into creating a type of image that contains such elusive qualities that no words can fully describe what it is or how it should look. For thousands of years, artists have been trying to capture or create images that portray romance. Photographers, painters, and sculptors alike all struggle with the same question, "What does romance look like?" For that matter, what is romance? Like beauty, romance is an elusive trait that only the eyes of the beholder can judge. Every person knows it when they see it, yet no two viewers see it in the same place.

Chapter 12 covers shooting at the reception. During the hours that follow the ceremony, you will have few responsibilities and only a couple of "must have" shots to capture. There are shots of the food, the first dance, the cake cutting, and the garter and bouquet toss. The last portion of this chapter introduces some advanced flash techniques that are so much fun to experiment with that you may find yourself staying at the reception far into the night.

Chapter 13 discusses the special requirements and rewards of destination weddings. Topics include options for marketing yourself to these clients, pricing the job, choosing the right equipment for travel, and getting there and back in one piece.

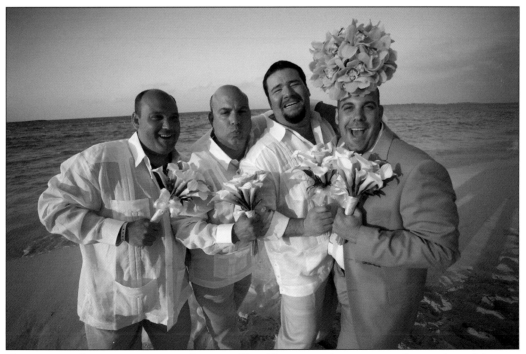

Figure FM-3: If you encourage people to get silly with a group shot, you never know what might happen. This fun loving group was shot on the beach by the RIU Resort on Paradise Island, Bahamas.
17mm, f4, 1/1500th, 250 ISO RAW

Part III: The Business of Digital Wedding Photography

The last section of the book looks at the most important and least glamorous side of wedding photography — running a business. Topics include how to create your own workspace, what types of equipment you need, and what sort of products you might offer to your clients.

Chapter 14 offers a brief overview of the types of locations and office equipment you need to create a full featured digital wedding business, capable of handling all aspects of image processing and client contacts. The space needed may be as small and unassuming as a spare bedroom or as large as a full-featured studio, without having any effect at all on the style or the quality of the final product. This chapter looks at the physical space where a wedding photographer works on a day-to-day basis, as well as the many different types of equipment and software needed to run a successful photography business.

The digital wedding photographer spends the vast majority of the total working hours sitting in front of a computer in a digital studio. Chapter 15 looks at the various jobs you must perform in this rewarding yet tedious part of a digital photographer's day. Tasks range from downloading and editing the previous weekend's images, to cropping, correcting, and touching up the images in Photoshop. This chapter also takes a much deeper look at the digital wedding workflow that Chapter 4 covers briefly.

Chapter 16 looks at the various ways you can deliver products to your clients, from online print sales, albums, DVD data discs, DVD slideshows, and more. The digital age has created an explosion of products that you can offer to your wedding clients. The choices are so numerous that the job of narrowing down to the best offerings is a very difficult and time-consuming task.

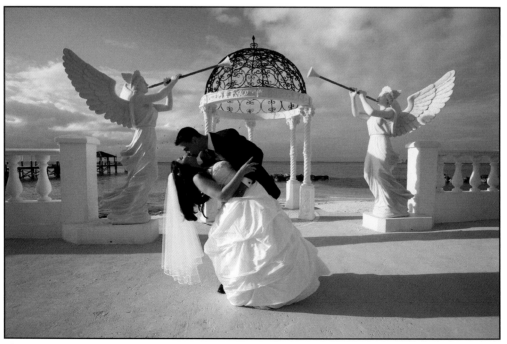

Figure FM-4: Dramatic couple portraits are a lot of fun. Finding a location and knowing how to use it are discussed in various chapters throughout this book.
17mm, f8, 1/1500th, 400 ISO

Contributing Photographers

Many thanks to the following photographers for sharing their wisdom and their images for this book.

Juan Carlos Torres
www.willamettephoto.com

Jay Kelly
www.jaykellyphoto.com

James McCormick
www.studiocoburg.com

Joe Milton
www.josephmilton.com

Bill and Anne Holland
www.HollandPhotoArts.com

Heather Mabry
www.eclecticimagesphotography.com

Amy Lizotte
www.aperturephotographics.com

Contacting the Author

Glen Johnson is available for speaking engagements and weddings. You can contact the author by e-mail at aperture1@hotmail.com or books@aperturephotographics.com.

For more information on the author and upcoming projects, you may visit his Web site at www.aperturephotographics.com.

Acknowledgments

I would like to thank the folks at Wiley for choosing me for this project, and giving a novice author a fantastic opportunity. Thanks especially to Mike Roney for his help and encouragement. Thank you Serge Timacheff for your very thorough tech review and for bringing me back to the point when I wandered off track, which I often do. Serge's input changed and improved this book tremendously — all for the better. Thanks again for your knowledge and for taking the time to help Serge!

Thanks to my Mom for being my constant cheerleader in all that I do. And thanks to my father for sending me to my first photo seminar, and for putting up with me stealing every camera he ever owned.

Contents at a Glance

Contents

Part II: Shooting Weddings on Location 97

Chapter 6: Finding Beauty and Emotion in the Dressing Rooms 99

Chapter 7: Shooting Outdoors . 117

Part III: The Business of Digital Wedding Photography 237

Chapter 14: Creating Your Own Workspace 239

Understanding Digital Wedding Photography

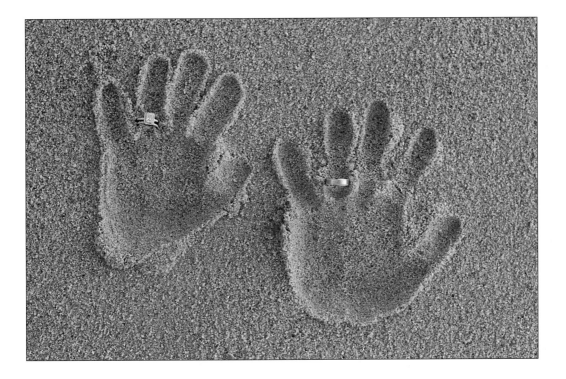

1

The World of Wedding Photography

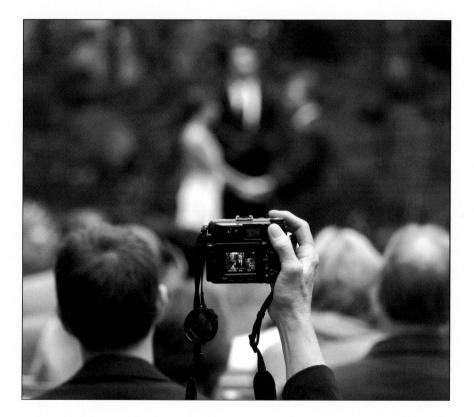

Wedding photography varies from other types of photography in that it moves from place to place as you are constantly trying to catch people in the act of doing something. The pressure to perform your duties quickly can seem extreme when you have to set up and compose twenty group shots with a hundred thirsty people that have only you standing between them and the bar. However, the external pressure from the guests is nothing compared to that internal nagging fear in the back of your mind that you have to get it right because you won't get any second chances to do it over.

Capturing Weddings

Wedding photography is not something that can be distilled into a simple formula that you can repeat over and over. No two weddings are alike and even if you do go back to the same location, the scene is always different every time. Every day has different light, different people, different customs, and so on. You can't sit down the night before and plan your workday or plan what kind of images you want to create. You have to be ready for anything, and you have to go into it with an open mind. Figure 1-1 is an example of the extreme lighting conditions you may face on a typical wedding day.

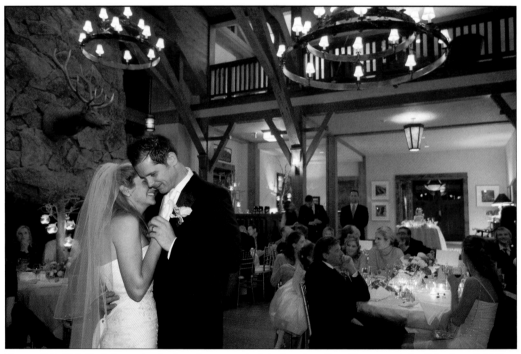

Figure 1-1: This first dance took place in a very dark indoor location. You can make it look well lit if you know how to mix your flash to get the foreground, while adjusting your ISO to get just enough of the background.
29mm, 1/8th, f4, 3200 ISO

If you are considering diving into wedding photography as a career, or even a part time job, Figure 1-2 is a typical scene you can expect to find at a wedding. Teaching you to see them and capture them with your camera is the goal of this book.

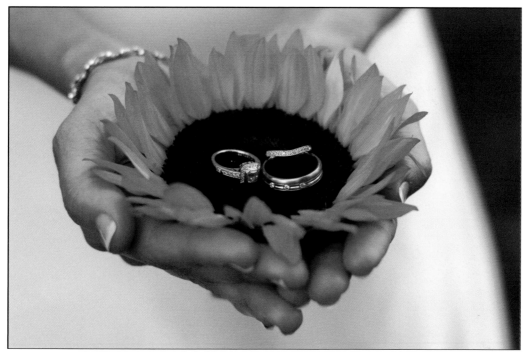

Figure 1-2: Ring shots are a great opportunity to push your creative limits.
50mm, f2.4, 1/256th, 400 ISO

Challenging and Rewarding Profession

The world of digital wedding photography can be both challenging and rewarding. You set your own hours during the week and then on the weekend, you work at the grandest party a couple may host in their entire lives. You get to be a "fly-on-the-wall" on one of the most important and emotional days in a couple's life, following every move the bride and groom make from the time they arrive in the morning until they leave at night. If you get good at it, they won't hesitate to pay you large sums of money and fly you around the globe in order to get your services.

As glamorous as the job may sound, the reality is that the digital wedding photographer spends long hours sitting in front of a computer, editing images, building a Web site, working on album pages, answering e-mails, burning discs, and more. The actual wedding shoot is only a small portion of the whole job.

A famous and very true saying about wedding photography is "You can be the best photographer in the world, and still starve if you don't know how to run a business; or you can be a mediocre photographer and make millions if you are a good business person."

I've had young people ask me what sort of college classes they should take to prepare them for a career in photography. My advice is to take classes in this priority: business management, advertising, Web site development, computer technology, art, and finally photography. Yes, that's right, photography is last on the list, because without a strong basis in the other skills, your photographic abilities are pointless.

Using the Tools of the Trade

The tools of the trade are few. As businesses go, wedding photography requires only a small cash outlay to get the few pieces of high quality equipment necessary for the job. Learning how to use the equipment is the real challenge, because, fortunately for photographers, having the best tools does not make you a good wedding photographer. Many excellent wedding photographers use old, beat up cameras that are much less capable than the cameras many wedding guests will be toting around during and after the ceremony. However, as you probably already know, cameras don't take pictures — photographers do! A good wedding photographer could do better with a point-and-shoot than what most people can do with a top of the line digital camera.

Camera choices

The specific tools that each photographer uses are a relatively minor part of the wedding photography business. As in Figure 1-3, the important part is how skilled the photographer is at seeing a beautiful moment and capturing it in an artistic manner. For example, when you admire a painting by Picasso, you don't wonder what brand of brush he was using. The tools he used are as irrelevant as the choice of Nikon versus Canon. The artistic vision of the person and the technical expertise necessary to capture that vision are what makes the real magic of wedding photography.

Figure 1-3: The last few moments before the bride heads down the aisle can yield some very emotional images.
100mm, f4.5, 1/90th, 400 ISO

Personality goes a long way

One of the most valuable tools you can have as a wedding photographer is the right kind of personality. You don't have to be the life of the party, but you should have a friendly and outgoing personality that puts people at ease almost immediately. If you don't like people, or if you are impatient or easily frustrated with people that are always late and just generally can't seem to get it together, then this job won't be a good match for you. If you function well under pressure, if you are flexible enough that you won't mind making last minute plan changes when the bride is late, and you like working with people, then this job might be a good match for you.

Training your eye

The last and most valuable tool that you need as a wedding photographer is knowledge. You need to develop your skills and understanding of photography to the point that taking a picture is no more difficult than walking across the room. When you see an activity taking place, you need to move to the location that will allow you to tell the story with your camera. With practice, your eyes will tune in to the types of locations that make good portrait backgrounds. Eventually you will find yourself noticing them even when you are not at a wedding. A trained eye can only be gained through experience and practice.

Getting experience

With this book, you can read all about how to make images as seen in Figure 1-4, but no amount of reading can substitute for the experience you get while actually working on a real wedding. I highly recommend that you seek out wedding professionals in your area and ask them if you can assist or shoot as a second photographer in order to gain the experience and confidence needed before you take on your own first wedding. In the beginning, you should expect little or no pay for the education you get on these jobs. Simply consider it the cheapest college course you ever bought and learn all you can. As your skills progress, you can start being paid for your work, but don't expect to be paid much when working as a second photographer. The point is to get experience. When you reach the point where your mentor has little left to offer, take your portfolio and seek out someone better. Eventually you will have to shoot a wedding on your own to understand the full impact of being a wedding photographer.

Other valuable sources of education include seminars at big photography conventions like the annual WPPI convention in Las Vegas, or your state branch of Professional Photographers of America (PPA). Of course, there are also photography schools where you can get classes on all types of photography and business topics as well.

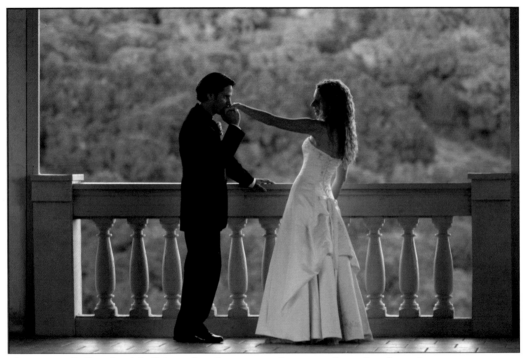

Figure 1-4: Finding the right light and posing a romantic scene takes a lot of practice.
118mm, f2.8, 1/128th, ISO 400

Recording Life's Milestone with Pictures

In almost every human life, there are at least four major milestones: birth, marriage, birth of the first child, and death. A wedding photographer has the privilege of being a witness and a historian on one of those four big days.

If you've ever looked through old albums of pictures from your childhood, you may realize that the memories you have of your childhood are actually somehow tied to the pictures. For example, you probably have many pictures where you can't remember anything else that happened during that day or even that month, but because you've looked at that picture many times over the years, the events immediately surrounding it are somehow burned into your memory. I can't explain how it works, but I do believe that photographs help us to store memories in a way that makes them last for the rest of our lives.

The first time a bride looks through her pictures, there is a very high likelihood that she will be moved to tears. If you've done a bad job, they will be tears of deep sorrow. If you've done a good job, they will be tears of joy—the same tears that she cried when the groom read his vows and when her father made a toast to their happiness. These are the memories, as in Figure 1-5, that you've frozen in time for her. Other types of photography are important of course, but few are as emotionally charged as wedding photography. What I like most about wedding photography is the fact that my clients think what I do is truly, important.

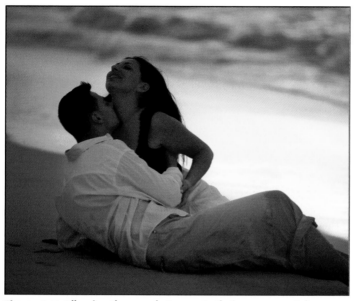

Figure 1-5: Allowing the couple to create their own pose takes a little bit of coaching and a lot of ability to see when they've got something good and press the shutter before it disappears.
195mm, f2.8, 1/512, 250 ISO

One of the greatest compliments I've ever received illustrated that point even more clearly when one of my past brides wrote to tell me how emotionally overwhelmed she was when she first saw her wedding pictures. Soon after that she decided she wanted to be able to give that same feeling to other brides, so she changed her career goals and she is now in her second year of college on the way to becoming a wedding photographer herself.

Breaking into the Business of Wedding Photography

What is it that attracts so many to the lure of wedding photography? Having been the paid photographer at hundreds of weddings, I still find myself amazed at the number of people that recognize the best angle, and stand up in front of me to try their hand at getting a good shot of the bride and groom. They are all interested in wedding photography on some level. Few have professional aspirations, but many will come up to me repeatedly throughout the day and ask questions because they are genuinely interested in the wedding photography business. You can see the gleam in their eye as they think to themselves, "I could do that!" More fuel is added to the fire when they find out that the bride not only paid my photography fee, but she also paid to fly me out to the wedding site. Then when I tell them that my next few weeks include weddings in Mexico, Jamaica, the Virgin Islands, Aruba, Greece, and Hong Kong, their eyes really get wide and the jaws drop open a bit in disbelief. After all, wasn't it only just a few short years ago that real photographers didn't shoot weddings?

Even today, there is a remnant of that feeling among some older photographers, but the younger crowd is embracing the new world of wedding photography like never before. With the likes of Joe Buissink and Mike Colon showing up on TV shows like regular celebrities, wedding photography is taking a decided turn in popularity. It's becoming downright stylish!

Of course, reading this book won't make you a celebrity wedding photographer, but it will give you all the information you need to start down the path in that direction. Who knows where that path may take you. Even if you don't want to go jetting off to exotic locales, shooting weddings right in your own neighborhood is a great way to make a very comfortable living while doing something that is fun, creative, and truly enjoyable.

Summary

The world of wedding photography is an exciting and challenging place to be. If you are an aspiring professional photographer or simply an amateur that wants to learn more about digital wedding photography, you will find that the business is surprisingly easy to enter into. After you've built a small portfolio by either working with an established photographer, or shooting free, there is no shortage of eager clients who are more than willing to try you. It may take several years to work your way into the higher price bracket, but when you do, you may find clients willing to pay outrageous fees to reserve your services.

The job definitely has its challenges. You have to learn to control your equipment in any sort of lighting conditions imaginable, with lots of hectic activity going on around you, and with lots of people watching and waiting on you, and you will end up spending much more time running the business than what you spend shooting pictures.

The rewards for your labor, aside from making a comfortable living, are that you get to perform a service that is extremely important to your clients. Many of them will tell you that your pictures are one of the most important things happening on the wedding day, second only to the act of getting married. They want very badly to remember this day for the rest of their lives, and they trust you to create the images that will keep the memories alive.

✦ ✦ ✦

2 Developing Your Own Style

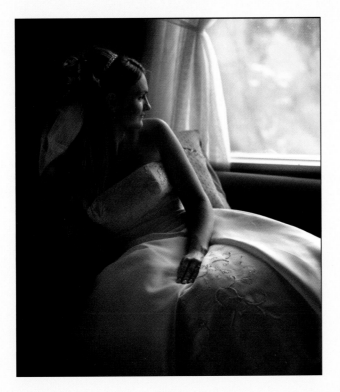

This chapter begins with a discussion about various methods for pricing wedding photography. Although the topic may appear to be misplaced, it is actually vital to understanding the different styles of wedding photography because the price structure you use determines your motivation for shooting the images you do.

Your "style" of photography is a combination of the way you act while shooting the pictures, and what sort of pictures you create. Wedding photographers generally fall into one of three styles; however, it is possible for one photographer to shoot in more than one style. This chapter takes an in-depth look at the three main stylistic approaches to wedding photography: traditional, photojournalistic, and portrait journalism. Topics include discussion on the different photographic techniques used in each style, how the images differ, what the clients want, and which style is right for them?

Two Business Models

There are two financial models for a wedding photography business. I call them the *Aftermarket Sales* business model and the *Creative Fee* business model. The one you choose determines your motivation for taking pictures, which then determines what sort of images you create.

Low prices up front

The oldest model and the one that has been a longstanding tradition in the wedding business, is the Aftermarket Sales model. These photographers charge a low initial fee and then rely heavily on aftermarket sales of prints, albums, frames, slide shows, and so on, to bring in the real profit. The typical wedding package includes the service of taking the pictures, but then clients must purchase any prints, albums, or other items after the wedding. These photographers keep the negatives or digital files in their possession. In a typical package, the clients have nothing but the images they purchase after the wedding is over. With this model, it is not unusual for clients to be surprised at the high cost of prints and then end up spending more on reprints than they originally spent on the entire photography fee. The photographers who use this model are not out to cheat anyone; they just know that human nature makes us all suckers for a low price, and with all the competition photographers face, any little thing you can do to lower your price or give the appearance of having a low price, helps to draw in more business.

In the traditional style of shooting seen in Figure 2-1, photographers are looking for images that the couple may want to purchase for framing or to put in an 8 x 10 album. These albums have thick pages that limit the size to a maximum of about 60 pages, and many of those pages are occupied by the group shots. Of course, the couple may also purchase many loose prints in smaller sizes to give as gifts to family and friends, but with this limited number of purchases in mind, it doesn't take much experience for a photographer to get a feel for the types of images that clients want to buy and then shoot only those.

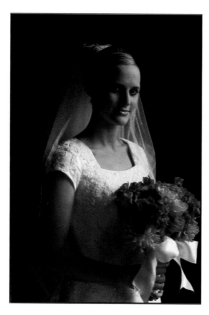

Figure 2-1: Traditional-style images are not found; the photographer creates them.
50mm, f2, 1/128, 1600 ISO

High prices up front

With the Creative Fee business model, photographers charge the full amount of the entire sale up front. The client pays for the photographer's style and expertise, and the photographer typically delivers images on a disc that the clients can keep and print in any quantity they like as long as it is for personal, noncommercial use. This Creative Fee pays for the photographer's talent, overhead, business expenses, and everything else that the photographer needs to make in order to stay in business and make the desired profit. With the Creative Fee business model, the finished product is frequently a full resolution set of images on DVD or CD, so when the photographer delivers the disc set to the client, it is often accompanied by a "good-bye!" After that day, the photographer and client may never speak again unless the client orders an album or custom prints.

The motivation factor

The price structure creates the motivation that influences what sort of images each photographer creates. For example, if you are paid a low price up front and the only remaining income is generated from print sales, then there is no motivation to take a shot unless it generates print sales (see Figure 2-2). You may take a few extra shots just to be nice, but you are not required or motivated to put any effort into anything unless you think it will sell.

On the other hand, if the photographer is paid up front to provide photographic services for the day, he or she has no thoughts about print sales. This person is thinking about shooting anything the bride and groom might find interesting. Instead of thinking of print sales, you become the bride and groom's personal photographer — shooting anything they ask for, and anything else you see, in an effort to create a complete record of the day. Instead of wondering what the bride and groom will buy, your driving motivation is to capture what the bride and groom will want to remember about this day. There is a huge difference in the pictures that result from each type of motivation, and these differences are the essence of what separates the traditional style of photography from the portrait journalism style. The traditional style is motivated by print sales and portrait journalism is motivated by the need to create a record of the day. The image in Figure 2-2 would not have been shot if I was concerned with print sales, but it makes an excellent contribution if you are trying to tell the story of the wedding day.

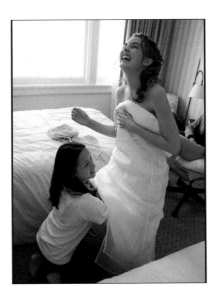

Figure 2-2: Cute little moments like this are of very little value to a photographer who is concerned with print sales.
18mm, f3.6, 1/181, 400 ISO

Follow the money trail

The vast majority of photojournalistic and portrait journalism style photographers operate a one-man-show sort of business with no studio and no staff. If you have to do everything yourself, it doesn't take long to realize that you can make much more money taking pictures than you can from printing a bunch of 4 x 6s for grandma. The Creative Fee model allows these photographers to concentrate on shooting weddings, which is what they do best and what makes the most money.

Traditional-style shooters tend to have a much larger operation. Having a large studio space and a staff of one to 20 people is not unusual, because these types of businesses rarely specialize in weddings. They are normally shooting something every day of the week. They might do weddings on the weekend and then portraits, school photos, and commercial work throughout the week. The staff takes care of all the non-photographic work, leaving the photographer to concentrate on the photography.

With total sales often reaching a third higher, the Aftermarket Sales business model may appear to make a lot more money than the Creative Fee business model. Even though the net income potential is high for the aftermarket model, there are also many more costs involved such as studio rent, staff salaries, an accountant to track staff and tax information, and large bills to suppliers of prints, frames, and other items. So the studio photographer may be supporting a whole community of staff, but if you average it all out, the gross income with both models from a single wedding is very close to even.

With the advent of the online storefront (see Chapter 16), all three styles are now taking advantage of increased print sales. This outlet allows the photographer to do a small amount of work by posting to the Web site and then completely removing oneself from the production of the prints after that point. Not only do the photographers reap the benefits of extra sales, but also many brides are requesting this service from all three styles of photographer, because it allows friends and relatives in distant places to view the pictures and purchase their own copies without hassling the bride and groom.

Traditional Wedding Photography

As the term implies, the traditional style is the oldest and still the most common style of wedding photography practiced today. The style can generally be summed up in one word — posed. The images created by photographers using this style are carefully arranged to bring out the absolute best in the client. There is very little effort made at creating images that capture reality. In fact, it could be said that these photographers don't capture images — they create them. Like the example in Figure 2-3, Traditional-style images are exquisite portraits of the people and typically a few of the major events from the wedding day.

Equipment

The tradition is so deeply ingrained in our culture that it remains by far the most popular style of wedding photography to this day. The style evolved in the early days of photography when professional cameras were large and bulky. The 4 x 5 Speed Graphic was the camera of choice for many years. As black-and-white film eventually gave way to color, the Hasselblad with its 6 x 6 centimeter negative and the Mamiya 6 x 7 centimeter gained popularity as the smaller, lighter cameras. Although not small or light by today's standards, these cameras reigned supreme throughout the film era, and many film camera users still produce wonderful work with them today. The size and weight of these cameras doesn't

exactly encourage fast shooting. In fact, they encourage a slow, methodical approach best suited to the photo studio and the meticulously posed group shots that are still associated with the traditional style today. The vast majority of these photographers still use film, although many are converting to digital.

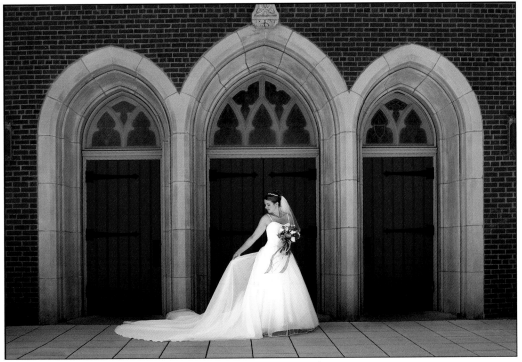

Figure 2-3: Traditional portraits are well lit and carefully posed.
28mm, f8, 1/250, 400 ISO

Personality

Another typical aspect of this style is that the photographer is very active and vocal about guiding the event. This can be an advantage if the couple failed to hire a coordinator. The photographer can organize and move people involved in the formals, as well as frequently ask the couple and guests to stop what they are doing and smile at the camera for a shot. This interaction is most noticeable during the reception as the cake cutting and first dance are often interrupted by the photographer asking the couple to look this way and smile. Although obviously very intrusive, this process of stopping people for a smile is so embedded in the tradition of the style that it is seen as completely acceptable. The tradition is so strong that sometimes the officiant or the DJ may actually stop the couple and tell them to look over at the photographer and smile without even checking with the photographer.

Services and items offered

Traditional-style photographers typically offer a package that consists of a few hours of coverage that includes all of the ceremony and the first hour or two of the reception. The initial payment for the photography is generally on the low side compared with other styles. This is partially because the photographer makes much of his or her income from the sale of prints and albums after the wedding is over. This is the Aftermarket Sales business model. At some time after the wedding day, the newlyweds meet with the photographer to view a set of proofs. At that time, they can place orders for wall portraits, prints for the album, and prints to give as gifts. A professional salesperson on the photographer's staff often conducts the proof-viewing session. This person is well trained at guiding the presentation for the ultimate emotional impact and then capitalizing on that emotion for high sales. The work of keeping track of these sales, filling print orders, framing prints, and constructing albums practically demands that the traditional photographer have a staff of at least one other person. If the studio does much volume at all, these jobs are far too demanding for a single photographer to keep up with and still hope to have any time left for taking pictures.

The wedding day

On the wedding day, the photography session often starts with a half-hour of setup time where the photographer and assistant set up two or more studio lights with umbrellas. This is in preparation for the *formals* or family group shots. If the altar area is acceptable, it is used as the background; if not, a large studio backdrop may be set up. At large weddings, two or more of these sets may be set up to work at the same time. The family and wedding party file in for group pictures. This portion of the shoot often requires two hours or more to get the many different combinations of the bride and groom with the wedding party and all the relatives attending. Each shot is meticulously arranged to very exacting standards. By the end, the bride and groom are frequently complaining of sore facial muscles from so much sustained fake smiling, and it is common for guests to complain about how long the photographer took even though it was the bride who insisted on the large shot list.

During this session, the photographer typically does not allow any of the guests to shoot images with their own cameras. This is occasionally a point of serious contention with guests trying to sneak in a shot and the photographer or assistant acting as police officer to stop them from doing so. The reason for this is that the photographer makes money from print sales. If a guest takes a picture of the same groups, they obviously won't need to purchase a print. In fact, they may later pass out their own prints free, which further erodes the photographer's potential income. The only way to deal with this without causing a lot of stress is to limit the number of guests that are present in the photo sessions and then to make a general announcement when the photo session is just beginning, requesting that no pictures be taken by the family or guests. If someone refuses to comply, it is debatable whether you will lose more in print sales by letting them take their shots or by causing an angry scene in the middle of the wedding. If you manage to anger the bride and her family, you stand to lose a lot more than the price of an 8 x 10.

After the formals session, the photographer typically captures images of all the big moments, such as the ceremony, the kiss, the couple leaving the altar, the couple entering the reception, the first dance, the father/daughter dance, the cake cutting, garter toss, and the bouquet toss.

After the wedding

After the couple returns from the honeymoon the studio schedules a viewing and ordering session. The final proof set (see Chapter 16) that the couple views may only include a few shots from each of the wedding events, because the photographer knows that clients won't purchase any more than that. The

typical traditional-style shooter takes roughly 350 shots, which are a combination of perhaps 50 shots (five rolls) of medium-format film taken during the formals and another 200 or so 35mm shots (seven rolls) from the ceremony and reception. These images are printed in 4 x 5 or 4 x 6 and the bride is allowed to borrow this set (often with a large deposit as insurance that it will be returned) for viewing purposes only and only for a limited time. From this selection, the couple and their families may purchase single prints and select images to include in albums.

Photojournalistic-Style Wedding Photography

Several key features such as large numbers of mostly black-and-white images, an unobtrusive presence of the photographer, and a distinct lack of posing characterize the photojournalistic style. The true photojournalist does not rearrange anything or ask anyone to do anything, such as smile, pose, or move to a better location for pictures. Images are captured without any disturbance from the photographer and they do not undergo any major changes in Photoshop aside from minimal sharpening and converting to black and white. Some photojournalistic purists flat-out refuse to do any sort of posed photo shoot at all. Being that strict may seem like a certain recipe for disaster, but a growing number of brides prefer this approach. It allows the couple and guests to enjoy the wedding day without worrying about turning it into a photo shoot.

History and current trends

The photojournalistic style evolved as a lucrative weekend opportunity for working photojournalists that were hired by newspapers during the week. Shooting with the same cameras in the same basic style they were trained in for the newspapers, and with the same ethic of unobtrusiveness soon won them a place all their own in the wedding photography world. The images they capture are often described as real and honest representations of the day. They simply capture what is actually happening. Nothing is made up for the pictures.

These photographers have converted from 35mm film to digital SLR right along with the newspapers they work for during the week. Many of the best photographers are in such high demand that they eventually leave their newspaper careers behind to focus on wedding photography full time. The photojournalistic style is attracting new photographers at a fast pace. Some of the newcomers simply have a quiet personality that fits well with the style. Others appreciate the hands-off approach to wedding photography.

Brides are seeking out photojournalistic-style photographers in record numbers. It is no accident that the sudden growth of this style coincides with the equally sudden growth of digital photography. Digital cameras have the perfect match of speed, quality, and low expense per shot that the photojournalistic style thrives on. This combination is very quickly changing the face of wedding photography.

Personality

Photographers using this style have the opposite of the intrusive mannerisms of the traditional style. In sharp contrast to stopping the first dance and asking the couple for a smile, the photojournalist is faced with the far more difficult task of catching the couple in the act of *really* smiling. Pulling this off takes a lot more patience and obviously a certain amount of luck as well. Without the ability to control and arrange matters, photojournalistic photographers must be tuned in to the people and events so that they can predict when the elements of a good photograph are about to come together. This sense of intuition and timing is far more difficult to achieve than simply asking someone to stand still and smile for the camera.

Informal formals

Group photos are not given much time, if any, with this style. A small number of groups are usually still included because they are so ingrained into the tradition of weddings that you simply cannot escape them. The difference is in the level of formality. Photojournalistic groups, as seen in Figure 2-4, are generally taken quickly as loose gatherings of friends and family with a scenic background. The number of groupings may be limited to 15 to 20, and all of these are frequently taken in less than half an hour.

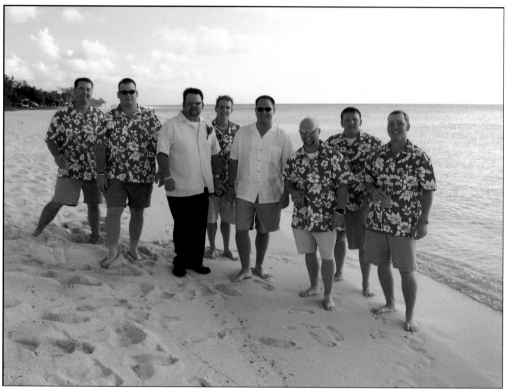

Figure 2-4: In the photojournalistic style, family groups are generally low key and quite a bit less formal than with the traditional style.
18mm, f5.6, 1/512, 100 ISO

During the group photo session, other photographers can be ignored as they snap away right over the photographer's shoulder. There is no motivation to clash with these folks because you've already been paid in full. If there is more than one or two of these amateur photographers, it will be in your best interest to get them in line with your own goals by telling them that they need to stay close behind you so that the people in the shot are all looking in the same direction. You might also make it clear that you won't be waiting for each photographer to snap a shot; they need to take their shot when you take yours so that you can keep moving quickly from one grouping to the next.

The wedding day

The photojournalistic photographer typically starts shooting in the dressing rooms and continues late into the evening, capturing images of all the big moments as well as the smaller details. Anything that catches the photographer's interest is captured along with anything that the photographer feels may be even mildly important to the bride and groom. As you can see in Figure 2-5, catching every event is important; every smile, every tear, nothing is too small and everything is fair game because the photographer is being paid to tell the whole story of the day. Of course, the goal is to tell the story in a way that is quite a lot more than simple documentary. Beautiful, unstaged images are the trademark of this style. How many images does it take to tell the whole story? The actual number of images depends largely on the wedding, but typically, the range is from 500 to 2,000 images per photographer, per day.

Figure 2-5: Instead of simply asking people to smile for the camera, photojournalistic photographers must actually catch them in the act.

135mm, f5.6, 1/320, 200 ISO Photo by: Amy Lizotte

After the wedding

Within a few weeks after the wedding, the typical photojournalistic-style photographer presents the bride and groom with a set of discs (data DVD) that contain high-resolution digital images. If the couple is interested in getting an album or custom prints, they may purchase those items at additional cost. Because the couple has the disc with all digital images, they typically choose to produce small prints for family and friends on their own. Figures 2-6 through 2-9 are representative of the types of images a photojournalist might capture.

Figure 2-6: Fun little images such as this contribute to the story, but they won't sell many prints.
50mm, f2, 1/320, 800 ISO

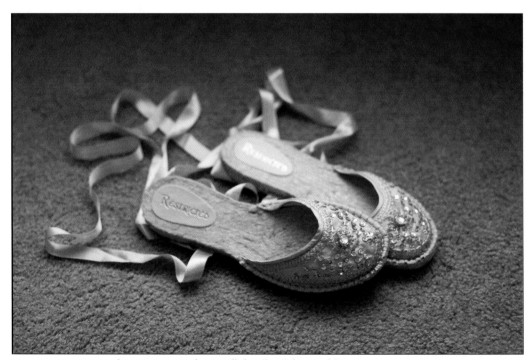

Figure 2-7: A setup shot to capture the small details of the wedding.
50mm, f2, 1/400, 800 ISO

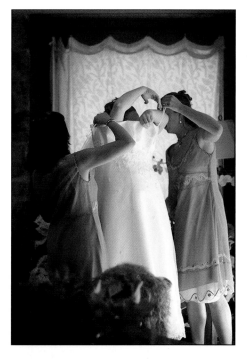

Figure 2-8: The most important shot in the dressing room is when the bridesmaids help the bride into her dress. Most brides have been waiting for this moment for years and it is very common for emotions to run high as the dress goes on.
17mm, f4, 1/90, 1600 ISO

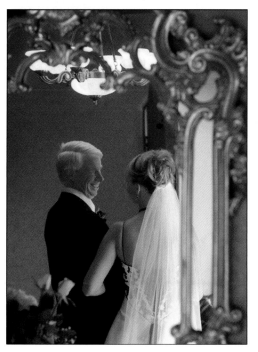

Figure 2-9: The moment before the bride and her father walk through the door to the church is often filled with emotion as they take that last glance at each other in private.
50mm, f2, 1/90, 400 ISO

Portrait Journalism

The term portrait journalism seems to imply a perfect blend of traditional and photojournalistic styles. However, as you can see in Figure 2-10, photographers using this style tend to produce results that look more like a collision between fine art, fashion, and wedding photography. In reality, this style produces portrait images that range from traditional to ultramodern to fine art and anything in between. With portrait journalism, you are not bound by the constraints of being non-intrusive like a true photojournalist. You can shoot in a photojournalistic style when things are happening, and then when there is a break in the action, you can pose the bride in a beautiful location for a portrait. This lack of constraint on posing combined with the Creative Fee business model, which pays you to shoot whatever you want, combines to release the truly creative potential of the photographer.

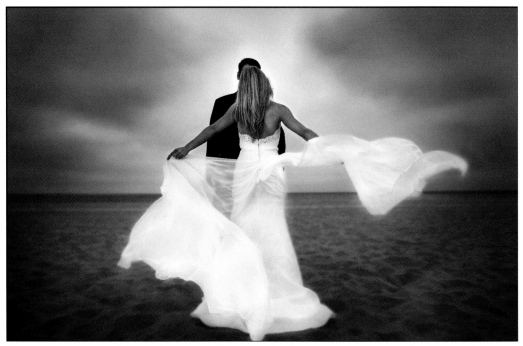

Figure 2-10: In portrait journalism, portrait images often lean toward fine art and fashion styles. Images are frequently manipulated in Photoshop to create artistic effects.
18mm, f3.5, 1/2000, 400 ISO

Distinguishing any difference between images shot by a traditional- or a portrait journalist-style photographer can be hard. Both styles allow the photographer to organize, pose, and manipulate the scene to any degree desired, and both styles create beautiful portraits. The portrait journalist is a bit more likely to use digital manipulation to enhance the image, but otherwise the techniques used are the same. The real differences between the two styles are found in things that you won't see in pictures. The most notable difference is in the way in which the two photographers work throughout the day. The portrait journalist only poses live subjects when it can be done without interfering with the natural progression of the wedding day. Any time there are events happening, such as the ceremony, reception, dancing, and cake cutting, the photographer shoots in an unobtrusive, journalistic style. Moreover, like the photojournalist, the portrait journalist shoots with the goal of telling the whole story of the day.

Current trends

Many of the most highly sought-after and highly paid photographers in the business today use this blend of styles to create exciting images for the biggest stars and celebrities around the globe. Although they often command prices in excess of $10,000 per wedding, they seem to have no shortage of clients that think their services are well worth the rates they charge.

The celebrity excitement is boosting the popularity of the style among clients, but the combination is catching on rapidly with new photographers as well. Most young photographers coming into the field today are adopting the portrait journalist style, and if that trend continues, it will soon outpace the traditional style, which is still the most common in the industry today.

The wedding day

What does this photographic style look like in action on the wedding day? For a portrait journalist, the wedding day looks very much like that of the photojournalist. Photography starts in the dressing rooms where the coverage is mostly journalistic, with some arranging of details, shots, and a few posed portraits if the location is good and the bride is willing. Before the ceremony is a group photo session that uses the same quick, low-key approach as the Photojournalistic style. The ceremony is covered in a purely photojournalistic style with no interference from the photographer. The reception is mostly photojournalistic, but any small group shots that the couple wants are accommodated. At some point in the evening, the photographer(s) and the couple sneak off for a portrait shoot, which gives this style the name portrait journalism. The photographer(s) scouts out the best locations in advance so that the session flows quickly from one prime spot to the next and back to the reception before anyone even notices they were gone.

Equipment

A portrait journalist uses a combination of traditional and journalistic equipment. Cameras are typically digital, but art lenses like a LensBaby and elaborate flash setups are not out of the question. Most practitioners tend to prefer natural light as a first choice, but they don't hesitate to use flash and other light sources when it adds to the image. Figures 2-11 through 2-13 are examples of natural light images taken in the portrait journalist style.

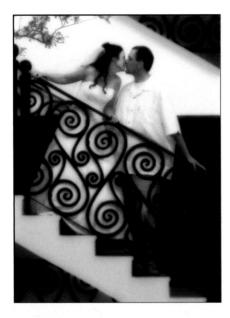

Figure 2-11: This image was pre-visualized and directed by the photographer to get the couple into a dramatic pose that complemented the lines of the stairway. *85mm, f5, 1/1250, 400 ISO*

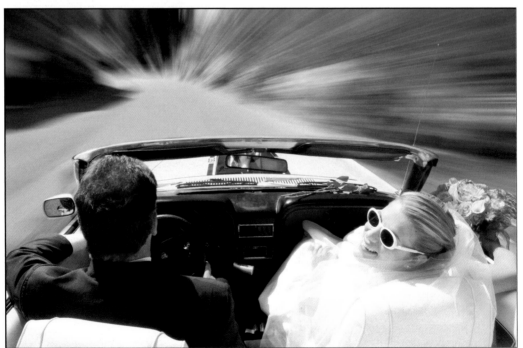

Figure 2-12: This was shot while the car was barely moving; the motion blur was added with Photoshop. The goal is not to tell the truth, but to create something dramatic or beautiful that your clients will love. *18mm, f22, 1/45, 100 ISO*

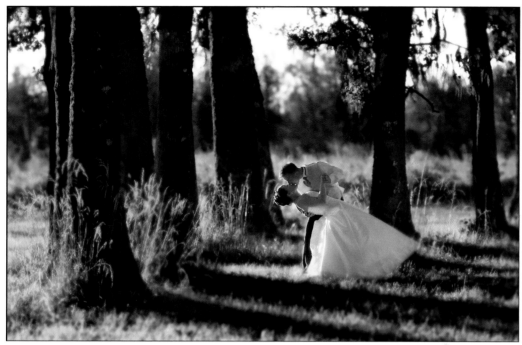

Figure 2-13: This was captured in a portrait journalist-style.
200mm, f2.8, 1/750, 400 ISO

Finding a Style That Works for You

If you are a newcomer to the wedding photography world, you may wonder where you fit in and what style you should use. You may be lucky or determined enough to land yourself in a place of employment with an experienced photographer who acts as your mentor. If so, the style you learn will certainly influence your own direction, even if only to teach you what you don't want to do. I highly recommend working with other photographers because this is by far the fastest way to learn the business and get some experience with people in front of your camera.

What is the best style to choose? There is no best style. Does it matter which style you choose? Absolutely! In fact, I would say that for every photographer there is only one best style — the right one for you depends on your personality. Which one depends on your personality? Are you the shy, introspective type who likes to hang on the sidelines and take it all in? If so, photojournalism is for you. Portrait journalism requires a similar personality but with the addition of a very strong creative streak. Traditional style calls to the photographer who has a slow, methodical approach to life — one who likes to be in control of the situation. As you work your way through the first few weddings, you are sure to find something that is comfortable for you.

The only real mistake you can make is to try to do it all. Never tell your clients you can shoot in any style they want. This is a certain recipe for mediocrity. Instead, pick a style and stick with it. It won't take long before you become known for what you do. Not all clients will like that style and many of them will pass

you by. Don't worry about that. You don't have to catch every single client out there. Just do what you love. As you get more experience, you will capture the attention of clients that are looking for what you do. Figure 2-14 is a type of image that I personally love to create. After shooting images like this for a couple years, I now have brides that come in asking if I can do something like this for them.

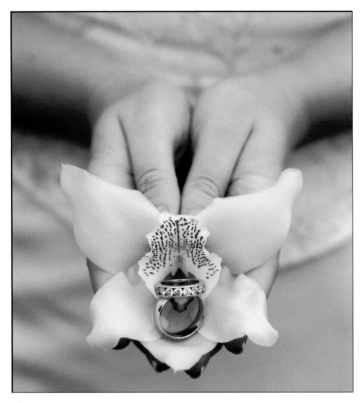

Figure 2-14: Do what you love, and clients that love what you do will find you.
50mm, f2, 1/250, 400 ISO

Giving Clients What They Want

One thing I learned in my transition from the traditional to portrait journalism style (which didn't exist when I first started) is that clients have a very predictable priority list when it comes to what they want. First, if they are forced to purchase prints by the photographer, they will almost invariably purchase the family group shots first. Then depending on their budget, they may also purchase a very simple portrait of the two of them together, then small groupings of friends, then overall shots of the event, and finally artsy shots. Even clients with the most limited of budgets invariably come back around Christmas to purchase a couple of 8 x 10s of the big family group. This says a lot about what clients need in order to fill their obligations of gift giving during the holidays, but does it say anything about what they want for themselves? As the photographer, it is your obligation to decide how you want to record the memories for your couples. What will they want to look at 30 years from now when they show their grandchildren what happened on their wedding day?

As I started incorporating more and more artsy images into my work, I realized that these images are what draws the clients in and attracts them to my work in the first place, but oddly enough, these are the last ones they purchase if they have a tight budget. It's clear that the family rules! If a young couple's house were to catch on fire, it's the family shots they grab as they run out the door, not the artsy shot of the bouquet or the bride's shoes laying on the floor. If I were to attempt to apply any logic to the situation, it would seem clear that all of my couples should have hired a photographer that specialized in the traditional style because these folks can certainly make better family group shots than I do.

Lucky for me, this logic isn't the leading factor in deciding who is hired to shoot the wedding. Of course, the family portraits are critical, but even in the traditional style, they are not what get you the job. In fact, all the standard shots, such as the family groups, the cake cutting, the first kiss, the first dance, and the bouquet toss, may make up the very core of wedding photography, but they are not what the couple looks at when choosing a photographer. In fact, I would go so far as to say that you could easily get clients to hire you without showing them a single shot from the core list I just mentioned.

Couples make hiring decisions according to a million little personality factors that make them unique individuals such as sense of taste, budget, level interest in art, how well they like you as a person, how professional you seem, and so on. None of these factors is based on logic. What couples really seem to be looking for most is some uniqueness in you as a photographer. They want something unique, as shown in Figure 2-15, created at their own wedding.

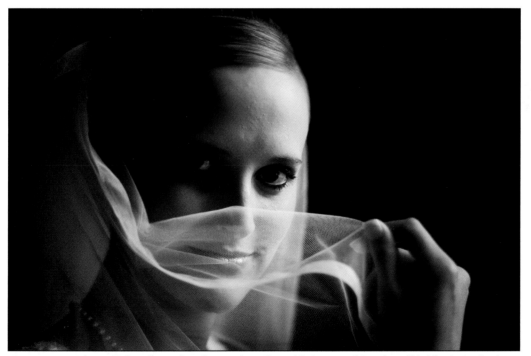

Figure 2-15: A beautiful and emotional portrait such as this is something that all brides hope for in their package.
50mm, f2, 1/125, 400 ISO

Instinctively, they know that they are only one little wedding out of the millions that take place this year, yet they want to stand out. They don't want their pictures to look like everyone else's. Right now, as you read this, there are literally thousands of brides sitting at their computers and studying Web sites in search of something different. The shooting style you choose is irrelevant because there will always be someone out there who likes your style. What matters most is that you grab them emotionally. They want to see a story on your Web site that brings tears to their eyes. If they find it, they'll turn to the new fiancé while wiping the tears away and they'll say, "Honey, where's that checkbook?"

Summary

Whether you are new to the wedding photography business or have been in it for many years, taking a good look at how your price structure determines the way you shoot is a very important step in deciding how you want to work. You must decide if you want to shoot for print sales or if you want to shoot for the bride.

Once you decide that, your personality eventually determines the type of wedding work you do. Outgoing people that like to be in control typically fall into the traditional style, while the quieter, more introverted types gravitate toward the portrait journalism or pure photojournalism styles. The style you choose won't affect your success because there are always plenty of brides around that like each style. The important thing is that you pick the style that is right for you.

CHAPTER

3

Choosing the Right Equipment for the Job

Wedding photographers have a set of unique and specific equipment needs. Many equipment choices are simply a matter of personal preference, while others are dictated almost completely by the specific requirements of the job at hand. What sort of shooting style you choose determines exactly what goes in your own gearbox. For example, traditional-style photographers typically carry a lot more studio-type lighting than photojournalistic-style shooters, and destination-wedding photographers may carry only the absolute essentials.

No matter how serious your business aspirations, this chapter covers the major equipment choices and challenges wedding photographers face. Included is information about demands your equipment might face, what equipment choices are available, and the pros and cons of each choice. If you're not yet completely satisfied with the tools in your gearbox, this chapter gives you a long list of qualities to look for as you shop for that perfect camera system.

Comparing Point-and-Shoot and SLR Cameras

A point-and-shoot camera is small, very portable, inexpensive, and yet very capable of getting good pictures even in the hands of a complete novice (see Figure 3-1). The trade-off for this small size is that the camera has a very limited set of features, including a non-interchangeable lens and functions that are very slow. In contrast, a single lens reflex, or SLR camera can use interchangeable lenses, has an add-on flash, and functions extremely fast. It is portable, but most people won't think of it as small in size. Prices currently start at around $1,000 just for the body, and an entire set with only the essential parts can cost in the $4,000 to $10,000 range. Is it easy to use? If you set it on Program Mode, it can be. A more realistic assessment would be to say that an SLR digital camera can be surprisingly simple and intuitive to use on a basic level, but a complete novice may require years of practice to understand it fully. The next few paragraphs list some specific differences between point-and-shoot and SLR digital cameras.

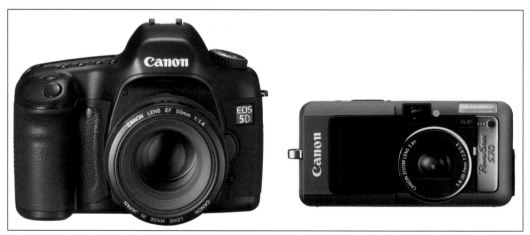

Figure 3-1: A point-and-shoot camera can get great snapshots — even in the hands of a complete novice — but it can't match the speed and flexibility of an SLR.

Point-and-shoot

I can't count the number of times I've had prospective clients ask this question with a tone of dread in their voice: "You don't shoot digital do you?" I never answer straight out because I can hear how hesitant they are about it. Instead, I ask, "Why do you ask that?" Invariably the answer is something along the line of, "I have a digital camera myself and it takes horrible pictures. It has so much shutter delay that when you push the shutter release button, people sometimes walk away before the thing goes off." This experience has rightfully tarnished opinions of digital cameras. It takes a little explaining and sometimes a little demonstration before they get the idea that professional cameras are a completely different breed of machine from the little digital point-and-shoot cameras that most people are accustomed to using.

Point-and-shoot cameras are not designed for wedding photography. Prospective clients that know little to nothing about photography will tell you that a point-and-shoot camera just won't do it when it comes to recording their precious wedding memories.

Strengths and weaknesses

To give point-and-shoot cameras their due, I own one, and I love using it for travel snapshots when I don't feel like dragging my big camera along. There are times when having a little point-and-shoot in your shirt pocket can allow you to get some great images that you would have missed otherwise. My own point-and-shoot creates 7-megapixel images that are wonderfully sharp and colorful. The problem is not that point-and-shoot cameras are incapable of making good images; the cameras are very limited in the speed at which they can function. This is true for both the speed at which the camera can perform, and the speed at which you can make the necessary changes to the camera settings to capture the next shot. Depending on whether or not the subject is moving, a point-and-shoot takes somewhere between one and three seconds to complete the basic process of focusing the lens, reading the exposure, setting shutter speed, setting aperture, and finally opening the shutter for the exposure. A Canon 20D can take 10 or more perfectly exposed and focused images in those same three seconds — even on a moving subject.

Major drawbacks

Point-and-shoot cameras have menu settings that are quite time consuming to access. If I want to change the white balance on my point-and-shoot, it can take 20 seconds or more to find the right menu and make the change. On my 20D, I'm sure I can do it in less than four seconds. Certainly a little of that is because I know my 20D so much better, but most of it is because the camera is specifically designed so that important controls can be accessed very quickly.

This difference is critical. Wedding photographers, especially those aspiring to shoot in a photojournalistic style, need to be able to make camera adjustments within seconds of the first moment when he or she first senses that something interesting is about to happen. If you fiddle around with your camera too long, or the camera takes two seconds to try to focus, the moment is gone.

I can't overemphasize how important this is in wedding photography. The knobs on professional cameras are placed in the perfect places to take advantage of the natural movements of your fingers and thumbs so that you don't even need to look at the camera to make it work. Taking a picture eventually becomes as natural as driving a car. You don't think about all the little adjustments you make to the steering wheel or the blinkers, you just think, "go left," and your body automatically flips the blinker, applies the brake, and turns the steering wheel. A professional-grade camera functions with that same amount of ease in the hands of a skilled photographer. A point-and-shoot is simply not designed to achieve such a fluid ease of use no matter who gets behind the wheel.

Choosing a Camera of Your Own

Several companies are constantly jockeying for lead position in the wedding camera market. Nikon, Canon, Fuji, and Kodak are the main players that target professional photographers. I have personally jumped ship several times in my quest for the ultimate camera system. My search has taken me from a Nikon D1x, which I believe was the very first camera with features suitable for wedding photography, to a Fuji S2, to a Canon 20D, and now to a Canon 5D. Every change resulted in very significant gains in image quality as well as increased functionality.

Choosing a digital wedding camera is a very personal decision. As such, it isn't possible for anyone to say whether this or that brand of camera is the best one for you. The camera market is also in an extremely fast growth spurt, so even if I were to point out which camera I think is the perfect wedding camera, there would probably be something better on the market by the time you read this book. Instead, what I can do is provide a list of qualities that combine to create the perfect digital wedding camera. These qualities will remain the same for years to come and they have no bearing on which brand of camera you choose. If you find yourself in the market for a new camera, using these qualities as a checklist can quickly narrow down your selection to only four or five camera models. If you are new to wedding photography, this chapter provides a good outline of what the most desirable features are, along with an explanation of why each is important to the wedding photographer. The following is a list of qualities that a good wedding photography camera should possess.

Lightweight

On the average wedding day, you may carry this camera in your hands anywhere from four to 12 hours. That's a lot of strain on the muscles in your wrists, back, shoulders, and neck, which must all work together to hold the camera up in front of your face for a large portion of the day.

Interchangeable lenses

Fixed-lens cameras have only one advantage: They don't get dust on the imaging chip because the lens and body are built into a single unit that can't be exposed to the air. This isn't enough of an issue to matter when compared to the quality advantages of using interchangeable lenses. There's an old saying: You can do many things poorly or one thing really well. Lenses are definitely subject to this rule. If you hope to get one zoom lens that covers everything from 10mm to 300mm, you're going to be sadly disappointed. Fixed-lens cameras run into this problem. For serious wedding work, you should only consider cameras that have interchangeable lenses.

Fast focus

Focus speed is critical to the wedding photographer. Your camera also needs to have options to choose either a single spot or a wide pattern of focus points. Focus should also have the option of a single focus with each touch of the shutter button or continual focusing while you hold down the shutter button halfway. Each of these features is useful at different times during an average wedding day. Most pro-level cameras actually have multiple ways that you can activate the autofocus mechanism including buttons on the lens as well as on the back of the camera body.

Fast shutter

In wedding photography, you may not need to shoot quick bursts of images very often, but when you do, you'll want a shutter speed of at least three frames per second. Most modern digital cameras function at least that fast.

Good color

A good wedding camera should produce rich, true colors with options for changing the saturation. The Auto White Balance setting should render accurate colors over a wide range of indoor and outdoor situations. In addition, making a custom white balance setting should not take a college degree. The white balance controls should be easy to access without having to scroll through hundreds of options in the menu.

No perceptible shutter lag

When you touch the shutter button, it should go off! Any delay can cause you to miss the magic moment. You can speed this process up focusing on a spot that has detail. If you focus on a smooth white wall or the center of a piece of smooth fabric, the camera, no matter what kind you're using, simply can't do anything. The focus point needs some texture to lock onto before the camera can work. Using multiple focus points can solve this problem in many situations.

Long battery life

How do batteries always seem to know when you are about as far away from your camera bag as you could possibly get before they die? Ideally, your camera should not require battery changes during an entire wedding. If your camera comes with a small battery, consider purchasing a battery pack that screws on to the bottom of the camera. These grips often include an additional shutter release button that allows you to shoot vertical images without having to raise your elbow up in the air.

Availability of a powerful TTL flash

A good camera is designed to take advantage of one or more flash units that are specifically designed to work with this camera. The flash unit should have very easy +/- exposure compensation controls to adjust the ratio of flash to ambient light. A good flash also has a little white reflector card that pulls up to deflect a small amount of light directly forward when you are bouncing the flash off the ceiling. An added bonus is a built-in slave transmitter and receiver. This enables you to use one flash on your camera to set off other flashes that are off-camera.

LCD screen

The LCD preview screen should be large and bright with vivid colors that very nearly match what you see on a color-calibrated monitor. Image scrolling speed should be adequate to allow speedy review of the images on your memory card. There should be a zoom feature that enables you to zoom in on an image to check for sharpness at 100 percent. While zoomed in, you should also be able to scroll around to see any part of the image you want. When viewing the LCD screen you should always be aware of the fact that it is not a 100 percent accurate preview of the image, especially when viewed under bright outdoor conditions where there may be so much light that the LCD image is practically invisible. Get to know the limitations of your screen, and as discussed later, learn how to read the histogram when shooting outdoors.

Vertical shutter-release button

This feature enables you to maintain the same relaxed hand/arm position when shooting either vertical or horizontal pictures. If your camera doesn't have this, check to see if the manufacturer offers an add-on battery pack. This addition often incorporates a vertical grip and a second shutter-release button.

Short power-on time

When you flip on the power button, how long does it take before you can shoot the first shot? More than a second is too long, especially if you shoot in a photojournalistic style. A good wedding camera also has an automatic power-off feature, which shuts down the camera after a few minutes of inactivity. This same feature should wake the camera when you touch the shutter button. This feature enables you to leave the camera turned on throughout the whole wedding without worrying about draining the batteries.

Lenses for the Wedding Photographer

The lenses you choose are an extremely important part of your photographic arsenal. The glass they contain is the only thing that modifies the light as it travels through the camera to eventually strike the sensor and become an image. This is an area where you do not want to conserve money. Instead, purchase lenses that are the absolute best you can afford, and then some.

Lenses obviously determine the critical quality of sharpness, but as you soon discover through the examples and text in this book, your lenses can also determine many other qualities about the way an image appears. Every type of lens has its own unique qualities and characteristics that it imparts to an image.

The f2.8 lenses that many pros think of as standard equipment often have huge glass elements that result in added weight and add an extra $1,000 on to the price tag. Is it worth it? Most professionals, including myself, agree that it is. Do you *have* to have f2.8 lenses in order to shoot good pictures? No! Most amateurs and professionals that are new to the business cannot afford the expense of purchasing a full set of top quality lenses all at once, so they may opt to purchase lenses with a variable aperture to cut down on start-up costs. Later, as the business grows, you can afford lenses that are more expensive.

Because of the fact that it is not vital to own a lens with wide apertures, I have purposefully left out any references to the aperture size in the following discussion about which lenses are best for wedding photography. It should be noted, however, that the wide aperture pro lenses are definitely the best choice. Of course, they won't make you a good photographer, but they can add a lot to the quality of your images and allow you to capture images in low-light situations that would otherwise be impossible.

The list of lenses that are essential for wedding photography is surprisingly short. There are really only three or four *must-have* lenses. The short list includes a wide zoom in the 17-35mm range, a medium zoom in the 35-135mm range, and a telephoto zoom in the 70-200mm range. These are the workhorse lenses that every wedding photographer needs.

Much of the unique flavor that each wedding photographer imparts to an image is derived from that person's choice of lenses. Some photographers seem particularly comfortable getting in close for a wide-angle view, while others like to stay on the sidelines with a long telephoto. A professional photographer has the ability to envision the look of the image he or she wants to create and then grab the lens that can do the job. One of the biggest faults for most beginners is using the wrong lens for the moment. While a professional may purposefully grab a wide-angle lens for a portrait and get stunning results, amateurs may grab the same lens without any clue as to why they did it or for what purpose the lens is normally used. The *"General Lens Information"* sidebar explains the basic uses for each type of lens with some examples of the various visual effects each lens creates. Bear in mind that when I refer to a specific lens for specific types of photos, these suggestions are only meant as general guidelines for beginners.

Wide-Angle Zoom

Wide-angle lenses are primarily used for documentary work. They can be useful for environmental portraits such as Figure 3-2 when you want to include a lot of the background. However, be particularly careful of the distance to your subject because this lens is perhaps most famous for its ability to make close-up things seem large while diminishing the size of other elements that are a little farther away. This effect can be particularly noticeable in a close up of a person's face where it makes the nose seem far larger than it should be. If you stand at normal height and shoot toward another person, you often find yourself tilting the lens downward to get the feet of your subject and to cut down on wasted space above the head. When you do this with a very wide-angle lens, it tends to make people have large heads and small feet. This is a great lens for wedding photography but it must be used with caution to avoid these distortion effects.

Figure 3-2: Environmental portraits can work great with this lens if the circumstances are right.
17mm, f/4, 1/8000s, 400 ISO

General Lens Information

Depth of field

When you focus on a particular object, there is a certain amount of space on either side of the focus point that is also in focus. This focused space is called the *depth of field*. Whether there is a lot of space in focus, or very little, is determined by the *aperture* setting. The aperture is a set of metal blades inside the lens that change the size of the opening through the lens as you change the aperture settings on the lens. Aperture sizes are listed as f-stops such as f/2.8, f/8, f/16, and so on. The smaller the f-number, the larger the opening inside the lens. Large apertures (like f/2.8) create a very shallow depth of field, while small apertures (like f/22) create a larger depth of field. The type of lens is important. In general, wide-angle lenses get a much larger depth of field than telephoto lenses.

Fixed and variable apertures

Many of the more expensive lenses are capable of holding the same aperture settings while you zoom the lens in and out. Most of the cheaper zoom lenses will change the aperture setting as you zoom. This means that as the lens is zoomed out to its wide-angle setting, the aperture will be something like f/3.5, and then as you zoom out to the telephoto setting, the aperture changes to something like f/4.5 or f/5.6. Being able to hold the aperture at a fixed position as you zoom in or out usually adds an extra $1,000 to the price of the lens.

Image stabilization

Image stabilization describes the effect achieved by placing a small motor inside the lens and attaching it to a moveable glass lens element. The motor is connected to sensors that detect small vibrations from normal camera shake. The motor is then engaged to shift an internal lens element in the opposite direction of the vibration so that it cancels out the motion. The result is the image stays in the same position in the back of the camera even though the outside of the camera is shaking slightly. Image stabilization enables wedding photographers to catch low-light images that would be completely impossible without it.

Dressing room shots

The wide zoom is the first thing I grab when heading into the dressing rooms. These places are often extremely cramped quarters and I frequently find myself standing in the shower stall or on top of a toilet just to keep from being trampled by bridesmaids jockeying for the mirror. The wide-angle zoom has a wonderful ability to capture practically everything in the room except the photographer. This lens is a wonderful storyteller, as seen in Figure 3-3.

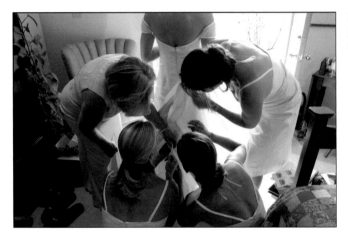

Figure 3-3: The wide-angle lens is great for shooting in tight places such as dressing rooms.
18mm, f/3.5, 1/45s, 1600 ISO

Dancing shots

Another use for the wide-angle lens is to capture dancing shots at the end of the reception. This is quite possibly my favorite part of the entire wedding day. I love the challenge of getting in close enough to the dancers to fill the frame, while trying to anticipate what they will do next. The action is fast paced, and there is no second chance to catch something. The music is usually too loud to communicate with your subjects so you are on your own to anticipate where the action will be. In Figure 3-4, these couples are the wildest dancers and definitely your best bet for dramatic images.

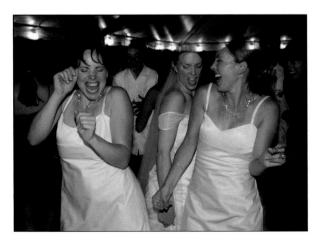

Figure 3-4: The wide angle is your best bet for catching action on the dance floor.
26mm, f/5.6, 1/6s, 400 ISO

Group shots

Group shots work well with the wide angle for a number of reasons. One, you can cover a very wide angle of view, which gets many people in the shot. Second, a wide angle puts you closer to the people in your groups. This is especially useful if you are using on-camera flash to add some fill light. This may not seem important on a cloudy day when there isn't much light out and your flash won't have to work very hard to match the low level of light. However, on a bright sunny day it's a completely different story. Most SLR cameras can only work with a flash if the shutter speed is 1/250 of a second or slower. On a bright sunny day, you may have to set your ISO to 100, and your aperture to f/16, just to get your shutter speed down this slow. This set of circumstances creates a very big challenge for a small flash unit. Most of these units can put out enough light for f/16, but only if the subject is closer than about 10 or 12 feet. Only the most powerful flash units can put out enough light for f/16 at a further distance. Using a wide-angle lens as in Figure 3-5 is your only hope for getting in close enough for your flash to work on a sunny day.

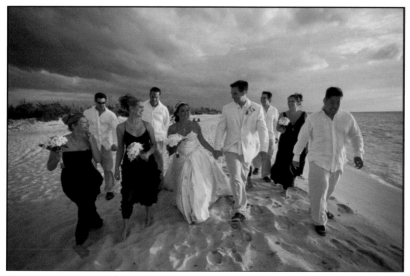

Figure 3-5: Use a wide angle when you need to get in close for your group shots.
17mm, f/4, 1/1250s, 400 ISO

Medium Zoom: A Little Bit of Everything

If you're just starting out and want to know which lens to purchase first, go with a medium zoom in the 35-135mm range. When I purchased my first digital camera system, a lens such as this was the only one I owned and I shot quite a few weddings without ever taking it off. You can easily use this one lens to shoot entire weddings without ever changing to anything else. However, it excels only at its ability to produce generic images. You won't get much flair or artistic feeling in your images if you spend a lot of time with this lens. What you do get is a zoom range that covers a little bit of everything. It works well in the dressing rooms, although it won't be the greatest in a small dressing room. This lens is perhaps the absolute best lens for small to medium-sized family group pictures. As shown in Figure 3-6, it also works well for portraits if you zoom out to the 100-135mm end of the zoom range. This lens is a real workhorse that consistently delivers good quality images in the widest possible variety of circumstances.

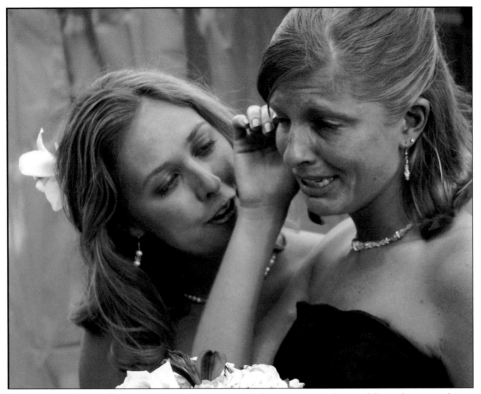

Figure 3-6: The medium zoom has the most useful zoom range for wedding photography.
56mm, f/4.5, 1/200s, 400 ISO

The drawback to using this lens for everything you encounter throughout the wedding day is that, although it does a lot, it doesn't do anything very well. You can get much better results with a lens that specializes in the effect you desire. For example, the medium zoom can do a little bit of a wide-angle effect, but a true wide-angle lens gets a much more dramatic effect.

Telephoto Zoom

By far the heaviest lens in my camera box is the 70-200mm f/2.8 with image stabilizer. This lens is so valuable to me that I absolutely have to carry it despite the weight and added expense. I typically shoot the entire ceremony, the romantic portraits, and some of the dressing room shots with this lens.

Many telephoto lenses on the market don't have the wide f/2.8 aperture, or the image stabilizer. You can save weight and money if you purchase one. However, if you can manage to scrape together enough cash for this lens, you will almost immediately fall in love with it. After the first wedding, you'll wonder how you ever worked without it.

Low-light shooting

The large f/2.8 aperture and the image stabilizer combine to make the 70–200mm lens great for shooting in the low-light conditions of late evening. When I schedule an evening portrait session with the bride and groom, I rely heavily on this lens to allow me to shoot right through sunset and on into the dark. Photographers refer to this time as the "magic hour." With a 70-200mm lens, you can leave the tripod and shoot handheld at speeds as slow as 1/40 second. As you can see in Figure 3-7, this lens enables me to continue shooting far into the evening than I ever could without the stabilizer. What a dream come true for wedding photographers!

Shallow depth-of-field effects

Another use for the 70-200mm lens is to create shallow depth-of-field effects, as in Figure 3-8. The sharp zone is so small that it serves to focus the viewer's attention on the subject by isolating it as the only sharply focused point in the image.

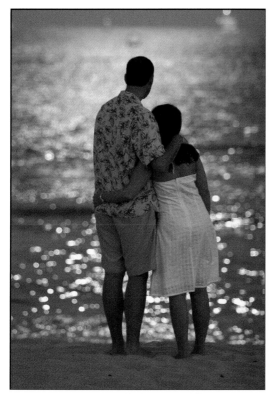

Figure 3-7: Thanks to the image stabilizer and the wide f/2.8 aperture, the 70-200mm telephoto zoom works great in low light.
140mm, f/2.8, 1/40s, 3200 ISO

Figure 3-8: One of the best features of the 70-200mm zoom is its ability to emphasize the subject by throwing everything else out of focus.
110mm, f/2.8, 1/160s, 1600 ISO

Candid shots

You can't beat the 70-200mm lens for catching candid shots of people interacting with each other, as in Figure 3-9. You can stand 30-40 feet away and still catch views that look as if you were right there with them. The magic here comes from the fact that you are so far away that people don't even know you're watching them. They often comment when viewing the images that they didn't even know the photographer was around when that happened. That's the point! If they knew the photographer was around, they probably wouldn't have acted so naturally.

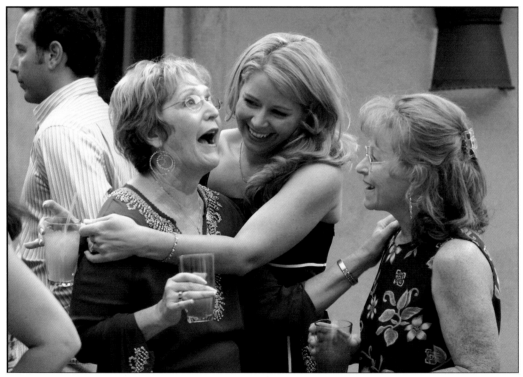

Figure 3-9: The 70-200mm lens is perfect for capturing candid shoots of people because you can stay so far away that that your subjects are unaware of your presence.
105mm, f/4, 1/125s, 400 ISO

Compression of subject and background

Telephoto lenses compress distant objects, as in Figure 3-10. This visual effect makes objects appear much closer together than they are in reality. You may be wondering how you could use this at a wedding, but it actually comes in handy quite often. For example, a bride may request to be photographed in front at an outdoor location that is sentimental to the couple. Accomplishing this is easy if the object is close by, but what if it's far away. Try putting the bride and groom about 40 yards away from your position, but between you and the object you want for the background. Shoot at a small aperture of f/8 or smaller to get some depth of field; you will be amazed at how close together your foreground and background appear to be.

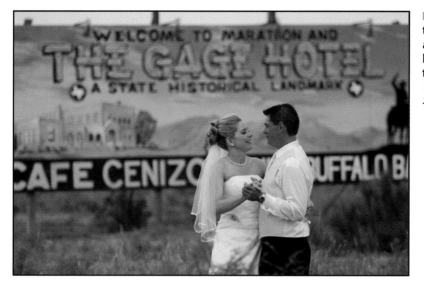

Figure 3-10: The telephoto lens has the ability to make objects look closer together than they really are.
135mm, f/2.8, 1/2500s, 200 ISO

Portraits

Portraits are another prime use for the telephoto zoom lens. Figure 3-11 illustrates how the 70-200mm lens can create a beautiful shallow depth-of-field effect. The blurriness of the foreground and background seem to accentuate the sharpness of the subject, making it appear as if it were somehow raised out of the blurry surroundings. The long working distance of this lens also has the advantage of putting you so far away from your subjects that they feel much more comfortable than they do if you stand right next to them with your camera pointed in their faces.

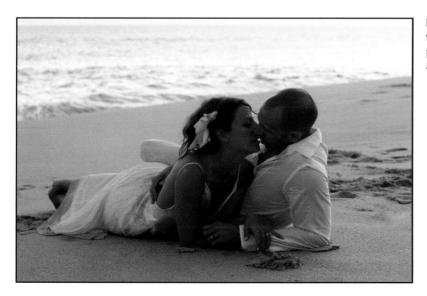

Figure 3-11: The telephoto lens is perfect for portraits.
50mm, f/4.5, 1/30s, 800 ISO

Art Lenses

I usually carry two secret weapons in the pockets of my vest. One is a 50mm f/1.4, and the other is a Lens Baby (www.lensbaby.com). Both fall into a category that I call *art lenses*.

50mm f/1.4

This lens excels at creating the extreme shallow depth-of-field effects seen in Figures 3-12 through 3-15. This extreme soft background emphasizes the subject. The effect works great for portraits. However, such a shallow depth of field can be very difficult to use. If you want your subject's eyes to be in focus, you have to be extremely careful to focus on the eye and then shoot quickly before your body sways forward or backward enough to ruin the shot. On a close-up portrait, you may have less than an inch of depth of field with which to work. Many shots are ruined with this lens because of missed focus. However, when you do get it right, the results are very impressive.

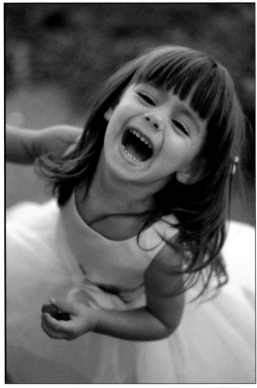

Figure 3-12: The 50mm f/1.4 lens is difficult to use for portraits but well worth the effort.
50mm, f/1.4, 1/250s, 200 ISO

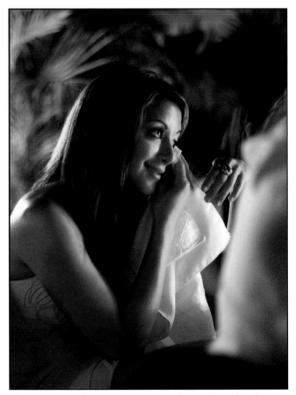

Figure 3-13: The 50mm f/1.4 is the perfect lens for shooting in very low light situations.
50mm, f/1.8, 1/15s, 3200 ISO

The 50mm has another use as well. During the reception, I sometimes use this lens to take natural-light shots even though the available light is extremely low, as in Figure 3-13. Of course, you must set your ISO to 1600 or 3200 but the grain is still quite acceptable if you give your subjects enough exposure. Shutter speeds are still slow so you must catch people that are not moving around too much in order for this to work. When it does work, surprisingly beautiful candids can be created at a time when your clients were expecting only flash images.

The image in Figure 3-14, captured at a reception in the Bahamas, was one of ten images I shot while this brother/sister couple was singing to the reception music. Had I flashed them in the face ten times in a row, you can bet I would not have continued getting such natural expressions.

Ring shots are one of my favorite types of wedding images, and I usually shoot them with a 50mm f/1.4. The shallow depth of field created by this lens serves to focus your attention right into the rings, as seen in Figure 3-15.

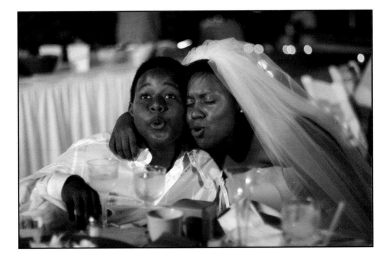

Figure 3-14: Shooting without a flash allowed me to take many shots without disturbing the action.
50mm, f/1.6, 1/125s, 1600 ISO

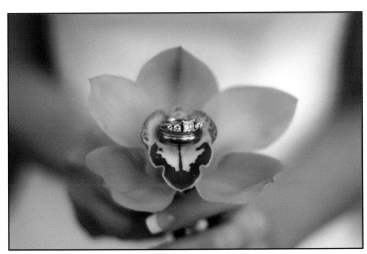

Figure 3-15: When I want something different for my ring shots, I reach for is the 50mm f/1.4.
50mm, f/1.7, 1/90s, 400 ISO

Lens Baby

This strange little lens creates an adjustable blurry/dreamy sort of look around the edges with a clear center. By changing the aperture rings in the Lens Baby II, shown in Figure 3-16, you can adjust the size of the clear area in the middle of the image and the amount of blurriness around the edges. The effect is very similar to the blurry, vignette edges seen in images shot with the old Holga or Diana film cameras but without all the hassle. This lens really shines when you want to add a little bit of a romantic dream world flavor to an image, as shown in Figures 3-17 and 3-18.

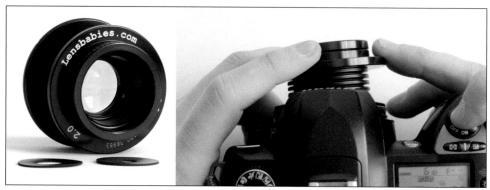

Figure 3-16: The Lens Baby is a fun, bendable throwback to the days when photography didn't look quite so real.

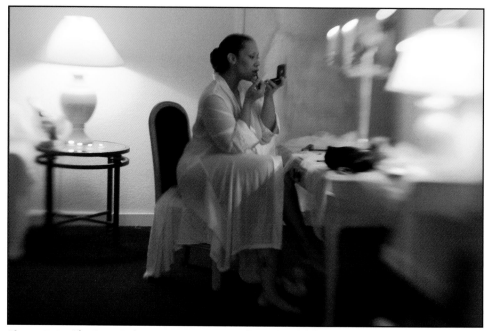

Figure 3-17: The Lens Baby creates a romantic dream world flavor.

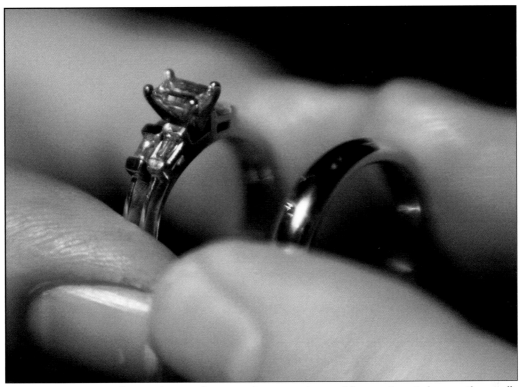

Figure 3-18: You can also purchase a close-up adapter set that enables you to get close on the small details.

Protective Filters

I don't recommend using a digital camera with any sort of special effects filters simply because the same effects can be achieved in Photoshop. However, I would never dream of using a lens without a filter attached. The sort of filters I'm speaking of are the UV type that filter out some UV light, but more importantly, they protect the large glass element on the front of your lens from scratches and chemical contact that could easily ruin the glass or the fragile coatings on the glass.

Think of these filters as a disposable protective bumper for your lens. The only reason for having them on there is to protect that lens when you drop it or bump it into the corner of a table as you're walking by. Unfortunately you can't just get the cheapest filter available because remember that the lens is the only thing in the path of the light as it travels from the outside world, into your camera. What is the point of purchasing an expensive lens if you put a cheap filter on the front of it?

Choose filters that are constructed from a grade of glass that is at least as good as the lens itself. If you have pro lenses, seek out the absolute highest quality glass filters from B+W or Heliopan. The cost may be over $100 each, but I consider that price to be a bargain compared to the thought of throwing away a $1,600 lens because I bumped it into something and scratched the front lens element. I have personally replaced several of these filters after smashing them into one thing or another. In every case, the lens came out without a scratch.

Lighting Choices

No matter what style of photography you choose, you will undoubtedly find yourself shooting wedding images in dark places that require additional light. The type of lighting gear you carry is determined to a certain extent by the style of images you shoot. Traditional-style photographers typically shoot more posed indoor images that require elaborate flash setups. Many of these people are also commercial or portrait photographers, and they simply carry a small set of studio gear to use at the wedding. Photojournalistic-style photographers tend to shoot fewer posed groups. Many photojournalistic photographers carry nothing more than an on-camera flash. No matter where you fall in the scale from traditional to photojournalistic, you certainly need to bring some sort of flash in order to shoot weddings.

The possibilities range from a simple on-camera-type flash, to larger studio flashes that sit on top of a stand and require a larger power source. Some large flash units are either powered with AC wall plugs or battery packs. This versatility is extremely valuable to the wedding photographer who seeks to bring some creativity to the group photos by getting them away from the altar area and out into unexpected places. While it is usually possible to run an extension cord to many good locations, it's still nice to be able to attach a battery pack to your light setup and walk out into a field with it if you want.

Portable flash systems

For wedding photographers, the two most popular portable light systems are made by Quantum and Lumedyne, as shown in Figure 3-19 and 3-20. Both systems offer a choice of either battery pack or AC power modules, and both of these systems offer more than enough power for the average wedding shoot. By stacking several power modules together, you can achieve even more power. Both also have the ability to work with the TTL features of many cameras. What is the difference? I give the Lumedyne points for simplicity and extreme durability, while the Qflash gets points for fancy electronic features but with a little less durability. Both systems also have the ability to connect multiple flash heads if you want to create an elaborate lighting setup.

TTL-Flash Refresher

Through the lens, or TTL, flash means that the metering happens through the camera lens. With this method, the flash emits a very short pre-flash that goes out and strikes the subject in front of the camera. The light that reflects off the subject then travels through the lens and is read on a sensor inside the back of the camera, thus coining the term through-the-lens metering. With this system, the lens also communicates how far out it is focused. The camera analyzes the focal distance and the reflected light that passes through the lens to come up with a final flash exposure.

Figure 3-19: The Lumedyne portable flash system is very durable and simple to use.

Figure 3-20: The Quantum Qflash is packed with electronic features.

On-camera flash systems

For on-camera flash at night, some photographers prefer to use a flash bracket, which enables you to shoot either vertical or horizontal; just flip your flash into the proper position directly above the lens. This bracket adds quite a bit of weight and bulkiness to your system, so many photographers choose not to use them. The advantage of using the bracket is that your shadows always fall down behind the subject because the flash is always directly over the lens. If you shoot a vertical shot without a flash bracket, the shadows can be seen falling upward at an angle behind the subject, as shown in figure 3-21.

Figure 3-21: Shooting without a bracket can create some very unnatural looking shadows on the wall if you turn your camera to the vertical position. *46mm, f/4, 1/60s, 400 ISO*

I choose to forego the flash bracket because I've learned a few tricks that allow me to work around the shadow problem. First, as a rule I avoid shooting subjects that are close to a wall. Bare walls usually make horrible backgrounds anyway, so I move either the subjects or myself until I have something in the background that is more interesting than a wall. In addition, I minimize shadows by shooting horizontal whenever possible. If I do shoot a vertical shot, I make sure to get close enough to fill the frame with my subjects, and there simply isn't any space for shadows to show up. Figure 3-22 shows that the real trick is to set your shutter speed slow enough and your ISO high enough so that the background lighting shows up behind your subjects. Finding just the right combination of shutter speed and ISO might take a few test shots, but once you get it dialed in, you can shoot with the same settings for the remainder of the reception.

The drawback to this technique, shown in Figure 3-23, is that the same slow shutter speeds required to achieve this effect also provide opportunities for *ghosting*. Ghosting is the blurry halo that happens when your subject moves during the exposure.

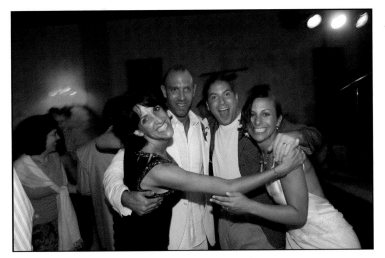

Figure 3-22: When on-camera flash is combined with a slow shutter speed the background light minimizes the appearance of any shadows from the flash. *17mm, f/4, 1/15s, 800 ISO*

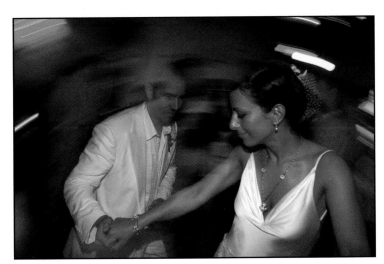

Figure 3-23: The trick is in finding the perfect shutter speed and ISO combination that allows some background light without creating too much ghosting. *17mm, f/4, 1/8s, 400 ISO*

Figures 3-24 through 3-26 illustrate the results you will see when using a flash in combination with very slow shutter speeds. Some areas appear sharp where the flash froze the subject, while other areas appear with double images or blurry halos around the subjects. The ambient light hitting your subject after the flash is what creates the blurry areas. It takes a lot of practice and experimentation to determine just how slow you can set your shutter and still create acceptable images. You also have to adjust your shutter speed depending on the subject. For example, people pictures should be sharper, while dancing pictures can look very good with some ghosting and light streaks in the background.

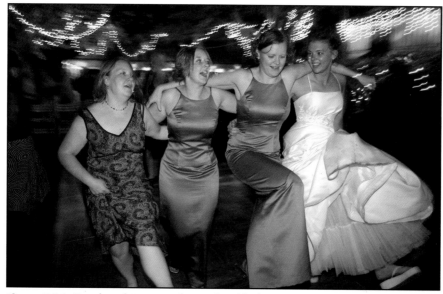

Figure 3-24: Dancing pictures can be made with shutter speeds in the range of 1/2 to 1/15 second.
18mm, f/3.5, 1/4s, 400 ISO

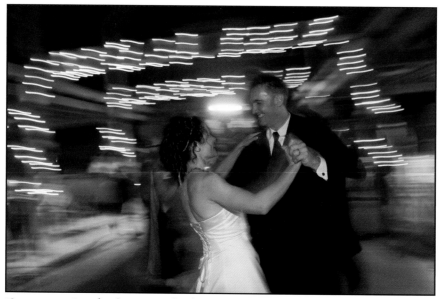

Figure 3-25: People pictures can be done with slow shutter speeds, but the extreme level of ghosting that you can get away with for a dancing shot won't look good in a night portrait.
17mm, f/4, 1/4s, 800 ISO

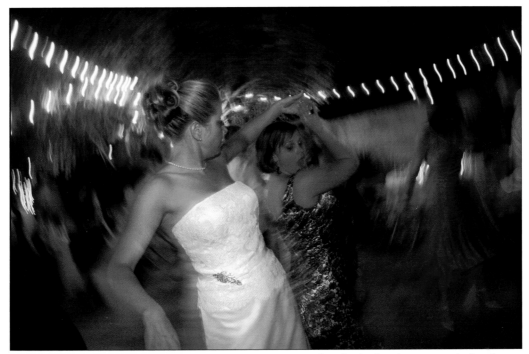

Figure 3-26: This image was made by shooting at 1/8 second and spinning the camera during the exposure.
17mm, f/4, 1/10s, 400 ISO

Color Balance

Digital cameras have very little ability to see the color of the light outside and adjust themselves so that things actually look like we think they are supposed to look. Cameras do have an *Auto White Balance* setting that performs an acceptable job in many situations. There are also preset white balance settings that you can choose for specific types of light. However, if you want to get accurate colors, you can either shoot RAW and adjust the white balance later, or you can set the white balance for each type of light you encounter. Much more information on this topic is covered in Chapter 8.

One piece of equipment that I find very useful for setting an extremely accurate white balance is called an Expodisc (www.expodisc.com). This little gadget is wonderful for creating custom white balance setting for the light in one particular location. During the wedding, every time I move to a new room where I will be shooting more than a few shots, I pull out the disc and make a new white balance reading. The whole process only takes about 20 seconds. Once set, I can still switch to the other standard preset choices in the white balance menu if I move outside or to other rooms. Figure 3.27 shows the effectiveness of a custom white balance setting made with an Expodisc. The first image was taken on the Auto white balance setting. The brown image in the center is the shot I made through the Expodisc itself. Then for the third shot, I went into the camera menu and chose the brown frame as the reference frame on which to set the white balance. If you don't like the absolute true whites, Expodisc makes a blue version (see Figure 3-28) that produces a slightly warm color balance.

Figure 3-27: This three-shot sequence shows the before and after images that are the typical result of using an Expodisc.

Figure 3-28: The Expodisc is color corrected to very exacting standards so that it produces the most realistic colors possible. Two versions are available. The one on the right looks blue but it actually produces a slightly warm color tone.
© Dave Maynard

Bags and Boxes for Carrying Your Gear

One of the things I learned from traveling to shoot destination weddings is how to lighten my load. I've got my camera case whittled down to the bare minimum. Every item in that case is a compromise between weight, quality, and usefulness. However, even before I began traveling on airplanes with my camera gear, I still always found myself traveling somewhere with it. By their very nature, weddings always take place away from your office/studio; they rarely happen in the same place, and always require that you move your gear around several times during the day. For example, you generally start the day in the dressing rooms, then move everything to the ceremony, and then move again to the reception location. Frequently, each of these places is miles apart. You also occasionally find yourself being sent to the wrong location, and now you suddenly have to grab everything up and jog with it. Only bring what you can carry in one load.

The photo backpack

One key piece of gear that makes it possible for you to move your gear around comfortably is a good camera bag of some sort. My preference is actually a Tamrac backpack (www.tamrac.com). With a backpack, as shown in Figure 3-29, you can get all your gear on your back and still shoot with your camera as you walk. You also have your hands free to carry lighter items, such as a tripod and a lighting kit. The backpack is easily the fastest and most comfortable way to carry your gear, especially over rough terrain. However, a full pack can weigh in at 40 pounds if you pack two camera bodies and many lenses.

Figure 3-29: A photo backpack is a very practical way to carry a lot of gear over any sort of terrain and still have your hands free to carry other items or shoot with your camera.

The rolling box

No matter how large or small you may be, if you know that you'll be moving long distances on paved ground, a rolling box is by far the most comfortable means of transporting your gear. You can find many excellent rolling cases at Porter Case (www.portercase.com). If you need waterproof and bombproof protection, check out Pelican cases at www.pelican.com. You can get these cases in all shapes and sizes to fit your needs. My personal favorite is the Pelican 1510, shown in Figure 3-30. The 1510 is designed around the exact dimensions allowed by the airlines for carry-on luggage. Several companies sell cases such as this but the Pelican offers extreme durability, a waterproof seal around the lid, and a Gore-Tex valve to equalize the pressure of going up and down in airplanes. These boxes are designed to take a real beating while protecting your gear.

Figure 3-30: Rolling camera boxes, such as this Pelican case, are the most comfortable way to move your gear if you know you will be traveling in areas with relatively smooth ground.

If you'll be traveling off the beaten path, a Pelican case is essential. The combination of tough and waterproof was very comforting recently when I tossed my box full of gear to the captain of a little water taxi near Cabo San Lucas. The bridal couple and I took a short ride out in the sea of Cortez to Lovers Beach where we were to do a two-hour portrait session. As we approached the beach, we had to jump out of the boat into waist deep surf and wade ashore carrying all our gear. Then we went on to spend the next couple of hours photographing in the sand, which is only slightly less deadly than salt water if you get in on your camera. This is a trip I would have never even considered without my Pelican case.

A very useful addition to a waterproof box is a moisture-absorbing silicon-gel desiccant pack sold by The Box Store (www.theboxstore.biz). The gel pack absorbs moisture from the air inside the box, which helps to prevent mildew from growing on your lenses. These little packets will eventually become saturated from the moisture they've absorbed. To rejuvenate them, all you have to do is drop them in the oven for a couple hours at 300 degrees and they're good as new. If you live or travel in areas with high humidity, you need something like this to absorb any moisture that is trapped inside your box.

Whether you decide to carry your gear to the event in a backpack or box, another item that can make your job a lot easier after you get there is a photo vest. A vest is a bit like a wearable camera bag. It fits comfortably over your shoulders and holds lenses, filters, a flash, memory cards, snacks, and any other small items you may need. A vest keeps all the important stuff right there in easy reach. I like the black Domke vest. Black feels a little more discreet than the tan version that seems to call a bit more attention to the fact that there is a photographer wandering around. What I've really been looking for is a black sports jacket with all the same pockets built in. Maybe some vest manufacturer will read this and get right on it.

Camera Settings and the Setup Menu

Every digital camera has a menu that you can access through the LCD screen. You may have several different menus with over 100 options for properties you can control. These options change the way your camera functions. Some options change the way the camera functions on the outside, such as how it focuses or how it behaves with your flash. Other options control the way the software functions inside the camera. They may change the file type, whether or not each image is sharpened, whether the images are color or black-and-white, and so on. Many of the available choices are simply a matter of personal preference. However, some of them have a very big effect on the end result. You have to get familiar with these settings so that you can make the appropriate adjustments for each type of job you do with your camera.

Color space

The term color space is used to describe a particular set of colors. Different devices can use different color spaces, and each color space has a slightly different set of colors in it. There are actually many different color spaces but the two that you encounter most often in digital wedding photography are called sRGB and Adobe RGB. The Adobe RGB space contains the most color tones, but most printers and computer monitors can only use the sRGB color space.

In your camera menu settings, you find a place where you must choose between Adobe RGB and sRGB. Choosing the right one is very important because it will have large effects on your workflow. For more information, see Chapter 4.

File format

In your camera setup menu, there is a section for file type and compression. The options vary among the different cameras, but for digital wedding photography there are essentially only two practical file formats — RAW and JPEG. Each of these file types has its strengths and weaknesses. Both work very well for wedding photography but depending on the circumstances and the way you want your workflow to function, you may find that one format works better for you than the other. Chapter 4 covers details about the two types of files as well as the many variables that go into choosing which one might be right for you.

Sharpening

All digital images should be sharpened before printing. However, the optimum amount of sharpening is completely dependent on the size of the print. If you sharpen the image to print at 4 x 6 and then try to print the same image at 20 x 30, you will not get good results in the larger print. A good general rule is that sharpening should be the last thing you do before printing. You should also be very careful to avoid saving the sharpened version over the original. Use the *Save As* option and rename the file so that you always keep your original in an unsharpened form. Later, when you get ready to make a different size print, you can start over with the unsharpened original.

All digital cameras have menu options for adjusting the amount of sharpening. The setting you choose depends on what you want to do with the images. If you plan to give your clients images on a disc, then you probably want to set your camera to do a small amount of sharpening. I say this because many clients are not going to remember to sharpen images before they take them to the lab. It is also highly possible that they won't know how to do this or that they won't have the computer software to accomplish the task.

If you are keeping the original images, you can turn off all sharpening in the camera menu. Just don't forget that every image that leaves for the lab must be sharpened in the computer — after resizing it to its final size. Photoshop has a feature called an Action that allows you to record a series of steps that you can later replay on a single image or on an entire folder full of images.

Exposure modes

All modern digital cameras are equipped with several different shooting modes that adjust how much control you want to give the camera in deciding the exposure settings for each shot. On one end of the scales, you have Manual Mode where you must personally set the aperture and f-stop for the right exposure. On the other end of the scale is "P" for Program Mode, where the camera decides the best setting for each shot. Each shooting mode is very different, and it functions best in different situations. For wedding photography, you could easily say that each shooting mode has its time during the wedding day. Knowing when to choose one over the others demands that you understand the strengths and weaknesses of each mode. The following four paragraphs provide some details of each mode and give examples of when each one might be used during a typical wedding day.

Aperture priority mode

This mode is perhaps the most useful for general daytime shooting. It allows you to pick the aperture and the camera chooses the shutter speed. This gives you the ability to pick the amount of depth of field needed in each scene. The drawback to this mode is that the camera sets slow shutter speeds, as the scene gets darker. This may cause unacceptable amounts of blur if you are handholding the camera. This mode works wonderfully well in the daytime but it demands that you pay attention to the shutter speed if the light gets low.

Shutter priority mode

This mode enables you to set the shutter speed while the camera sets the aperture automatically. This lessens your chance of having the camera set shutter speeds that are too slow to use, such as when shooting late in the evening. Another time to use this mode is when you want to create a certain amount of blur for a visual effect such as panning. Shutter priority allows you to fix the shutter speed while the camera takes care of everything else. Another time to use Shutter Priority Mode is when you want to fix a fast shutter speed in order to stop action. Sports photographers use this mode a lot but there are very few times that you need to be that concerned with stopping action at a wedding.

Program mode

This mode puts the camera in charge of determining both the aperture and the shutter speed. I rarely use this mode, but I do find it useful when shooting outside on cloudy days when the light is very even. Photographers call this type of light *flat light* because the clouds create a huge light diffuser from above that practically eliminates all shadows. In these conditions, the camera's internal computer is very accurate and very fast at determining the best settings.

Manual mode

This mode puts you in complete control. At a wedding, Manual Mode is most useful when shooting many shots in the same place and in the same lighting conditions. Manual lets you find the correct exposure and stick with it. I use this mode for shooting portraits and group photos. If you were to use one of the automatic settings for a group shot, the camera would change the exposure every time you recompose because different things will be in the metering area each time. With Manual Mode, you don't have to worry about the camera making changes.

Manual Mode works especially well for groups when you turn your subjects away from the light (this is called backlighting) and use a fill flash to light the faces. If you attempt to use Aperture Priority, the camera tries to expose for the faces of the people, which is not what you want. In Manual Mode, you can set your exposure for the background and use a flash to light up the faces.

When shooting portraits, I frequently want to control the exposure to create the mood I'm looking for or to re-create the real appearance of the scene. For example, if I'm shooting in moonlight or candlelight, the camera doesn't know this so it tries to set an exposure that makes the image appear as if it were shot in the daytime. Manual enables me to adjust the exposure until I get the scene to look as dark as it is in real life.

Manual Mode is also good for shooting at night with a flash because it allows you the control of being able to dial in just the right shutter speed to get some ambient light in the background, without causing too much ghosting around the subject. Flash techniques are discussed in much more detail in Chapter 12.

Methods of exposure compensation

Many times while shooting with a digital camera you will look at the LCD preview and realize that you disagree with how the camera's meter is reading the scene. To correct the exposure you need to make exposure compensation in one of the two ways explained in the following sections.

Exposure lock button

All professional and most consumer cameras have a button (usually operated by the right thumb) that enables you to lock the exposure and then recompose before shooting. This is sometimes the fastest way of accomplishing the exposure compensation talked about in the previous paragraph. If you look again at the example of the bride and her father walking toward the brightly lit doorway, this time you would simply turn the camera toward another area of the room (without the bright light) and press the exposure lock button. Then you recompose on the doorway and release the shutter.

The advantage to this method is that it is very fast. The disadvantage is that it only locks the exposure once; after the shutter is released, it goes back to normal. If you want to make a second shot the same way, you have to repeat the process.

Metering for Proper Exposures

Understanding how your camera sees the world allows you to take a meter reading and then make any necessary corrections before you shoot your first test shot. Having the ability to do this helps you capture a much higher percentage of fleeting events and expressions that pass by so quickly on the wedding day. For example, if you suddenly notice the bride and her father walking toward a beautiful doorway with bright light streaming in from outside, you could just point the camera and shoot. However, if you know that your meter will set itself for the bright outside light—which it will—you can quickly dial in an exposure compensation of +2 stops before you take that first shot. This gives you some good detail in the shadowed side of the subjects while creating a glowing white wash from the bright light outdoors. You would have missed this shot if you relied completely on the camera's meter or on your ability to look at the LCD after the first shot and then make corrections.

Digital cameras have a tendency to breed lazy photographers who think they don't need to understand metering because they can just look on the LCD and make corrections for the second shot. The bad news is that many of the best moments happen far too quickly for you to shoot test shots before you have the exposure correct. You have to cultivate your ability to predict what your meter will do in many different situations so that you know when to override the meter and by how much.

One of the most confusing aspects about metering a scene is that the camera is always trying to average things out no matter what you put in front of it. This works great if you have a scene with many average tones in the central area. The camera sees the average tones and sets the exposure to produce an average, or 18 percent gray in those areas. However, if you put a groom and all his groomsmen in the center, the camera meters the scene and very effectively makes everything appear average, or 18 percent gray. The groom will almost certainly not appreciate the change. With a little practice, you can predict that this will happen and set your camera to a -1 exposure compensation, which underexposes just enough to make the blacks appear black again.

The camera's meter tries to make everything look average. If your subject is not composed of average tones, you have to make an exposure compensation to correct the exposure.

The same process happens in reverse when you have a white object like a bride's dress dominating the center of the image. The camera sees the white of the bride's dress, assumes that it should be average and creates a gray dress. You have to dial in a +1 exposure compensation to make white objects show up as white.

The important thing to remember is that a camera is not intelligent. It is great at only one job and that is to expose for an average scene and make it look average. You are responsible for supplying the intelligence and the artistic vision needed to create a great image. Get to know the limitations of your meter and you start to appreciate how wonderfully predictable it is. It will consistently give you a baseline exposure that is incredibly accurate. You just have to know how to do your part by correcting the exposure to make bright things appear bright and dark things appear dark.

+/- Dial adjustment

Your camera has a dial that changes your exposure to create either overexposure or underexposure while still allowing you to use the automatic modes. You can continue using modes like Aperture Priority, Shutter Priority, or Program, but the exposure compensation is added or subtracted from this setting. For example, if you shoot into the sun you might dial in a +1 exposure compensation to bring out some shadow detail while letting the highlights overexpose a little. The camera still functions in an automated mode like Aperture Priority but your +1 compensation is added to each shot. This is the preferred method of exposure compensation if you are shooting in the same type of light condition for some time.

The only drawback to this method is that you will invariably forget that you moved the dial, and when you continue to shoot this way in a different sort of light, you may end up ruining a number of images before you notice the problem. If you have a bad memory as I do, you may want to rely on the exposure lock button whenever possible because it automatically switches back to normal after each shot.

Manual mode

Manual Mode is also an excellent way to make exposure compensations. With this mode, the camera's meter still tells you what it calculates as the correct exposure, but you can purposefully dial in whatever exposure you want without worrying about the camera changing the settings on you.

Summary

Whether you are interested in shooting a few weddings on the side or diving into it as a new career, you need a good set of equipment to perform the job. The information in this chapter should give you a good idea of what sort of features to look for in a camera, lenses, and basic flash equipment.

✦ ✦ ✦

4 Creating Your Wedding Day Workflow

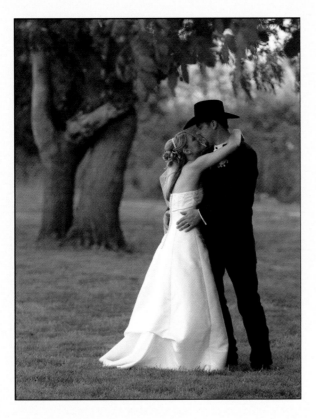

The reality of day-to-day business as a photographer is that we must each develop an organized system that allows work to flow from one task to the next as each job progresses from beginning to end. The term *workflow* refers to the sequence of steps involved in taking one job from start to finish. In theory, it might seem as if someone could simply jot down a workflow for you and you would be ready to go. In reality, developing a workflow for your business is a process that evolves from your own unique

preferences and the way you like to work. There are many possible variables and many different ways of accomplishing the same task. The technology involved is also changing — often demanding that you change right along with it. Developing your own workflow is a challenge that you face every day that you work in the wedding photography business. This chapter gives you an idea of what some of the many options are and some examples of what other photographers in the industry are doing right now.

Discovering Workflow

The world of photography is changing quickly. If you pay attention to these changes, you will almost certainly find new cameras, electronic products, software, Photoshop techniques, album companies, and ways to use the Internet. Any one of these has the potential to change your business enough that you have to throw your current workflow right out the window and start over. It's safe to say that you shouldn't expect your workflow to remain the same for more than a few months at a time.

Being the creative and independent types most photographers are, almost every person involved in this business develops a unique workflow that helps him or her consistently achieve what is thought to be the ultimate in efficiency. Your own workflow will also be unique. It will reflect the type of clients you serve, which products you promote, and what sort of sales strategy you use. For example, someone who shoots in a traditional style and projects images on a screen while taking print orders will have a very different workflow from someone who shoots in a photojournalistic style and provides a DVD with all the images. Your own individual workflow will grow and change on a regular basis in order to reflect changes in your business and changes in the industry.

I like to think of workflow as having two distinct parts — the work, provided by you; and the flow, provided by your system. There is a definite relationship between the two parts. The more your system flows, the less work you do. If something jams up the flow, you have to make up for it with more work. The goal is to set things up so they flow as smoothly as possible from one job to the next.

Before reviewing the details of each step in the wedding-day workflow, keep in mind that there are many aspects of a wedding photography business that can be considered part of the whole wedding workflow. Each part of the business will need a little mini-workflow all its own. For example, you may have a workflow for advertising, another for interviewing clients, another for filling print orders, another for making albums, another for uploading images to a Web site, and so on. These are all repetitive tasks that you must do constantly in order to maintain a successful wedding business.

Wedding Shoot Workflow

For the purpose of this book, the discussion of workflow is limited to the actual wedding shoot workflow, which starts sometime before the day of the wedding and ends when the images are finished and ready for use. These are just the steps necessary to take one wedding from beginning to end. This is the core workflow for the wedding photography business.

In general, all digital wedding photographers use six basic steps in their wedding shoot workflow:

1. **Prepare for the shoot.**

2. **Shoot the pictures.**

3. **Transfer the images from camera to computer.**

4. **Create a backup image set.**

5. **Review and edit images.**

6. **Archive the finished image set.**

The following sections break down each of these steps in detail.

Preparing for the Shoot

Preparation for a digital wedding shoot should start several days before the event. You have batteries to charge and cards to format, and of course, you have to confirm all the details with the bride.

As you formulate your own system for the preparation phase, bear in mind that a wedding is not a very good place to be going unprepared. The last thing you need is to arrive at the location only to realize you forgot something and you have to go back home. To prevent this, make some 5 x 7 cards with a checklist of all the things you need to do and all the gear you need to pack in order to arrive on the scene with everything you need to do the job.

Batteries

Charge those batteries! Digital cameras and flashes take a LOT of battery power. Before you purchase a single alkaline battery, do yourself (and the environment) a favor by purchasing a couple sets of high-capacity NiMH (Nickel-Metal Hydride) batteries. By purchasing NiMH batteries, you can actually save yourself hundreds of dollars over the lifetime of the battery set. Think about this: One NiMH battery costs roughly $4 while one alkaline battery costs roughly $1. Every time you charge each NiMH battery, you are essentially saving $1. Many NiMH batteries claim to last 500 charges. That's a savings of up to $500 per battery! If you're like me, you'll never know if this is true or not because you'll lose them long before you wear them out.

Many pro-level cameras come with a battery pack that is unique to that camera. These packs are made of several smaller batteries that are simply bound together in a small plastic package. If you want spare batteries, look around on the market to see who else (aside from the manufacturer) makes batteries for your camera. There may well be several other companies that make batteries that are significantly more powerful than the standard battery produced by the manufacturer.

When you shop for batteries for either your camera or flash, purchase the highest mAh (milliamp-hour) batteries you can find. The mAh number translates into the amount of power the battery can hold. The higher the number, the more power it can hold. It is impossible to tell you what a good number is for your battery because every battery is different, and the manufacturers are constantly developing new technology that makes them increasingly powerful.

NiMH batteries self-discharge, which means that they lose roughly 10 percent of their charge within the first 24 hours, and then they continue to lose several percent per day even though they may be just sitting there in your camera bag. They also lose power much faster as the temperature gets higher. The best practice is to put your batteries on the charger two days before you need them, and then pull them off on the morning of the wedding day.

If you happen to be traveling to a destination wedding, you might want to carry a couple sets of standard alkaline batteries because they hold a charge for years and you won't have to worry about them losing power before you get there. However, don't count on buying these batteries in a third-world country. I once purchased 16 new alkaline batteries from a hardware store in Port Antonio, Jamaica, and none of them had enough power left to turn on the camera.

Battery packs

Several companies make battery packs that can power your camera, your flash, or even both at the same time. These packs are usually large enough to need to be attached to your belt, but a few of them will attach into the tripod screw on the bottom of your camera. This adds some extra weight, but a battery pack also decreases the amount of time your flash takes to recharge. A fast flash can mean the difference between one shot of the bouquet toss and three or four shots. Fast-moving moments like that are so unpredictable that having several shots increases your chances of getting something good. Check out the following companies for battery packs: Quantum Instruments (www.qtm.com) and Lumedyne (www.lumedyne.com).

Both Nikon and Canon also make battery packs that you fill with six standard "C" size batteries. These packs are very economical, and they can reduce your full-power recharge time from about 6 seconds to less than 2 seconds.

Battery chargers

A portable charger is an essential item for your camera bag. After you run through your first set of batteries, just pop them in the charger and they'll be ready to go again before you run through your second set. NiMH batteries can be charged with a special type of charger called a "quick charger." As the name suggests, this device will charge your batteries very fast, making it perfect for recharging during the middle of a wedding shoot. However, the quick chargers also create a significant amount of heat in the process, which leads to shorter battery life. Use the slower "trickle" chargers at home when you have lots of time, and save the quick charges for emergencies.

Color space

In your camera menu settings, there is a place where you must choose the color space to shoot your pictures in. The two most common options are Adobe RGB and sRGB. Choosing the right one is very important because it can have a significant effect on your workflow. While Adobe RGB can contain more color information than sRGB, no printer in the current market can actually create all those colors.

When you run an Adobe RGB image straight to a printer without any conversion, the red end of the color spectrum is clipped off because the printer is expecting an sRGB file, which has fewer red tones than an Adobe RGB file. The resulting loss of red tones makes a print with gray skin tones that make people look dead. If you convert your files in Photoshop from Adobe RGB to sRGB, the bigger color space is rebuilt to fit the smaller space while retaining the original appearance of the image. This must be done by either the photographer, or the lab, but it must be done before printing every image shot in the Adobe RGB color space.

Most print labs recommend that you send them sRGB files because that is the only color space that their printers can use. Those labs that don't specifically make this request, are counting on their own ability to convert files from other color spaces to the sRGB space.

What to give your clients

If you give images directly to your client on a disc, you can do them a big favor by shooting in the sRGB color space. If you shoot in Adobe RGB, it is unlikely that your clients will educate themselves about how to make the necessary conversion from Adobe RGB to sRGB before printing the files.

Getting your own prints

If you make your own prints, or if you work through a custom lab, then you have the option of using Adobe RGB or one of the other color spaces that can contain much more color data than the sRGB space. This enables you to do all your Photoshop work in the larger color space, but then you (or your lab) must still convert your files to the sRGB space before printing.

Many consumer printers contain software that automatically converts images to the appropriate color space without the user even knowing what is happening. This creates much confusion among consumers because they get incredibly rich, saturated color from their cheap home printer, and then horrible color from a photo lab that has printers costing tens of thousands of dollars more.

Another thing to consider is that your image-editing software must be set to view in the correct color space. Both ACDSee and BreezeBrowser have the ability to set the color space for viewing. The default is sRGB. If you shoot in Adobe RGB and you don't change the settings in your browser, images will look washed out and lifeless on the screen. For a more in-depth look at color spaces, check out `www.drycreekphoto.com`.

File format

In your camera setup menu, there is a section for file type and compression. You may find several choices for file type but for digital wedding photography there are essentially only two practical file formats that you should choose between — RAW and JPEG. Each of these file types has its strengths and weaknesses. When you snap the shutter, your camera automatically captures a RAW file. If you choose JPEG as your file type in the setup menu, then the camera performs a complex set of adjustments as it takes that RAW data and converts it into a much smaller JPEG file — throwing away the bulk of the data in the process. The obvious advantage is that you now have a very acceptable file that occupies a much smaller space on your memory card.

JPEG

Most digital wedding photographers use the JPEG format because they must deal with hundreds and sometimes thousands of images per wedding. They have a greater need for fast image processing and storing large numbers of images on each memory card than they have for being able to exert complete control over every image created. JPEG fills this need perfectly in most circumstances.

JPEG is called a *lossy* file type because the camera deletes the majority of the original data as it renders a JPEG file. The good news is that most digital cameras do a wonderful job in this conversion — creating JPEG files with great color and very little loss of highlight or shadow detail.

RAW

RAW files are the original, untouched data captured by your camera's sensor. These files are saved in various types, none of which is recognized as standard file type. To open a RAW file, you have to use the software that comes with your camera, or you will need Photoshop, ACDSee Pro, BreezeBrowser Pro, or some other type of advanced image-manipulation software.

The main drawbacks to the RAW format are that the files are large, slow to use, and they occupy much more storage space. These same qualities are also the advantages to using RAW if you don't happen to be in a hurry. How big of an advantage is it? RAW files capture 4096 tones of brightness. To produce a JPEG file, the camera deletes all but 256 of those tones. The difference between 4096 and 256 is a factor of 16. That means you're throwing away 15/16ths or about 94 percent of the original data.

To better understand this process, imagine that your file looks like a big comb with the teeth pointing upward. To start out, the comb has 4096 teeth. These teeth are packed so tightly together that you decide to go through and break out 15 teeth and leave one, repeating this process all the way across the comb. When you finish, you only have 256 teeth left but if you squeeze the ends of the comb together, you now have a much smaller comb that appears very much like the original.

The big advantage to RAW is in the editing stage. You can make changes to everything about the files except the ISO, shutter speed, and aperture settings that were used to create the original image. You can change the white balance, and you can make large changes to color and brightness of the image without creating any banding or other ill effects. This is especially helpful if you accidentally shoot the image too dark or too light to start with. Having this much flexibility is a great safety net that gives you the ability to correct most of the small mistakes you make in exposing your images.

Adjusting the file type to the job

JPEG files are perfectly adequate for most things a wedding photographer needs to do, but RAW files really do shine in certain situations. Because of this, many photographers choose to change file types throughout the day in order to get the maximum advantage from the strengths of each file type. If you know when your camera will have a hard time producing a good JPEG file, you can start switching back and forth between file types to take advantage of the RAW format's strength when you really need it. Some of the times that you might want to shoot in RAW include:

✦ Anything happening in bright sun

✦ When you want to be able to adjust the white balance later

✦ When you think the image might be printed in a large size

To translate this into action on a typical wedding day, adjust the file size and type as follows:

✦ **Dressing rooms:** Shoot medium-large JPEG.

✦ **Ceremony:** If sunny, shoot RAW; if overcast, shoot largest JPEG.

✦ **Groups:** Always shoot in RAW.

✦ **Romantic portraits:** Always shoot in RAW.

✦ **Reception:** Shoot in medium-large JPEG.

Working like this allows you to conserve disk space for things that are unlikely to end up being printed very large, while maximizing file size and quality on types of images that are the most important. Most importantly, varying your file size allows you to play it safe when shooting images that are the most difficult to expose properly in the camera. More information on shooting in RAW is covered in Chapter 7.

What file type is right for you?

Choosing what file type to use is a major decision that will have a large effect on the part of your workflow that takes place after the wedding is over. There is really no right way to do things here. Many fine photographers shoot with each file type, and many others use a mix. The trade-off that you have to juggle here is one of control versus time. RAW gives you a lot of control over each image, but it takes more time to fine-tune each one, and then it takes a lot of computer time to process all the changes and output useable images to a new folder. JPEG is quick and easy, and it produces excellent image quality but with the loss of some control over the image. Of course, you don't need this control if you shoot the image correctly in the first place. So shooting RAW is sort of like making yourself a little insurance plan that can bail you out if you make a mistake. Some people like the extra control and some think it is overkill for most wedding images. Many of the most active wedding shooters wouldn't dare shoot in RAW because it takes so much more time. If you shoot three weddings per weekend, every weekend, then shooting in RAW is almost guaranteed to slow down your system enough that you can't keep up with the processing of all the image files. If you shoot only three or four weddings per month, then this extra time may not bother you at all.

Memory Cards

When choosing which memory cards to purchase, you have two considerations: which type of card and how fast it is. First is the choice between the two types of cards — CompactFlash cards and Microdrives. Examples of the two types can be seen in Figure 4-1. The difference between the two is that Microdrives have moving parts, while CompactFlash cards don't. This makes Microdrives a poor choice for wedding photography. These tiny drives have a large number of very small moving parts, all of which create opportunities for failure. Every time you touch the shutter button on your camera, a little motor inside the Microdrive spins the card the entire time your camera stays on. Because of this, Microdrives take much more battery power to run than CompactFlash cards. CompactFlash cards are much more forgiving of abuses — such as being dropped — simply because they have no moving parts.

Figure 4-1: CompactFlash memory cards have a much lower failure rate because they have no moving parts to break down. In addition, they use much less battery power than Microdrives.

The second choice is how much speed you need. The speed of a flash card is called its write speed. The *write speed* indicates how fast the memory card can accept and store the data from your camera. Cheaper cards have slower write speeds while cards that have faster write speeds are generally more expensive. Write speed is not a huge concern for most wedding photographers because today's cameras have an internal memory that allows the camera to hold quite a few images before it needs to write the data to the flash card. You may need to shoot quick bursts of four or five images at a time during a wedding, but you will rarely have a real need to shoot much more than that. Because of this, wedding photographers don't have to worry so much about the write speed of the memory card. Sports photographers may need the fastest write speeds available so that they can shoot long bursts of images to capture the peak moments of a fast-moving sport.

Formatting your cards

Always format your flash cards before you leave for a wedding. Nothing is worse than realizing that you just shot 50 pictures on a flash card that was nearly full because you forgot to format it after the last job. Now you can't format it without losing the new shots and you don't have time to stand around deleting all the old images, so you're stuck with a flash card that is out of commission with only a few new images on it. It is a good idea to carry backup cards or have some sort of device that you can use to download images in the field in case this happens.

For CompactFlash cards that are to be used in a camera, you should make a practice of never using a computer to delete, or format the cards. You should also never copy images or any other data from the computer to a memory card. If you do, you risk losing images and possibly corrupting the card. If you have done any of these things, format the card, shoot some scrap images, and then format it again. Do this several times to make sure that the card is clean and functioning properly before you trust it to work reliably on a job. Any time you mess with your memory card from the computer, you risk causing problems.

Cameras have very specific naming conventions and methods for storing images on the card. If you accidentally do something that doesn't fit in the camera's file naming conventions, then the camera may not recognize the files or even the entire memory card. I once used the computer to copy some images to a 1GB CompactFlash card so I could move them between my PC and my laptop. It sounded like a great plan and in fact, it worked perfectly. However, as I soon found out, if you don't place the images in the same folders your camera uses, the camera won't see them at all. So a week later here I go to a wedding shooting away and imagine my surprise when the card says, "disk full" with only about 50 new images on it. The old images weren't in the right folder, so I couldn't see them on the LCD screen—I just thought the disk was empty. I also had no way to delete the images because I couldn't access them through the camera. Once again, I learned the lesson: Always format your cards before the wedding!

Memory card failure

Another item that photographers often argue about these days is the possibility of having a memory card malfunction during a job. If you use one large card, as seen in Figure 4-2, you could potentially shoot several weddings in a row without downloading anything to your computer.

However, all it takes is one failure to create a major catastrophe for your business. Some think that the risk is great enough that you should purchase many small memory cards so that if one fails, you don't lose the whole event. It's the old "don't put all your eggs in one basket" philosophy. The downside to this method is that higher numbers of cards equal more opportunity for losing cards and skipping cards during downloads. No matter what you do, there are always possibilities for loss of images. Personally, I

prefer to use a few 1GB or 2GB disks, as shown in Figure 4-3, combined with other backup options, such as having a second shooter with me on big weddings, making a good contract, and purchasing business insurance that covers me against any lawsuits arising from equipment failure. Having a second shooter along has saved the day so many times that I've become very hesitant to go to a wedding alone any more. Chapter 15 has much more information on software that can help you in the event of a memory card failure.

Figure 4-2: Huge cards can hold so many images that a malfunction would be truly catastrophic.

Figure 4-3: 1GB and 2GB cards are a good balance between size and quantity.

Deciding whether to format

The prospect of owning all these expensive memory cards may tempt you to simply bring your laptop to the wedding and download each card as you fill it, then format the card and shoot it again. Theoretically, with this method you could work with as few as two memory cards — perhaps even just one if you download at times when there is a break in the action. However, I caution against trying this. The reason is that occasionally image downloads don't work for some reason. Perhaps the cord wasn't plugged in all the way or the software just got things wrong. Whatever it was, the result is that you either get nothing or a list of files that show data but won't open in any image editor.

If you have enough memory cards to shoot the whole event without formatting, you can relax with the knowledge that if there is ever a mistake in an image transfer, you can just pull out your memory cards and download the bad images again. Chapter 15 covers in much more detail the subject of downloading malfunctions and media card corruption, as well as listing a number of software programs that can rescue you from such disasters.

Packing up

At some time on the day before the wedding, you might want to spend some time going over a checklist of the gear you need. Having such a list, and using it before each wedding, can help make sure you arrive with everything you need to do the job.

Final details

Now that all the batteries are charged, the cards are formatted, and the gear is packed, the last detail is to check in with the bride to make sure you have the correct address and the agreed upon time to start taking photos. If the wedding is at a place you've never been before, you should look up the address on Mapquest.com and print out directions to both the ceremony and reception sites. If you're traveling a long distance, or if you've never been to the site before, be sure you have the bride's and groom's cell phone numbers handy just in case you have travel delays.

Make sure to give yourself enough time to deal with most travel delays. I try to always leave early enough to change a flat if I have to. It's amazing to me how often I get lost or stuck in traffic and that 45 minutes of extra time that might have gotten me there early, just barely gets me there on time. And if I do end up getting there early, it's great to have a few minutes of down time before the show, which can be spent walking around the grounds looking for any promising spots to use for the creative portraits later in the evening.

Shooting the Pictures

Shooting the pictures sounds like the easy part, but there are a few other factors you need to consider because they will determine what your workflow looks like later. Some of these factors have a large effect on whether your system does a lot of flowing, or you do a lot of working.

One simple detail is to make sure that everyone who is shooting with you and all of your backup cameras are all set to exactly the same time and date. If you do this before the wedding, later you can put all the images together in a single folder and sort by the date to get them all mixed in the order they actually happened.

Portable Storage Options

While at the wedding, many digital photographers like to use either a laptop computer or some other device to store the images. There are many options available for this purpose, and they come in three basic styles. Below is a list of options comparing the advantages and disadvantages of each.

✦ **Laptop:** This is perhaps the most versatile of all the options listed here. Among its advantages are its many other uses, a large LCD screen, fast download times, and its ability to burn DVDs for backup. Disadvantages include its large size, heavier weight, and it's somewhat fragile.

✦ **Image tank:** This is simply a small hard drive (from a laptop computer) encased in a box with a slot for inserting memory cards. Many of these devices have an LCD screen for viewing the images. Advantages include its light weight and LCD screen for viewing. Among its disadvantages are that it's easily damaged from being dropped, resulting in complete image loss.

✦ **DVD burner:** This device is a stand-alone DVD drive with a slot that accepts memory cards. You simply insert your memory card and press a button to start the device burning the images onto a DVD. The advantages of this device include its extremely small size, its light weight, and its unlimited storage capacity (as long as you don't run out of blank discs). Disadvantages include its slow write times and the lack of a viewing screen to show you that the images are in fact successfully written to the disc. In use, it is a bit disconcerting to simply trust that the device worked without being able to see that the images are actually there.

Transferring Images from Camera to Computer

You can find many types of media card readers, such as those shown in Figure 4-4. If you happen to be shopping for one, look for the type that uses the newer USB 2.0 connection. USB 2.0 is capable of transferring 480 megabits per second (Mbps) while FireWire can transfer roughly 400 Mbps. This difference is relatively small so either of these types of connections is acceptable. USB 1.1 can transfer only 12 Mbps so if your computer is equipped with this older type of port, you should purchase a new card that plugs into the slots inside your computer and provides several USB 2.0 ports.

Look for the USB 2.0 designation to get the fastest download speeds. The Delkin Burn-Away drive provides a USB 2.0 media port while also allowing you to burn your media cards directly to CD or DVD while in the field. If you plug this device into your computer, it shows up as both a USB 2.0 media card reader and a CD/DVD writer.

When you plug your memory card into the card reader, do not try to view, sort, delete, or do anything else to the images while they are still on the memory card. Remember, this is a very delicate time because you do not yet have a second copy to use as a backup. The ONLY action you should do now is simply select the entire set of images, then drag and drop them into the destination folder on your hard drive.

An even better way to do this is to use a downloader program that is designed specifically for the task of moving images from your memory card to the folder of your choice on the hard drive. Both Breeze Browser and ACDSee have companion programs that perform this function. The downloader has many renaming options as well as options for changing all images from 72 dpi to 300 dpi, assigning camera profiles during download, rotating during download, and so on. Adobe also has a downloader that is part of Photoshop Elements 3. Many camera manufacturers include simple downloaders with the software that comes with each new camera. Using a downloader program lessens the chances of causing any sort of file corruption problems.

Figure 4-4: Media card readers come in many shapes and sizes.

Creating a Backup Image Set

As soon as you get all your images loaded on the computer and you've scanned to make sure all the thumbnails are there, you should make a backup set. You can do this by copying the images to a second computer or by making a DVD. The simplest and least expensive method is the DVD disc. I like to label the disc with the client's name and the word "originals," then I stash the disc away in the fire safe. Remember that this disc is not the finished set so it doesn't need to be archival. This disc is only a temporary backup to keep in case you have problems while editing.

Normally, I never see that disc again except to throw it away when I clean everything out in the fall. However, occasionally I may accidentally delete an image or save over an image while I'm editing and then I pull out the DVD of originals to retrieve the missing files.

Reviewing and Editing Images

Many software programs are available for image review and editing. Figures 4-5 and 4-6 show the interface of two of the most popular programs.

Figure 4-5: ACDSee Pro is a professional-level image browser with many features that can be appreciated by professional photographers and amateurs alike.

Whatever software program you choose, the basic process is to edit out the bad images. Depending on what you do with the images later, you may need to edit more carefully or hardly at all. For example, if you sell prints and albums without giving away the negatives (digital files in this case), you really don't need to edit out any bad images because the client will never see them anyway. Instead, you may want to set up a folder of "Keepers" and edit in the good ones instead of editing out the bad ones. This is a much simpler way to edit if you want to separate out a small number of images. Something about the psychology of deleting files makes it much harder to do and much more time consuming than simply selecting your favorites and dragging them out. There is much more information about editing images in Chapter 15.

Figure 4-6: Breeze Browser Pro is all business. The number of professional features packed in this little program is truly amazing.

Archiving Finished Files

Now that you've edited everything, it's time to make a backup of the *final image set* on DVD. This disc is different from the first DVD set that is made immediately after downloading. The first set contains all original images from the shoot. The finished images disc contains only those images that passed the editing phase and those that you may have created or modified in Photoshop.

Some photographers prefer to place this backup set on a second computer hard drive instead of a DVD. The advantage of this method is that the images are always very accessible. The disadvantage is that hard drives are made up of many small moving parts, and they all eventually die.

DVD is by far the simplest and most economical format for long-term image storage, and you certainly don't have to worry about hard drive failure or anything like that. But are DVD discs archival? If so, what formats are available? These questions and more are answered at length in Chapter 15.

Photographer Interview: Juan Carlos Torres

Any time I have a question about how cameras and computers work together, I call my friend and fellow photographer Juan Carlos Torres. Juan Carlos is a digital wedding photographer living in Corvallis, Oregon (www.Willamettephoto.com). He works part time as a certified computer systems administrator and part time on his wedding photography business. He and his wife Sandra currently shoot 30-40 weddings per year. Juan Carlos and many other fine digital wedding photographers come from a long background of working with computers. While it may be true that our stereotypical ideas of computer geeks and artists are so different that it hardly seems possible they could be contained in one person. But in the digital photography business, the two are not only compatible, they actually create a wildly successful combination. Mix in a little business experience and you have a top-notch photography business. The following advice comes from one of the few people with this rare combination of skills.

The risk of losing precious wedding images can bring nightmares and anxiety to both photographers and couples alike. I asked Juan Carlos for his professional advice on the best way to protect digital images both on media cards and in the computer. The following is a summary of his comments.

Do you have any tips for using media cards?

Start by formatting the flash cards and/or Microdrives in the camera that you will use to take the photos. Even when it is possible to format the flash cards in your computer using a flash card reader, it can lead to compatibility issues and data loss. Although flash cards are very resistant to abuse, it is always better to play it safe by keeping them away from shock, heat, and magnetic sources.

Do you use CD or DVD backup?

In our studio, we create two DVD copies of the files and then we copy them to the hard drives on two different computers. One of the DVD copies is stored at a different location to protect against fire and theft.

Do you use any special computer setup to prevent image loss?

We set up our hard drives in a RAID configuration. RAID stands for Redundant Array of Independent Disks. The term redundant array refers to several hard drives that function as one, and each of them contains the exact same information as the others. When we use our computers, all we see is one hard drive for a RAID system. The fact that there are multiple drives containing exactly the same data offers a great deal of fault protection. If, or when, one drive dies, the data is still there on the other drives. There are several levels of RAID and each of them offers different levels of data protection. The following are the most common types of RAID systems that are of benefit to wedding photographers who want to create a failure-proof backup system.

✦ **Level 1 RAID:** Requires two drives and the data is written on the two drives simultaneously so that they are always identical. If one of the drives fails, the data can be recovered from the good drive.

✦ **Level 5 RAID:** This is one of the most common and solid implementations of RAID. It requires a minimum of three drives and allows the data to be written across all of the drives simultaneously. If one drive fails, you simply replace the failed drive and the RAID is automatically rebuilt.

Most operating systems enable you to build some form of RAID system: however, this is not recommended because if the operating system fails, you also lose the RAID setup. This makes it much more difficult to recover the information.

Continued

Continued

Is a RAID system difficult to set up?

Not at all! You simply purchase a RAID controller card and the required number of drives for your chosen RAID type. These hard drives must be identical in every way. After purchasing the components, you simply plug the controller card in to one of the empty slots inside your computer using no more tools than a screwdriver. The card comes with cables that you need to plug in from the new controller card to each of the hard drives. Finally, the RAID controller card comes with software that walks you through a very simple setup process. As you follow the directions on the screen, it sets up your system in the RAID style of your choice.

Would you recommend using external hard drives?

With the price of hard drives dropping every day, they present a great alternative for backups. Units equipped with USB 2.0 or FireWire ports are the most recommended because they transfer data very fast. You can either buy ready-to-use units, or you can buy an enclosure that holds several drives and populate it with hard drives yourself. Some of the ready-to-use units come with basic backup programs that enable one-touch backup of specified directories or complete hard drives.

Any other thoughts?

Keeping a backup copy at a remote location is necessary to protect against fire and theft. It doesn't matter how many copies of your data you have; if all of them reside at the same location, they are potentially exposed to the same level of risk. I also recommend that you take the utmost precautions at your place of business, including the use of an alarm system and antitheft cables that secure your computers. To some, the above guidelines may seem paranoid. However, wedding-day memories are too precious to be lost and if you ask any bride, I'm sure she will appreciate a little paranoia in this particular area.

Workflow Samples

The following outlines can give you an idea of what a workflow looks like in action. The first sample is my own workflow. The second samples are from photographers that shoot and sell in a completely different style from me. Note the variety of methods used to achieve basically the same results.

The Author's Digital Wedding Workflow

I shoot in a photojournalistic style and deliver my finished images on DVD. All editing is done with ACDSee Pro.

Pre-wedding phase

1. **Two days before the wedding, charge camera batteries and AA batteries for the flashes, format all flash cards, and contact the bride to confirm time and directions to location.**

2. **Check all camera settings — Synchronize the time, set the resolution to high, set file type to JPEG, turn off sharpening, and set for sRGB color space.**

Post-wedding phase

1. Place all full memory cards on the table to the left of the computer. After each one is downloaded, it is moved to the right of the computer, being very careful not to miss any cards in the process. I download all images using Breeze Downloader Pro, which I set to rotate automatically and rename the images using the original file number plus the day, date, and time. I also set Downloader Pro to automatically resize the images from 72 dpi (which all Canon cameras produce) to 300 dpi.

2. Burn nonarchival DVD and label it with the client's names and the word "originals." View DVD with BreezeBrowser to make sure all images produce thumbnails. Put this disc in a folder in the fireproof safe. This disc is only a temporary backup and it is discarded after the final discs are made in Step 7, at which time the disc with the finished image set replaces it in the fireproof safe.

3. Delete bad images with ACDSee Pro and tag the best images so that they can be found later.

4. Rename all remaining images with a four-digit number (0001.jpg).

5. Burn final DVD copies.

6. Create a custom label for the DVD box and print on inkjet printer.

7. Create a custom label for the DVD itself and print directly on the disc surface with Epson R200 inkjet printer.

8. Contact the client for delivery options.

9. One week later, follow up with calls and e-mail to make sure all discs arrived safely.

10. Upload best 300 or so images to online gallery and send e-mail to clients with directions on how to find it.

Studio Coburg's Digital Wedding Workflow

James McCormick offers this outline of his current digital wedding workflow. James shoots in a photojournalistic style and provides his finished images to the client on DVD, in both color and black and white. All editing and downloading is done with BreezeBrowser Pro. For more information on James and his business, go to www.Studiocoburg.com.

1. Shoot everything as large JPEG files.

2. Create a folder on the hard drive with the groom's last name. Inside that folder, create two folders—one named originals and another named keepers.

3. Download the cards to the "originals" folder using Breeze Downloader Pro.

4. During downloading, we have Downloader Pro rename the files using the date/hour/minute/second as well as the original file name.

5. Burn two DVDs from this folder and imprint these discs with the groom's last name, the date, and the word "originals."

6. Rename the files using the time/date stamp function to get them in chronological order, no matter which camera shot them. We rename them 0000_ (groom's last name).

7. Select the best images by "tagging" them in BreezeBrowser Pro.

8. Those images are then moved to the *keepers* folder where they are rotated to the correct orientation and renamed again with `0000_(groom's last name)`.

9. Using Photoshop droplets, we make any minor global adjustments that may be needed (we have +1/2 stop, +1 stop, -1/2 stop droplets). Probably fewer than 15 percent of files require these adjustments.

10. Using Photoshop, we run a batch using our black-and-white conversion and create a black-and-white file of every keeper image (we prefer this to the lab just de-saturating the images).

11. Now, again using BreezeBrowser and the EOS plug-in by Peter Berger, (`www.peterberger.at`) we create an HTML viewing and ordering gallery for the couple. We burn this gallery to a CD and label it "Do not make prints from this disc."

12. We burn two DVDs of the keepers (in both color and black and white) and label it with copyright information and "Make prints from this disc." One disc goes to the client and the other stays here in the studio.

Holland Photo Arts' Digital Wedding Workflow

Anne and Bill Holland offer this outline of their current digital wedding workflow. For more information on their business, go to `www.hollandphotoarts.com`.

Before the wedding

1. Charge all batteries.

2. Erase previous week's wedding images from Epson P2000 (portable storage device).

3. Quick check of all cameras and flashes for proper operation. Zero out camera and flash compensation adjustments, put flash on E-TTL, cameras on P mode with 400 ISO. Verify RAW capture and Auto WB settings. Clean lenses and CMOS sensors if needed (usually once monthly).

4. Create index card of family formals list, including group names and people in each group.

5. Synchronize clocks on all camera bodies.

6. Format all CF (CompactFlash) cards.

7. Print out maps/directions to all venues, contact information for all vendors.

8. Print out CF card check-out/check-in list.

9. Load all equipment into vehicle, double-check presence of all camera bodies, flashes, lenses, tripods, and accessories using a list.

After the wedding

1. Copy all CF cards to Epson P2000 after returning to hotel room. As each is copied, a mark is placed next to its number on the CF card check-out/check-in list.

2. Back at home: Use Downloader Pro (`www.breezesys.com`) to copy all files from Epson P2000 to computer.

3. Copy all RAW files to RAW Original directory within client folder. Then copy all RAW files to Maxtor 250GB external hard drive for backup.

4. Examine the take to ensure no images are missing.

5. Using Adobe Bridge, identify up to 650 images (two-photographer coverage) or 350-400 images (one-photographer coverage) that are keepers from the entire batch, using colored labels. Move these images to a directory called RAW Keepers.

6. Using Adobe Camera Raw, adjust each of the RAW Keepers for color temperature, exposure, brightness, shadows, contrast, and saturation.

7. Export all adjusted RAW Keepers as JPEG files at highest quality.

8. Make DVD backup copies of all files in the client folder.

Summary

Developing your own wedding-day workflow is an ongoing process. At first, it may seem as if there are a million options and tiny details to consider. As long as you stick to the basic steps, you can hardly go wrong. Knowing how to back up, edit, and archive your images will be the very core of a workflow that prepares your images for sale and protects them from loss. Your creativity and your decisions about how you want to structure your business all dictate the finer details of your own workflow.

Preparation is the key. Before you set off for each wedding, prepare your equipment, prepare your computer setup, and prepare your plan for how to proceed when you get back home with all those beautiful images. Media card corruption is another factor for which you can prepare. In this chapter, you learned how to prevent the most common download problems.

The workflow information you gained in this chapter can help you streamline your business so that it functions as efficiently as possible, while the data protection information helps you to relax and sleep well at night, knowing that you're doing everything possible to prevent image losses.

✦ ✦ ✦

5 Composing Your Art

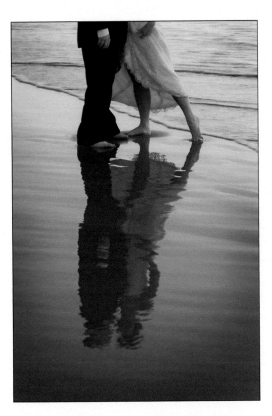

The *rules* of composition are designed to help maintain some sense of law and order in the art world. Just kidding! There aren't any rules to creating art, nor are there any rules to creating wedding images. However, having some guidelines can be helpful in setting you on your way towards creating great art. These guidelines are valuable to all artists, but the beginner stands to gain the most from learning and adhering to them. As you master the basics, you develop a *feel* for when you can bend or break the rules and still create images that work. The feel of an image is what is important. In fact, all of the rules or guidelines are based on gut feelings. When a viewer sees an image that breaks the rules, it frequently creates a feeling of distress inside the viewer and this person can almost immediately tell you that they don't like the image even if they can't tell you why. The opposite is true for images that follow the rules. The viewer can feel that the image has a natural balance to it and they feel comfortable looking at it. They may not have any idea which rules it follows, they just know they like it.

The Rule of Thirds

The Rule of Thirds is perhaps the most commonly known and used concept in the art world. As the name implies, the image is divided into thirds both horizontally and vertically as in Figure 5-1. This division creates four lines and four spots where the lines intersect. Both the lines and the intersections can be thought of as the most powerful location for subjects or other items of interest in the image. For example, as in Figure 5-2, you might place the horizon on one of the horizontal third lines. Which line you choose can depend on whether the main subject of the image is in the foreground below the horizon or in the sky above the horizon.

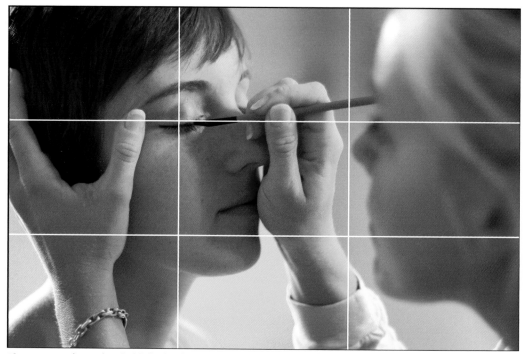

Figure 5-1: The Rule of Thirds divides an image into thirds both horizontally and vertically.

The intersection where two of the third lines meet is the most powerful spot to place singular subjects. When dealing with a person, as in Figure 5-3, the eyes are usually considered the real central focus point of that person. Placing the eyes on the intersection where the third lines meet generally creates a very pleasing composition. It should be noted that the lines and intersections are not thought of as tiny points like those that you see when there is a grid placed over the image, but rather as a zone, or a general area where the subject can be placed.

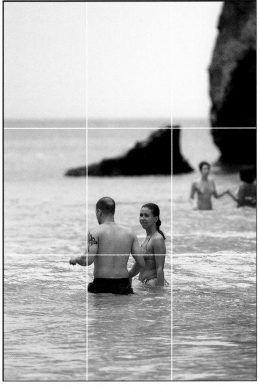

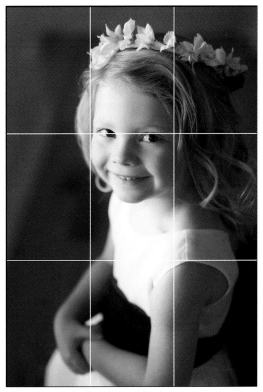

Figure 5-2: If you place linear subjects, such as the horizon on one of the lines, you get a very balanced feel.

Figure 5-3: Placing the subject's eyes, on the intersections, tends to give a very balanced feel.

Moving into the Frame

If there is any motion in your subject, always provide some space for the subject to move into, as in Figure 5-4. Don't place a moving subject so near the side of the image that it feels like they are about to walk right out of view. To understand this concept, you have to understand a little bit about human nature.

Imagine that you have been placed in a small box and just left there. When you get comfortable, you will invariably settle on a spot with your back to the wall and all the space out in front of you. You would never choose to stand with your nose against the wall and all the empty space behind you. Images are very similar to that box in that they have very solid walls. Good composition places subjects so that they are near one wall, looking into the open space of the box.

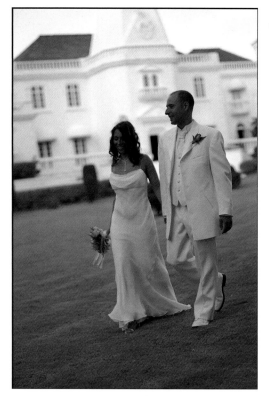

Figure 5-4: Whenever your subjects are looking out of the side of the image, you should place more empty space in front of the subject's face than behind the subject's head.

Use of Empty Space

You can create a very dramatic feel by placing your subject with a lot of empty space either all around, or in one direction. If the empty space were in one direction, then it is preferable to have it in front of the subject as mentioned in the previous section. The emptiness in Figure 5-5 is often referred to as "negative" space, and it gives the viewer a sense of place. It says something about where the image was made.

If you produce albums, sell wedding images as stock, or if you simply want to have something for your Web site, then you might purposefully shoot images with empty space, which can be filled with text later. If you make albums, you can create images with wide-open empty spaces that you can later fill with a montage of smaller images when you design the album.

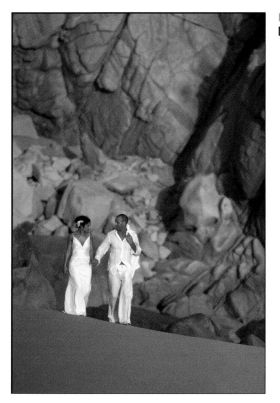

Figure 5-5: Use empty space to show off a dramatic landscape or to provide room to place text later.

Cropping People

When shooting group photos, you have two main compositional factors to consider. One is that most people like to purchase 8 x 10s because the manufacturers of cheap frames don't produce many 8 x 12 frames. Figure 5-6 shows how you can frame your groups to allow for sizing by leaving enough space on the ends of the frame, which allows for cropping one inch from either end of the 8 x 12 print.

The second consideration is where to crop your subjects. There are definitely good and bad places to cut someone off. Figure 5-7 shows the most comfortable places where you can place the bottom of the frame. Cut your group at waist level and nobody notices. However, cut everyone off at crotch level and you are certain to create some discomfort in your viewers. People don't like having their feet or the tops of their heads cut off. You can comfortably crop at the waist, through the thighs, and through the shins.

Allowing room for cropping also affects the amount of print sales the image can generate. For example, if an image is shot without room for cropping, then you can only print it in the 2:3 format (4 x 6, 6 x 9, 10 x 15, and so on), which is the native format that most 35mm SLR type cameras produce. However, if you leave empty space on the sides, you can print the image in the 4:5 format (4 x 5, 8 x 10, 16 x 20, and so on), giving it greater sales potential.

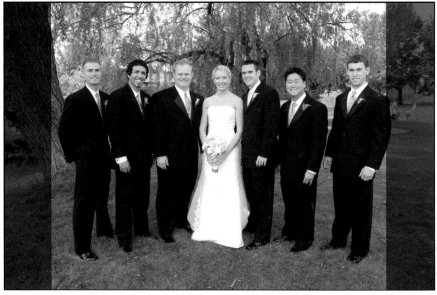

Figure 5-6: Make sure to leave room on your group shots so they can easily be cropped to the dimension of an 8x10 frame. Although this image seems to have a lot of empty space on the sides, it would just barely fit in an 8x10 frame.

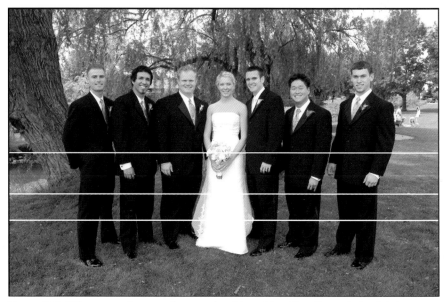

Figure 5-7: When cropping people, you should avoid cutting through the joints.

Shooting a Bull's-Eye

Most people know the word bull's-eye as a shooting term. In photography, *bull's-eye* is a composition term meaning that you placed the subject right in the very center of the image. For wedding photography, this is usually a bad quality, because the subject of most of our images is a person — and specifically, the eyes of that person. If you place the eyes in the middle of the image, as in Figure 5-8, you tend to have a lot of wasted space above the head, and not enough room down lower to show what was really going on in the scene. If you accidentally shoot a bull's-eye image, you can often improve it with some cropping; however, it is better to make the best use of your image space. Of course, there will be many exceptions where you may intentionally want to place the subject in the center. In Figure 5-9, the domed tops of a resort called the Riu Palace in Mexico, add a nice element to the scene even though it puts the subject in the bull's-eye spot when you include them both together.

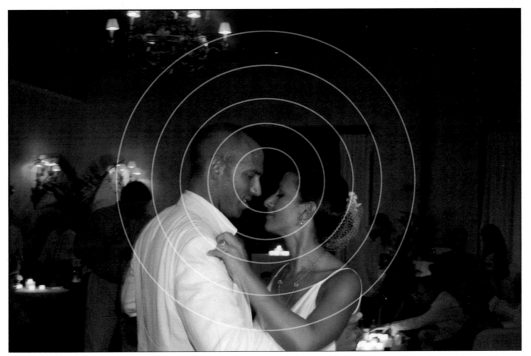

Figure 5-8: Bull's-eye! This shot would have been much better if I had lowered the frame to get less of the ceiling and more of the subjects.

Even after learning about the rule of thirds, most beginners still shoot bull's-eye images quite frequently, and most professionals will occasionally do the same. The reason for these accidental bull's-eye images is that photographers get mentally and emotionally caught up in the wedding. This emotional interaction automatically focuses your attention on the eyes of the subject, because this is how we normally look at each other. I've seen new photographers get so caught up "into" the experience of the wedding that they forgot for a moment that they were there to photograph it. This happens to a smaller extent as a photographer gets more experienced. This is especially true when the action is both emotional and fast paced. As a person moves in front of you, your sense of the other person naturally focuses on the eyes, and until you learn to detach yourself, you naturally point your camera at the other person's eye.

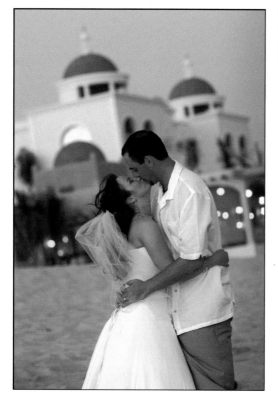

Figure 5-9: This framing puts the main subject in the Bull's-eye spot but the domed buildings add a secondary subject that allows the composition to work.

The trick to avoiding the bull's-eye is to keep yourself mentally and emotionally detached from the wedding. Mentally maintain the idea that you are there to photograph the event, not to be a part of it. Of course, you are a part of it just by being there, however, if you maintain a detached state, you will find that you are more able to focus your attention on the photography, and at the same time, broaden your perception of the event.

Instead of focusing on the emotion of what the people are saying or doing, focus on composing the picture so that it tells the story. Instead of focusing your attention only on what the bride is doing, you can also be aware of what the grandparents and friends are doing off on the sidelines. If you work on maintaining a broad sense of the event, you will find that it is easier to predict what is going to happen next and get yourself in a position to take advantage of it. Instead of just seeing the bride and groom walking towards the crowd, you may see a palm tree that they are about to walk under and get yourself down low to catch that in the background as they come by.

This sort of perception, combined with the technical skill to capture it, is what separates the average wedding photographers from the truly great ones. There is no magic to it. I am convinced that anyone who truly cares about shooting weddings can learn to expand their vision and perception. It's not that some lucky people are just born with an artistic eye while others aren't. There is certainly some genetic component to artistic ability, but for the most part, I believe it's a cultivated skill.

Leading the Focal Point

As a viewer looks at one of your images, the eyes of the viewer travel over the image in very predictable ways. The usual pattern is for the viewer to take in a very brief general overview first before zooming all attention in on the subject. If the subject is not obvious, the viewer's eyes may wander around searching for a subject. If nothing is found, the viewer feels stressed and/or dissatisfied and moves on to something else. If that image was in your portfolio, the something else the viewer may move on to is another photographer.

You have many tools at your disposal that you can use to lead a viewer around in an image. Figure 5-10 is an example of how you can intentionally blur parts of your image to lead the viewer to the subject. This very powerful tool can isolate and separate a subject out from the surroundings because our eyes naturally seek out the sharply focused points. Figure 5-11 shows how you can use lines in an image to draw the viewer up to the subject. No matter where your eyes wander around over the image, the leading lines always draw you back to the subject. Figure 5-12 shows the effect of darkening the edges of an image. This is called a vignette and it is very effective at drawing the viewer's attention in to the lighter portion in the center. If the lighting doesn't exist naturally, you can create it or enhance it by darkening the edges of the images in Photoshop.

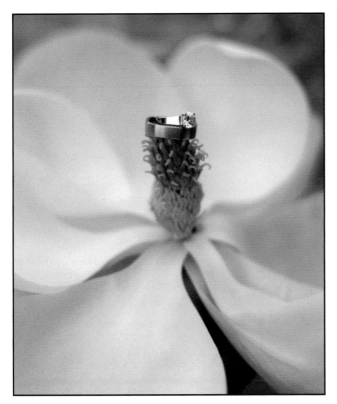

Figure 5-10: You can use a wide aperture to blur all parts of the image except that small portion you want to make sharp.

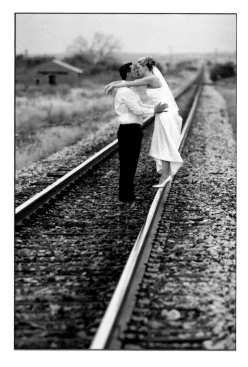

Figure 5-11: In this image, strong lines lead your view right up to the subject.

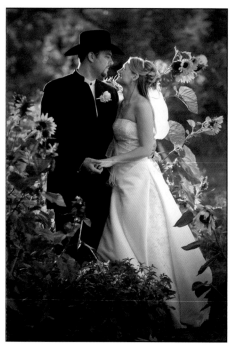

Figure 5-12: A subject can be defined by unique lighting that separates it from the rest of the image and draws the viewer's eyes in.

Natural Posing

Every photographer has experienced the gruesome distorted face of a child who has just been told to smile. Yikes! Sometimes the groom is almost as bad. Maybe the last time he was in front of a professional photographer was way back when he was a ring bearer and somehow he still remembers how to do it. Most of the clients we work with in the wedding business do not have any experience at modeling. In fact, it seems far more normal to find subjects that are shy, insecure about their appearance, and generally uncomfortable in front of the camera — at least for the first hour. If you have a friendly personality that helps people feel at ease, most of the normal fears will disappear quickly. However finding someone who completely loosens up and acts naturally when you raise your camera is rare. The worst thing you can do to a camera-shy couple is to give many specific directions about how to smile and how to hold their body. The more you do this, the more likely you are to get the same results as the child who has just been told to smile — he or she gets stiffer and stiffer.

Getting over the camera-shy stage takes some time. I like to start the wedding day shooting in the dressing rooms, because it gives me a chance to bond with the clients and for them to get comfortable being in front of the camera. During this time, I start creating a few directed pictures. Not many because you can capture most of this time in a photojournalistic style, but just a few to get them used to working purposefully in front of the camera. Occasionally, I see some fleeting movement or glance that looked beautiful and I give the bride some direction to re-create it. A few window light portraits in the dressing room can also help to break the ice.

The Creative Portrait Session

During the creative portrait session, which usually takes place in the late evening, you can focus on finding beautiful locations with spectacular lighting, and then put the couple in there and let them do their own thing. By now, the bride and groom should be more comfortable in front of the camera but you still have to be careful about giving them too much direction. I find that a few general directions are helpful if I deliver them when we are all standing together and just talking — before we begin taking pictures.

My speech covers these main points:

✦ I like to do very little posing because it tends to make your pictures more unique if you come up with ideas of your own. If you have an idea, please feel free to throw it out there, even though it may sound silly or impossible to do. Sometimes your idea won't work, but when you say it, the idea may evolve into other ideas that eventually create a great picture.

✦ When we find a good spot, I'll tell you roughly where to stand and then you can hug, kiss, play, dance around. . . anything you like — just don't look at the photographer because the goal is to make it look like you didn't even know you were being photographed.

✦ When I ask you to kiss, do it very slowly and give a lot of extra pause at the moment just before your lips touch because this is the most photogenic and romantic part of the kiss. In addition, when you kiss, don't pucker your lips out, just relax your face, and allow your mouth to stay slightly open.

✦ Your hands tell a lot about how you feel so be aware of relaxing your hands and placing them on your partner in ways that feel comfortable.

Figures 5-13 through 5-16 show a few of the results of this method. Figure 5-13 was taken from a high balcony at the Villa Antonia near Austin, Texas. I told the couple where to go and they did the rest. In Figure 5-14, Lisa and Mike were feeling very relaxed and playful as we walked down to the beach after their ceremony at Half Moon Bay resort in Montego Bay, Jamaica. They played around with a lot of kissing poses until I asked them for something with a bit more drama and they came up with this pose.

For Figure 5-15, I shot 20 or so images of Catherine and Scott playing around in the rocks by the McKenzie River before Catherine suddenly jumped up into his arms. They both threw back their heads in a laugh before Scott put her back down.

I like to put couples in places where I can get several good backgrounds just by walking around them. For this shot on a cliff near Negril, Jamaica, Figure 5-16, I found the spot and told the couple where to go, what they did in that spot was completely up to them.

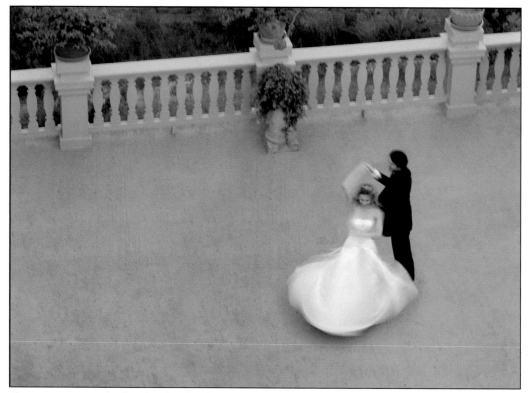

Figure 5-13: My only direction for this shot was to tell the couple where to go.

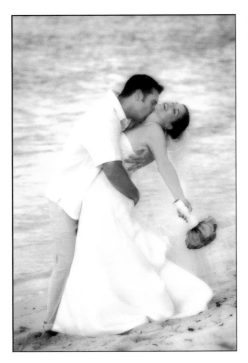

Figure 5-14: This shot is the result of simply asking the couple to do something with a bit more drama.

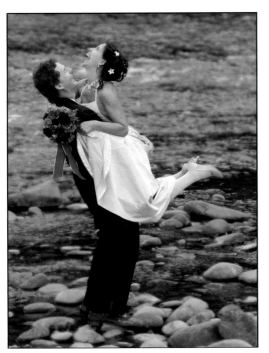

Figure 5-15: This image was not directed at all. It is simply the result of giving the couple permission and time to come up with something of their own.

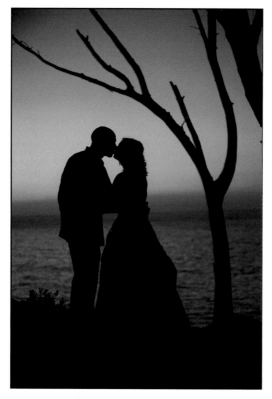

Figure 5-16: I found the place; the couple came up with the poses on their own.

Think Creative Thoughts

When I first started out in weddings, I had another photographer offer to loan me his *system*. The system consisted of a set of flash cards with pictures on them showing each of the standard poses that he would shoot throughout the wedding day. Even at that early stage, the thought of doing the same thing, the same way, every day, sent shudders through my body. Something inside me just can't stand the thought of doing the same thing every day.

This sort of mentality is what creates and encourages heartless wedding photography. Try approaching each wedding with a completely open mind, recognizing the fact that there is absolutely no reason the pictures you shoot today should have any similarity to the ones you shot yesterday. It's a new adventure every day. Every wedding is unique — why should your photography be any different?

As part of your preparations for each wedding day, take a moment to clear your mind and say to yourself, "I'm going to forget about every wedding image I ever saw before this day. I'm going to keep my mind relaxed, but aware and open, watching for the uniqueness of the people and the environment at hand so that I can act on the creative possibilities they present."

The truth is that anyone can practice, and learn, and grow as an artist if they really put their heart into it. It's not about genetics — it's about determination. You can see the difference when you look through a photographer's Internet portfolio. Most of the online portfolios you'll find look as if the photographer is just going through the motions, doing the same thing day after day. The images they show are heartless. The few photographers that stand out from that crowd are truly inspiring and you feel amazed at the creativity and the beauty they can capture in seemingly ordinary moments.

Summary

There are no rules that determine what makes a beautiful wedding image and what makes another bad. This is a judgment that comes from the viewer. We create images to please viewers. With that in mind, there are a few basic photographic concepts that we loosely call "rules", but the real purpose of these rules is to guide beginning photographers in a way that provides some direction that helps them to see how an image will affect the viewer.

The "rules" eventually become meaningless as you develop your own unique and very heightened perception of what viewers will find pleasant. This is the point where a photographer slowly graduates from craftsperson to artist. A craft is something another person can teach you. Art is where you make the craft your own by taking it off in new directions where no one has gone before.

✦ ✦ ✦

Shooting Weddings on Location

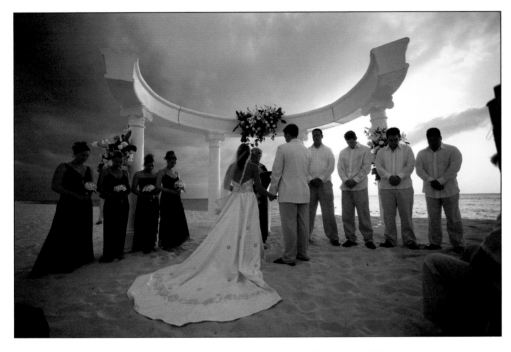

6 Finding Beauty and Emotion in the Dressing Rooms

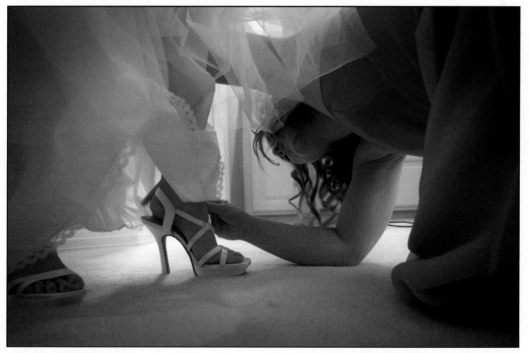

18mm, f3.5, 1/20th, 400 ISO

This chapter covers information on how to develop a comfortable relationship with people in the dressing rooms. If you're just getting started in wedding photography, you need to know how to approach the dressing rooms so that your clients trust you to capture great images while still respecting everyone's need for privacy. Other topics range from what sort of equipment is needed, what settings to use, dressing room etiquette, how to arrange the room, and how to create detail shots that capture the

feeling of the day. The dressing room is where most of the behind-the-scenes action takes place in a swirl of activity around the bride. Without the images you capture for her, the bride would almost certainly not remember the events that happen here.

To the average bride, getting married has been a lifelong dream. As the preparations start to come together and she finds herself in the dressing room, there comes a moment as the dress is held aloft by her mother and all of her most cherished friends, that she is suddenly struck by the overwhelming feeling that the day has arrived. . . it's really happening, and here I am in my dress! As the bridesmaids raise the dress over the bride's head, there is a similar feeling that this is truly a momentous occasion for these people. What a privilege it is as a photographer to attempt to capture all that emotion and preserve it for them.

Equipment

The list of equipment you might use in the dressing rooms can easily encompass every piece of photographic gear you own. Your needs on any particular day depend on the location. I've seen dressing rooms that could easily house a small family and others with barely enough room to squeeze in without bumping out one of the bridesmaids. The smaller version is by far the most common. Rarely do you get a room that is considered large by any standards. This is especially true with the men's dressing room where you are likely to be so close as to be bumping up against someone much of the time. The girl's dressing room is usually slightly larger, and if you're lucky, it even has a few north-facing windows to let in some light. In either case, the main action takes place around the mirror so you'll still need to get in close to see anything. I can't count the number of times I've stood in bathtubs, shower stalls, and on top of toilets to get images of the bride in the mirror. Figure 6-1 is a self-portrait to illustrate my point.

Figure 6-1: Shooting in the dressing room means close quarters.
25mm, f4, 1/30th, 400 ISO

Wide angle lens

For these close quarters you need a lens with a wide view. The wide-angle zoom is the most commonly used lens in the dressing room. Due to the small size of the room, you may not be able to get more than a few feet away from your subjects, but even at this short distance, a wide-angle lens can still include a surprisingly large amount of the scene. Figures 6-2 and 6-3 illustrate the close range storytelling abilities of a wide-angle lens.

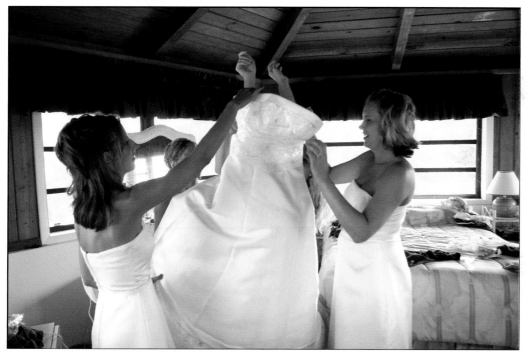

Figure 6-2: Everybody wants to help with the bride's dress and a wide-angle lens such as this 17mm, includes everyone but the photographer.
17mm, f4, 1/200th, 400 ISO

When you use this lens, remember that its major image characteristic is that it makes close things look larger and far things look smaller. If you want everything to look normal size, just make sure that all of your subjects are roughly the same distance away from you. The size factor can be used to great advantage if you have something that you want to emphasize and you can get it up close in the foreground.

A second image characteristic for this lens is that it includes a *lot* of the background. If you like the background, then this is the lens to use. If you want to minimize the background, choose a longer lens which has a much narrower view, and gets a much smaller piece of the background.

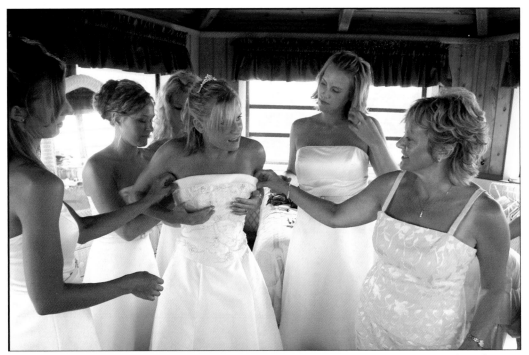

Figure 6-3: When the space is limited, a wide-angle lens can capture all the action even though you may only be four or five feet away.
18mm, f3.5, 1/60th, 400 ISO

Medium lens

Although the wide angle excels at telling stories, it isn't very good at capturing romance. This is where the medium range 50mm f1.4 lenses really start to shine. Some photographers prefer the 35mm f1.4 because it gives a slightly wider view than the 50mm while still retaining the same shallow depth of field effects that you see in Figure 6-4. In either case, this lens is wonderful for working around the bride's mirror to get close-ups of the makeup going on and the attendants working their magic with brushes and curling irons. You could use a medium range zoom lens like a 28-105mm. These medium range zoom lenses will work fine, but they typically don't offer the super wide apertures that create the beautiful shallow depth-of-field effects.

You can't get a very large view of the scene with these medium lenses, but much of the human perception of romance is achieved by leaving something to the imagination. Sometimes, as in Figure 6-5, showing a tiny slice of what was going on can be a lot more effective than showing everything, because it lets your imagination fill in the missing details. The human mind is great at imagining romance and beauty — especially if you give it a little piece of something romantic to start with. If you shoot the same picture with a wide angle, you get the truth, and the truth is that most dressing rooms are not that romantic. The shot in Figure 6-5 isolates a small portion of the dressing room action to create the romantic look in this image. The romantic feeling is further enhanced by the blurry motion of the hand sweeping the hair back. Does the blur detract from the image? Personally, I think it adds some life to it. Life isn't always sharp and it doesn't sit still, it moves constantly.

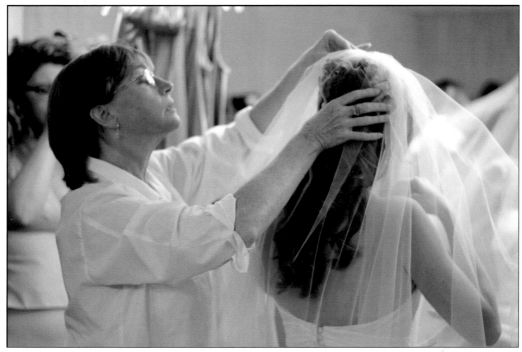

Figure 6-4: A moment such as this between mother and daughter is something you wouldn't want to miss.
50mm, f1.7, 1/250th, 400 ISO

Figure 6-5: Isolating a small portion of the action creates the romantic look in this image.
90mm, f4.5, 1/10th, 400 ISO

70-200 telephoto

Another lens that works great around the mirror is the 70-200mm telephoto. If you happen to be stuck in a small room, you can still use this lens by zooming in really close on faces and other small details as the makeup is going on. However, if you can get back a little farther away from the action, you can still zoom in close on your subjects while taking advantage of the fact that your distance puts them much more at ease.

Positioning myself in a nearby room and shooting through an open doorway into the bride's dressing room allowed me to take the image in Figure 6-6. The telephoto allowed me to get so far away that the bride completely forgot I was there. This is a huge advantage over shorter lenses like the 50mm, which can get a very similar image, but from a much closer range.

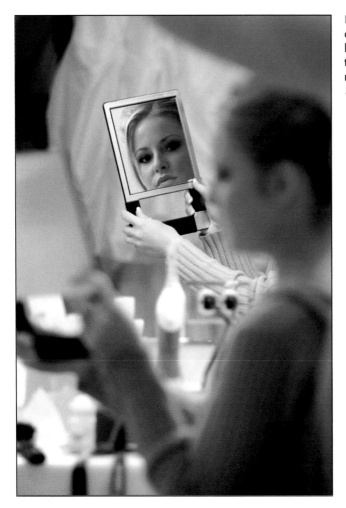

Figure 6-6: For this shot, the bride was completely unaware of my presence because I used a long lens and shot through a doorway from an adjacent room.
150mm, f2.8, 1/64, 800 ISO

Lens Baby

The Lens Baby also works well for creating romantic portraits, close-ups, and detail shots in the dressing room. The blurry effect created by this lens can easily be overdone, so I recommend using it sparingly. My own experiences with the Lens Baby have shown that the effect is either *really* good or *really* bad. This makes it easy for me to shoot a lot of images while I'm working on an idea, and then afterwards, I edit out the vast majority and only include a few of the best. Figure 6-7 shows one of my favorite ways to use this lens. As you squeeze the front of the lens into focus, you can also tilt and shift the front at odd angles to move the sharply focused spot around the scene. Some of my favorite images have been the ones with the most obvious subject being out of focus and some other area getting emphasized with the focus point. This lens is fun to use but I would caution you not to leave it on your camera too long. If you include a few Lens Baby shots, your bride will probably be very happy. If you include hundreds, she'll be mad. More information on this unique lens can be found in chapter 3, and at www.lensbaby.com.

Figure 6-7: This pair of images illustrates how you can bend the Lens Baby to place the focus anywhere you want it.
Lens Baby2, 1/60th, 800 ISO

A new accessory for the Lens Baby that I've come to enjoy is the close-up adapter kit. This kit consists of two screw-on lens elements (4x and 10x) that attach to the front of the Lens Baby and enables you to focus in close on small items such as jewelry, as shown in Figure 6-8. This can work wonders in the dressing room where you have the time to grab objects such as shoes and jewelry to do a little setup shot. One of my favorite places to make this sort of arrangement is on a large windowsill. Chairs with nice fabric upholstery can also work well.

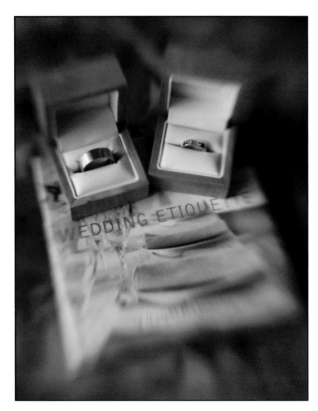

Figure 6-8: The Lens Baby can add a bit of mystery to a small detail shot in the dressing room.
Lens Baby 2, with 4x macro lens attachment

Lighting the Dressing Rooms

There are basically three different types of images you might try to create in the dressing rooms: documentary, romantic, and details shots. Documentary images tell the story of what was happening and they can be shot either with or without flash. Details shots and romantic portraits are best made without the use of electronic flash whenever possible. Occasionally a dressing room may be so dark as to require additional light, so I always make sure to have an on-camera flash with me, but I like to affectionately

call my flash the *romance sucker* because it completely removes the romantic feel you can get with natural light. Natural light is far better if you're trying to create a romantic image.

If you must use a flash in the dressing room, you can minimize the unnatural look in two ways. One method is to bounce the light off the ceiling as in Figure 6-9. This creates a very even illumination that looks much like a room that is lit by fluorescent ceiling lights. The other method is to set your flash to be a fill light at about 1 f-stop under the ambient light exposure. The term ambient light refers to the natural light, which is everything except the light created by your flash. If you set your camera to make a proper exposure for the ambient light, and then set your on-camera flash to produce a –1 flash exposure (do this with the exposure compensation control either on the camera, or on the flash itself) then you get a very well balanced indoor exposure with good color and some shadows but not really dark shadows.

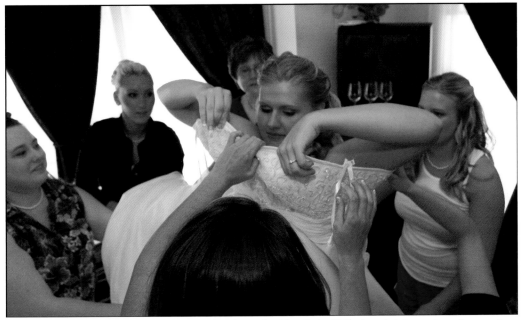

Figure 6-9: Documentary shots such as this do well with a little fill flash to brighten the colors and fill in the shadows. You can make the light look a bit more natural by bouncing it off the ceiling.
17mm, f4, 1/200th, 400 ISO

Window light

One of the best and most commonly available light sources in a dressing room is from a large window. If you have such a window available, the bride will almost always have a few minutes to work with you in the creation of a window light portrait. After all the dressing and makeup are complete, there will usually

be a little down-time when the bride is waiting to head for the altar. By then the nerves are usually start-ing to get the best of her and she will be more than happy to do something distracting. There are many ways that you can do this shot. You can shoot towards the window and get the bride in silhouette, or you can place the bride near the window and simply use the light without getting the window in the image at all. This is how I created the image in Figure 6-10. For this shot, I turned the bride's face away from the light to create more of a mysterious, moody feeling with the dark shadows.

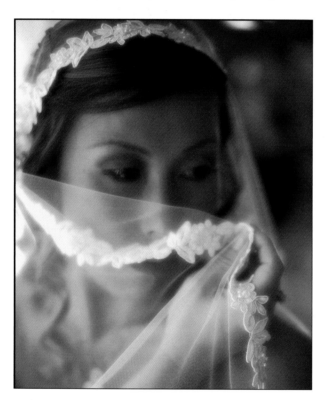

Figure 6-10: The girl's dressing rooms almost always have a window where you can create a few portraits.
50mm, f1.8, 1/250th, 200 ISO

Balancing light sources

The light you encounter most often in dressing rooms is Tungsten in the girl's room and fluorescent in the guy's room. Either of these can be balanced out fairly well with the Auto white balance setting, and a little better with the specific setting for that light source, which can be found in the white balance menu on your camera. The best way to get true colors and neutralize any strange light sources is by using an Expodisc. Check out Chapter 3 for more information on the Expodisc. The Expodisc is especially useful when there is a combination of light sources. Only a custom white balance can completely neutralize mixed light sources.

The only drawback to using a custom white balance setting is that it will balance only one lighting location at a time. If you need to move back and forth between several rooms or between completely different lighting in one area, you would be much better off to stick with the Auto white balance setting. You could also shoot in RAW, which allows you to adjust the white balance settings to perfection when you process the images in the computer.

Balancing out the light for true colors works great for the majority of the images you create. However, after you capture the essentials of the story, try experimenting with different white balance settings. Sometimes the setting for some other light source produces a very different and pleasant look. Obviously the effect will not look realistic, but if you want to try something different that has the potential to produce dramatic results, try switching to the wrong white balance setting.

For example, shooting with the shade setting in a room with Tungsten lights produces a beautiful golden glow such as that in Figure 6-11, that can work great for a romantic scene. Shooting with the Tungsten setting in window light produces a striking blue tone. Once again, the easiest and most adjustable way to experiment with this is to shoot in RAW and pick through the different white balance settings later.

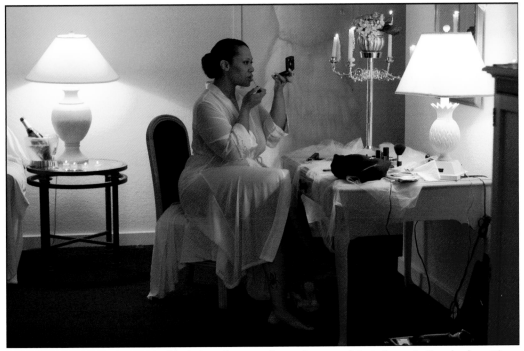

Figure 6-11: I love the warm golden glow that I get by setting my white balance to the shade setting in a room with Tungsten lights.
50mm, f2.8, 1/200th, 1600 ISO, white balance = shade setting

Giving the Bride Advice

If you have the opportunity to talk with the bride before she chooses her dressing room location, you could mention some of the following points to her so that she'll know what to look for in a good dressing room. I have shared this information with many brides over the past years and I'm always surprised at how many of them follow every little detail. Brides are extremely interested in getting good pictures, and they appreciate every little tip you share with them to make their wedding day better or more photogenic. The primary benefit to you in sharing this information is that a good dressing room makes your pictures look better, so you should have as much interest as she does in the location. The following is a selection of tips I give the bride.

Decorate the girl's dressing room just as carefully as you would any other part of the wedding location, because a large portion of your pictures will be taken here. When you choose a location, pick a room with some r-o-o-m and lots of natural light. On the wedding day, have your girls clean up all the non-wedding messes such as piles of blue jeans and tennis shoes or other clothing that are not wedding related, but don't make the room look too neat; messes are okay if they're wedding messes. Empty boxes and bags should be placed somewhere outside the dressing room. It looks wonderful to have all the dresses hanging and shoes lying around on the floor, but they look awful if they're still in the box, or if they have piles of plastic wrappers and cardboard boxes lying next to them. Flowers also look much better in some sort of vases instead of the cardboard boxes the florist packed them in. Cover up any ugly furniture with plain white drape cloth.

Lighting is extremely important for the girl's dressing room. The windows absolutely must be open to bring in the natural light. If you have anything distracting or unsightly that would be visible through the open windows, place some light gauzy curtains over them to cut back on the view while still allowing the light to come in. If you have no window light, think romance, and get creative. Use lots of candles or little Christmas lights placed around the room.

Shafts of sunlight streaming in the windows may look great to human eyes, but that extreme level of brightness in an otherwise dark room is a photographer's nightmare. If you must use a room with direct sun on the windows, put up some curtains to diffuse it. You can also put light cotton cloth over the outside of the window in order to cut down the direct sun. If you want the absolute best lighting for your dressing room, pick something with large, north facing windows—this is a photographer's dream come true.

As the photographer, you may be thinking, "would a bride really do all this?" Never underestimate the lengths a bride will go to for good pictures. The people we work for border on fanatical when it comes to pictures. I can't count the number of times I've walked into a dressing room in a third-world country only to find every detail of this list followed to perfection.

The guy's room

The guys tend to care very little about seeing the exact colors of their makeup, so the room they choose can have almost anything for light. Fluorescent seems to be very common. I always bring my on-camera flash (the kind that mounts on the camera hotshoe) to this room because it enables me to overpower any strange lights. The guys tend to care a lot less about the whole getting dressed scene. When they finally decide to head for the dressing room, they gather everything up, pack in the nearest hotel room or large bathroom, and start putting on the tux. They almost always help each other out with cufflinks and the tie, but you better be quick if you want to catch it because it consists of a little. . . tighten this, pull that strap, straighten here, pat on the back, and it's done. There isn't much standing around debating about hairstyles, and there definitely isn't a lot of emotional hugging and kissing or anything like that. The whole operation usually takes about 10-15 minutes. As the photographer, you have to watch carefully for moments such as those in Figures 6-12 and 6-13 when the groom needs help with the tie or cufflinks. You

should already be in position and waiting for it to happen so you can shoot it fast. You absolutely must be ready to shoot quickly and without interfering in the process because guys are notoriously impatient with photographers that want them to repeat something just for a picture. This encounter is your first chance to make an impression on the groom and his crew. If you make it painless, you can earn a lot of respect that translates into the guys being much more willing to work with you later in the day.

Figure 6-12: A tender moment between father and son is a rare treat in the guy's dressing room.
23mm, f4, 1/40th, 400 ISO

Figure 6-13: Moments such as this don't last long in the guy's dressing room—you have to be ready to shoot fast.
17mm, f4, 1/60th, 400 ISO

Fluorescent Banding Alert!

While shooting in the dressing rooms, you will often encounter mixed light — tungsten lights in one fixture, fluorescent in another, and maybe some candles as well. Normally these combinations won't cause much difficulty but occasionally you will encounter green banding in your images as seen here.

This is caused by the pulses of light a fluorescent tube makes. We don't see this because the pulses are so rapid that it just looks like a solid light to us. Computer screens are the same way. However, if you use any shutter speed faster than about 1/60th of a second, you risk catching only part of the pulse as the blades of your shutter close. This creates an image with even tungsten light over the whole thing, and a band of green-ish yellow from the fluorescent lights. The only way to solve the problem is to shoot slower than 1/60th, or simply reshoot the image until you miss the fluorescent pulses.

Details shots

A medium lens such as the 50mm f1.4 is very good at isolating small details from the day. I always enjoy the challenge of roaming around the dressing room with this lens while searching out all the tiny details that this bride has prepared for her wedding day. Each one gets its own portrait. As you can see in Figure 6-14 through Figure 6-17, everything in the room is fair game from the curls in her hair, to the pearls, the rings, makeup, shoes, flowers, wine bottles, cards from the family, and so on.

The shallow depth of field this lens produces works great to isolate small portions of each little set you create. Just pick a point of interest to place the focus on and the rest gets a soft blur. Be careful with these set shots so that you don't create a look that appears too organized or too well lit. The goal is not to get the perfect look of a studio photograph—just a casual portrait of the small details. To the untrained viewer, the scene should look as if you just found it that way.

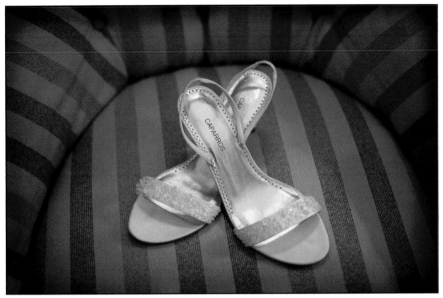

Figure 6-14: A nice piece of upholstery makes a good background for this shot of the bride's shoes.
50mm, f2.5, 1/60th, 400 ISO

Figure 6-15: Small sets such as this are loosely arranged to look as though they might have actually just been found this way.
50mm, f2.8, 1/50th, 400 ISO

Figure 6-16: Objects you see in the dressing room may have great significance later in the day.
50mm, f2, 1/60th, 800 ISO, white balance = shade

Figure 6-17: I put the note from the bride's mom together with the flower, and propped it up with the bride's shoes.
50mm, f5, 1/60th, 800 ISO

Dressing Room Etiquette

Working in the dressing room that belongs to the opposite gender from yourself is obviously a little tricky. Many expectations and a lot of trust can be built-up or destroyed depending on how you handle yourself during this delicate time. Almost every bride has a bit of an awkward feeling around the nudity issue. They're torn between wanting you to leave and wanting you to keep taking pictures. The following tips give you some ideas for ways to approach the dressing rooms in a manner that can avoid embarrassment and bad feelings for both yourself and your clients.

Knock before entering

Perhaps this sounds self-explanatory but you should definitely knock before entering any dressing room — even the one for your own gender. Most people have a certain amount of uneasiness associated with undressing in front of strangers. In order for them to trust you in the dressing rooms, they need to see that you have respect for their privacy. If you build this trust early in the day by always knocking and yelling through the door, "the photographer is here, is everybody decent?" then they can soon trust you enough to allow you to come and go as you wish throughout the day.

Talk about the nudity issue

Everyone is different when it comes to modesty. I have seen some brides strip down completely naked without a care, and others that asked me to leave every time they wanted to adjust the veil. In order to check in and make sure everyone is comfortable with your being there, it's best to approach this issue yourself, early in the day, and just get it out in the open for all to hear. That way it alleviates any stress and gives everyone involved a feeling that you are acting in a professional manner and you will stay or go any time they wish. I try to bring it up when I'm first entering the dressing rooms, right after introductions and before the picture taking starts. My speech goes something like this:

"Hello everyone, my name is ____ and this is ____. We are the photographers and we'll be shooting photos with you today. While we're here in the dressing room, if you want us to step outside while you change, or for any reason at all, just let us know and we'll wait outside. If we don't hear any requests to leave, we'll assume that whatever you are doing is something you are okay having in the pictures. If there are any images that contain nudity we put them on a separate disc so that the bride and groom can control who sees them."

Just hearing a speech like that often gets a sigh of relief from the bride. I think that it eases her tension and reassures her that you are simply there to capture images of the day — if she wants pictures of her getting dressed — that's up to her.

What not to shoot

Taking photos of children in the dressing room is an extremely touchy area. All it would take is one accusation of child pornographer and you would be ruined! This is obviously something you need to avoid at all costs. My general rule is never photograph nude or partially nude children unless they are actively involved in a photo, which was requested and arranged by the other adults in the wedding party. For example, I once shot pictures of all the guys in their underwear, at their request, and they also requested that the ring bearers be included. I can't imagine anyone complaining to me about something like that because I was simply doing what my clients asked me to do, and I had nothing to do with arranging the shot.

Another general rule that keeps everything safe is the swimsuit rule. If it shows more than what you could see if the person were in a swimsuit at the public pool, don't shoot it.

Older women will often ask to be excluded from pictures in the dressing room — especially if they don't have the makeup on yet. Use your own instincts in deciding if you want to obey this request or not because many of these requests are simply mild insecurities about their own appearance. After everything gets going, the self-conscious crowd usually loosens up a bit and then they won't care about the pictures. The bride will definitely want to see all the moms and grandmas in the photos. Of course, any person that seems to feel genuinely uncomfortable with being photographed should be avoided if possible.

Summary

Developing a comfortable relationship with everyone in the dressing rooms is vital to reportage style photography. If you set the scene with a professional attitude right from the beginning, your clients will soon learn that they can trust you to capture great images while still respecting everyone's differing needs for privacy.

Equipment for lighting and shooting in the dressing rooms run the entire gamut. All your lenses and lights can be useful depending on the size of the room and how much window light you have available. The guy's room can be the worst with funky lights and very cramped quarters. If you're lucky, you will have talked the girls into finding a north-facing room and decorating it to look a bit more elegant and wedding-like than the average hotel room.

7 Shooting Outdoors

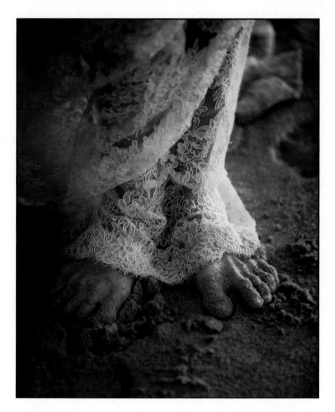

Any discussion about shooting outdoor weddings requires that the day be broken down into the different types of light you might possibly encounter on the job. This chapter covers general concepts as well as specific techniques that help you deal with bright sun, complete darkness, and everything in between.

Knowing how to shoot is only half the problem when working outdoors. You also have to know how to look around and pick places where the light has certain desirable characteristics that will enhance your group shots or your romantic portraits. The final portion of this chapter discusses the key elements to look for in recognizing good outdoor lighting opportunities.

Equipment

The good news is that there is no special equipment required for shooting an outdoor wedding. You won't need anything more than your standard set of gear including a camera, three lenses, a couple CompactFlash cards, and a hotshoe mounted flash.

Except for the time spent in the dressing rooms, many weddings take place completely outdoors. On these days you may find yourself going from the dressing rooms straight out into one of the most challenging light situations a wedding photographer can experience — bright sun. Later in the evening, you have to deal with low light as twilight approaches, and then darkness as the reception carries on into the night. One thing is for sure, a wedding photographer's job is never the same — it changes drastically from one job to the next, and when you're shooting outdoors, the job also changes from moment to moment throughout the day.

The types of equipment do not change from indoor to outdoor pictures; what changes is how you use that equipment. For example, the same flash that provides your only light indoors can be used as a fill light to brighten up the shadows in an outdoor shot. The same wide-angle lens you might use indoors in the bride's dressing room can be used to capture the ceremony outside.

Working in Bright Sun

Bright sun is one of the most difficult factors to deal with as a digital wedding photographer. Wasn't it only a few short years ago that we all shot film and didn't worry too much about exposure? Film captured such a wide range of brightness that we could be pretty careless about exposures, and the lab could always correct it. In fact, overexposing negative film a stop or two actually improved it.

Those days are long gone, and unfortunately so is the ability to be carefree about your exposure on a sunny day. Because there is such a wide range of light values on bright sunny days, you have to worry about overexposure of the highlights and underexposure of the shadows at the same time. Understanding this problem requires a little background on the limitations of your digital camera.

Dynamic range

The problem you encounter on a sunny day is that there is a difference of about 10 f-stops between the areas in direct sun and those in complete shadow. When you expose an image in these conditions, you can either set your exposure for the sunny side or the shady side, but you can't make a correct exposure for both at the same time. This is a limitation of all cameras — film or digital. The total range of light that you can capture in one image, from brightest white that still contains detail to darkest black that still contains detail, is called the *dynamic range*. If you shoot film, each film has a different dynamic range, so the dynamic range is a quality of the film and not the camera. With digital, there are many different manufacturers of digital chips, and each type of chip has a different dynamic range. However, after they build that chip into a camera, the dynamic range becomes a fixed quality of your camera and it cannot be changed.

The light recording chip in a digital camera is referred to as either a CMOS (complementary metal oxide semiconductor) or CCD (charge-coupled device). Both types of light gathering chips have a similar dynamic range, and both are smaller than what you may have experienced in the days of shooting

negative film. This smaller dynamic range means that if you miss your exposure by very much at all, you start to get pure white highlights with no detail, or pure black shadows with no detail, depending on which way your exposure was off. This makes it very easy to miss your exposure enough to ruin the image, especially if you miss in the direction of overexposure.

The simplified explanation of the dynamic range problem is that while the scene may encompass ten or more stops between the lightest and darkest areas, your camera cannot possibly capture all of it in one shot. Some digital cameras capture more and some less, but they all have a limit that is far less than what can exist on a sunny day. This problem was a horrible drawback in the first generation of digital cameras, but as the technology improves, so does the dynamic range of each successive generation of digital camera. At the time of this writing, technology has progressed to the point that most high-quality digital cameras have at least a 5–6 f-stop dynamic range.

What Is a Histogram?

This book makes many references to histograms. A *histogram* is basically a bar graph that shows where all the brightness values are in an image. The histogram, though it may appear solid, is actually made up of many tiny vertical bars much like the teeth of a comb, each one representing a single level of brightness. The histogram of a JPEG file only has 256 bars, while the histogram of a RAW file has 4,096 bars.

When you look at the histogram as a bar graph, all the white or bright toned objects are represented on the right of the graph, while darker tones are represented on the left of the graph. The height of each bar tells you how many pixels in the image share that level of brightness. If the image has a lot of white tones, the histogram rises up on the right side. If there are a lot of darker tones in the image, the graph rises up on the left. An average scene has a graph that rises in the middle.

The fact that JPEG has 256 tones and RAW has 4096 is a very important difference if you want to change the brightness, contrast, or color of an image. Making anything more than the most minor of changes to a JPEG file causes the bars to pull apart, leaving gaps in the histogram. A RAW file has 16 times as many bars to start with, so you can make huge changes without causing any noticeable gaps in the histogram.

Images A, C, and D in this sidebar figure were derived from a single RAW file. The first image (A) was made by converting the original RAW file straight to JPEG. Image (C) was darkened (while still in the RAW format) using the brightness controls. The third image (D) was converted to JPEG exactly as image (A), before being darkened with a *Levels* adjustment. The histograms for images (C) and (D) show the difference between performing a brightness adjustment on a RAW file and a JPEG. The same darkening that didn't seem to damage the RAW file has produced large gaps in the histogram of the JPEG file.

When the bars pull apart, this represents an area in the image where the colors no longer change smoothly from one tone to the next; instead, you will see blocks of color that are obviously the same. This effect, shown in Image B, is called *banding,* and it is most noticeable in smooth-toned areas like the sky. The blue image was given an extreme brightness change to show an exaggerated example of banding. Notice how the sky is reduced to large blocks of single colors. The large gaps in the histogram represent missing tones. Missing colors are filled in with the same tone as that of the next nearest neighboring tone, resulting in large bands of single colors like that seen in the sidebar figure.

Continued

Continued

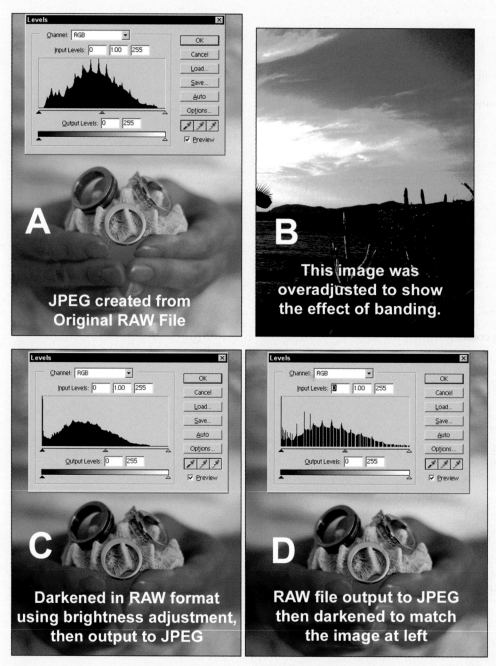

How to cut your losses

On a sunny day it may be impossible for your camera to capture every tone of brightness with the limited dynamic range of a digital camera. However, you can do several things to maximize the range of tones that your camera can record. The first is to set your file type to RAW. Shooting in RAW format extends the latitude of your digital camera to the absolute maximum, but still not quite to the degree of color negative film. This is why RAW file is sometimes referred to as a *digital negative*. The RAW format captures all the preprocessed data that your camera can possibly record and saves it directly to a file without any processing. You can't really use a RAW file in its raw format. You have to process the file in your computer and save it to another format like JPEG or TIFF. The truly great part is that you can change every variable about the shot except the aperture, shutter speed, and ISO settings that you used in capture. You can change the white balance and the color, and most importantly, you can make drastic changes to the brightness levels before you render the image out to another format.

In comparison, if you save your images in the JPEG format, much of the original data captured by your camera is deleted. As you may know, JPEG is a compressed file type that loses some of the image data in order to conserve file size. However, in the case of a sunny day, the bigger concern with using the JPEG file type is that it loses most of the *tones* that your camera can produce. This loss of tones isn't so noticeable in an average scene, but when you want to record the largest range from bright to dark tones, you definitely don't want to be throwing anything away. The JPEG file type is an 8-bit (2^8) file, which means that it can contain only 256 tones. The original RAW data captured by most medium and high-quality digital cameras is a 12-bit (2^{12}) file type that can contain 4096 tones. That's quite a lot of potential data to be losing. The worst part is that when a camera converts the data from RAW to JPEG format, it very appropriately puts the emphasis on capturing the largest amount of data possible. If the scene had ten stops between the brightest spot and the darkest, and the camera can only keep five, something has to go. The camera software saves the majority of the scene by capturing the best chunk of data that it can encompass in the five stops it has to work with, and then it crops off the rest. Unfortunately the "rest" is the part that contains either the highlights or the shadows and quite possibly some of both.

Figure 7-1 shows a histogram, which represents the full range of tones that may be encountered on a sunny day. Each vertical bar represents one f-stop of light in the scene. The dark lines labeled A and B represent the possible exposures that a camera can make to position its dynamic range in a place that would capture the best portion of data possible in the scene. As you can see, the camera is faced with a choice because it can't possibly get everything. In exposure A, the camera captures all the detail in the highlights, but it loses much of the shadow detail. This creates very dark shadows. In exposure B (Figure 7-1), you would see much better detail in the shadows, but the highlights would be very blown out, with large areas having no detail at all. Figure 7-2 shows a histogram that you might encounter on a cloudy day. This histogram is much less spread out because the range of brightness values from the brightest thing to the darkest is not so great as on a sunny day.

If you use the RAW file type, you can process the files afterwards in a manner that compresses the histogram from the side so that all the data will fit into a smaller range that can be encompassed by the JPEG file type. This produces a JPEG file with a much larger tonal range than what your camera captures on its own if you use the JPEG file type.

Figure 7-3 illustrates the difference between the two file types in a more visual way. This simple test was performed by placing two objects outside on a sunny day. The piece of paper on the left has type on the back of the page, but you can still see it very lightly on the side that is visible in the sun. Next to the paper, I placed a black photo vest in a shadow. I set my Canon 20D to 100 ISO and changed the file type to record both RAW and full resolution JPEG images simultaneously with each shot.

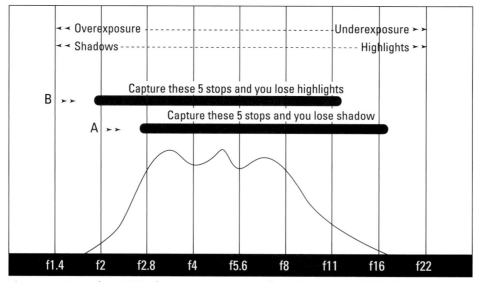

Figure 7-1: To make a JPEG, the camera automatically assigns the available dynamic range to the place where it just barely encompasses the highlights.

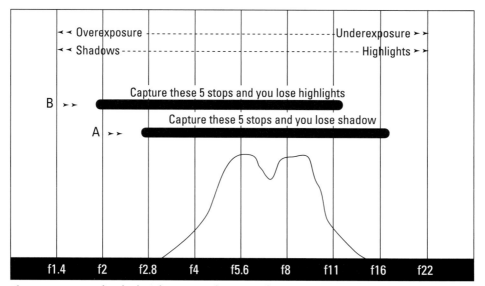

Figure 7-2: On a cloudy day, the camera has a much easier time assigning the dynamic range so that it completely encompasses the brightest and darkest values in the scene.

The comparison you see in Figure 7-3 is between the two files that were recorded in a single shot. Notice that both images appear to have lost much of the detail in the blackest shadows. I measured the scene myself and got a difference of nine f-stops, from brightest to darkest so it should be no surprise that all the details don't show up here. However, to be fair to this incredible camera, I should mention that with a little work in Photoshop, I was able to see that both files contained detail right down into the darkest shadows, and there was not a single spot that registered without any detail. If you wanted, you could easily brighten up the black vest until it was visible in the shadows.

What does it all mean? The first thing to notice is that both files get data in the highlights and shadows. The real difference is that when the camera produces its own JPEG file, it compresses all the tones together, producing a much more contrasty image. When you process a RAW file and then convert it to JPEG yourself, you have the option of expanding the tonal range so that you get a much smoother grading of tones. Notice the difference in the shadows below the piece of paper, and in the rocks below the black vest. You can see how much darker the shadows are in the image that was captured in JPEG compared to the image that was captured in RAW and then converted to JPEG.

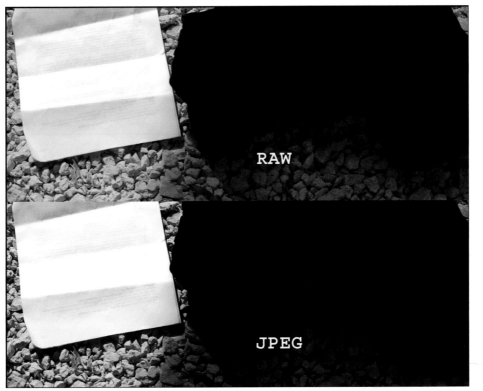

Figure 7-3: These two files were captured in a single shot. As you can see, the RAW file has a far greater level of detail in the highlights, and the graduation between the shadows and highlights is much smoother.

Another detail that compounds this whole problem is that your computer monitor and your printer also have a dynamic range all their own which is dictated by, and limited to, the sRGB color space. If you try to print an image that does not fit within the dynamic range of the sRGB color space, the printer ignores every color tone outside the range. This problem is all too apparent in Figure 7-3 because the shadow detail is currently far beyond the ability of any printer — making the black material of my photo vest appear as a black blob. If I were to use the RAW file to lighten up the shadows and then output the image to the sRGB color space, I could easily bring the whole image into the range of any printer or monitor.

Using JPEG on a sunny day

Shooting RAW files and manipulating them in your computer does require a fairly high understanding of a software program such as Photoshop, ACDSee Pro, or the manufacturer's software that you may have gotten when you purchased your camera. If you don't feel up to the task, don't despair — there is still hope. It is quite possible to shoot a wedding in the sun while saving in the JPEG format. If you don't want to shoot in RAW for whatever reason, you still have three more options that will improve the images you can create in bright sun.

1. **Go into your settings menu and set your contrast and saturation to the lowest possible settings.** This makes your images look a little on the flat side, but it also gives you a lot more dynamic range when shooting in the sun. Just don't forget to change the settings back to normal as soon as you get out of the sun.

2. **Set the ISO at the lowest setting you have.** ISO settings have progressively less and less dynamic range as the numbers go up.

3. **Put on your flash and use it to fill in the shadows.** This has the effect of lowering the brightness range in the scene by filling in the shadows to match the level of brightness in the highlights.

Watch the histogram and blinking highlight warning

Most pro-level digital cameras have the option of turning on the histogram and the blinking highlight warning. Both of these features are much easier to see on a bright sunny day than simply looking at an image on the LCD. The blinking highlight warning helps to make sure you don't blow out the highlights while shooting in bright sun by showing a blinking spot for any blown-out areas. You simply correct the exposure and shoot again until you don't see the blinking areas.

Exposure Latitude

Exposure latitude is the amount by which you can miss the correct exposure and still get a useable image. This is a very nonscientific and subjective term because what one photographer sees as acceptable loss of highlights may seem awful and completely unacceptable to the next. How far can you miss your exposure? The answer depends on the personal tastes of the photographer doing the judging.

Overexposure

On a sunny day, an overexposure of only 1/2 stop can cause very noticeable color shifts and loss of detail in the brightest highlight areas. This means that there is simply nothing recorded in those places, which show up as paper white when you try to print them. Photographers call these "blown-out highlights," and no amount of Photoshop doctoring can bring these areas of the image back to life. Depending on the size of the highlights, a certain amount of lost detail may be acceptable.

How to Rescue a Dark Image with Photoshop

In Photoshop, duplicate the original image layer and set the new (upper) layer to Screen mode. This lightens the whole image by about one f-stop. If the image is still too dark, drag the upper layer to the Duplicate Layer icon (next to the trash bin). This often brightens the image a little too much. If that happens, click one of the screen layers and lower the opacity. The opacity adjustment is a slider that enables you to tone down the effect very gradually until you get the desired result. For an overexposed image, use the same basic process but substitute the Multiply mode, which darkens the whole image.

On an overcast day there won't be any bright highlights to blow out, so you may not start to notice any loss of information until you get two or more full stops over the correct exposure. Of course this causes the image to look bright and the colors to appear washed out, but there are Photoshop tricks you can do to save such an image as long as it still contains detail.

Underexposure

Underexposure is where digital cameras do actually have some exposure latitude. In general, you can miss your exposure by several stops in the direction of underexposure and still be able to brighten it back up to an acceptable level. Even on a sunny day you can underexpose an image at least two stops before it starts to reach the point where you can no longer save it in Photoshop.

Tips for Group Photos

Making a good group shot is a lot more complex than simply lining up the people. The hardest part actually happens before your subjects are even involved, because this is when you must survey the scene to pick out the best location and the best light. There are many factors to consider, such as: How far can you make everyone walk in order to get to a great spot? Are you going to include the background, or are you going to blur it out? Do you need a flash, or are you going to use natural light? All of these factors and more must be calculated before you ever fire a shot.

As you scan your wedding location in search of a place to do your group shots, you have many factors to consider, but first and foremost is to get even light on all the faces. It doesn't matter whether the light is direct sunlight, shade, or anything in between. All that matters is the light be the same on everyone in the group.

Dealing with direct sun

Shooting group shots in direct sunlight should be an absolute last option. The only time I would ever recommend trying it is in the late evening when the light is much less harsh. If you absolutely have to shoot a group in direct midday sunlight, you need to know a few tricks that will help you make the best of the situation. The first is that the entire group must be in the same light. If you place one part of the group in shade and the other part in sun, you're wasting everyone's time. The shade under a large tree, near a building, or behind a hillside can provide the perfect spot for group shots on a sunny day. Figure 7-4 shows an example of the light I found on the shaded side of a cliff right at the beach on Crooked Island in the Bahamas. This was the only shady spot in the entire area, so I talked the entire family and wedding party into trekking down the trail just to get in this one patch of shade. The advantage of a spot such is that it provides shade early in the day and allows me to save the golden hour for working with just the bride and groom.

Figure 7-4: This afternoon shot was taken in the shade of a high cliff along the beach. The cliff is not seen in the image, but the beautiful shaded light was not available anywhere else in the area.
130mm, f4, 1/1000th, 400 ISO, no flash

Late afternoon direct sunlight

A late-afternoon sun that is low on the horizon typically produces an extremely warm color tone. This warm glow can be a quite beautiful effect, but if you want more normal colors you could shoot in RAW, or use an Expodisc. After you get the color right, turn your group at an angle so that the sun hits everyone evenly without any one person throwing a shadow onto the face of the person nearby. You can see this angle in Figure 7-5. If you turn your group members too much towards the sun, they won't be able to look at you without squinting. The trick is in finding the perfect angle that puts everyone in the light but that doesn't require squinting. I tend to get the best results by facing my group at roughly a 45-degree angle from the sun.

Figure 7-5: For this shot I turned the bride and groom 45 degrees away from the evening sun. This angle cuts down on squinting while still keeping everyone in the same light.
90mm, f4, 1/8000th, 400 ISO

Exposure Formula for Shooting Groups in Sunlight

If you absolutely have to shoot your groups in direct, midday sun, try these techniques.

✦ Choose a location that has the same light hitting the entire group.

✦ Set your flash on TTL without dialing in any exposure compensation.

✦ Set your ISO to the lowest possible speed.

✦ If possible, turn your group members so the sun is on their backs and use your flash to light their faces.

✦ Use a wide lens to get you in close enough for your flash to work.

✦ Raise your aperture (higher numbers) until you get a shutter speed that syncs with your flash.

Fill flash

On-camera flash can also be used outdoors during the day. Figure 7-6 shows how much brighter the colors appear when you use a fill flash. The term *fill flash* means to set the flash so that it produces less light than the outdoor light—just enough to fill in any dark shadows. You do this by dialing in a flash exposure compensation in the direction of underexposure. How much underexposure depends on the type of lighting you have that day. My general rule is: for sunny days set the flash at –1/2 stop, for cloudy days use –1 stop, and for overcast days use –2 stops. For example, if the outdoor (ambient) light exposure were f8 on an overcast day, you would set the flash to produce a –2 exposure (f4). This gives just enough light to brighten up the colors and eliminate or reduce the shadows under the eyes, but not so much as to make the image look obviously flashed. The flashed look can be fine for group shots, but it does not add to the realistic feel of a journalistic-style image, and it definitely takes away from any feelings of romance in your couple shots.

Figure 7-6: Fill flash adds just enough light to brighten the colors and add a little sparkle to the eyes.
95mm, f2.8, 1/60th, 400 ISO

Backlight techniques

Backlighting is when you turn the subjects so that the sun is hitting their backs and their faces are completely in shadow. This technique creates a beautiful glowing highlight around the subject. With backlighting, you have two possible choices of how to create the image, and each produces a very different look. The first method is to simply expose for the shadow side where the faces are, and let the background be extra bright. The second method is to expose for the background and then fill the shadows in with a flash. Either method produces excellent results, but for group shots where you want the subjects to be well lit and easily recognizable, the best result is usually achieved with the fill flash method. I don't particularly like the flashed look, but on a sunny day, the difference in exposure from the shaded side (the faces) to the background can be more than a digital camera can handle, and the result is blown out highlights in the background if you don't use the flash. Using a fill flash as in Figure 7-7 allows you to set your shutter speed so that you get a decent exposure on the background, while the flash fills in the foreground to match. To do this, simply set the flash on TTL, with no exposure compensation, and then dial in the correct exposure for your background.

Figure 7-7: Backlight creates a nice halo of light around the edges of your subject.
105mm, f9.5, 1/180s, 200 ISO

Outdoor Flash Concepts

There are two parts to the light in every outdoor flash exposure: the light from the flash and the ambient light. The *ambient light* is basically the light from all sources except your flash. When you prepare each outdoor flash shot, you manipulate the two parts of the light with different controls on your camera. This allows you to adjust each part of the light independently until you achieve the desired balance between flash and ambient. To do this, you simply set the aperture to get the desired amount of flash in the scene, then adjust the shutter speed to get a pleasant brightness for the ambient light.

In order to work with outdoor flash, it is vital that you understand the simple fact that the shutter speed has no effect at all on the flash. This is because the flash is a very short burst of light that must take place while the shutter is completely open. The duration of the flash is usually many times shorter than the shutter speed. For example, the fastest shutter speed at which most modern SLR-type cameras will function with a flash (this is called the *sync speed*) is 1/250th of a second. However, the burst of light from the flash usually lasts 1/500th of a second or less, so it only takes up a small portion of the time that the shutter is actually open. If you use a slower shutter speed like 1/30th, the flash duration will still be 1/500th or faster. This causes the flash portion of the exposure to look exactly the same no matter what shutter speed you use — as long as the speed is at or below the sync speed for your camera. This is a very complex idea that you don't want to have to try to calculate in your head each time you shoot a flash picture.

Remember these two basic points:

✦ The aperture modifies the light from your flash.

✦ The shutter speed modifies the ambient light (light from all other sources).

Now for the advanced tip! When you set your camera up for a flash shot, you will occasionally find that the shutter speed required to get a good balance of ambient light is either too fast or too slow for your needs. If this is the case, simply adjust the ISO. Every change in ISO requires a corresponding change in either aperture or shutter speed to return the exposure to a balanced state. For example, if your shutter speed was 1/2s at 400 ISO, and you thought that was too slow, you could change your ISO from 400 to 3200 (three stops). This requires that you make a change (to either shutter speed or aperture) of three stops to bring the exposure back to balanced. So if your previous shutter speed was 1/2s, you could now change it three stops from 1/2, to 1/4, to 1/8th, to 1/16th of a second.

Overcast light

Shooting in overcast light is far easier than direct sunlight. The clouds create a huge cover that seems to radiate and diffuse the light in all directions at the same time. To the human eye it appears as if there are no shadows anywhere. However, all it takes is a couple of shots to see that this isn't exactly true. Overcast light still produces shadows, and the quality and severity of those shadows still depend on the angle your subject is facing to the sun. Finding the angle to the sun may be difficult because the sun is above the clouds, but you can be assured that this angle is still affecting your images just as it did in direct sunlight — although with a much less extreme effect.

Overcast light seems so even and mild that you may be lulled into thinking that you don't need any flash at all. This is true if you happen to be shooting for romantic portraits, but as you can see in Figure 7-8, a fill flash can add just enough direct light to fill in the shadows under the eyebrows and brighten up the colors. The trick is to set the flash so low that it isn't noticeable to the untrained eye. This requires an exposure compensation setting of roughly −1.5 on a mildly overcast day to −2 on a heavily overcast day.

Figure 7-8: Notice how the eye shadows disappear and the colors brighten up with just a tiny bit of fill flash.

Simple Fill Flash Formula

Follow this simple formula to produce fill flash in various outdoor conditions.

✦ On a bright sunny day, set the flash to normal (no exposure compensation).

✦ On a mildly overcast day, set the flash exposure compensation to −1.

✦ On a heavily overcast day, set the flash exposure compensation to −2.

Flash exposure compensation can be set either on the camera, or on the flash. Refer to your manual for specific information about how to do this on your particular model of camera and flash.

Despite the shadows, journalistic and romantic images both work well with natural light on overcast days. Group shots can also work well on overcast days; however, the cool bluish tint to this light can often leave your images looking a bit dull and lifeless unless you add in a bit of flash to brighten things up. Overcast days require so little flash that you no longer have to be concerned with using a wide-angle lens to get in close to your groups.

Finding shade

Perhaps the single most important aspect to look for in choosing a location for portrait and group images is the availability of a big solid block of shade. The even light you can find under a nice thick shade tree or beside a tall building can create a softness that will almost always be a vast improvement over the results you would get from shooting in direct sunlight.

If you're looking at a tree as a potential shady spot, bear in mind that you need solid shade, not the patchy, dappled light you get under a small tree. This sort of mixed light is difficult to use because no matter how you move people around, it seems like the tree always gets a puff of wind just before you press the shutter, and a shaft of light sneaks in to cause a big bright spot on somebody.

Here's a tip for using trees as shade: Don't position your subjects too far under the tree. They should be standing slightly under and facing out away from the tree. If you put your subjects so that they are facing towards the inside of the tree, you get dark shadows on their faces and a much brighter background behind them. This happens because the foliage blocks off the direct light from above, and the only remaining light coming under the tree is going to be reflecting in from the outside.

Light reflectors

One type of location that you should always be on the lookout for is a shaded area that has a large reflective surface nearby that throws light into the shadows. For example, Figure 7-9 has a shade tree with a white house nearby that is in full sun. This can create a very beautiful light source.

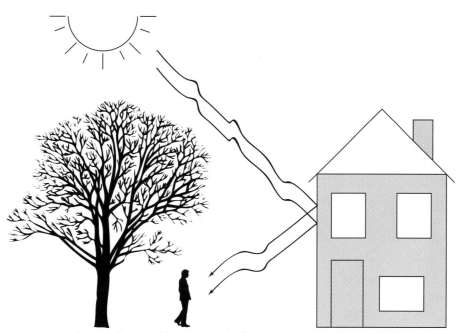

Figure 7-9: A large reflective object near a shady spot can create beautiful light.

These conditions are not exactly common; fortunately there is a portable version that produces similar results. Figure 7-10 shows the effect of using a commercially available light reflector to bounce light into a shaded area. Using a reflector such as this requires an assistant, but even if you shoot weddings alone, you can always find a bridesmaid or groomsman that would love to help out by holding the reflector for you. Many reflectors provide a frame with a set of different reflective materials that can be stretched over it to create different lighting effects. The standard reflective materials include black, gold, silver, and translucent white.

✦ The black material is not reflective, and in fact it is used to subtract or absorb light. This is rarely used at a wedding, but the general idea is that by holding it near your subject, you increase the strength of the shadows by removing most of the reflected light that would otherwise be hitting that side.

✦ Gold is used to create a warm glowing sort of light.

✦ Silver creates a very brilliant white light.

✦ Translucent white actually has several uses. The most obvious is simply as a reflector where it casts a beautiful soft white light. However, it can also be held above your subject to diffuse bright sun. This gives you the ability to create an effect similar to a cloudy day even though you may actually be right out in the bright sun. If you use a reflector above your subject to diffuse the direct sun, you may need another reflector to throw some light in towards the front of your subject.

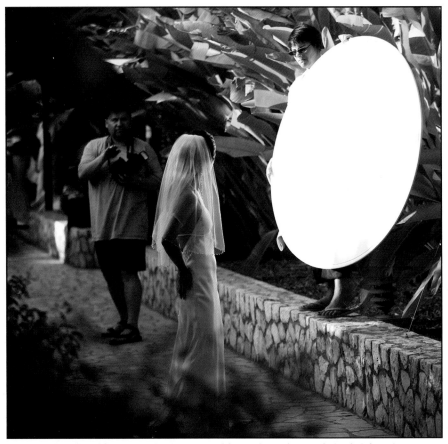

Figure 7-10: Portable light reflectors can add just the right touch for brightening up a shady spot without the artificial look of an electronic flash.

Late Evening Light

Shooting with natural light in the late evening requires an extremely fast lens with an aperture of 2.8 or wider. My favorite lens for this time of day is the 50mm f1.4, which I used to create the image in Figure 7-11. This lens lets in a huge amount of light that allows me to continue shooting even though there may be nothing more than a few candles lighting the scene.

Of course shooting at this time of day requires a high ISO speed. As the light falls lower and lower in the evening, you can continually raise your ISO speed until it reaches the maximum of 3200. High ISO speeds allow you to shoot in low light, but the trade-off is that they create quite a bit of what is called *digital noise*. This appears very much like the graininess you may have seen in film images. With the current generation of digital cameras, the digital noise (grain) is already at an incredibly low level, and I have no

doubt that future generations of cameras will see even more improvement in this area. There are also software programs and Photoshop plug-ins that can reduce the digital noise in your images. To find the current offerings, try searching Google for "digital noise reduction software," or "digital noise reduction actions."

As evening gives way to the darkness of night, you may want to go back and forth from the low-light technique mentioned previously to the more widely accepted look of flash. This is easily accomplished if you have two camera bodies and you can set one for low light and the other for flash shooting. When using a flash outdoors at night, it can be difficult to get any light in the background to prevent what I call the "black pit" look. This is where your subjects are surrounded by complete and total darkness. This is not a flattering look. If there is any background light at all, including it in the image by using a slow shutter speed creates a background that is far more flattering than the black pit.

Many photographers get the black pit look on a normal basis because they refuse to lower their shutter speeds into a range that might create some unwanted blur. If you happen to be shooting film in your camera, then it may feel quite disconcerting to shoot slow shutter speeds because you can't see the results. Thank goodness for digital! Digital allows us to review the little LCD screen to see the results of a slow shutter speed. If there is a problem with too much ghosting or too little background light, we can easily make a change to fix the problem. See Chapter 3 and Chapter 12 for more information on shooting a flash. Figure 7-12 and Figure 7-13 are examples of night shots made with and without flash.

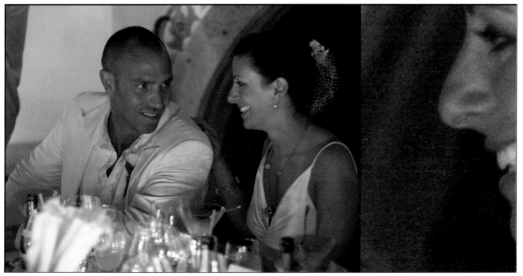

Figure 7-11: This image was shot at 3200 ISO. In the enlarged portion, notice how drastically the digital noise increases in the underexposed shadow areas.
50mm, f1.8, 1/30th, 3200 ISO

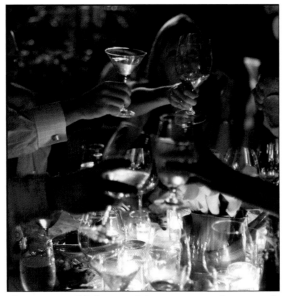

Figure 7-12: This image of the guests toasting was taken with no flash and only a few candles.
50mm, f1.4, 1/200s, 3200 ISO

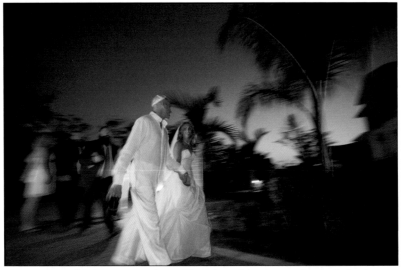

Figure 7-13: This image was shot with a slow shutter speed to include the background light. Although not perfect, the image gets a sense of movement and excitement from the background blur.
17mm, f4, 1/10s, 3200 ISO

Background Choices

My preference is a background that is somewhat uniform and a medium to dark tone. Dark tones allow your subjects to stand out much better than light tones. The sky is probably the worst background because it is always going to be much brighter than the subjects. Figure 7-14 shows a group shot with a light sky background.

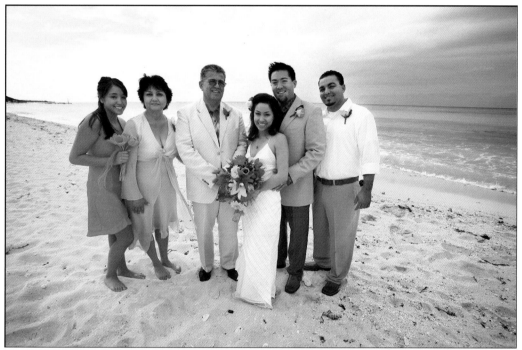

Figure 7-14: This image shot on the island of Cozumel suffers a bit from the bright sky behind the subjects.
17mm, f6.7, 1/700th, 200 ISO

Including the background

If the background itself is interesting enough to make it actually part of the subject of the image, you will want to place your group close to the background so that you can make them both appear sharp and clear. To do this, shoot with a smaller aperture like f8 or f16. This gives you a large amount of depth of field that captures every detail of the background while keeping your subjects sharp as well.

Minimizing the background

In general, a background is just that—a background. As such it should complement the scene while commanding much less attention than the subjects. My favorite way of accomplishing this feat is to put some distance between the subject and the background. When this is done correctly, it allows the background to be recognizable but slightly blurred at the same time. Some of the worst group shots I've ever created were done by placing my subjects too close to a group of bushes or trees and then shooting with a wide-angle lens, which gets a lot of depth of field and creates a busy background.

Let the background pick your lens

The size and beauty of your background can determine which lens you use to shoot your group and portrait pictures. For example, if you have a large and beautiful background, you can use a wide-angle lens, which includes a big chunk of real estate behind the subject. If you have a less attractive background, use a telephoto to capture only a very small piece of the background behind the subject.

Deciding whether or not you want to include the background also determines what sort of aperture you will use. Large apertures (small numbers) get a very shallow depth-of-field, which de-emphasizes the background by blurring it out. Smaller apertures (bigger numbers) create much more depth-of-field, making foreground and background details sharp.

Summary

Learning how to handle direct sun is one of the most difficult of all the skills a wedding photographer must possess. This chapter provides you with some background that makes it easier to understand what is happening inside your camera that makes shooting on a sunny day so difficult. For your next wedding, the only fears you'll have about working in the sun will be whether or not you have enough sunscreen.

Shooting in overcast and late evening light also present a few challenges—although none so daunting as direct sun. Knowing when to use the fill flash and how much exposure compensation to use to match different levels of outdoor light can improve your images tremendously by brightening up colors and skin tones, while still preserving the natural look.

Knowing how to shoot is no more important than knowing where to shoot. What makes a good background? What type of light should you look for? These are aspects of a good group shot that are hidden from the average viewer, who simply appreciates the great light and the beautiful background. Finding those great backgrounds and setting up for an angle that has great light are skills that may take years of practice for the beginning wedding photographer. With the guidance and knowledge you gain from this chapter, you may start to see these opportunities much more quickly.

✦ ✦ ✦

8 Shooting Indoors

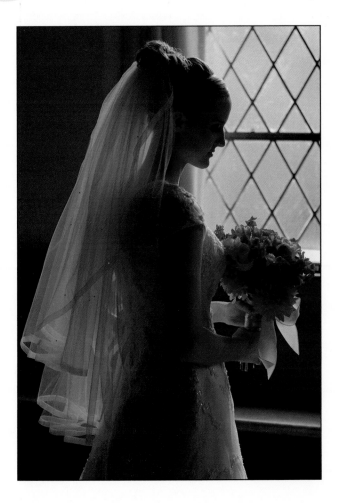

Shooting indoor weddings requires some specialized equipment as well as a lot of knowledge about how an indoor ceremony works. Topics covered in this chapter include how to set up your lights; how to avoid reflection; and how to see what locations would make a good background for family groups. Reflections are discussed in detail because they are a constant threat to your indoor images and you need to know why they happen and how to avoid them if you want to shoot indoors.

Equipment

Depending on the type of images you shoot, indoor weddings may require a bit more specialized equipment than outdoor weddings. The majority of your camera equipment remains the same, but shooting low light indoor locations may require you to supply a tripod and your own light sources. Traditionalists and Portrait Journalists alike will probably bring additional flash units for the portraits and group shots, as well as to light up the reception room. However, no matter how large, or small, or bright, or dark the venue may be, most Photojournalistic style photographers and many Portrait Journalists will bring no more lighting equipment than the standard on-camera flash.

Tripod

Many ceremony locations such as that seen in Figure 8-1 are so dark as to practically require the use of a tripod. A tripod allows you to use the slow shutter speeds necessary to get some background light in the image. Handholding the camera with slow shutter speeds may be fine for dancing shots at the reception because these images rarely make it into any sort of print larger than a 5x7. At that size, a little blur won't make much difference. However, with family groups, your images stand a very good chance of being printed at 10x15 or even larger. In fact, the family group shots are easily the best sellers when it comes time for the bride to order prints for the friends and relatives. In order to get an acceptably sharp print at 10x15 or larger, you really should be using a tripod to steady your camera.

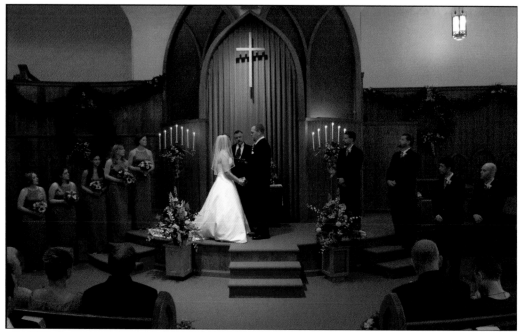

Figure 8-1: Shooting in a dark church requires that you either use a tripod or set your ISO up very high and suffer the consequence of a noisy image.
18mm, f3.5, 1/20th, 400 ISO, (-1 exposure compensation)

Aside from increasing the sharpness of your images, a tripod also frees you up to move around without a camera dangling from your neck. After you get the tripod set up and the scene carefully framed in the viewfinder, the tripod keeps it that way as you arrange your subjects and move the lights here or there. The importance of keeping the framing stationary can't be overemphasized. The tripod gives you the time to arrange your group and place the subjects while calculating the amount of extra space needed on the sides to allow for cropping into the 8x10 format. Of course, it is much faster and easier to shoot hand-held, but it is also much less deliberate, and these images are important enough that they deserve some careful consideration to get everything just right. To see an example of cropping guidelines see Chapter 5.

Slaves

Should you choose to bring lighting equipment, you may want to purchase one additional piece of equipment: a radio slave set. In photography, *slave* is a term used to describe a piece of equipment that sends out a signal that triggers one or more flashes at the same time. A flash triggering system such as this allows you to place your flashes at various points around the room without any connecting cords for you and the wedding guests to trip on. A slave set comes in two parts. The transmitter, which attaches to your camera and transmits a signal when you fire the shutter; and a receiver, which attaches to the flash head to receive the signal and fire the flash. Many of these units can be set to change from transmitter to receiver with the flip of a switch (see Figure 8-2).

Three basic types of triggering signals are flash, radio, and infrared. Wedding photographers tend to prefer the radio signal type for several reasons.

✦ Every flash in the room sets off standard flash slaves, and because it's practically impossible to stop guests from shooting flash images, this triggering system is useless for wedding work.

✦ Infrared slaves can occasionally be sensitive to fluorescent lights, which make them trigger the flash continually, every time it recharges.

✦ The flash and infrared types are both light beams, and as such they cannot penetrate walls or other solid objects. There must be a direct line of sight between the transmitter and receiver.

✦ The flash and infrared types have a limited range, especially outdoors and on sunny days.

✦ A radio slave produces signals that pass through walls and across distances up to several hundred feet depending on the model you purchase.

You obviously can use a slave setup for the group photo session and bridal portraits, but a slightly less obvious use is to place several flash heads with receivers around the reception location and point them up at the roof. When you fire your camera, all the flashes go off together and provide a very even light for the entire room. The most difficult part in a setup such as this is in setting it up so that the light doesn't hit directly on your lens. If this happens, you get a very bright hotspot in the image. The overall effect of this system is to create a background that is well lit with a very white light source.

As mentioned in several other chapters on flash use (see Chapters 3 and 12), the alternative is to use your on-camera flash with a slow shutter speed and get background light from whatever lights are actually present in the scene. However, there are occasions where there is very little background light present, and on nights like this, having a portable system that can provide some illumination can add a tremendous amount of light to your images.

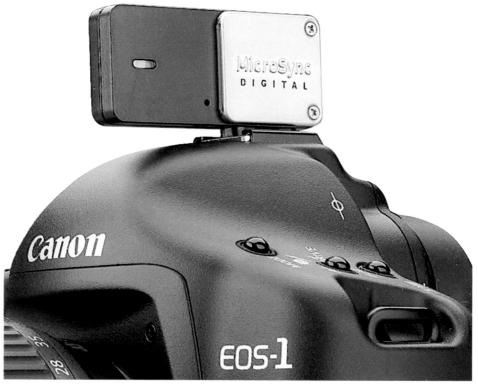

Figure 8-2: A radio slave, such as this Tamrac MicroSync, can make it easy to control your flash from a distance.

Lighting the Set

Chapter 3 discusses two of the most popular portable flash options available to the wedding photographer. Almost any sort of flash system works, but portability and the option to use battery power are of more concern to the wedding photographer than large amounts of power. Large flash systems may have enough wattage to light a stadium, but when the bride says, "Hey, let's shoot another one over there," the large system won't look so attractive. Wedding photography doesn't require a lot of flash power. Most hotshoe-mounted flashes have plenty of power for the distances involved in wedding photography and several of these small units are often mounted on stands to light up a portrait location.

Common lighting setups

Many possible combinations of lights can be used at a wedding. The three discussed here are the most common setups used for the group photography and portrait session. The descriptions provided are the absolute basics of each setup. As you get more experienced, you will certainly develop your own set of equipment and exposure combinations that make your work unique.

On-camera flash

As you might guess, this method uses a single on-camera flash unit. This may work fine if there is a bit of background light that you can include by setting your shutter speed to a slow setting such as 1/20th or 1/15th. If the background is totally dark, you risk getting the black pit look unless you set up additional flash units to provide some background illumination. A major drawback to the on-camera flash system is that it produces a lot of reflections on your background. Because the light is going straight out to your subject and straight back to the camera, any reflective surfaces in the scene will cause a very bright reflection from your flash.

One way to improve the single light setup is to put it three or four feet off to the side of the camera. This creates a more natural 3-D look by making small shadows. To do this you can use a simple sync cord, a slave unit, or a TTL cord. I recommend the TTL cord, as it makes your exposures much quicker and more accurate. Some slave systems also enable you to use your flash in TTL mode. Placing the camera on a tripod and then handholding the flash off to the side with a TTL sync cord created the image in Figure 8-3.

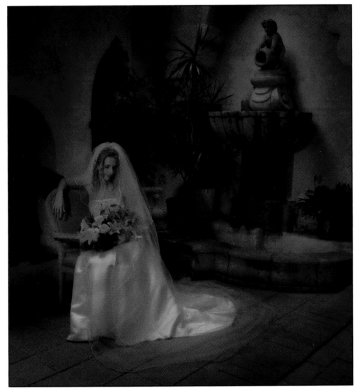

Figure 8-3: For this image, the subject was brightened up with a small amount of flash to provide separation from the background. The flash was placed on a TTL sync cord and held off to the left side of the camera position. Selective brightening and darkening of different areas was done in Photoshop.
50mm, f2, 1/125th, 400 ISO, tripod

Single main light plus on-camera flash

With this system, you set up two lights. The first flash is mounted with an umbrella to soften the light. This is your main light and it throws shadows across your subject from the side to create a very 3-D look (see figure 8-4). Place it about 20 feet from the group and off to the side of center (your position) by 10 to 15 feet. Next, set your on-camera flash unit to produce about 1.5 stops less light than the main light. This light fills in the shadows but not so much that they disappear. The easiest way to set these exposures is to start with the main light and shoot test exposures while watching the resulting histograms on your LCD. Even if the background has a lot of black in it, you really only need to watch the right (highlight side) of the histogram. You want your main light to produce a histogram that touches the bottom of the scale near the right side without raising up the wall on the right side. Shoot some test shots and adjust your aperture until you get the right exposure. If your on-camera flash is a TTL model, setting the exposure is as easy as adjusting the flash exposure compensation to -1.5 stops. This can usually be done either on the flash or on the camera; the result is the same either way.

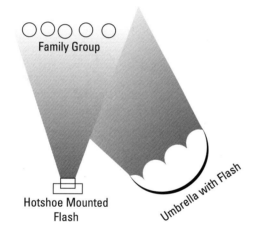

Figure 8-4: The umbrella provides the main light source, while the on-camera flash fills in the shadows.

Family Group

Hotshoe Mounted Flash

Umbrella with Flash

This system produces a very even light on smaller groups but because the main light is off on one side, larger groups can tend to look brighter on the side with the main light. To counteract this problem, simply angle the flash head (or umbrella) so that it points across the front of the group towards the people on the far side. This projects the central part of the flash beam towards the far side while still allowing enough light to hit the closer side. This technique is called *feathering the light*.

Dual umbrella

This light system requires two portable flash units set at about 45 degrees off on either side of center and about 20 feet from the group. If the group is large, you can get the most even light by feathering both lights across towards the far side of the group. This light setup tends to create very even illumination from side to side.

On smaller groups you can create some shadows for a more three dimensional look by setting one of the lights to put out 1.5 stops less than the other.

This basic setup is only a starting point for many studio-trained photographers. Adding additional lights for each portion of the background would be another option. Some may even choose to add a hair light, which would shine down from above and behind the group to add a little sparkling highlight to the hair.

Set Lights Closer

The distance you use for your lighting setup is very important. If you set the lights too far away, you may not be able to get the f8 or f11 that you need in order to have enough depth of field for the front and back rows of your group to both be in sharp focus. However, setting your flash too close is a far worse concern. The reason for this is that the light from your flash drops off very rapidly at close distances, and much less rapidly as the distance increases. For example, if you have a group where the closest person is at six feet and the farthest is at eight feet, the farther person is going to be noticeably darker because the light drops off very fast at such a close distance. However, if you place your closest and farthest subjects at 20 and 22 feet from the lights, the same two-foot difference between the closest and farthest person will be a much smaller percentage of the total distance. Now the exposure difference between the front and back of your group is so small that the average person won't be able to notice. Setting your lights at roughly 20 feet gives your subjects a large *working area* where they can move side to side, and several feet forwards and backwards without you having to constantly change your exposure or reposition your flash.

Bounce flash

Bouncing is when an on-camera flash is turned up towards the roof where it will bounce back down on your subjects with a very even and natural look. This technique has its limitations of course. For example, if the ceiling is very high, or if it is colored, then you should probably avoid this technique completely. If you are low on batteries for your flash, you should also consider other options because bouncing takes a lot more flash power than direct flash. This is mostly due to the fact that the ceiling is never made of a highly reflective material, so a large portion of your flash output will be absorbed by the ceiling instead of reflecting back down where you want it.

One of the main drawbacks to using bounce flash occurs when you get very close to your subject. The light coming down from the ceiling is brighter at the top and tapers off in brightness towards the bottom. This becomes particularly noticeable if you happen to be shooting with a wide-angle lens that captures your subject from head to toe. The easiest way to get around this problem is to use either a reflector attached to your flash, or a flash diffuser.

Reflectors

Most on-camera flashes come with a small plastic reflector that pulls out of the end of the flash head. This piece catches a small portion of the original flash burst and deflects it directly forward towards the subject. Using this reflector will eliminate the harsh shadows caused by bouncing when your subjects are very close. When you mix this small amount of direct light with the larger portion of bounced light, the effect looks quite natural and even.

Reflectors come in many shapes and sizes but the common purpose is that they throw a small amount of light directly forward while the majority of the light is sent out in various directions (mostly up) where it will bounce around and illuminate the entire room.

Some of these items are simply large reflectors that bounce around and illuminate the entire room. Commercial reflectors are available through www.lumiquest.com.

Diffusers

Another type of light modifier is a diffuser, seen in Figure 8-5. These items attach to the end of your flash head and act to redirect the light. Some models redirect the light in all directions equally while others redirect most of it forward. Two popular models can be found at `www.omnibounce.com` and `www.garyfong.com`. An example of the even light that results from using an Omnibounce diffuser can be seen in Figure 8-6.

Figure 8-5: The Omnibounce diffuser is small and very effective at illuminating the room with a soft, even light.

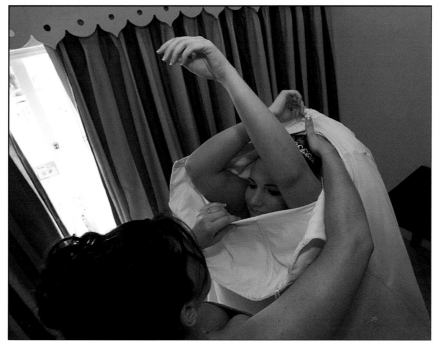

Figure 8-6: The light from a diffuser is very subtle.

Using Indirect Flash Outdoors

So often I see amateurs and even occasionally professional photographers using some sort of indirect flash methods outdoors. This is a total waste of your time and battery power. Indoors, these methods work wonderfully well because the light has walls to contain it and cause it to bounce all around the room. Outdoors, there are no walls! Any light that you send off in any direction other than straight at the subject, is totally wasted!

This is obviously true for techniques like bouncing, where the light would have to bounce off the next nearest star before it can return to your subject. However, the use of modifiers like the Omnibounce, and Gary Fong Light Sphere also fall into this trap. Many photographers use them outdoors with the thought that the light will be softer and more diffused. This is a total myth. The light may look less intense because much of it is being wasted, but the same low intensity light could be achieved by simply dialing in a -2 or -3 flash exposure compensation. Other photographers say that these light modifiers add softness because they are larger in diameter than the flash head. If you were to put your flash into a two-foot wide softbox then you could easily make such a claim, but the difference between a three inch wide flash head, and a five inch wide flash head with a light modifier on it, is too small to be worth the trouble. And, although the diffuser is slightly larger, it will always throw large amounts of light off in the wrong direction, wasting much of your battery power. The trade-off of getting a very slightly softer look, compared to the amount of battery power wasted, is definitely not worth it.

The only real effect you will get from using small light modifiers outdoors is to waste your batteries very quickly. Save these gadgets for indoors where they can really make a difference.

White Balance

When shooting indoors you constantly encounter lights that add a strange color to the image. Your eyes have a wonderful ability to balance all the lights out so that everything appears as white light to you. To a certain degree, your camera has this same ability; it's called *Auto White Balance*. When you use this setting, the software in your camera assesses the light and adjusts the white balance to the best of its ability. Depending on the particular brand of camera you own, this ability may be somewhere between less-than-perfect and non-existent. If you are in a hurry, you can always change the white balance setting in the camera menu to match the light source as closely as possible. Sometimes this works just fine, but unfortunately every type of light bulb has a slightly different color cast; so the results you get depend entirely on what lights you happen to be standing under at the moment. For example, fluorescent lights have a huge range of colors from very green, to slightly yellow. Even if your camera has several different preset settings for fluorescent light, there is no way that you can always get a match. The same is true with tungsten lights. There are many thousands of different types of bulb and each one has its own unique color tone.

JPEG shooters

The solution is to make a custom white balance setting for the specific type of light you are encountering at the moment. As discussed in Chapter 3, an Expodisc is the optimum tool for this job. There are other methods of creating a custom white balance. You can shoot an image of a white piece of paper or a Kodak gray card and use that for the white balance, but neither of those items are as small, portable, and durable as an Expodisc. Also, with the paper or gray card, you must place the card in the correct light and then shoot it without getting yourself between the card and the light source—easier said than done. With the Expodisc, you simply place the disk over your lens, point the lens at the light, and shoot your reference image. That image is then used to set the white balance in the LCD menu. The process is so fast and accurate that it simply can't be compared to the paper or gray card methods.

When I go to an indoor wedding, the first thing I take out of my camera box is my Expodisc. I use it to set the white balance on my own camera and that of my second photographer. Every time the activity moves to a new room, (dressing rooms, ceremony, reception), we create a new white balance for that particular room.

As much as I praise the Expodisc, I don't recommend that you use it all the time. I frequently change my white balance to a different setting to purposefully change the color tone in an image. Balancing this color out is an option, but the bride may appreciate some variety. To maximize this warm glow and even bring it out more, try setting your camera to the white balance preset for shade. The Expodisc also comes in a warm tone version that balances the light out a little on the warm side instead of the exact neutral colors you get with the standard Expodisc.

RAW shooters

If you don't mind the extra time it will add to your workflow, you can shoot RAW files for anything that has unusual colored lighting. With RAW, it's as if you're starting over from scratch when you first open the file. For color balance, you can switch from one preset to the next as you preview what your image will look like in Tungsten, Fluorescent, Daylight, Shade, and so on. If none of the preset settings looks acceptable, you can always dial in the exact color you want with any of the other color adjustment controls RAW files have to offer.

When shooting in RAW, if you set your camera preset to the *Auto White Balance* setting, you will have a very close starting point from which to work as you make corrections to the white balance later.

Minimizing Reflections

Shooting indoors requires that you pay special attention to the way your lights bounce back from reflective surfaces. At the altar area you may have flat panels of wood that are certain to cause headaches. In the reception hall there may be mirrors and windows to work around. Every one of these can cause a reflection that can ruin your picture.

Reflections are easily avoided as soon as you understand the basic principle of reflection. That is, light reflects out at the same angle it went in. For example, as you can see in Figure 8-6, if a light beam approaches a mirror at 45 degrees, it will reflect out at 45 degrees on the opposite side. You can use this concept at a wedding to place your lights so that they do not cause reflections to show up in your pictures. For example, if you have a mirror on the wall behind a family group shot, you can easily remember that the reflection will show up halfway between your camera and your flash. If your flash is mounted on your camera, then the reflection will be directly in the middle of the group. If you move the flash to the side, for every two feet you move the flash over, the reflection will move over one foot. If our hypothetical group is ten feet wide, we need the reflection to go over at least seven feet to get it out of the image. That means the flash must go over at least 14 feet. Figure 8-7 shows a sketch of how this works.

Figure 8-7: Reflections have the same angle coming in as they do going out from a reflective surface. After you understand this basic principle, you can arrange your lights or your groups to minimize reflections in your images.

Another way to move the reflection is to move yourself so that you don't shoot directly into a shiny surface. If you must put your subject in front of something shiny, turn them so that you can shoot at an angle towards the surface, allowing the reflection to bounce off in another direction. Most reflection problems can be solved in this way. In the real world, all you have to do is step sideways a couple of steps and your group automatically rearranges themselves to face you, thus turning everything just enough for the reflection to go away without much fuss.

Sometimes you can solve this same problem by rearranging your group. Simply shoot a test shot to see where the reflection is going to show up, then move one of the people in your group to stand between you and that spot. This effectively blocks the reflection off. This method works particularly well if your camera is on a tripod where you can make small adjustments to the group without moving the camera.

Another common reflection problem is with eyeglasses. This problem cannot be helped if the lenses on the glasses are highly curved on the front. If the lenses are relatively flat, try asking your subject to raise the part that goes over the ear so that it is about an inch up above the ear. Raising this piece tilts the lenses slightly downward and usually this will cause the reflection to disappear.

Choosing Your Locations

Shooting indoors requires that you develop your ability to look around the location and see places that can work for different types of images. The locations you choose to actually use are determined by factors, such as your shooting style, the couple's requests, and most likely, the amount of time they give you.

You may find six or eight great locations but when it comes right down to it, events usually conspire to shorten the time the bride originally allotted for photography. This shouldn't upset you. In fact, after ten or so weddings you'll see that it is more common than not for the photography time to get shortened due to the many millions of factors that can work to push back the schedule on an average wedding day. This is all part of the territory. It may upset the bride, but as the photographer, you quickly realize that this is a very normal part of your workday.

Taking these normal time delays into consideration means that you may want to look over your six or eight great locations and prioritize them in your mind so that you make sure to catch the best ones first and then use as many as possible in whatever amount of time you actually end up getting.

The Altar Area

If your wedding couple sets up an elaborate altar area for an indoor wedding (which they usually do), you are almost certainly going to be expected to use it for the family group shots. This is the normal location where you set up your lights and prepare the scene for the family group shots.

If you are doing photos before the ceremony, there are a few details to consider about working around the altar area. In most locations, it is acceptable for you to rearrange the furniture, flowers, candles, and so forth as long as you remember where they were and return them to the exact same location after the pictures are done. I can't stress enough that you get the locations exact because many ceremonies are planned out very carefully and a slight rearrangement can cause serious problems if it went unnoticed until the ceremony was underway. Be particularly careful not to remove any small pieces of tape on the floor, as these are used as reference spots and each bridesmaid and groomsman will be looking for that tape marker to tell them where to stand during the ceremony.

Check with the bride to see if you can light candles for the pictures. On many occasions there are two complete sets of candles, one for the pictures and a fresh set for the ceremony. When the candles are lit, be especially aware of dripping wax. Most candles have some sort of cloth placed beneath them to keep the drips off the carpet and other furniture. Be sure to keep the cloth in place if you move the candles.

Be extremely wary of liability issues when working with candles. If you move the candles (even at your client's request) and something happens while they are in this new location, you could easily be held responsible. For example, someone could bump into the candles and knock them over, or bump into them and catch themselves on fire, or they could fall out of the holders and catch something else on fire... too many possibilities. I personally witnessed an amateur photographer back up into a set of candles and catch her long curly hair on fire.

Snuff the Candles

If you happen to be working with the candles at a wedding altar and you need to put them out, use the snuffer to cut down on the smoke. I once blew out all the candles after the pictures for a large wedding ceremony and I had no idea how much smoke all those smoldering wicks would create. In fact, it was enough that after a few minutes it rose up into the second floor and set off the fire alarm. Luckily the photo session was taking place after the ceremony because within minutes, two big pumper trucks, four police cars and two ambulances arrived. Despite my story about the candle smoke, the firemen came rushing in with their fire suits, axes, and air tanks, then they quickly herded everyone out the front of the church. After a thorough search of the building, they calmed down a bit, and we got some great photos of the bride and groom posing with the firemen on the back of the pumper truck. Then, as if all that wasn't enough chaos, as the fire trucks were leaving, a big pumper truck pulled out and collided with a city bus, causing even more excitement. I didn't know my little town of Eugene, Oregon had so many police cars.

On smaller weddings there may be many occasions where the altar area is not the most photogenic location around. When you encounter this, you may need to do some delicate maneuvering to talk the bride into using a different location. You obviously won't be able to just come out and say that the altar is ugly. You might say something such as, "That stairway over there has wonderful light, what do you think of shooting pictures over there?" Most brides will trust your judgment and appreciate that you found a better location; just be careful about how you request the move so that nobody gets offended.

Seeing Good Locations

As you look around an indoor wedding site, what qualities should you look for in a photo location? What should you watch out for in a bad location? Many of the same principles apply that were discussed in Chapter 7 on outdoor locations.

For your indoor groups you'll be looking for architectural features that make an interesting background while watching out for reflective surfaces and bright spots that could prove troublesome. If you want to give the background a little blur to provide some separation between the subject and the background, you'll need to determine if there is enough space to get yourself and the subject out in front of the background a bit.

The quality and type of light on the background is also a consideration. For example, if the background light is fluorescent and you light the front of your subjects with a flash, then the fluorescent lights will make your background green. The same problem exists if the background is lit with tungsten lights except that the golden tones produced by Tungsten are not nearly so objectionable as green.

Another consideration is the strength of the lights. If they happen to be very bright, it's easy to use them as they are or tone them down by adjusting your exposure to underexpose the background a little. If the lights are very dim, a tripod helps keep your equipment steady, but you still may not be able to use a slow enough shutter speed without also causing a lot of ghosting as your subjects move. In this case, you may have to rely on lighting both the subjects and the background with your flashes.

Summary

Shooting indoors presents a unique set of challenges. The darkness of many locations requires you to make decisions about whether to set your ISO high and go for the natural light look or use artificial light and lose the naturalness of the scene. The tradeoff is one of grainy natural light images, versus the sharp clear look of a flash. Your personal shooting style dictates which type of images you choose to create.

The equipment you use indoors can be the exact same as for any other aspect of the wedding, however, the addition of a tripod, a radio slave, and a few extra flashes often come in handy.

Tips gained in this chapter can help you to choose the right equipment, avoid reflections, and recognize the difference between good and bad locations for group photos.

✦ ✦ ✦

9 Documenting the Ceremony

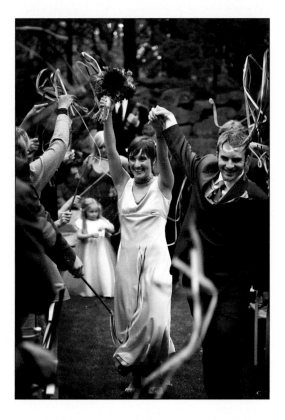

The ceremony can easily be considered the pinnacle of every wedding day. Months of preparation lead up to this one moment and yet, when it actually happens, it seems to go by so fast that I often find myself standing there thinking, "Is that it? Is that all of it?" As the photographers, we may very well be the only ones in the house wishing it would last longer. Thankfully, most weddings follow a very predictable sequence of events that seldom varies within the U.S. Granted each religion has a few different traditions here and there but for the most part, an experienced wedding photographer can easily manage to be standing in exactly the right spot at exactly the right time to catch the most important events.

The predictability of the event is a blessing that allows the photographer to know exactly when to walk slowly to a certain spot while changing to exactly the right lens to catch an image that is almost certain to take place in a very predictable way. As soon as each shot is captured, the photographer can walk slowly around to the next location and be there just in time for the next important shot. To the untrained eye, it may seem as if the photographer is just wandering here and there, but to an experienced wedding photographer, the sequence of events is so predictable that being in the right place at the right time has nothing to do with luck. This chapter shares some of that insight and the thought process that goes into every movement that a professional photographer makes during those few fleeting moments of the ceremony.

Must-Have Shots

Most photographers have a list of shots that are considered the "must-have" shots for the ceremony. The list may be longer for some, but the main events that qualify for this list are:

✦ Bride walking down aisle with father

✦ Father giving bride to groom

✦ Bride looking at groom during ceremony

✦ Groom looking at bride during ceremony

✦ Close-up of the officiant

✦ Close-up of anyone doing a reading or singing a song

✦ Wide shot from the back showing the entire ceremony

✦ Putting on rings

✦ The kiss

✦ Bride and groom leaving down the aisle

The top ten must-have ceremony shot list gets longer if you add images that you feel you should capture:

✦ Close-up shots of the wedding party members — especially crying or doing anything unusual

✦ Shots of each person as the family and entire wedding party are coming and going down the aisle

✦ Shots of the parents — especially if you can get them crying or wiping tears

✦ Wide shot from a distance that shows the entire scene of the wedding taking place

✦ Wide shots from back center of ceremony and from each back corner

The list can go on and on. However, I would not recommend that you actually write this list down on paper and scratch off each shot as you go, unless you are just starting out in the wedding business. The reason is that a list tends to focus your attention on getting just those images on the list and it distracts you from being open and aware to what is happening at the moment. At first a list like this can be helpful, but after about fifteen weddings, it will only get in the way.

It should be noted that the ceremony is one time during a wedding day when you really do have some solid obligations to the couple that has hired you. You really should get the top ten images listed previously in a way that is clear and clean, without any gimmicky effects. This is a time to make sure that you fulfill your professional obligation to document the moment. After you do that, you can feel free to exercise your creativity. Figure 9-1 through Figure 9-3 are images from the top ten list.

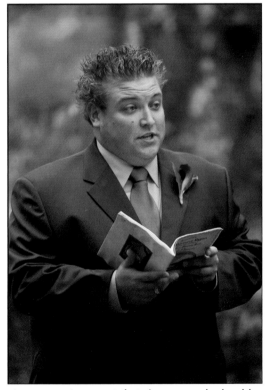

Figure 9-1: Any guest that sings or reads should definitely get a portrait.
200mm, f2.8, 1/100th, 400 ISO

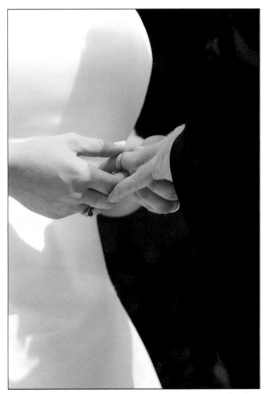

Figure 9-2: The ring exchange is always on the list.
200mm, f4, 1/360th, 100 ISO

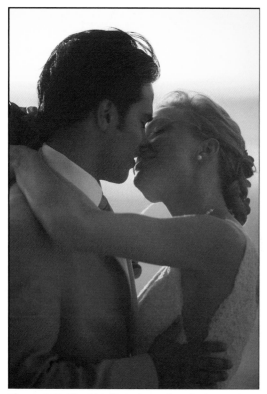

Figure 9-3: The kiss is perhaps the single most important shot to get during the ceremony.
200mm, f2.8, 1/2000th, 400 ISO

Ceremony Etiquette

As easy as it is to think of the ceremony as a photographic opportunity, it should always be remembered that it is foremost, a religious ceremony. As such, it should be given a certain amount of respect and reverence. We photographers are given the task of treading a very fine line between irreverence and getting the shot. How much attention can you attract without really disturbing the event in an unacceptable manner? Does the click of your shutter constitute sacrilege? Some may think so. The only opinion that really matters is that of the bridal couple. You should make a point of talking with them about where you can go, how close you can get, when you should stay quiet, and when they don't care.

Your client isn't the only one that matters however, all the guests are there to experience the wedding as well. Do you have the right to disturb them or block their view? To a certain extent you do simply because of the long tradition of photographers doing these things at weddings. The adult guests all know and accept your job as a necessary part of the ceremony. They put up with your clicking shutter and the floor creaking loudly as you walk by. You can even stand right in front of them without ruffling any feathers. In Figure 9-4, you can see that it's sometimes hard to be respectful. Here are a few tips you can do to minimize the amount of distraction you cause.

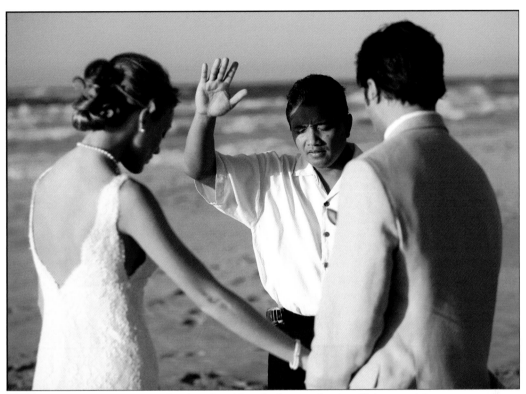

Figure 9-4: On a remote, Hawaiian beach, with only the couple, the officiant, and the two photographers in sight, minimizing your presence is practically impossible.
90mm, f3.5, 1/6000th, 400 ISO

You're in My Way!

One afternoon as I was wandering slowly around the side of the ceremony shooting pictures, I came to a spot where there was a great shot of the couple but a post was blocking me. I was standing on the side of the crowd and I just knew that if I could get a little more towards the middle I could shoot around the post. I noticed a couple rows of empty seats. The seats behind these were filled but I figured I could walk in there for a couple of shots without disturbing anyone too much. After all, everyone knows that the photographer can do such things and it's okay, right?

I slid in there and just barely got my shot when a little five or six-year-old tyke behind me stood up with a scowl on his face and proclaimed loudly, "Hey! You're standing right in front of me." His little voice echoed around the room and everyone looked over to see what was happening. His mother turned bright red as she quickly clamped a hand over his mouth and pulled him back down in his chair. All the other adults chuckled at the fact that he just didn't know the rules about photographers yet. I'm sure I turned a little red, too, as I whispered an apology and quickly got out of his way. Through his mother's fingers I could see that he was still scowling indignantly at me as I moved away.

✦ **Move slowly.** Any quick motion is very distracting to the guests but a photographer that walks slowly from place to place is easily ignored and soon disappears into the background of the event.

✦ **Move around.** Don't stay in one place too long. It's better to annoy everyone a tiny bit than to completely ruin one person's experience by standing right in front of them the whole time.

✦ **Wear dark clothing.** Dark toned clothing attracts much less attention than lighter tones and bright colors are absolutely unacceptable for the photographer. The only exceptions to these guidelines are if you wear certain clothing to fit in with the dress code for that particular event. For example, a bright red shirt with flower patterns may get you banned from the church in your hometown, but it fits right in at a Hawaiian beach wedding.

✦ **Don't do any acrobatics.** Never attempt to climb over something, or stand on a chair, or climb to a vantage point in a small tree, or any other acrobatics that can potentially result in you falling on your head right in the middle of the ceremony. Any great shot you might possibly get by climbing up there would certainly be overshadowed by the embarrassment of falling. Don't risk it.

✦ **Time your disturbances.** Certain moments are better at camouflaging a disturbance. For example, the best times to move are when the guests are standing up, sitting down, or praying. A prayer generally gets all heads down and eyes closed. This is your chance to quietly walk around to a new location. Every time they come up from a prayer you should be in a different spot.

✦ **Keep away from the couple.** In my opinion, ten feet is about as close as you should ever get to the bride and groom. At that range you can easily see the tears on a bride's face with your 200mm lens. If you get any closer to the couple than that, you had better be doing so at their request, otherwise you risk annoying everyone involved. Instead of worrying about getting closer you could spend that energy getting a better angle to see the action.

Flash Etiquette

Rarely do you need set up any lights for an indoor ceremony and more often than not, you are banned from using any sort of artificial light whatsoever. This is entirely understandable because a professional level flash unit puts out enough light to briefly stun anyone it catches in the face — especially in a dark room where the eyes are dilated wide open. The officiant is normally the one dictating the no-flash rule because he/she is the person most likely to get stunned first. One good blast in the eyes could easily distract and annoy this person enough to cause them to lose their place in the reading. It could also annoy them enough to stop the ceremony while they ask you to leave. For this reason you should always make it a point to introduce yourself to the officiant before the ceremony and ask them if they have any rules or concerns about photography. Sometimes they set boundaries on how close you can get to the altar or certain places where you can't go after the ceremony is underway. Frequently they ask you to stop using flash after the father gives the bride to the groom and then you can start using it again beginning with the kiss. Some officiants may have no limits whatsoever. These are usually the young ones. The old ones have experienced enough overeager photographers to know that they need some rules. It has been my experience that the more genuinely concerned and respectful you are when talking with this person, the more they try to help you out and the less restrictive they are. Whatever rules they set out for you, by all means obey them. It's far easier to obey the rules than it is to suffer the embarrassment of being kicked out of the ceremony in front of a huge crowd of people.

If, in the unlikely event that an officiant or other person sets some limit on you that you feel is unreasonable or will severely limit your ability to do your job, simply nod your head and then set off to find your client — the bride. If she doesn't agree with the requested limitation, you can respectfully approach the person and tell them that your client has asked you to shoot pictures in a way that differs from the rules and that you are obligated to do as she requests. If there is still some disagreement, he or she should

discuss the matter directly with the bride. Whatever you do, be sure to make every attempt to act respectful while trying to make it clear that the disagreement is between them and the bride, and not with you. Bear in mind that a coordinator who works for a location has the power to ban you from ever working there again, and in fact it is not at all uncommon for a location to have a list of photographers that are no longer allowed on the property.

General Ceremony Information

The following are a few general wedding tips that don't really fall into any other category, but are definitely worth mentioning.

Networking

Any effort you make to talk with the other wedding vendors at each event will be well worth your time. Not only will these people take care of you by making sure you have food and drinks, but they will also clue you in on many little things that are happening around the wedding that you might have missed. Wedding vendors also need images for their own advertisement, and I highly recommend that you provide them with the simple stipulation that your website address appear as a credit line whenever they use one of your images. If they want large prints, by all means spend a few bucks and make the prints for them. This is extremely good advertising for you and for them as well. Every chance you get to help other wedding vendors — take it!

Some religions and/or churches/mosques/temples do not allow photography during the ceremony. When this happens, talk with the bride and groom to find out if there is an alternate time when you can get together to stage some of the most important scenes. Even the most restrictive religious groups will usually allow photography at a time when there is no formal ceremony taking place.

Strange situations

Occasionally you will run into some really weird situations at a wedding. People faint, they fall down on the dance floor and break bones, they get in fistfights, sometimes a "colorful" person will wander in off the street, etc. Whether or not you take pictures of these events is up to you. Will the bride and groom want to remember these things? Maybe... maybe not! Some things are best forgotten. I tend to shoot everything on the theory that it's always safer to shoot first and have the option of deleting later. Unfortunately I missed my chance to get shots of the mother of the bride getting in a fistfight with the coordinator. I guess I was just too shocked to remember I had a camera in my hands. Maybe that's for the best!

Emotional moments

There are moments at almost every wedding where someone gets extremely emotional — sometimes crying uncontrollably. Times like this can be very tender moments that the bride and groom will certainly want to remember. However, after having seen photographers jump up and run over to a father who was crying on his daughter's shoulder and start snapping wide-angle shots from about a foot away, I would just like to give a little reminder to observe the sanctity of the event. Remember that this is not a photo shoot, it's real life for these people and you shouldn't do anything to cheapen a real moment by dancing around with your camera. You can shoot a few shots with your telephoto and nobody will even know you're there. I think the best compliment you could get after capturing a delicate scene like this is if the bride comes up later and says she thought you must have surely missed it because she didn't even know you were there.

Working with Extreme Light

Taking pictures of a wedding ceremony is often made more difficult by the two extremes of light. Occasionally you are blessed with an overcast day that provides beautiful, even illumination to your subjects, but more often than not you will find yourself shooting in the much more extreme lighting conditions of either a dark church or blazing hot sun. This section provides tips and helpful information to make either experience a bit less difficult.

Direct sun

Direct sunlight can cause all sorts of headaches during the ceremony. Not only is it difficult to see what you're getting because the LCD appears so dark in the sunlight, but also your camera has a very difficult time capturing all of the range of tones from brightest to darkest.

To deal with the LCD problem, set your LCD to show a histogram. This graphic display is often much easier to see than the image. Interpreting the histogram takes some practice, but the easiest detail to remember is that the graph should come down close to the very bottom-right corner with a proper exposure. If the graph rises up the wall on the right, this indicates a highlight area with no detail. The higher the histogram meets on the wall, the more highlights you lose. The upper histogram in Figure 9-5 is a well-exposed image of a scene with a very average tonal range. The lower histogram is from a scene with many bright areas, as evidenced by the mass of data stacked to the right side of the scale. Since the histogram hits high on the right side wall, this image will have a significant amount of highlights with no detail. It should be shot again with changes made to either the aperture or shutter speed so that there is less light in the exposure.

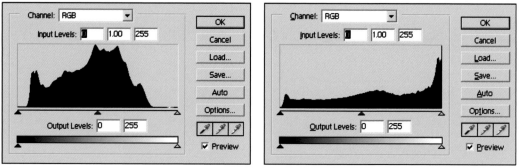

Figure 9-5: The higher the histogram touches on the right side, the more your highlights will be blown out.

Figure 9-6 shows two dark scenes where the histogram is heavily stacked on the left side. This is normal for a scene with lots of dark tones. When the histogram hits the left wall there is nothing to worry about as long as you know that the scene is actually supposed to look dark. This is very different from the bad effects you get when the histogram hits the right wall and starts losing detail in the highlights.

The single most important function you can do to help your camera capture all the tones it can is to set your file type to RAW. This creates a much less contrasty image with a full range of tones and a smooth gradation from highlights to shadows. RAW files can capture far more tones than a JPEG file.

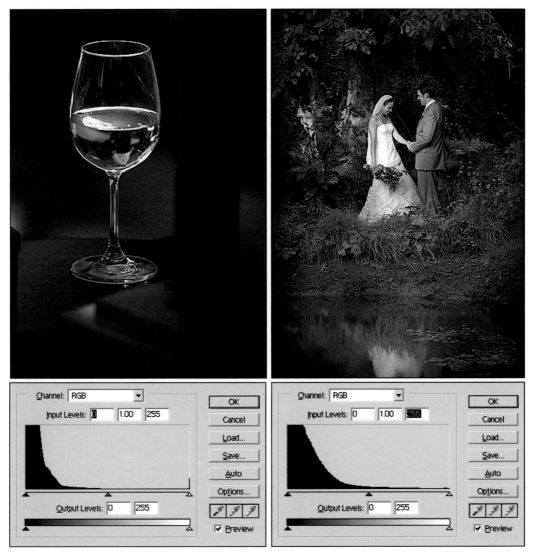

Figure 9-6: A histogram that leans to the left side is not bad if you know that the scene really does have a lot of dark tones.

Low-light ceremony shots

Shooting an indoor ceremony will push the limits of your low-light photography skills. If you have fast (wide aperture) lenses, you may be able to get away with handholding your camera as you move from place to place. If you don't have fast lenses, you can still place the camera on a tripod and shoot with a slow shutter speed. Shooting slow can result in many ruined images because one person or another almost always moves during a long exposure. However, if you're persistent, it's very possible to get good ceremony shots with shutter speeds in the one second range. You just have to be willing to shoot six or eight shots before you eventually get a sharp one where everybody is standing still for the full second.

Fast lenses often give you enough shutter speed to enable you to shoot handheld if you push your ISO up to 1600 or 3200. The resulting graininess may be somewhat acceptable although not optimum. Even if you do have fast lenses, you can diminish the grain a great deal by placing the camera on a tripod and lowering the ISO down to 400 or 800. This setting gives you much smoother images without all the grain.

The tripod is also great for maintaining the perfect framing on your subject while you watch for the best expressions or a laugh, as seen in Figure 9-7. After you get your framing set, you can move your face off to the side where it's more comfortable to watch for long periods of time. Just keep your finger on the shutter release button, and you'll be ready to catch any action.

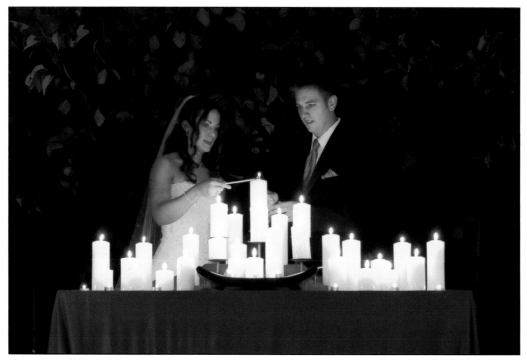

Figure 9-7: Using a tripod guarantees more sharpness when you are in a dark area that limits your shutter speed.
95mm, f2.8, 1/25th, 400 ISO, tripod Image
© Joseph Milton

Catching the Guests

One of the most difficult parts about photographing a wedding ceremony is that you have such an obvious focus to the event with the bride and groom up at the altar, that it can be hard to remain aware of the parents and other guests that are part of the ceremony as well. For a few moments of the ceremony you absolutely must be focused on catching one of the big top ten shots. This leaves a lot of time for you to move around to get images of both parents watching from the front row, the grandparents, friends, and so on. You should be especially aware of getting emotional shots of anyone in the crowd that may be laughing or crying as in Figure 9-8.

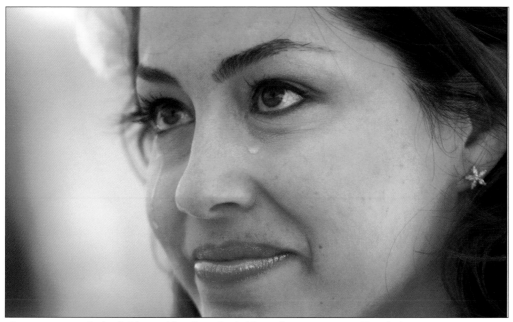

Figure 9-8: Watch the bridesmaids when the bride and groom are reading their vows.
200mm, f2.8, 1/1000th, 200 ISO

I always like to try to catch a shot of the parents that shows their bond with the newlyweds in the background. Sometimes it may be that they are holding hands, or looking at each other, or mom may be leaning into dad as she wipes a tear from her eye. Better yet would be to catch dad wiping the tear from her eyes. My favorite of these images (so far) can be seen in Figure 9-9.

How do you make your ceremony work stand out? Obviously you won't be the first photographer to shoot a ceremony, so making your work look genuinely unique can be quite a challenge. Instead of trying to do something different, the ceremony is a good time to focus on catching expressions and documenting the event in a way that tells the story for the couple. Your clients will appreciate that you captured every smile and every tear and every event that took place. They will love it if you catch someone laughing just as much as they will certainly love it if you catch someone crying. As in Figure 9-10 and Figure 9-11, they will be delighted if you catch a look of sheer joy and elation as the bride and groom are leaving down the aisle. Your work during the ceremony won't be judged on how different it is from that of other photographers. Instead, it will be judged by how much emotion it captured.

Figure 9-9: The juxtaposition of two couples in love is one of my favorite ceremony images.
95mm, f4, 1/3000th, 400 ISO

Figure 9-10: A look of sheer delight in a groom's face is something you may have to wait patiently for, but it's worth it when the moment finally arrives.
170mm, f4, 1/8000, 400 ISO

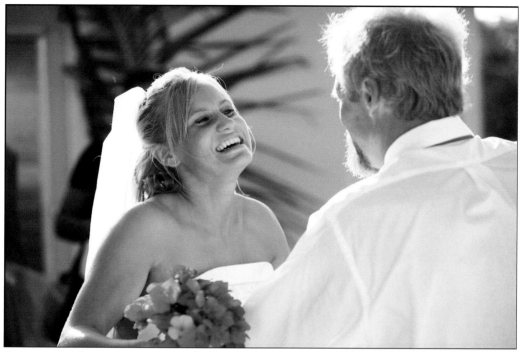

Figure 9-11: When you see two people that you know are really close, coming together for a hug, start shooting. You don't ever really know what sort of images you'll get but there's a good chance a few of them will be worth the effort.
105mm, f4, 1/1000, 400 ISO

Where to Be and When

Walking through the ceremony in the mind of a professional photographer, you might hear the following mental conversation taking place.

Pre-ceremony

Talk with second photographer and discuss where each person is going to be. I'm following the bride and her father while second photographer shoots from the front to get everyone entering the ceremony. Remind second photographer to watch for me so we don't end up in each other's shot.

Go find bride. Set camera to Aperture Priority mode. Shoot bride and father from behind, as in Figure 9-12 and Figure 9-13, with wide angle to get the whole dress and train. Switch to 50mm f1.4. Watch and wait for shot of the bride looking around the corner at the ceremony. Move to side and try to get a shot of bride looking at Dad. Move to other side and try to get a shot of Dad looking at bride. Switch to 70-200mm f2.8. Follow them out and get shot of them walking towards the aisle arm in arm with ceremony blurry in background. Move to left side of ceremony and shoot them from the side as they come down aisle. Move to front and look for good angle to shoot dad passing off bride to groom. Being on the left side puts you in the right spot to see Dad and the groom's faces because they will both be on the opposite side, facing towards you. Watch for handshake or pat on back from dad to groom. Get Dad kissing and hugging bride. Watch for smiles from bride and groom.

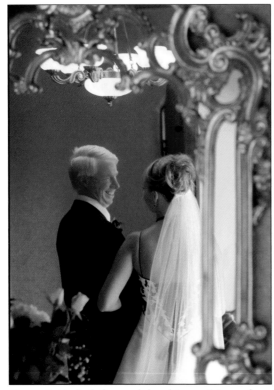

Figure 9-12: As father and daughter wait to go down the aisle, there are almost always a few glances exchanged that make beautiful images.
50mm, f2, 1/90, 400 ISO

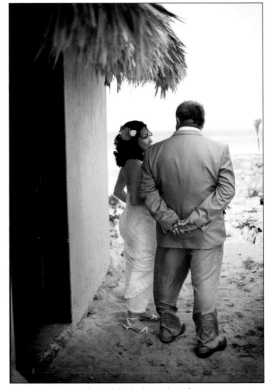

Figure 9-13: I shot this father-daughter moment from behind so that I could include the ocean and the little hut they were hiding behind.
50mm, f2, 1/4000, 400 ISO

Mid-ceremony

Mid-ceremony is a good time to wander around looking for miscellaneous images because not much important or emotional usually happens in the beginning. Shoot individual shots of each groomsman and the officiant. Shoot over bride's shoulder to get groom smiling at bride. If I'm outside, I'll walk 50 yards or so off to the side to get a wide shot of the whole event. Move to back of ceremony and shoot wide shots from both corners and the center aisle. Move to right side and put on 70-200mm again. Shoot individual shots of each bridesmaid and the officiant. Shoot over groom's shoulder to get bride smiling at groom. Move closer and watch for tears from bride, groom, and parents as vows are being read. Watch for singers or speakers. Move to get a good angle and the best light as bride and groom put on rings. As ring time approaches focus on officiant and wait for him/her to ask for rings as in Figure 9-14. Try to get the ring bearer delivering rings to officiant. To get an image such as that in Figure 9-15, watch for officiant to hold up rings and show them to crowd. Get waist-up shot of bride putting on ring then zoom in close to get hands only. Same for groom.

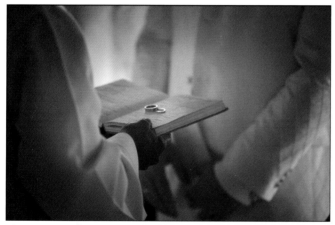

Figure 9-14: The 200mm telephoto lens is perfect for capturing a close-up of the rings waiting on the officiant's bible.
200mm, f2.8, 1/700, 400 ISO

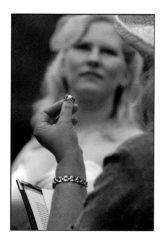

Figure 9-15: Capturing an image such as this only happens if you're ready for it before it happens. It takes concentration, and the knowledge that many officiants hold up the rings like this before they hand them to the bride and groom.
140mm, f2.8, 1/500, 400 ISO

End of ceremony

Walk to the back end of the aisle and put on flash. Switch to wide-angle zoom lens. Wait at back for officiant to start pronouncing them husband and wife then move down aisle to about twenty feet from the front to get the kiss shot. Wait near middle of aisle and shoot couple as they go out. Stay about fifteen feet in front of the couple and keep shooting while looking over your shoulder as the couple moves down the aisle. Stop just behind back row of seats and shoot the couple as they pass close by on their way out as in Figure 9-16. Shoot wedding party couples and family as they file out. An alternative to this method would be to use two cameras, one with the 70-200mm lens, which you would use to shoot the kiss, and then a wide angle zoom to shoot the couple coming down the aisle.

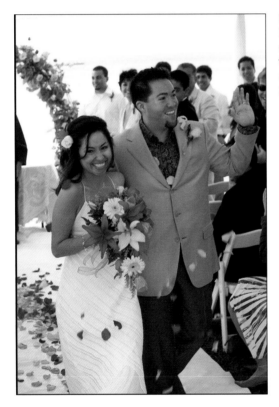

Figure 9-16: This is one time when the action happens way too fast to predict it. I rely heavily on a fast motor drive to get a lot of images as the couple walks past and I just hope that one or two of them turn out such as this.
70mm, f6.7, 1/128th, 200 ISO

Move to a spot just behind couple for receiving line. As in Figure 9-17, get in close to catch hugs and kisses from friends and family. If you miss a hug as people come together, shoot it as they come apart — it looks the same either way. Unless the bride has requested otherwise, you probably only need to stay while the first fifteen or twenty people go through the receiving line, because these will be the closest friends and family. As soon as that is done, start setting up a spot for group photos. If you have lights to set up, this is the time to get them ready. If you're outdoors, look around to find a shady location for the group shots and get it all ready by cleaning up the ground and moving anything that detracts from the background.

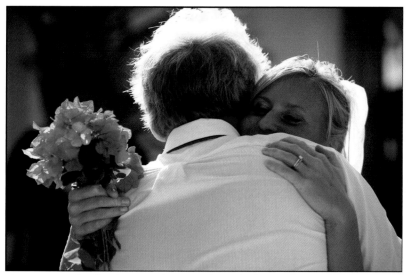

Figure 9-17: The first few people going through the receiving line
are your best photo opportunities.
140mm, f4, 1/2000, 400 ISO

Interview: Joseph Milton

Joseph Milton Photography www.josepmilton.com

Joe is a Photojournalistic style photographer from the Portland, Oregon area who has shot hundreds of weddings in the Pacific Northwest and beyond since 1990. He has been a member of the Wedding Photojournalist Association since its inception in 2002 and has won three first place awards and eight other awards in the top ten. He was also selected as the top photographer of the year for 2005 in the Artist Guild of the WPJA.

Joseph was kind enough to answer some questions about the techniques and equipment he uses for shooting the ceremony.

Do you use any special equipment for shooting during the ceremony?

For the procession (going towards the altar), I'll use a mix of flash shots and ambient light shots depending on the existing light situation. The flash shots are the "safe" shots so I'll get those first. For an outdoor ceremony, I'll use fill flash set to one stop under ambient (-1 exposure compensation). After the procession and the hand off of the bride from the father to the groom, I'll turn the flash off for the rest of the ceremony except for extreme cases when the venue is very dark. For large churches and venues, I'll use the Nikon 70-200 2.8 VR lens that allows me to handhold down to 1/20th of a second. I'll also have two other cameras available to allow for a variety of lenses: 10.5mm f2.8 fisheye, 12-24mm f4.0, 50mm f1.4, 17-55mm f2.8. This allows for a large variety of images. I'll only use a tripod if absolutely necessary, such as an extremely dark church, but this is probably only about ten percent of the time. I'll catch the kiss at the end, typically with the 70-200, then put the flash on and use the 17-55 for the recessional shots (bride and groom leaving the altar).

Continued

Continued

What do you mean by "safe" shots?

When you shoot with flash the outcome is fairly predictable. It will be sharp and colorful — perfect for a documentary image. However, it probably won't be very romantic or moody like what you might get with natural light. Natural light looks great but it's also much more likely to give you a blurry image if anyone moves much. Maybe the blur will look really good, maybe it won't. For this reason, I get the "safe" shot first, and then I can experiment with things that may or may not work out.

Why do you use more than one camera at a time?

Using two or more cameras during the ceremony is very convenient if you have them. You can use the telephoto on one and a wide angle on the other. This is especially helpful when you need to shoot the kiss from the back of the room with a telephoto and then use a wide angle and flash just seconds later as the couple comes down the aisle.

Is there anything special that you try to watch for?

I look for good reactions from the crowd as the bride is walking up (procession). I also look for little kids who will sit in the aisle during the ceremony, or turn and look at me as I'm shooting the ceremony. That adds a different focus to the ceremony shots. For the most part I'm concerned with documenting the couple, the environment, and the people involved with the ceremony, such as the musicians, readers, singers, bridal party, and so on. I don't really look for anything in particular; it's more about staying alert and aware so that if something special DOES happen, I'm ready to get it.

What do you consider to be your "must have" shots?

Of course you have to anticipate the main events in the ceremony. Don't get caught fiddling with your cameras or lenses during the vows, ring exchange, unity candle, or kiss. Be ready. Sometimes these are not done according to the anticipated script and can catch you by surprise. Some other "must have" shots are the bride processing up the aisle with her father, the passing off of the bride to the groom, a wide shot of the church/building/outdoor setting, a wide shot showing the bridal party at the altar, and any other key ceremony event that you have discussed with the client in the planning meeting. You DO have a planning meeting right?

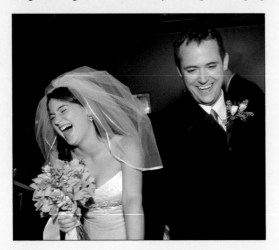

Do you have any shots that you feel are your "signature shots" that make your work unique during the ceremony?

I have seen so many other photographers' work that it's hard to say I have many signature shots that NOBODY else has. However, I don't think it's necessarily about pre-planning a particular "signature" shot that you try to do at every wedding. For me it's more important to react and respond to a particular event. What is unique about it? How can I capture it in a way that is above and beyond the expected shot? What environmental factors are unique here that I can utilize to make a more interesting shot?

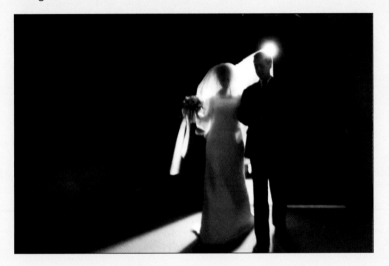

Do you have any unique angles that you try to get on a regular basis?

I'll try and get a wide shot of the ceremony from the middle and the back from both corners. I'll also get a balcony shot if one is available. And I like the dramatic look of a wide-angle shot that is taken from ground level (placing the camera on the ground). If there are nice floral decorations on the pews I like to shoot those with the couple out of focus in the background. These can be taken while the officiant is giving the sermon/speech and they only take a few seconds. During the key parts of the ceremony (vows, ring exchange, kiss), I'll always use my zoom to come in close because sometimes there are some great facial expressions or tears that you MUST catch! After I have these basics covered I'll look for other more unique opportunities. I know many photographers have no qualms about walking up into the altar area during the ceremony, but I prefer to stay back and not draw attention to myself. If there is a way I can get a side angle or even a front angle if I'm not noticed I'll try to get that also.

Do you have any special tricks for dealing with direct sunlight??

Direct sunlight in an outdoor ceremony is always tricky, since as the photographer we don't have any control over the time of the ceremony, or the location, or the orientation of the couple in respect to the direction of the light. If the dress is in direct sunlight, I'll check the histogram and blinking highlight warning to make sure I'm not blowing out the highlights and once I've dialed that in, I just keep shooting (in manual mode) with that same setting.

Summary

Shooting the ceremony is less about showing off your creative skills and more about documenting an event in the most beautiful way possible. There are certain decisive moments where everyone involved will expect you to capture a decent image simply to record the passing of the moment. These "must have" shots needn't be particularly artistic. The true art of capturing the ceremony is in capturing the emotion.

Your clients will appreciate that you got every smile and every tear and every event that took place. They won't be looking for special effects from the ceremony. They'll be looking for that I-love-you-so-much-I-could-just-die look in the bride's eyes as she stares up at the groom. They'll be looking for that I-can't-believe-my-baby's-all-grown-up look in mom's eyes. They'll want to see the tears on Dad's face when he was so choked up that he couldn't even get the words "her mother and I" to come out of his mouth. It's all about emotion!

✦ ✦ ✦

10

Capturing Candid Moments

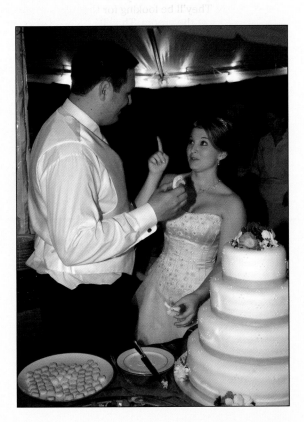

A good candid image is a snapshot that captures a spontaneous natural moment. Candids frequently tell a story, but more importantly, they simply capture people living their lives. The images are not contrived or posed. Candids catch rare and fleeting moments of reality without concentrating on perfect photographic technique. Can a picture really say a thousand words? A good candid image may not capture the whole story with all the elements necessary to let you know what was taking place, but even so, candid images often speak to us in a language all their own.

This chapter provides information on equipment to use as well as a few tips that will help you capture candids by teaching you how to see them coming.

Seeing Candid Moments

A truly beautiful candid moment such as the one in Figure 10-1, is one of the most elusive shots you will ever try to capture with your camera. When they happen in real-life they're very fleeting moments. You may see one happening and think about how it would have looked frozen in an image, but by the time you process all this in your head, of course it's already long gone. To capture these moments, you have to learn to react without thinking.

Perhaps this chapter should have been titled "Zen and the Art of Capturing Candid Moments" because it really is a Zen sort of challenge to chase these moments with your camera. To catch them, you have to learn to turn off the logical part of your brain and trust your gut feelings about when something is about to happen and when to press the shutter.

It would be impossible for anything in this chapter to tell you the perfect moment to press the shutter, but fortunately, there are many teachable techniques and thought processes that can help you anticipate when something good is about to happen and get you in the right position to capture these moments before they pass you by.

Figure 10-1: Pressing the shutter at the right moment is not something that someone can teach you. It's a gut feeling that comes from somewhere inside you and your reaction to that feeling is what makes your work unique.
50mm, f1.4, 1/1000th, 800 ISO

Equipment

No single combination of equipment and camera settings should be used for candids. In fact, you can capture candid moments with virtually any piece of camera gear and any camera settings. The specific equipment and settings are dictated to a certain degree by the place and time of day. Because of the fact that these fleeting moments may happen at any location, and at any time of the day or night, catching them is more about being in the right place at the right time than it is about what equipment you use.

An early photojournalist named Weegee was once asked, "What is the key to your success?" Weegee answered, "f8 and be there." Because f8 is about as average of a camera setting as there could possibly be, he was basically saying that there is no camera magic to it. It's about perseverance more than anything else. You have to get yourself out there and keep trying.

Dennis Reggie, who is widely accepted as the founding father of the modern photojournalistic wedding photography movement, was asked the same question as Weegee and his answer was, "f2.8 and be there." Obviously playing on the famous quote from Weegee, Dennis put a twist on it to reflect the current use of wide aperture lenses that capture a very narrow depth of field, but his statement also serves to emphasize the fact that what Weegee said still rings true after all these years. The real trick is still perseverance. The image in Figure 10-2 resulted from a combination of skill, and being in the right place at the right time.

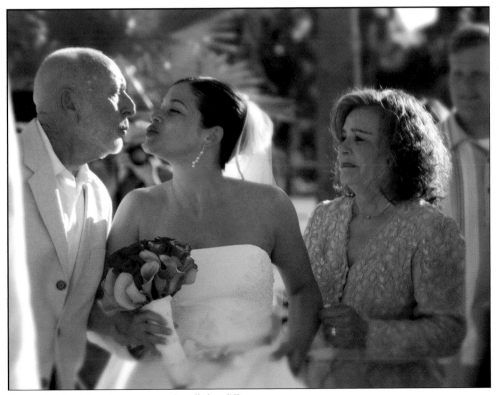

Figure 10-2: Being there can make all the difference.
105mm, f4.5, 1/350th, 400 ISO Photo by: Amy Lizotte

When to use a long lens

Shooting with a long lens has several distinct advantages. It isolates the subject by creating a strong blur both in the foreground and in the background, and it also gets you so far away from the subject that your presence is rarely noticed. Even if you are noticed while shooting with a long lens, the distance tends to put your subjects at ease than if you were standing beside them with a wide-angle lens.

Shooting with long lenses doesn't always require that you use a wide aperture that gets very little depth of field. More depth is often an advantage in storytelling because there are frequently several people in the scene and a very shallow depth of field only gets one of them in focus. Using a medium aperture such as f5.6 or f8 creates a larger depth of field and gets more of the people in focus. In the real world, you might vary your aperture based on the amount of light. If you're shooting in the middle of the day, you can easily use medium apertures. If you're shooting in the late evening, a wide aperture may be required to get an acceptable shutter speed.

Telephoto lenses are sometimes much more difficult to use for candid images because many candids rely on the story that they tell and the story often has aspects that are spread several feet apart. A telephoto is great at isolating and zooming in close to the subject. Use it for candid portraits, as in Figure 10-3, when the whole story is in one person's face.

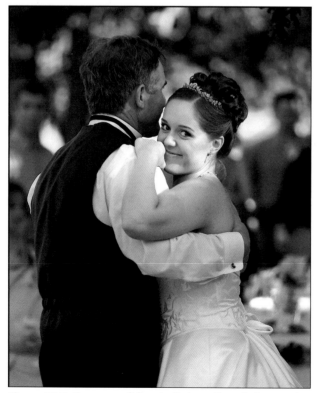

Figure 10-3: Some candid portraits have the whole story in one person's face. This is a perfect time to use a long zoom lens.
145mm, f2.8, 1/1000th, 400 ISO

When to use a wide lens

The wide-angle lens is a storyteller. It excels at capturing everything in the room but the photographer. One of the only drawbacks to using this lens is that it requires you to be so close to your subject. Being close isn't a drawback as far as the pictures are concerned, but it can have a huge effect on the behavior of the subjects you hope to photograph. In any case, your very presence cuts down on your chances of catching your subjects in a genuinely natural candid state, and the closer you get, the more you throw them off.

There are exceptions to this rule that depend on the physical space you are in and on the activity taking place. For example, people don't seem so intimidated if the space is small and everyone *has* to be close, or if they're involved in some action that distracts them from the fact that they're being photographed.

Based on this idea, the optimum places to capture candids with a wide-angle are:

✦ In small rooms where the space is so tight that everyone has to be close.

✦ In the ceremony and receiving line where everyone is too busy to notice you, and

✦ During the dancing at the reception following the first few formal dances.

If your subjects happen to be drinking a little alcohol later in the evening, your presence can even start to have a reverse effect. The closer you get, the more they tend to act silly and show off for the camera. All of which, although not exactly candid, makes for some great images. Figures 10-4 and 10-5 are examples of candids shot with a wide-angle lens.

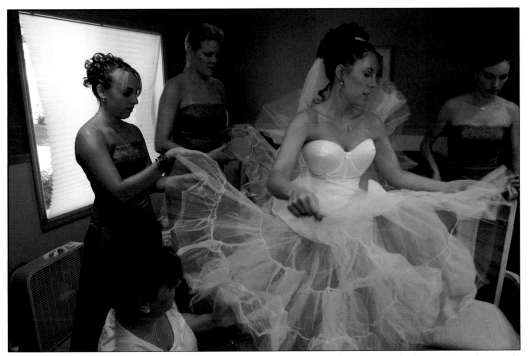

Figure 10-4: In the cramped quarters of a dressing room, the bride and her maids go about their tasks.
17mm, f4, 1/60th, 400 ISO

Figure 10-5: Children are more interested in what you're doing than in what the bride is doing.
17mm, f4, 1/180th, 400 ISO

Catching Candid Moments

How do photographers manage to capture incredible storytelling candid images of such fleeting moments? Is it luck? I don't think so. Of course there is a small amount of luck to it simply because the action is often happening quickly; however, luck alone wouldn't explain why the best photographers tend to capture these moments on a fairly consistent basis.

Character studies

One of the tricks to predicting a candid moment is that you have to study the personalities of the individuals at the wedding and learn which ones are most likely to cause interesting events to happen. For example, during the early parts of the day, in the dressing rooms and around the family, you can start to notice and jot down in your mind little notes about the different characters involved in the day. Make little notes about which ones are laughers, which ones are the cryers, which ones are the energetic dancers, and which ones are just plain wild. Watch these people like a hawk and if one of them heads toward the bride or groom, get ready.

Face the face

One of the hardest aspects of storytelling for the new photographer is realizing that you can't tell the story from the same angle that a participant sees it. For example, if you take images of the couple and the wedding party signing the wedding license, there are two possible perspectives. One is the perspective of the participant. They stand on one side of the table and look down on the document they are about to sign. The other perspective is that of a viewer. If the viewer were on the same side as the participants, all the viewer would see is the people's backs. Seeing a photo of a bunch of people's backs obviously won't tell much of the story. If you want to tell the story, you have to get on the other side of the event so that you can see the faces of the participants, *and* what they are doing, as in Figure 10-6. A composition such as this has a shared subject — the people, and what they are doing. Both parts are necessary to tell the story.

In the real world this may mean you have to move around a lot. Eventually, it becomes completely ingrained in your subconscious to automatically move to the opposite side of the action from the participants.

In newspaper photojournalism where the photographer is working for a newspaper, the pictures are used as an accompaniment to the text and it is the text writer who is responsible for telling the majority of the story. However, as the sole storyteller for the entire day, the wedding photojournalist has a much more difficult task. Any part of the story that you miss will soon be forgotten.

Figure 10-6: To tell the story, you have to get on the opposite side of the action from the participants.
18mm, f6.7, 1/16th, 400 ISO

Watching and waiting

For candid portraits of a single person, as shown in Figure 10-7, you can focus your attention, and your lens, on this one person and simply follow them while watching for facial expressions, hand gestures or laughs. This takes a lot of patience but your perseverance will occasionally be rewarded with stunning images that are impossible to catch otherwise. For example, an average laugh may last one to two seconds. If you walk around with your camera at waist level, it could easily take you longer than that to raise the camera up, check the settings, and shoot. Even if you just try to raise up and shoot, you still may not have time, and you're highly likely to blur the shot by moving so fast.

My favorite technique for getting good images this way is to find a good vantage point that is a little out of the way, and just let my lens roam from person to person around the crowd. I spend most of my time following the bride and groom, but if they wander out of view, I concentrate on any family members or bridal party members that I can find. Each person that falls under my lens is watched for any expressions or interesting hand gestures that might make the image stand out.

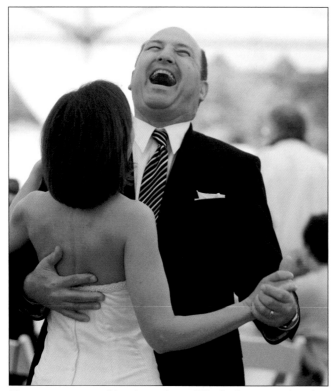

Figure 10-7: A good laugh can be a difficult shot to catch unless you have the patience to watch and wait until it happens.
110mm, f2.8, 1/250th, 400 ISO

Summary

Capturing candid moments is quite challenging even for the most experienced wedding photographers. Most people find it practically impossible to pick up on the first few weddings and then slowly but surely, they get more and more tuned in to the flow of the event and the way certain charismatic people always seem to be at the center of the action. The next step is to learn to see the characters coming and anticipate the fact that they are very likely to cause interesting events to happen.

Tips gained in this chapter can also give you a better idea for when to use a long lens and when to use a wide lens. This will help keep your clients and other guests feeling comfortable enough to act like themselves while you concentrate on catching the candid moments.

✦ ✦ ✦

CHAPTER

11

Creating Romance in the Magic Hour

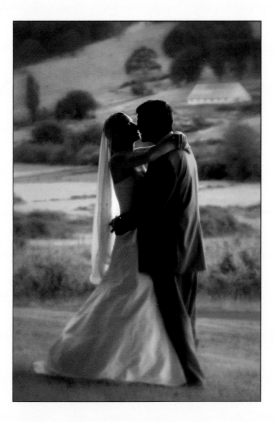

For thousands of years artists have been trying to capture or create images that portray romance. Photographers and painters and sculptors alike all struggle with the same question, "What does romance look like?" For that matter, what is romance? We have romance novels, romance languages, romantic music, and even romantic places. You can have a childhood romance, you can have a romantic encounter, and an old car can even have a certain romance about it. None of that really tells us much

about what romance is. Like beauty, romance is an elusive trait that can only be judged in the eyes of the beholder. Every person knows it when they see it, yet no two viewers will see it in the same place. This chapter describes a few of the techniques and thought processes that go into creating a type of image that contains such elusive qualities that no words can fully describe what it is or how it should look.

Defining the Romantic Image

According to the definitions, a romantic image is idealized, not based on fact, and remote from everyday life. It displays, expresses or is conducive to love. It is imaginary! Perhaps not completely imaginary, but certainly a romantic image does get much of its appeal and expression of love, from the fact that it leaves a lot to the imagination. The part not shown allows the viewer to imagine all sorts of things. Upon seeing a romantic image, one person may imagine, and even actually feel, just a bit of the deep feelings of love that every bride is supposed to have for her new husband. Another may imagine that there is more going on in the scene than what is shown. Another may imagine what it would be like if she were actually there — if she was the one in the picture, "What would that dress feel like? How would the sand feel between my toes? What would my man be like? No . . . I know what he would be like . . . he's all the things I've ever dreamed of." A romantic image, like the one in Figure 11-1, sets the viewer's mind free to imagine the love and emotion that they themselves want to experience. If you can create images that inspire romantic feelings in a woman, you can bet she will remember your name when she finds "Mr. Right".

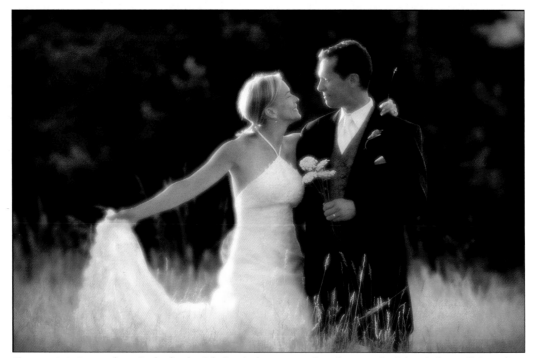

Figure 11-1: Somewhere in the back of their mind, everyone has dreams of a fairytale love affair and a fairytale wedding. A good romantic image brings those dreams out and lets them run around for a while. *300mm, f4.5, 1/500th, 400 ISO*

Deconstructing Romance

Is it possible to make a list of the photographic elements that give an image a feeling of romance? To some degree, many of these images have similar qualities that can be defined and spelled out, but it would be impossible to set out a single formula for the creation of a romantic image. The images in this chapter were not shot in a photojournalistic fashion. If it seems as if they might have been, then the goal of creating an image that looks completely natural has been accomplished. While these images are purposefully contrived and orchestrated by the photographer, I wouldn't say that they are "posed" in the traditional sense of the word. Much effort is spent on creating the feeling of being at ease and comfortable in a natural scene. Perhaps the most difficult aspect of working with clients that are not professional models is that they don't know how to fake looking natural, and you, as the photographer, must somehow coax them into it.

The most fundamental element of a romantic image is that there is no interaction between the subject and photographer. If the subject looks at the camera, you have a portrait, not a romantic image. The difference is that a portrait is about a person, while a romantic image is about a feeling—an imaginary, idealized, and fictitious feeling that relies in part on the notion that the subject of the picture is originally the one feeling the romantic feelings. The viewer experiences the same romantic feelings through empathy with the subject. The dream can only exist while the subject is experiencing it. If the subject looks up at the photographer, the dream disappears.

Romantic images that don't show faces are great for your portfolio because the anonymous quality makes it easy for viewers to imagine themselves being there in the image, as shown in Figure 11-2. When you work with your clients to develop a pose, pay particular attention to creating a relaxed feeling in the hands. Hand positions communicate an amazing amount of detail about how a person is feeling about themselves and about the person they are with. Notice the relaxed hand positions in Figure 11-3 and throughout the images in this chapter.

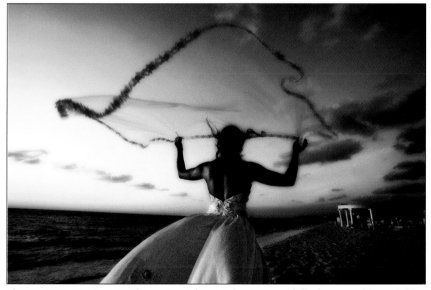

Figure 11-2: Anonymous images work great in your portfolio because it's easy for clients to imagine themselves in it.
80mm, f4.5, 1/30th, 400 ISO

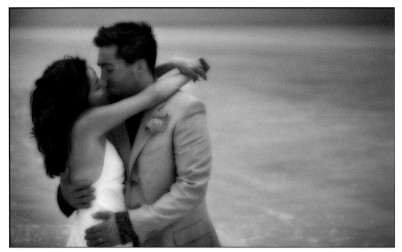

Figure 11-3: Notice the casually draped hands, which communicate a feeling that these two people are very comfortable together. The softness of this image also adds to the romantic feel.
70mm, f2.8, 1/1400, 100 ISO

As you can see in Figure 11-4, the eyes also communicate a lot of feeling. Posing the couple with eyes closed creates a feeling that they are enjoying a blissful moment together. This is a very different feeling from what the same image would have with the eyes open. And yet another very different type of feeling would be generated if the eyes were engaged with the camera.

Figure 11-4: Closing the eyes can create a relaxed, dreamy look.
50mm, f8, 1/125, 400 ISO

I like to coach my couples on kissing for the camera. I tell them to kiss straight on without tilting the head off to the side, and I tell them that the best part of the kiss is the moment just before contact is made. As they kiss, they should hover at a point where they have less than an inch between them like the image in Figure 11-5. Once they have their faces smashed together, you might get a passionate kiss shot, but for the most part, all the mystery is gone. That moment just before the lips touch is when you capture a feeling of anticipation. Always leave a little something to the imagination.

Blurred, grainy, poorly lit images can add quite a lot to the mystery by departing from reality and leaning towards imaginary or fictitious as in Figure 11-6. These images don't rely on sharpness to convey a feeling of romance. In fact, they seem to gain more of a romantic air because the identity of the subject is somewhat veiled and blurry.

The direction of the woman's gaze is particularly important to a romantic image. This is not nearly so important for the man who generally is looking at the woman. Having the woman look down or off to the side creates a feeling of feigned disinterest while the man counterbalances that with a direct and very interested gaze towards the woman. Body positions often mimic this idea as well, with the woman having a more relaxed stance that does not need to face the man, and the man almost always facing the woman to indicate interest, as shown in Figures 11-7, 11-9, and 11-11.

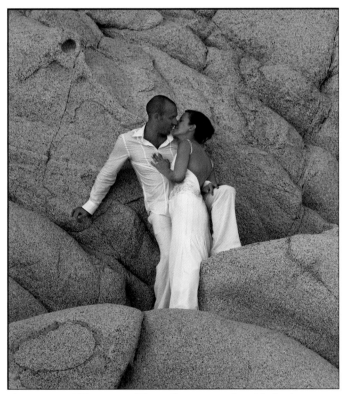

Figure 11-5: This composition relies on comfortable body positions and catching the moment just before the kiss.
150mm, f4.5, 1/1000, 800 ISO

Motion and the blur it creates, can also be used to create a sense of mystery by erasing the identity of the individual in the picture. This can be seen in Figure 11-8.

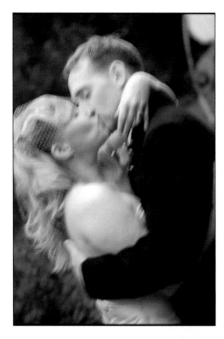

Figure 11-6: Sharpness is not required in a romantic image. In fact, mystery and romance can often be conveyed through the use of techniques that would otherwise be considered undesirable.
50mm, f2, 1/10th, 200 ISO

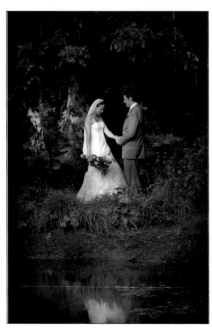

Figure 11-7: Having the woman look down or off to the side creates a feeling of slight disinterest while the man counterbalances that with a direct and very interested gaze towards the woman.
105mm, f6.7, 1/45, 400 ISO

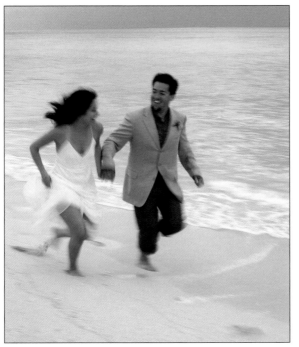

Figure 11-8: Motion often creates softness and mystery.
50mm, f22, 1/20th, 100 ISO

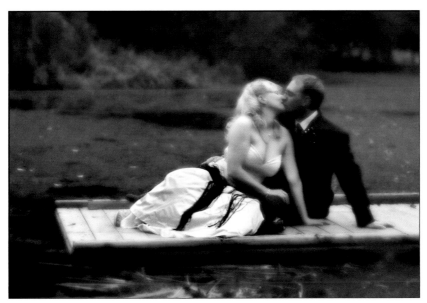

Figure 11-9: This image has comfortable body positions with hands draped very naturally. Note the man is almost always facing the woman.
50mm, f2, 1/16th, 800 ISO

Another strong aspect of many romantic images is that they have a slightly voyeuristic feeling, as if the viewer were spying on the couple as they shared a quiet moment alone. As the photographer creating these images, of course you won't be spying on them, but you can create a bit of this feeling by shooting through objects. For example, indoors you can shoot through a small opening in a doorway, or through a crack in the curtains. Outdoors, the effect is the same if you shoot through some foliage that partially obscures the scene. Something in our mind accepts the foliage or other obstacle as a validation that the scene must be completely natural. Perhaps the thought is if the photographer were posing the scene, the photographer would have certainly taken the time to get around those branches. Figure 11-10 and Figure 11-11 give the impression that the couple was completely unaware of the photographer.

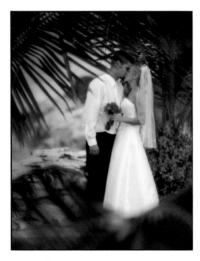

Figure 11-10: The palm leaves obscuring the couple add to the feeling that this is a perfectly natural moment captured by the photographer. Only the couple and the photographer know that it took careful positioning to get it just right.
200mm, f4, 1/1400, 400 ISO

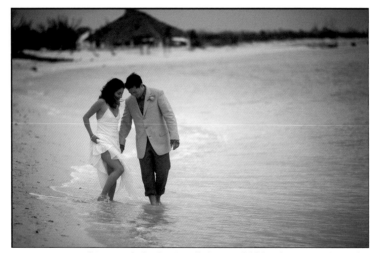

Figure 11-11: This couple looks for all the world like they were just playing in the water, completely unaware of the photographer's presence.
185mm, f2.8, 1/1000, 100 ISO

Figures 11-12 through 11-14 illustrate various combinations of the basic features of a romantic image.

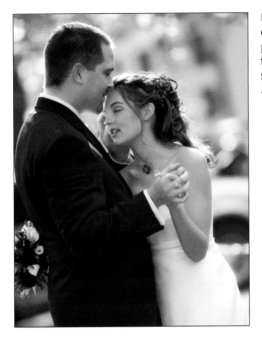

Figure 11-12: This image incorporates many aspects of a romantic photo. Notice the comfortable body positions, small space between the lips and forehead, and the relaxed face of the bride with lips slightly open and eyes closed.
200, f2.8, 1/180th, 400 ISO

Figure 11-13: I purposefully focused on the veil for this image so that the couple would be a blur ust under the fabric.
155 mm, f2.8, 1/1500, 400 ISO

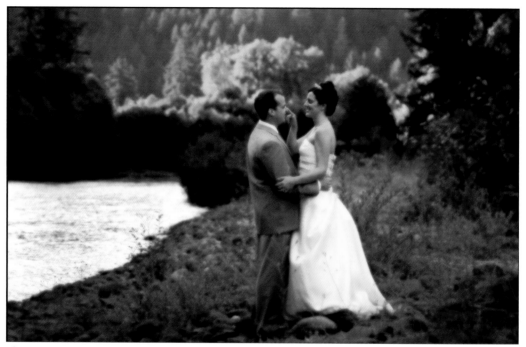

Figure 11-14: This image of the couple beside a river was manipulated heavily in Photoshop to get the soft blur and the golden colors. ·
85mm, f4.5, 1/500th, 400 ISO

Equipment

Romantic images don't require any specific type of equipment. However, it would be safe to say that a large majority of them benefit greatly from the use of extreme lenses — either long telephoto or very wide-angle. The telephoto adds two aspects, the shallow depth of field and the compression of subject and background so that they look very close together. The telephoto also captures a very narrow angle behind the subject, which makes it easier to find a good location because you only need a very small piece of good background to work with; if there are people or trash cans nearby, nobody will ever know. The wide-angle is much harder to get something romantic with, but on those occasions when you do have a large and very beautiful background, a wide-angle lens will certainly get it all in there.

Art lenses such as the 50mm f1.4 and the Lens Baby can also be very successful for the creation of romantic images. See Chapter 3 for more information on lenses. Most of my romantic images are shot with either the 70-200mm f2.8 or the 50mm f1.4. However, as you can see in Figure 11-15, it is possible to create a romantic feel with a wide-angle lens.

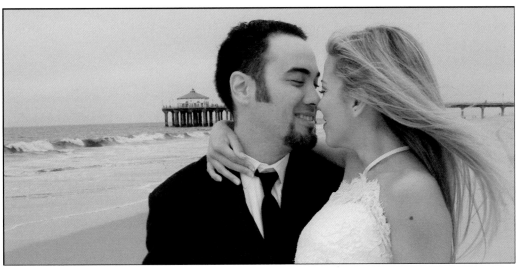

Figure 11-15: It may not be very common, but it is possible to create a romantic image with a wide-angle lens.
18mm, f8, 1/80th, 400 ISO

Creating the Photo Shoot

Getting the time to create a romantic image doesn't happen all on its own. You have to request it and work it into your whole business plan so that you begin talking about it to the bride the moment you meet her. You have to also talk about it to the groom and the coordinator so that they will all be on your team trying to make it happen.

The absolute best time for a romantic photo shoot is the hour before sunset and about twenty or so minutes past sunset. This is what photographers refer to as the "Golden Hour." The light is low, golden, and very soft. Just after the sun disappears over the horizon you have about twenty minutes when, even on a sunny day, there will be a very even light in the sky much like that of an overcast day. The Golden Hour is the time to try to schedule your romantic photo shoot.

Frequently this time will fall after the ceremony and in the last half of dinner. If this is the case, you are truly in luck because the bride and groom will be finished eating and you can easily slip away with them for a half hour without anyone ever noticing. This requires that you pre-plan to eat your meals at the same time as the bride and groom so that you can be finished eating when they are. If you talk with the coordinator about your plans, he or she will help to make sure it falls into place right on time.

How much time do you need? One factor is for certain, and that is that you will rarely get enough. Occasionally you will get an hour but frequently other events will conspire to put the schedule off and you may only end up with twenty minutes. Is it possible to shoot even one romantic picture in twenty minutes? It is if you plan your shots carefully. That means walking the area in advance to scout your favorite locations. After you get some ideas for places, you can get your assistant in the scene to act out some poses while you decide which lens and camera settings you want to use to get the desired results.

If you have three or four places chosen and all the details planned out, you can definitely get through at least three of them in twenty minutes. Unfortunately, one of the most frustrating aspects of wedding photography is that you are constantly expected to create a work of art in twenty minutes or less. Your clients hire you for the beautiful images you create but they have no idea how long it can take to create them. You have to make sure this time gets worked into the schedule.

Pre-bridal shoot

I always try to talk my couples into a pre- (or post-) wedding shoot on a different day than the wedding. If you can convince them to do this, you can spend as much time as you like on the creation of a set of really good images. This removes you from the frantic rush of the wedding day and it allows you to get some really good pictures of the couple by themselves. This is a great relief because often the images of the couple alone are given the lowest priority on the wedding day. Couples tend to want so many images of them with all their guests that by the time it's all done, so is the time.

Pep talk before the photo shoot

You might want to coach your couples before you start shooting. The following paragraph is being reprinted from Chapter 5 because it is vital to the success of the creative, romantic portrait session.

During the photo session, which hopefully takes place in the late evening, I focus on finding beautiful locations with spectacular lighting and then I put the couple in there to let them do their own thing. By now (late evening) the bride and groom should be more comfortable in front of the camera but you still have to be careful about giving them too much direction. I find that a few general directions are helpful if I deliver them when we are all standing together and just talking — before we begin taking pictures. The speech goes something like this . . .

"I like to do very little posing because it tends to make your pictures more unique if you come up with ideas of your own. So if you have an idea, please feel free to throw it out there even though it may sound silly or impossible to do. Sometimes your idea won't work but when you say it, someone else may think of something that turns it into a great picture. When we find a good spot, I'll tell you roughly where to stand and then you can hug, kiss, play, dance around . . . anything you like."

The following are a few general guidelines for suggestions the couple can do to improve their romantic pictures . . . (Like all photographic guidelines, every one of them can occasionally be broken with very good results.)

- ✦ Don't smash faces together when you kiss. The most romantic part of the kiss is that moment just before the lips actually make contact. Take it slow as you get in close and linger at that place where there is about an inch between your lips.

- ✦ Try not to tilt your head to the side when you kiss. Face straight on at your partner so that the photographer can see both faces from the side.

- ✦ Don't pucker your lips out when you kiss. Kiss with a relaxed face. When you're not kissing, relax your face so much that your mouth hangs slightly open.

- ✦ Don't smile when you kiss. Smiling lifts the cheek muscles and turns the romantic feeling into a playful feeling. Playful can be good occasionally, but most romantic images are a bit more serious.

- ✦ When you're walking, try to occasionally lean in for a kiss without completely stopping.

- ✦ Be aware of draping your hands over your partner in a very relaxed way. Clenched fists and stiff fingers translate that strained feeling into the whole image.

Digital Romanticizing

Many straight images are not very romantic as they come out of the camera. As a digital wedding photographer, it's not required that you master Photoshop, but I think I can safely say that it puts you at a distinct advantage if you know it well. With a wide variety of artistic effects, your portfolio and Web site can shine far above and beyond your less digitally inclined competitors. The time you spend learning even a moderately high level of skill with Photoshop will come back to you many times over in the form of higher paying clients that appreciate your artistic abilities.

If you don't think you have the time to spend learning Photoshop, your options include, hiring someone to do the work for you or purchasing some good Actions. *Actions* are a part of Photoshop that enable you to automate a series of steps. Each Action contains a set of instructions for the specific steps Photoshop performs on an image. Running these Actions is as simple as opening an image, choosing an Action from the list, and pressing the play button on the Actions palette. You can make Actions yourself, and if you purchase a set, you can even modify them to fit your taste. Good places to find commercially available artistic actions are www.fredmiranda.com and www.kubotaworkshops.com. Adobe (www.adobe.com) also has a library of free actions that you can download. The list of effects you can achieve using Actions is practically unlimited. Figure 11-16 shows a few of the results you can get from one set of Actions purchased from Kevin Kubota at www.kubotaworkshops.com.

Figure 11-16: This is a before and after view showing what Kevin Kubota's Actions are capable of.

Another good source for help with the creation of some beautiful digital effects is a program called Nik Color Effects 2 (www.niksoftware.com). This package is actually a plug-in that works within Photoshop to create some stunning digital effects. Figure 11-2 was made with a combination of two of the seventy-five or so filter effects that you can apply using Nik Color Effects 2 Pro. The great part about Nik is that you can adjust the filter effect as you first apply it, but then when the program renders the effect it does so on a new layer, which is masked out. This allows you to paint on the mask to adjust where the effect shows up in the image. Nik is a huge timesaver for anyone that wants to add creative digital effects to photos.

Whether you choose to really learn Photoshop or just purchase something to do the job, digital effects can quickly elevate your work above your competition. With a little study, you can quickly learn how to do basic color correction and blemish removal first, and then eventually you will begin to pick up tricks for digitally increasing the romantic feeling of an image. Figure 11-17 shows a few of the original images that were the starting point for the finished images in this chapter. Photoshop is the only tool used to transform these images into the finished version, and none of these were created using commercially available Actions or plug-ins.

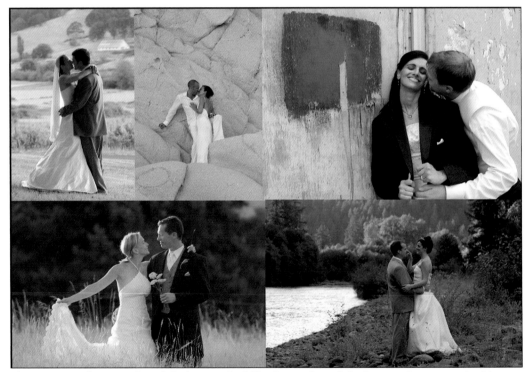

Figure 11-17: These are the original untouched files from a few of the images that appear in this chapter. As you can see, some of them needed a lot of help.

Summary

Romance is an elusive quality that is very difficult to capture with a camera. After all, camera manufacturers go to extreme pains to build cameras that capture a very close representation of reality. They simply don't build cameras with the goal of capturing qualities like mysterious, fictitious, dreamy, imaginary, or idealized. You have to work those elements into your image through posing, lens selection, choosing the right background, and perhaps even a few digital adjustments.

✦ ✦ ✦

12

Jazzing Up the Reception

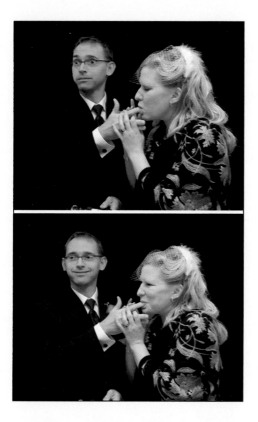

After the ceremony and the formal pictures are all done, everyone can breathe a deep sigh of relief. The groom grabs a beer, the bride grabs a glass of wine, and someone shouts, "Let the party begin!"

During the hours that follow, you have few responsibilities with only a couple of "must have" shots to capture. There are shots of the food, the first dance, the cake cutting, and the garter and bouquet tosses. Other than that, you have free reign to photograph whatever you find interesting. You may discover a unique portrait opportunity that you can talk the bride and groom into, or you might spend hours wandering the dance floor trying to capture that elusive perfect dance shot. Whatever you find yourself photographing during the reception, it is certain to be the most enjoyable part of the average wedding day.

Must-Have Shots

This section focuses on the specific "must have" shots you are required to get during the reception. These "must-have" shots are similar to the "must-haves" from the ceremony in that they are entirely predictable. You can easily predict when and where they will happen in time to beat the crowd of spectators armed with cameras who will also be jockeying for that prime location. Getting there first is far easier than trying to ask someone to move.

You can do yourself a huge benefit by befriending the coordinator and the DJ as soon as possible. These people watch out for you and make sure that you are notified when anything important is about to happen. Frequently it is the DJ that is responsible for announcing each event as it is about to happen. If this person is on your side, he/she will be checking to make sure you're there and ready before the announcement is made to cut the cake or some other event. If the location is particularly small and you know there will be a tight crowd around a certain reception event, you can get the DJ to alert you first so that you can be standing in your favorite spot before the announcement is even made. The image in Figure 12-1 was made in the last few minutes before the couple arrived to cut the cake.

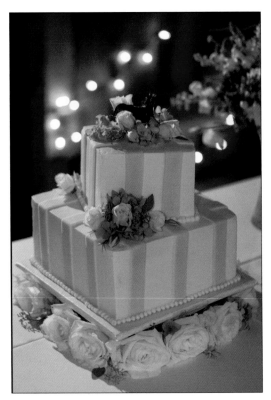

Figure 12-1: A portrait of the cake is always a nice addition to the image set.
50mm, f2, 1/30th, 800 ISO second flash on slave.

Cutting the cake

The cake cutting ceremony is a standard part of the average wedding day. As the DJ announces that the bride and groom are about to cut the cake, and the couple approaches their spot behind the cake, you may see them look at the knife . . . then look at each other . . . then back at the knife . . . neither of them has the slightest idea how the traditional cake cutting works. You are usually the closest person around with any experience on the subject and if you can manage to very discreetly whisper some instructions, they will certainly appreciate your help.

For the photographer, the most critical part of capturing the cake cutting is getting into position before the guests get the prime spot. Figure 12-2 shows the standard angle and composition for the cake-cutting shot. Notice that it tells the whole story by including the cake as a prominent part of the composition. The best place to stand is about five feet in front of the cake table and about 45 degrees off on the bride's side (see Figure 12-3). If you position yourself on the groom's side (see Figure 12-4), you may find that when he bends over with the knife to cut into the cake, the bride is almost completely obscured behind his arm and shoulder.

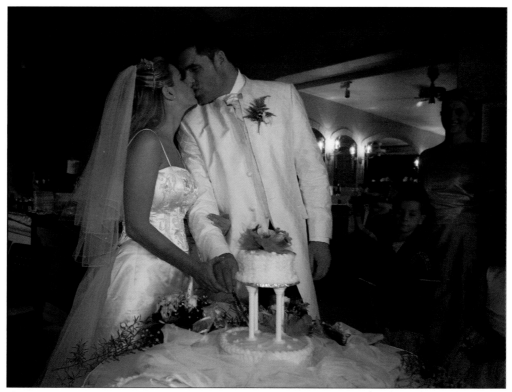

Figure 12-2: Correct framing tells the whole story of the cake cutting by showing both the people and the cake.
35mm, f4.8, 1/16th, 400 ISO

Grey Zone = Prime Location Spot

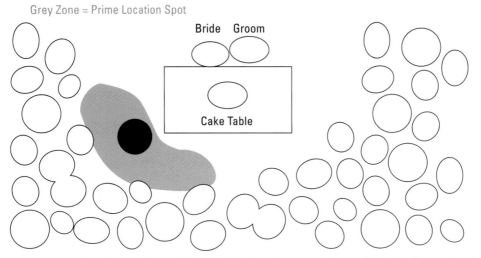

Figure 12-3: This diagram shows the prime location for getting the traditional cake cutting shot.

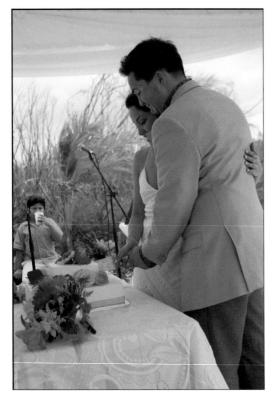

Figure 12-4: This is a good example of how not to do it. The bride is almost always the prime focus of any wedding image that she appears in. Take care to get an angle that sets her in the prominent position whenever possible.

As soon as you get the prime spot you can concentrate on getting the right lens for the framing you want and then on setting up your flash. Configuring your flash can be done in several ways. You can create a more even light by bouncing the flash off the roof. However, this method takes a lot of battery power, which requires more recharge time between flashes. The result is that you are much more likely to miss the action if the couple does anything fast, which they almost always do. If there is any cake smashing in faces, or interesting facial expressions, you have to be ready to shoot incredibly fast to catch it. You won't get any second chances. Because of this, I recommend shooting with direct flash for this particular event. Direct flash takes much less power, resulting in fast recharge times. Using a portable power pack for your flash will allow you to bounce and still get fast recharge times.

With direct flash there is a temptation to use slow shutter speeds to get some background light in the exposures as in Figure 12-5. This takes extreme care because this particular event is likely to involve a lot of fast motion — especially if the couple gets carried away with smashing cake in each other's faces. If your shutter speed is below about 1/30th of a second, the fast motion will create an unacceptable amount of ghosting around your subjects.

The prime spot puts you a few feet away from the cake table, which unfortunately opens a gap for smaller people to step in front of you right at the last minute as in Figure 12-6. Figure 12-7 shows what happens when the photographer gets so far around to the bride's side that the groom can hardly be seen.

Figure 12-5: Using a slow shutter speed is likely to create too much ghosting. This image also suffers from not showing enough of the cake to tell what's happening.
28mm, f3.5, 1/8s, 800 ISO

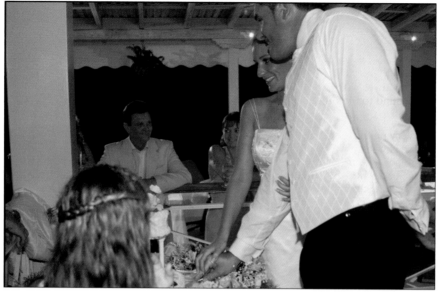

Figure 12-6: This image doesn't tell the story because it was shot from the groom's side, and a little girl stepped in front of the camera at the last minute.

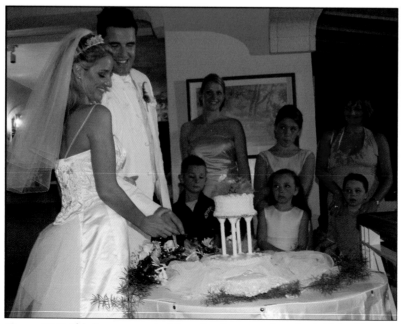

Figure 12-7: This image was shot from too far around on the bride's side.

Capturing the first dance and parent dance

The couple's first dance is an emotional moment that you certainly don't want to miss. The event normally takes place on a dance floor with the entire crowd either seated at the dinner tables or gathered on one side of the dance area. The first time you see the event, your natural reaction may be to shoot pictures from the same location as everyone else in the crowd. However, if you do this, the background to the couple's dancing pictures will be either the band, or a bare wall. In order to get the full story in your images, try moving around to the other side until the crowd becomes the backdrop for the dancing couple.

The first dance is a very personal and emotional moment much like the quiet parts of the ceremony (see Figure 12-8). This is not a good time to put on your wide-angle lens and get out on the floor right next to the couple; this is a good time to give them some space. Shoot with a long lens so that you can stay back on the edge of the floor where you won't attract much attention. This allows the crowd to focus on this very special moment without much distraction from you. As the parents are added in to the dances, you can get a little closer, and by the time the whole dance floor fills up nobody will notice or care what you do.

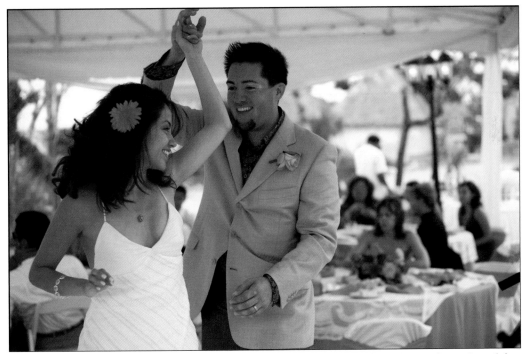

Figure 12-8: The couple's first dance has a lot of potential for showing the action and emotion of the moment.

Capturing the first dance and the parent dances can be done in stages. First, use a wide-angle lens (from a distance) to show a broad view of the whole event. Next, switch to a medium zoom and zoom in close to capture facial expressions. As the dance progresses the couple will turn slowly, giving you new opportunities for a shot every few seconds. It takes a lot of patience to capture good facial expressions on each person, but if you can manage it, as in Figure 12-9 and Figure 12-10, your efforts will be much appreciated.

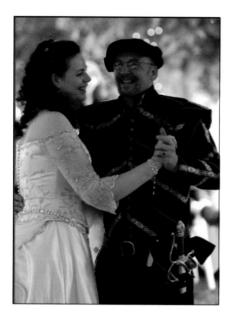

Figure 12-9: Parent-child dances are always emotional and full of smiles.

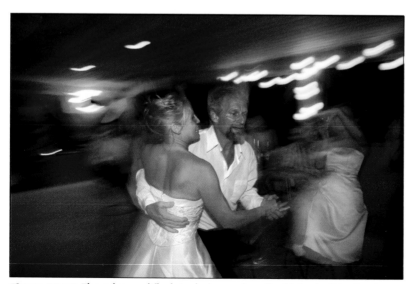

Figure 12-10: The advanced flash techniques described later in this chapter can be put to good use for parent-child dancing pictures.

Bouquet and garter tosses

Technically speaking, the bouquet and garter toss shots are some of the most difficult shots to capture during the entire wedding day. The combination of rapidly moving action, darkness and the fact that the subject is so far separated from the action, make for a very difficult challenge indeed. If you use a single on-camera flash system, the challenges are even greater because the light from your flash can only be properly exposed for one distance at a time.

The light problem can be solved in one of three ways. The complicated method is to use a second flash on a slave to light up the crowd, while your on-camera flash lights up the bride or groom as they throw. The second option is to try to capture the event in several shots. For example, the first shot might be of the bride holding the flowers and looking over her shoulder at the crowd of girls, and the second shot would be of the girls leaping into the air to catch the flowers as they drop from the sky. The third option is to stand off on the side to capture both thrower and catchers in one image. My own personal favorite is the multiple shot technique because it allows me to focus in on one part of the action at a time, without trying to catch it all in one shot. Figures 12-11 through Figure 12-13 are examples of this technique.

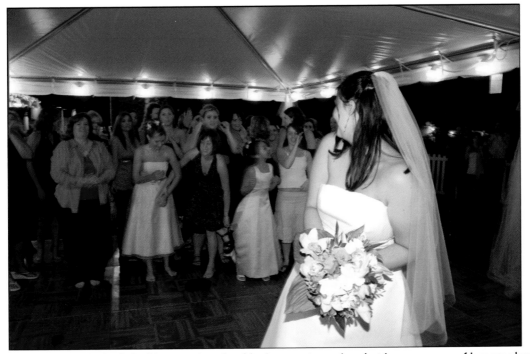

Figure 12-11: The bride looking over her shoulder is a great opening shot in a sequence of images about the bouquet toss.

As with the cake cutting, the bouquet and garter tosses also take place in a matter of seconds. Setting your flash to direct saves your battery power and allows you to shoot several shots in quick succession. Bouncing the light up to the roof limits your shooting speed by increasing the battery recharge time.

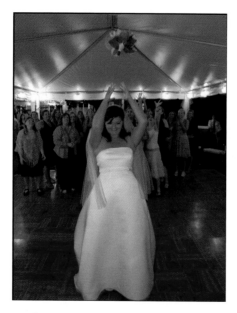

Figure 12-12: The bride throwing the bouquet into the air is the second shot.

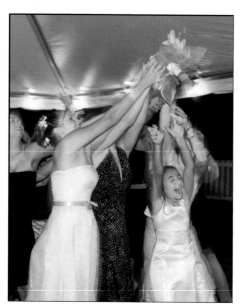

Figure 12-13: The single ladies leaping up after the flowers completes the set.

Timing is everything with this shot, and since there are only two chances to practice this at each wedding, you would do well to practice by having some friends toss a ball back and forth while you try to catch the peak action just before the catch. It takes a lot of practice to get a feel for where you need to start pressing the button to catch an object in the air. Ideally you want to catch the garter or flowers as they are just about a foot out in front of the catch as in Figure 12-14.

This point is the peak of the action but it's definitely not the end of the action. As the catch is made you can quickly move in close just in case anything interesting happens. Occasionally you may see two people grab on at the same time and a mini wrestling match breaks out. You may get a pack of guys rolling around on the ground trying to get control of the garter, or several ladies ripping the bouquet apart amid a shower of flower petals.

If you can find a few minutes to talk with your bridal couple before these events take place, you might spare them some of the troubles that are almost standard for this event. The first and most common mishap is that the bride throws her bouquet up and hits either a light fixture or the ceiling and it falls down before the bridesmaids can get it. The second most common mishap is that the groom thinks he can throw the garter twenty or thirty feet but the garter is so light and fluffy that it only goes half that distance. Talk to the groom about throwing hard and make some suggestions to the bride for places with a high ceiling that won't obstruct the flight of the bouquet.

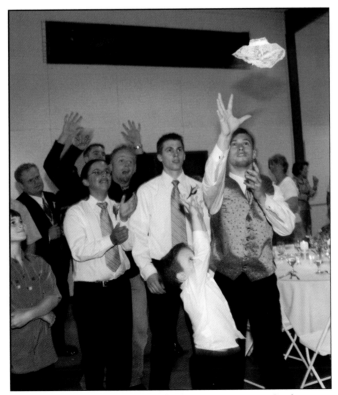

Figure 12-14: Peak action for the bouquet or garter is about a foot away from the catcher's hands.

Signing the wedding license

The signing process usually takes place right after the ceremony and the participants frequently forget to invite the photographer. The officiant often quietly pulls the bride and groom aside to sign the documents and if you don't happen to be paying attention, you can miss the whole process. Talk to the officiant in advance so that you don't get left out for this important moment. If possible, scout out a location for the signing and set up the table yourself so that you can have a bit more control over where it is and what light you have to deal with. You want to avoid having the minister pick a spot as in Figure 12-15.

Figure 12-16 shows a typical signing shot including a good view of all the participants and the document. Try to discourage the bride from bending over to sign the documents. Find her a chair to sit in while she signs and you won't have to worry about this.

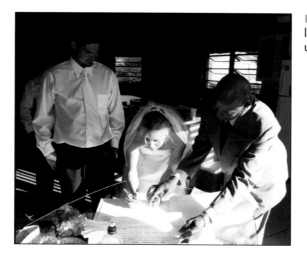

Figure 12-15: If you let the minister pick the location for document signing, you may end up with awful light like this.

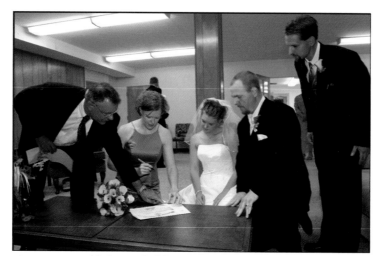

Figure 12-16: This is a typical license signing shot with all participants and the document clearly visible.

Advanced Flash Techniques

The normal technique for properly using your flash is to hold your camera steady and push the shutter button slowly so as not to add extra camera shake. However, as the night wears on and you feel you've got enough sharply focused images to satisfy your obligation to document the event, you can finally afford to do a little experimenting. If you slow your shutter speed down into the range of 1 to 1/10th of a second, you open up a whole new world of creative flash possibilities.

The techniques described here help you create some wonderful effects with light streaks and blur. These techniques have a few basic concepts that are vital to your understanding of how the light is recording in your camera.

✦ A flash is such a short burst of light that it essentially freezes the subject. If there is no other light, the flash will create a sharply frozen subject no matter how long the shutter stays open.

✦ Background lights that are behind the subject appear to burn through the subject if the subject moves out of the way during the exposure.

✦ When you move the camera, the lights appear as streaks that move in the opposite direction on the image. For example, move the camera down and the light streaks go up on the image.

Equipment setup

With these three basic concepts in mind you can start to explore the world of slow shutter speeds. Set your camera on Manual mode and set the flash for direct light (pointing forward). The flash works fine on either the TTL or Auto setting.

Now set your shutter speed and ISO to settings that get a pleasing amount of background light. The typical camera setting in a reception hall is something like 400 ISO at 1/20th of a second or 200 ISO at 1/10th of a second.

Techniques

The following two techniques have evolved from many happy mistakes and much experimentation. These images can be a fun and very wonderful addition to your wedding work, but they are so unpredictable that you should only attempt them *after* you have already gotten plenty of sharply focused images to satisfy your client.

The number one killer of great dancing pictures is a glaring light that burns through from the background and obliterates part of your subject. As you experiment with the following techniques, always be on the lookout for where the background lights are, and try to keep them from being behind your subject. If you get a light behind your subject, it will appear to burn right through the person, usually resulting in a ruined image.

The twirl

The first technique involves twirling the camera in front of you as you press the shutter. I like to start with the camera held out in front of me and tilted around to the side at about a forty-five degree angle. As I rotate the camera and flash back towards the normal upright position, I press the shutter roughly at the point where it passes the normal vertical camera position. You don't need to spin it very fast to get a good effect. You also don't need to spin it very far. As you get some practice you find that a very short spin works just fine. After you find a comfortable speed at which to spin the camera, you then need to experiment to find a shutter speed that creates just the right amount of blur. Every person has a slightly different rate of spin that feels comfortable to them. To start off, try a shutter speed around 1/4 second. After you settle on a shutter speed, adjust the ISO until you have a pleasing amount of light in the background. The ISO setting needs to be changed for different rooms with different levels of light, but the shutter speeds needed to create this effect are the same anywhere you go. Figures 12-17 through Figure 12-19 are examples of spinning the camera.

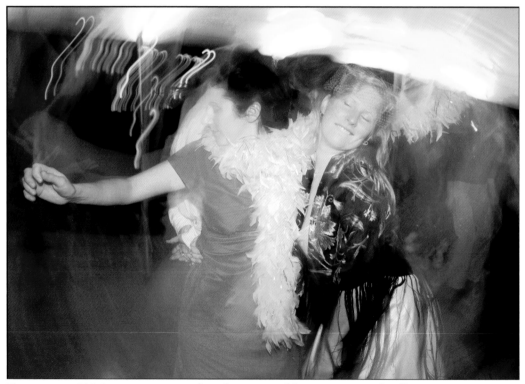

Figure 12-17: This image uses a very slow shutter speed for an extreme spin effect.
18mm, f4.8, 1/3rd, 400 ISO

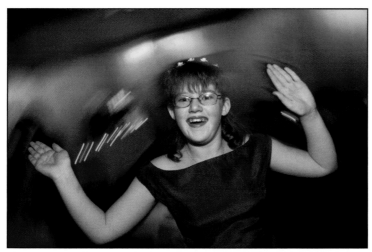

Figure 12-18: If you can find someone willing to dance for the camera, you get a perfect opportunity to experiment with this technique.
18mm, f4, 1/2, 400 ISO

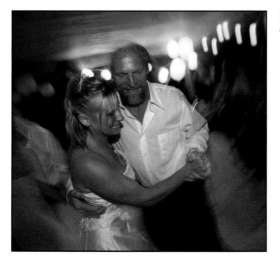

Figure 12-19: This image has a very mild amount of spin that is limited by the faster shutter speed.
17mm, f4, 1/8th, 1250 ISO

Panning

Panning means to follow a moving subject with your camera. When done properly, the background blurs and the subject stays relatively sharp. The blurred background creates a very convincing feel of motion in a still picture. This is my favorite technique to use with dancing people. In order to use this technique at all you have to find a subject that is moving with a predictable sideways motion.

To prepare your camera, set your flash, ISO, and shutter speed the same as for the twirling technique, direct flash, 1/4 second, ISO (depends on the room light). The difference is that this time you move the

camera and perhaps even yourself so that you match the motion of your subject. Sometimes you can do this by staying in one place and rotating your body as the subject moves past you. You can also try moving your whole body along with the dancers. Figures 12-20 through Figure 12-22 are examples of this technique.

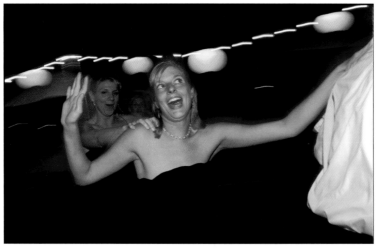

Figure 12-20: Thankfully some people are just natural hams and they have to do something for the camera every time they come by. Recognize and memorize these people early so that you can be ready when they come your way.
17mm, f5, 1/6th, 400 ISO

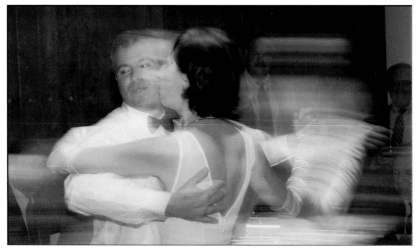

Figure 12-21: Slow panning works well to create a sense of movement in a dancing picture.
56mm, f4, 1/4th, 400 ISO

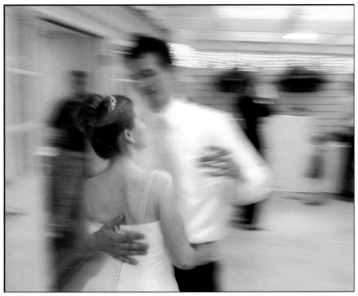

Figure 12-22: These techniques can be used in the daytime as well. Just turn off the flash and set your aperture to f16 or f22, which then requires a slow shutter speed in order to get a proper exposure.
20mm, f16, 1/8th, 100 ISO

Reception Advice to Give the Bride

Most brides and even most coordinators have little or no idea about how to decorate for the camera. They arrange the room to please their own eyes with no consideration for how it will all look in pictures. The following are some tips that you can pass on to help them make their own pictures look better. This impacts you as well by making it much easier for you to get great images, which will increase your sales and add to your portfolio. This info is reprinted from my Web site `www.aperturephotographics.com`, and I highly recommend that you add similar educational materials to your own site. Educating your customers can make your job easier and your pictures better.

Light the reception carefully

Personally I do not like having a black background for dancing photos. A little bit of light in the background makes a huge difference. Christmas lights, hanging bulbs and rope lights all look good in the background, especially if you hang them just above head high. If the reception is outdoors, placing your dance floor under a tent will make a world of difference because the photographers can bounce the flash up into the tent roof and make a much more even light than what you would get with direct flash. A tent also gives you a structure to hang the small lights in the roof, which create a mellow warm background light. Trees are also great for hanging lights and small jars with candles inside.

Continued

Continued

Strobe lights

If you hire a DJ who uses moving strobe lights on the dance floor, every place where the lights hit will be much brighter than the rest of the image. These lights are usually moving rapidly making it impossible for the photographer to calculate them into the exposure. This ruins many of the dancing photos unless you shoot with a fast shutter speed to cut out the disco lights. The bad news is that if you shoot with a fast shutter speed, you also cut out the light from the background and you end up with a black pit behind your subjects. It's always preferable to get some room light showing in the background by using slower shutter speeds, so if you can have the DJ cut the disco lights down low, or use constant colored lights that don't move, that would be a big help. Lights that throw colors or patterns on the wall or roof are great, but ideally you would not let them hit the crowd. The best way to handle disco lights is to get on the opposite side of the dance floor and shoot toward the lights. This allows the lights to be prominent in the image, but they don't affect your exposure because they only hit the backs of your subjects.

Don't rush through the flower and garter toss

Take a few minutes to play with your crowd. This gives us time to get a shot of you holding the flowers and looking back over your shoulder at all the gang getting lined up. Before you throw, I recommend chasing off all the little kids because they are quick little rascals and they will almost always beat your bridesmaids and friends out of the flowers. Now look up and make sure you don't have anything low like lights and ceiling fans that are going to intercept your flowers before they get to the crowd.

Do-over

When you throw the garter or flowers, be ready to call for a do-over if it doesn't go as planned. I've seen it go wrong many times. One time I was standing beside the groom and he somehow managed to turn far enough around to shoot me in the back of the head with the garter, then it fell to the ground and a little kid grabbed it and ran off. If something strange like that happens, please call for a do-over and try it again.

Dance to the photographer

During the formal dances like the first dance or the father daughter dance, you should try to ignore us completely. However, later in the evening when we come around to shoot some fun dancing shots, it would be wonderful if you and your wedding party would occasionally turn and dance facing towards us. Otherwise we get a lot of dancing pictures with your backside showing. Don't worry about doing this all evening, but once in a while, if you just turn and show off for the camera a little, the pictures usually turn out really good.

Other Reception Images

The "must-have" images are certainly important but they are by no means the only events you can photograph during the reception. There are toasts, people singing songs, cigar smoking, children playing, and lots of opportunities for candid images of guests interacting. The bride will also certainly appreciate a few shots showing all the tiny decorations that she created just for this day. The best time to capture many of these images will be in the early evening before the guests fill the room. You can get a shot of the place settings, the cake table, the bar, and the food. You will also want to be sure to capture any people that do readings or play music. Toasts are almost always a part of the reception and occasionally you will have people approach the mic carrying several typed pages of things they want to embarrass the bride and groom with. On these occasions, take a shot or two of the speaker and then find a good angle to get the bride and groom because there will almost certainly be a lot of laughing, and perhaps even a few tears. Figures 12-23 through 12-27 show some typical images that might be created throughout the evening.

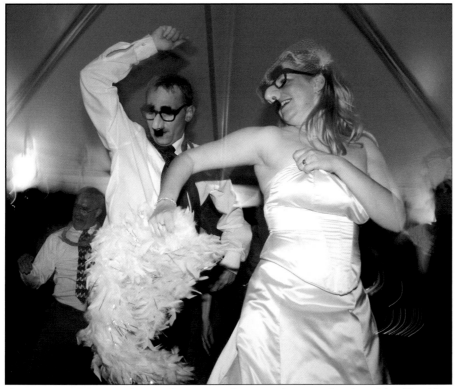

Figure 12-23: You never know what you might see at the reception, but sights like this don't come along very often.
18mm, f5, 1/6th, 400 ISO

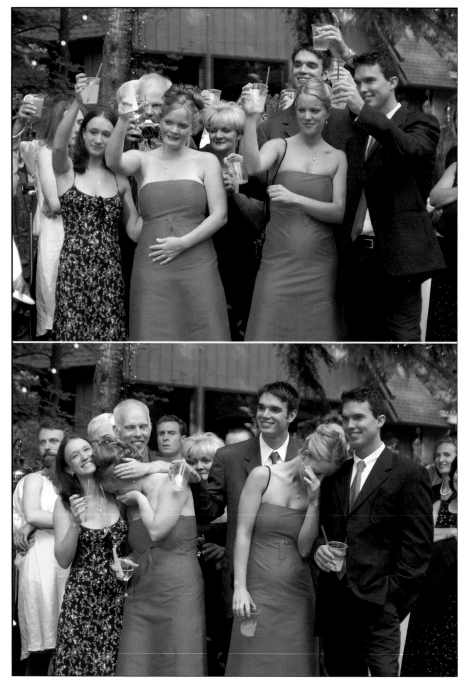

Figure 12-24: Toasting the bride and groom is always an emotional moment. Keep an eye on the crowd as many of the best scenes are away from the main action.
75mm, f4.5, 1/180th, 400 ISO

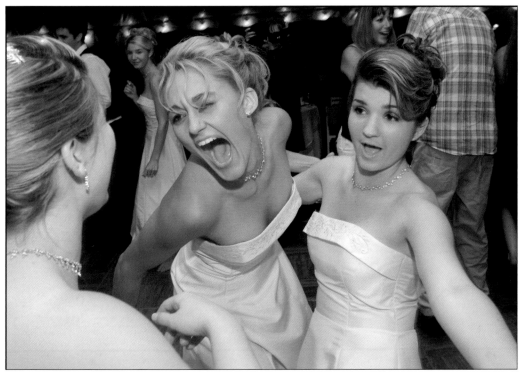

Figure 12-25: The even lighting in this image is created by bouncing the flash up into the top of the reception tent. A small reflector on the flash head acts to direct some of the light straight forward while the main portion goes up and bounces off the roof to light the whole room.
17mm, f5.6, 1/16th, 400 ISO

Drinking Alcohol at a Wedding

You will almost always be offered alcohol at a wedding. The guests will typically be drinking (sometimes too much) and it is tradition to offer everyone in the room a drink, including the photographer. Should you take it? The risk is that if something goes bad with the pictures someone is certain to bring up the fact that you were drinking and that would only make the situation worse. If someone gets mad at you for any reason, one drink may quickly be translated into, "your photographer was drunk!"

When someone offers me a drink early in the day (which they always do) I tell them that I have to try to keep everything in focus right now, but I'll be happy to join them for a drink later in the evening. And then later in the evening when I've got all the dancing shots I really need and I know there will be few demands on my skills anyway, I do have a drink.

I once witnessed a scene where the DJ got drunk and was out on the dance floor groping the maid of honor while guzzling beer out of a full pitcher. I'm sure you won't be surprised to hear that I've never seen that guy again.

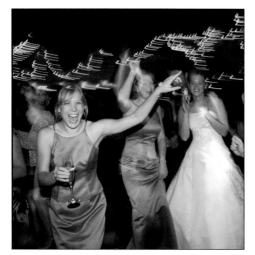

Figure 12-26: Despite the extremely slow shutter speed, the subject of this image appears frozen by the flash. The green blurry spots are caused by the DJ's disco lights hitting random spots on the guests. *18mm, f3.5, 1/8th, 400 ISO*

Figure 12-27: A cake portrait is much more interesting if you can add a human element. Sometimes you can even catch the bride and groom in the background. *17mm, f3.5, 1/500th, 400 ISO*

Summary

The reception is both an enjoyable and challenging time of the wedding day. With the tips you gain in this chapter you should have no trouble getting into position for each of the must-have shots and then framing them to tell the whole story.

The advanced flash techniques discussed in this chapter are so much fun to experiment with that you may find yourself staying at the reception far later into the night than ever before. As you get familiar with these techniques, the wild effects they produce will increase your sales and add a tremendous amount of spice to your portfolio.

13 Destination Weddings

By some estimates, as many as 10 percent of all weddings take place outside of the couple's home area, and many of those are even out of the couple's home country. This small but growing segment of the wedding population is also among the wealthiest of all potential clients out there. They travel to exotic locations and put on lavish ceremonies for their guests. They certainly don't want to miss out on the unique photo opportunities that this sort of wedding presents. In fact, all the extra work and money they put into the event seems to make them that much more concerned with finding just the right photographer to capture the images and preserve the event in a way that they will enjoy showing off for years to come.

The very nature of a destination wedding requires that everyone must travel from somewhere to get to the event, so when a couple starts looking for a photographer, it really doesn't matter if that photographer lives just down the street from them or on another continent. This fact, combined with the worldwide shopping potential of the Internet, opens up the search for photographers to include a large portion of the globe.

Destination wedding couples are computer-savvy people, and they typically feel very comfortable functioning in a high-tech world. They sit in front of their computers for hours at a time, seeking out and comparing the absolute best photographers. If they find someone whose style matches what they want, they won't hesitate to make all the arrangements over the phone and via e-mail without actually meeting the photographer in person.

This chapter discusses options for marketing yourself to these clients, pricing the job, choosing the right equipment for travel, and getting there and back in one piece.

Reality Check

For many wedding photographers, the dream of shooting a destination wedding ranks right up there with shooting a celebrity wedding. Shooting a destination celebrity wedding — well, that would just be it!

Is the reality as good as the dream? In some aspects it is, but other aspects weigh heavily against the fantasy of shooting destination weddings. For example, walking all day on a deserted beach in the Bahamas in December can seem like quite a treat. However, eventually you have to leave that peaceful world and dive into the world of transportation, where you get to experience the joys of getting stranded in airports with overbooked flights; bumping from one standby flight to the next; eating nasty airport food because you have no choice; getting a courtesy room at a hotel at 2 a.m. because of the missed flights, only to find you're checked in at the Roach Motel with no running water and couples having loud sex in the rooms next to yours all night long; getting the wake-up call two hours later and not being able to remember whether you're in L.A. or Miami but remembering that you have to get halfway around the globe today or you'll miss the next wedding tomorrow.

So you catch a cab back to the airport for another day of standing in long security lines, where you unpack the backpack, pull out the laptop, take off the shoes, stand still while they rub you all over with some sort of metal detector, then put it all back together. Sitting on the airplane, you once again try to suppress your secret fear that the wings may fall off at any moment leaving your child to grow up without a father…Yikes! Snap out of it! Try to sleep while you sit upright in a small chair for four hours without getting up except to use the restroom.

Upon landing, you get off the plane and run a mile through a crowded airport to the next terminal dragging all your photography gear behind you. Once there you pass through more security checks — unpack the backpack, pull out the laptop, take off the shoes, stand still and spread your arms out for the metal detector, then put it all back together again only to get back on another flight. The fears nag at you again as the plane bounces wildly up and down and sways side to side in a little patch of turbulence. You sit there for eight hours this time without getting up except to use the restroom. When you finally get off and find your baggage (you hope), you try to slide through customs without attracting too much attention.

If they do decide to search you, be prepared to hand over a substantial wad of cash to the nice man who is offering to hold your camera for you until you leave the country, then you head outside to deal with cab drivers that pretend not to speak English so they can charge you twice the normal fare without bargaining, then hope you survive the cab ride because your driver is secretly practicing for the Indy 500. Finally, you stumble out of the cab into paradise! After downing a piña colada with a double shot of rum you start

to feel better. The shimmering water, the warm sun, and the coral sand between your toes all slowly melt away the strangeness of the past two days. Just try to enjoy it without thinking about the trip back home.

How to Find the Jobs

Landing your first destination wedding job is not something you should be too concerned about when you first start off in the business of wedding photography. However, as your skills grow and you gain the experience and talent necessary to compete in the market, you will start to catch the attention of a few destination brides.

You have basically four different sources for finding these jobs. The first is, of course, blind luck. Occasionally you will shoot a wedding for one person who absolutely loves your work and her sister remembers you when she plans her wedding. Of course, the second sister has to outdo the first, and before you know it, you're packing up for your first destination wedding.

The other three sources of jobs are your Web site, coordinators, and paid advertising. These sources are much more reliable, and they have the ability to supply a steady flow of potential customers.

Your Web site

Building a Web site is only the first of many steps to being found by destination brides. Simply having a Web site won't get you very far no matter how incredible it is, however. You have to know how to market that Web site so that you are found when someone searches for the place you want to work. For example, if you want to work in New York City, design your Web site so that when a bride goes to one of the big three search engines (Google.com, Yahoo.com, or MSN.com) and types a search phrase, such as "New York wedding photographer" your Web site appears on either the first or second page. Occasionally a bride will look through to the third or fourth page, but if your Web site doesn't appear until Page 5 or later, for all practical purposes, you don't exist! It's a bit like making business cards and then never handing them out. Your Web site is worthless if nobody can find it.

To get to the top of the list, do some research on the topic of Search Engine Optimization, or SEO, as it is commonly called. This is the science of creating a Web page so that the search engines not only find it, but when they do find it, you've got all the parts in place for that particular search engine to use as it determines whether your page will show up at position number one or number 500. If you don't want to spend the time it takes to learn all about SEO, you can hire an expert in the field to analyze your Web site and make recommendations about what you need to change to increase your chances of getting to the top of the list. You can easily find such a person by searching Google for "SEO consulting."

If you concentrate on other types of advertising, such as working with coordinators and wedding locations, or purchasing ad space in magazines, then you can use your Web site as a portfolio without trying to make it show up in the search engines. In this case, a potential client finds out about you from some other source and then goes home to look your site up on the computer.

In any case, having a well-designed Web site with lots of great images is the key to convincing brides to spend the money to fly you to some far-away place and pay all your expenses. If you want some ideas on designing your Website specifically for destination weddings, you can check out my own site at www.aperturephotographics.com. In 2004, I redesigned the site (see Figure 13-1) specifically to attract destination weddings. So far this year, that Web site has managed to land me 22 weddings outside the U.S., eight more scattered around the U.S., and another eight in my home state of Oregon. Chapter 14 discusses Web sites in more detail.

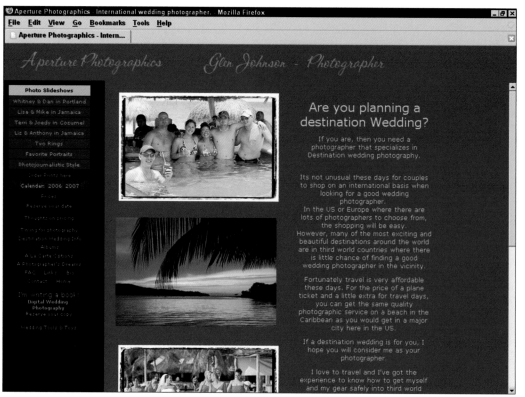

Figure 13-1: Web sites are great advertising tools for wedding photographers.

Coordinators

Your Web site is only one aspect of a good Internet marketing plan. After you have a Web site, you have to start telling people how to find it by passing out information about yourself that can lead potential clients to your site. You can spread the word about your Web site in many places, but the source brides trust the most is a good coordinator. These people make it their job to know everything there is to know about planning a wedding, and they are hired to take over the job for brides that have more money than time. Many coordinators are responsible for finding and hiring all the vendors that work on the wedding. If you are hired for one of these events, you may never even talk with the bride until the day of the wedding because all planning is done through the coordinator.

If you manage to get in good with a high-end wedding coordinator, you can count on a steady flow of new clients. Most of these relationships start by accident when you happen to get hired by a bride that is also hiring a coordinator. As you work together with the coordinator on this first wedding, the coordinator gets a sense of your personality, and then after the wedding when you send her a slide show or a small album, she knows that you can be counted on to produce good work. Every time you impress a coordinator it can then turn into multiple jobs in the future.

Many coordinators can be contacted through their own Web sites. If you can manage to talk them into visiting your Web site and looking through your portfolio, you may be able to get jobs without meeting them first in person. However, there are thousands of good photographers in the world, and coordinators know very well that it is your personality and your professionalism that make you stand out from the crowd. Coordinators will be looking for an outstanding portfolio, but they also want to see a good business structure with a solid contract and a very professional attitude. These are details a bride might not care so much about, but a coordinator is much more business oriented than the average bride.

If a coordinator finds a job for you, it is not at all unreasonable for you to voluntarily send him or her a little "thank you" in the sum of 5-10 percent of your profit. This money may or may not be required but if you pay it voluntarily, as a gift of course, you can bet that you will be on top of the list next time around.

With some coordinators, and particularly those that work for big hotels, the kickback is a required part of the partnership, and they may even stipulate it in a contract. I've always thought it mildly amusing that they want 10 percent of the photographer's $3,000 profit, but would they pay 10 percent of their $50,000 profit if you sent a wedding to them?

Advertising

Destination brides need information! These ladies must do all their planning through magazines and Web sites using only phone calls and e-mail to contact the vendors. They want to know about locations, coordinators, bands, photographers, catering, dresses, and all sorts of other details. Fortunately most of these magazines and Web sites will also sell you ad space.

Web

The two most prominent Web sites that brides look to for general information are `www.theknot.com` and `www.weddingchannel.com`. Both of these sites sell ad space for photographers at a very reasonable rate, which you can easily recoup in your first sale. My favorite feature of these Web sites is called a discussion board. This is where a bride goes to post a question to thousands of other brides. You can get on there yourself and look but don't dare make comments or you'll be blackballed because vendors are generally not allowed. What you can do is ask your current brides to post a good reference about you on one of these boards. This can be an incredible source for new business. All it takes is one talkative bride to get new jobs flowing in from all over the world. This also works in reverse: If you make a bride angry she can put a huge long-term dent in your business by posting her story on a couple of discussion boards.

Magazine

There is not a shortage of bridal magazines on the bookstore shelves today. Many brides go through five or six magazines a month as they plan their wedding. Magazines are a great place to spend your advertising dollars if you want to do destination weddings. Most of these magazines gladly sell you as much space as you can afford — which may not be much at the rates they charge. However, even at the outrageous rates, it would be hard for you to not make money with this sort of advertising. The thing to remember with magazine advertising is that it is a long-term endeavor. You won't land many new clients on the first few times around but if you can maintain a steady campaign of continual ads, you will eventually build up some name recognition. The best magazine that caters specifically to the destination bride is *Destination Weddings and Honeymoons*. This is a great source for finding contacts that you can send a portfolio to, as well as a great place to purchase ad space.

You can occasionally get free space by sending in a selection of pictures from one of your weddings for the "Real Weddings" section. This is a regular section of most bridal magazines that features two or three real weddings with pictures and text telling all about the details of the wedding. This coverage may not feature your name very prominently but it gets you out there for free, and any bride that wants to find you after seeing the pictures can do so.

Travel Arrangements

The physical act of getting there and back is sometimes the most adventurous part of a destination wedding. There are airplanes, buses, taxis, and rental cars to get you where you're going. You have to learn how to use them all and when to use each one. The following are some tips and techniques for traveling to your next destination wedding.

Airline travel tips

Working as a destination photographer also means working as a travel agent. You may eventually decide you want to hire a travel agent to take care of the details, but even then you need to know how to arrange your own travel in case emergencies pop up. You need to develop the skills necessary to find tickets, order tickets, and change tickets. Much of this job can be done through the Internet, but often the Internet is not the best way to go. The following is a collection of tips and techniques that I've gained while organizing my own travel over the past few years.

The main Web sites for airline travel arrangements are `www.Orbitz.com`, `www.Expedia.com` and `www.Travelocity.com`. Travelocity tends to have the worst prices, so I rarely use it. Expedia works great for normal tickets within the U.S., where you go straight out to one destination and then straight back home. Orbitz works much better than the others if you have complex travel plans that involve multiple countries or travels that require stopping overnight and then continuing on the next day. The online trip finder at Orbitz brings up hundreds of flight combinations to get you where you need to go. You can look through the selections and choose your favorite single flights, or you can choose a whole package of flights.

For a really complex flight, what seems to work best for me is to use the Orbitz Web site to see what flights are available at the times I want. As I find each flight segment that works, I copy the details from the Orbitz site and paste them into a text document. When I get the whole potential itinerary together, I call an agent at my favorite airline, American Airlines, and he or she puts it all together in a finished itinerary. After you purchase your ticket, make sure to get a receipt via e-mail and check it thoroughly for mistakes. If you said Aspen and the ticket agent thought you said Austin, this is the time to catch the mistake. If you happen to be purchasing a ticket for two or more different locations, it is much better to talk with an actual person at one of the airlines. This person can make sure your tickets work without any overlapping times, and he or she can find the best rates — often far better than what you can find on your own with the Internet.

You can cancel or change a ticket within the first 24 hours and there is no fee.

When you make a reservation with a ticket agent, be sure to get the name and direct phone number so that you can get back in contact with this same person again if there is a mistake on the ticket.

When you call an airline sales desk, make sure you get a person on the line that you can understand. Many of the airline ticket agents are international, and they speak your language with a very heavy

accent that may make it difficult for you to understand. When this happens, simply request to be transferred to a different agent until you get someone that you can understand.

Smaller airlines are not as reliable as the major players when it comes to keeping on schedule. The price may look better, but a half-hour delay could cause you to miss all your connecting flights. This might not be a big deal if you're just headed home, but if you have another wedding to shoot the next day, you really don't want to get stuck in the airport. Stick with the major airlines when you have a tight schedule.

Missing one flight at the beginning of a long trip may cause you to miss all the others as well. The airlines will generally accommodate you and keep you moving without making you buy new tickets (unless it was your fault that you missed it), but you will not get first priority on the next flight. Instead, you get bumped into the world of "standby," which means that you can get on the next flight with an empty seat. They give you a list of each flight that goes to your destination that day and you walk from one gate to the next until eventually, hopefully, one of the flights has an empty seat. If the flights are packed, they buy you a hotel room (if it was their fault), and it all starts again at 4 a.m. the next day.

If your flight is overbooked, don't take an offer to give up your seat unless you have several days to spend in the airport. The airlines will offer you money and swear to you that there is another flight leaving in a few minutes, but what they don't say is that as soon as you get out of line, you go into standby status, so if the other flights are also overbooked, you don't get on. If this happens during a major holiday or spring break, you could be there for days, walking from plane to plane without finding an empty seat.

Wait until about three months before the date of the wedding before purchasing your tickets. There are two reasons for this. One is that if you make a reservation six months in advance, you may get another booking that requires you to change your first ticket in order to accommodate the second wedding. Changing tickets costs you at least $100 and occasionally you have to forfeit the original ticket completely and start over. The second reason for booking three months in advance is that this is the best time for low prices. The airlines wait until the date gets close before they make the best ticket rates available.

Taxi travel tips

Make sure to negotiate your taxi rate with the driver *before* you get in the taxi. The reason for this is that in many places tourists are frequent targets of inflated taxi prices. The drivers know that if there is a long line of taxis parked in a row, they have to give you a competitive price or you can just walk down to the next one. However, if you get in and take off without talking price, you just lost your ability to negotiate. The driver can pretty much make up any rate he wants, and you can't say anything about it. What are you going to do, get out and walk?

Never pay your taxi driver until you get there. This gives you a bit of extra bargaining power for drivers that do things you might not like, such as driving crazy, blasting the radio, or stopping to buy groceries on the way to your hotel. If you threaten to not pay, you can usually get your trip to go the way you want.

Bus travel tips

In many developing countries, the bus is by far the cheapest and safest way to travel, although at first it may be difficult to find. As you arrive in a new place and begin to exit the airport, you will typically be accosted by a hungry mob of taxi drivers waiting to catch you as you come off the plane. You can certainly hire one of the helpful gentlemen to take you where you want to go, and if you happen to be in a hurry, they will definitely be your best bet. If you're not in a big hurry, the bus can save you a lot of money.

Don't bother asking a taxi driver where the public bus is because he'll just swear that it doesn't exist. If you can find a person who lives in the area, he or she will gladly direct you to the public bus, which is usually parked somewhere close by. These buses will take you to the same places, at a slightly slower pace, and at a fraction of the cost compared to a taxi or tour van. Many countries in the Caribbean have a medium-sized bus called a Jitney that serves as the normal mode of transportation for all the locals.

Health Issues

Health concerns should be high on the priority of the traveling wedding photographer. Not only do you have your health to worry about, but you have an obligation to your clients to show up. If you catch any of the thousands of ailments out there that can endanger your health, missing a wedding might be the least of your worries.

Travelers' diarrhea

Travelers' diarrhea is a major concern for the wedding photographer. This common condition is rarely dangerous, but it makes you very uncomfortable for three to five days. There are roughly 20 different germs that can cause this ailment; most of them are easily acquired through food and drinks that are prepared with little or no hygiene. The easiest way to avoid it is to drink bottled water and don't consume the local water in any form. This includes brushing your teeth with the local water, eating salads washed in it, drinking drinks with ice, and so on. Be particularly aware of this at least until after the wedding is over. Wash your hands and eat only well-cooked foods. If you think you might be in a really remote area, take along an iodine water purification kit. Find out more at www.traveldoctor.co.uk.

Travelers' diarrhea is normally self-limiting, and if you get it you should be back to normal within a few days without any treatment other than drinking lots of water to combat dehydration. However, as a wedding photographer you may not be able to wait that long. If you do find yourself with this condition, be prepared with an anti motility drug that slows the diarrhea, thus retaining water and allowing your body to function semi-normally for a while so that you can work — sort of. Imodium is one common brand name for this type of drug.

Dangerous critters

If you are the more adventurous type and you decide to go trekking around in the countryside (which I highly recommend), you should also check with the locals to get a rundown on all the dangerous critters to watch out for. You should have some idea about local wildlife, such as snakes, spiders, scorpions, centipedes, ants, bees, and plants that can hurt or even kill you. On my own travels, I've run into a brown spider as big as the palm of my hand in the jungle on the north shore of Kauai, an 11-inch centipede that didn't seem at all frightened of me on Crooked Island in the Bahamas, and in Barbados, we found a plant that causes severe skin rashes if you touch it or if rainwater drips off of it onto you. Moray eels and fire corals abound in all Caribbean snorkeling areas, and it is not at all unusual to look up from your snorkeling and see a six-foot Barracuda circling around to check you out. And in pretty much every warm place on the planet, you have to watch out for the ever-present mosquito. Malaria is still a concern in many destination wedding locations (especially Haiti and the Dominican Republic), and you need to know this before you go because you have to start taking the drugs before you get malaria — not after. Find specifics about your destination at www.cdc.gov.

Vaccinations

Before you travel to any other country, check out the destination with a good travel doctor to see what sort of vaccinations you may need. You need to keep updated on tetanus but there are also many other strange diseases for which you may need shots. The best Web site to check for disease-related dangers is www.cdc.gov.

Make sure that your own normal vaccinations are up-to-date and never travel out of the U.S. with an unvaccinated child. If you have an unvaccinated child at home, you should also be very careful to clean yourself and your clothing before coming into contact with this person. There are many diseases in a third-world destination that will gladly hitch a ride home on you or in you.

International Travel Paperwork

As a photographer traveling the world with a lot of expensive photo gear, dealing with border crossing officials can be one of the most frustrating parts of the entire experience. Every country you visit has a different set of regulations for border crossings and for acquiring a legal work permit. Some countries may be very relaxed about enforcing these laws while other countries may be extremely rigid. The amount of enforcement you encounter also depends on the personality and the mood of the particular officer you happen to run into that day.

Every country has a legal requirement that you obtain a work permit (or business visa) before performing any professional services in that country. However, the fact that most third-world countries have Web sites that are minimal at best, can make it very difficult to find out how to comply with the legal work requirements. Your best bet is to look on the Web site for the country you are interested in and find the phone number for the Customs and Immigration office in that country. It is very doubtful that the Web site has a section dealing with traveling photographers because there simply aren't that many of us around. Call the country to ask about what paperwork you need.

Do you really need to do all that just to shoot a wedding? Legally, yes! If you try to slip around the laws and you get caught, you might end up in jail or sitting on an airplane after having all your equipment confiscated. The possibilities are serious enough that you would do best to call the customs agent for the country you are visiting several months in advance and make sure you have all the necessary paperwork completed before you leave home.

Crossing U.S. borders

U.S. customs law says that if you carry commercial equipment across the border and you want to return with it, you need to register it before leaving; otherwise, it could be subjected to duty as "new" equipment upon reentry to the U.S. There are various options as to how it can be registered, but the easiest and least expensive method which will get you in and out of the U.S. is a simple form. On the U.S. Customs and Border Protection Web site (www.cbp.gov/xp/cgov/toolbox/forms) are forms 4457 and 4455. These two forms allow you to declare a list of equipment to the customs office before you exit the U.S. Form 4457 is for personal effects and perhaps a small list of gear. Form 4455 is for a larger list of gear, and you are allowed to attach an inventory list to this document. Form 4455 also works for any associate photographers or assistants that travel with your company equipment. The main difference is that you can keep 4457 and use it over and over, while form 4455 may be collected as you reenter the U.S. If you save a copy of form 4455 on your computer you can print it every time you need to travel.

Form 4457 is the most appropriate for a traveling photographer and getting one completed and stamped will only take approximately 30 minutes. You should have your printed equipment list and form in hand when you go through customs upon departure for international travel. If you are attempting to comply with the laws, US Customs officials are extremely helpful.

Crossing international borders

The only internationally accepted document that you can purchase to facilitate the transfer of equipment without paying import duties on it is called a *carnet*. Purchasing a carnet is generally considered overkill for most wedding photographers. If you carry a very large amount of gear, and if you travel frequently in European countries, perhaps you could benefit from the carnet system. If you travel mostly in Caribbean countries, the carnet system will not help you enough to make it worth laying out thousands of dollars for the deposit.

Carnets are "merchandise passports." They are international customs documents that simplify customs procedures for the temporary importation of various types of goods. In the U.S., two types are issued: ATA (for most countries) and TECRO/AIT carnets (for Taiwan).

ATA carnets ease the temporary importation of commercial samples (CS), professional equipment (PE), and goods for exhibitions and fairs (EF). They facilitate international business by avoiding extensive customs procedures, eliminating payment of duties and value-added taxes (minimum 20 percent in Europe, 27 percent in China), and replacing the purchase of temporary import bonds.

The benefits of using a carnet include:

✦ May be used for unlimited exits from and entries into the U.S. and foreign countries (carnets are valid for one year).

✦ Accepted in over 75 countries and territories.

✦ Eliminate value-added taxes (VAT), duties, and the posting of security normally required at the time of importation.

✦ Simplify customs procedures. Carnets allow a temporary exporter to use a single document for all customs transactions, and make arrangements in advance at a predetermined cost.

✦ Facilitate reentry into the U.S. by eliminating the need to register the goods with U.S. Customs at the time of departure.

The disadvantages of using a carnet include:

✦ Costs of $200 to $250 per year (depending on how much gear you carry).

✦ Costs $10 per use (for the papers necessary to enter and exit from each country).

✦ Requires a deposit equal to 40 percent of the entire value of the equipment you are traveling with. Yikes! Of course, this deposit is returned whenever you want as long as you've had no problems with your border crossings. However, coming up with $5,000 to $10,000 that you don't need is no small matter to most photographers.

To apply for an ATA carnet, contact the ATA Carnet Department (a nonprofit organization set up by the U.S. government) at 1212 Avenue of the Americas, New York, NY 10036, or call (866) 786-5625 or (212) 703-5078. The fax number is (212) 944-0012. You can e-mail this office at atacarnet@uscib.org. The West Coast office can be reached at (415) 564-2600.

Case Study

After traveling into Mexico perhaps ten times, I was finally stopped and taxed for having too many cameras. I was unaware of the rule that you can only have one free camera (any value) and another with a value under $400 U.S. dollars. On this one occasion, I somehow managed to jam my little point-and-shoot camera into my carry-on box with all my pro gear and that little camera put me over the two-camera limit, so I had to pay a 15 percent duty on my Canon 20D. I lied and told them the value was only $800 and they charged me $125 to bring it in the country for the rest of the year (if I keep the receipt). If I'd filled out the form 4455 I doubt they would have charged me anything, even though that form is not an official document pertaining to Mexico. If they really cared to press the issue, they could have checked the values of the gear on a Web site and I would have had to pay 15 percent tax on about $14,000, which is what my gear would add up to if you include the laptop computer and everything else I carry. A carnet would have prevented any charge at all. Form 4455 performs the basic function of declaring the items you have when you start so that they can be compared against the list when you return. If you have form 4455, most other countries accept that you are at least attempting to follow the regulations.

Specialized Equipment

If you do more than an occasional destination wedding, you need to travel light. I've whittled down my own gear box to just the essentials listed here. Depending on your style of shooting, you may require more camera gear, and you certainly don't have to travel with the laptop and all the associated computer gear unless you will be gone for extended lengths of time. If you are shooting a single destination wedding, you can easily get by without the laptop by just bringing your CompactFlash memory cards back home (on your person) before downloading them to your home computer.

The carry-on camera case

I personally don't like to trust the airlines with my camera gear, so in order to be able to take it all with me it has to fit in something that conforms to the regulation size dimensions for carry-on luggage. My favorite is the Pelican 1510. This rolling box is the exact maximum dimensions allowed for carry-on luggage. The fact that it rolls on its own wheels and is practically bombproof makes it perfect for protecting your delicate gear on long-distance travels. Other travel cases that are excellent, although not quite so durable, can be found at www.tamrac.com and www.portercase.com.

As tough as these boxes are, I don't recommend checking them on with the regular checked baggage. The results you get with checking your bags simply depend on who is throwing it that day and how good of a shot he or she is because all baggage handlers throw the bags and boxes that get checked on the plane, some of them just miss the pile and suddenly your box is falling ten feet or so to the ground beside the plane. A Pelican box, as shown in Figure 13-2, would survive such a fall, but the G-forces inside the box would still be dangerous for your gear.

Checked baggage

Aside from the normal clothes and snorkeling gear, in my checked baggage I carry things that are not so easily damaged and can be replaced if they are damaged. I always travel with a padded folio with space for 50 CD/DVDs. I fill the pages with blank DVDs before I leave. I also carry a small tripod and a spare flash unit in this bag.

Figure 13-2: A Pelican rolling case is perfect for the traveling photographer.

One other item that I've found to be an essential part of moving around over rough ground is a strap that allows you to attach your camera box to your rolling suitcase so that they both roll as one unit. This greatly increases your ability to move around over short distances as you go from hotel to cab to bus to plane, and so on. You can easily make your own strap for this use. When you do, try to make it just long enough that the two boxes are balanced over the wheels when you walk with them. If the weight is too far forward or back, moving over rough ground is very difficult.

Carry-on camera box

The Pelican 1510 with padded dividers and lid organizer containing the following:

- ✦ Canon 20D and 5D bodies
- ✦ Flash (and a backup in the suitcase)
- ✦ 17-35mm f/4
- ✦ 50mm f/1.4
- ✦ 70-200mm f/2.8 with Image Stabilizer
- ✦ LensBaby with close-up adapter

- ✦ Air blower and other CCD cleaning materials
- ✦ Padded metal case containing memory cards
- ✦ Batteries and battery chargers for camera and flash
- ✦ Tamrac Syncmaster radio slave
- ✦ 120GB USB 2.0 external hard drive
- ✦ Stepdown transformer to convert the 220-volt power to 110 in European destinations
- ✦ Snack bars in case you miss lunch while shooting in the dressing rooms

Carry-on backpack

My backpack holds the most fragile items as well as those that I must keep with me at all times while traveling. In it I pack my laptop, snacks, something to read, and my wallet with passport, tickets, and money.

Laptop

I don't know how I would function as a traveling photographer without my Sony Vaio laptop (VGN FS790P) that contains all business and photo software needed to run my business, upload files to my online storefront, burn DVDs, edit my Web site, create DVD video slide shows, and everything else I need to do to keep things running while I'm away from home for as long as two months at a time. This book would simply not exist were it not for the help of a good laptop. Not only was the text written and formatted entirely on this laptop but I also used it for color correction and Photoshop work on the images as well.

When you travel with a laptop in your backpack, make sure to purchase a padded case to go inside the backpack to protect the laptop from minor bumps and from abrasion against all the other items in your backpack.

Wi-Fi connection

One of the most valuable gadgets I've ever found for staying connected while on the road is the Hawking Wi-Fi signal locator and amplified directional antenna (HWL2 from `www.hawkingtech.com`). This item (see Figure 13-3) is about the size of a cell phone, and when you flip up the antenna and press the button it tells you what types of Wi-Fi signals are within about 1,500 to 2,000 feet in the direction the antenna is pointing. It also tells you if the signals are encrypted or not. Connect it to your computer with the supplied USB 2.0 cord and it becomes an amplified antenna that allows you to log on to signals you could never have detected with the normal built-in laptop antenna. It does this by providing a 5dBi Hi-Gain antenna compared to the 2dBi antenna found on most laptops. Many times when my laptop gave the message "no networks in range" I connected the Hawking antenna and easily logged on to one of several networks that were somewhere in the area. In my hometown, I once walked two miles through a residential area without ever getting out of range of an unsecured wireless connection. In third-world countries, signals are not quite so common but they certainly are out there and you can easily find them with this device.

When detecting wireless signals, the Hi-Gain antenna helps determine exactly where the source of the wireless network is by showing stronger signals at different angles. The HWL2 also uses the power in the USB 2.0 connection to automatically recharge its batteries when connected to a laptop so you never have to worry about replacing the batteries.

Gate-Checking Your Camera Box

When you travel on very small planes there may physically not be enough space inside for you to keep your camera box with you. When this happens, you are required to part with your precious gear just outside the door of the plane. You are generally given a receipt ticket and then your gear is taken to the cargo hold where it is "placed" safely inside. Every time this happens to me, I open the box immediately afterward to make sure none of the contents "accidentally fell out." I've also noticed at least one new large scar or gouge in the box after every one of these trips. This is one of those times that you'd better hope you have a tough camera box. And by all means, tell the person you drop the box off with that the contents are very fragile so that when they throw it, maybe they won't throw it quite so far.

Much of this book and the images in it were uploaded via free signals I found in airports or in the neighborhood around my hotel while traveling to shoot destination weddings. For example, today there is no connection here at my hotel or anywhere in the neighborhood as far as my laptop antenna can detect, but when I go up to the roof and point the Hawking antenna out over downtown Montego Bay, Jamaica, there is a weak signal that I will use to transmit this very chapter and check my e-mail later tonight.

Figure 13-3: A Wi-Fi Locator can locate signals within 500 to 2,000 feet.

Is It a Job or a Vacation?

Every job you do as a wedding photographer has to make money. That is a very simple fact of our existence. Destination weddings may seem at first like they would be so much fun that you might even be tempted to do them for free. Many photographers that are new to the destination wedding business undercharge just to get what seems like a "free ride" to some beautiful and exotic location. After all, going to Hawaii for a wedding sounds like the perfect excuse for a vacation in Hawaii. However, as photographers, we must collectively realize that destination weddings are a growing part of our market, and in the future they are certain to become much more common. With that in mind, the concept of undercharging to get the job has the same effect abroad that it does for wedding photography at home. For example, if you are an established wedding photographer and one of your competitors starts charging a fee so low that they barely break even, you would be knocking on their door to preach at them for devaluing the whole business of wedding photography. Of course, beginners have to start low, but decent photographers should always check the local market to see what everyone else is charging so as not to degrade the business by running prices down. Pricing for destination wedding photography works exactly the same way.

As you can see from looking at the figures in the section "How to Calculate a Fee," you are much better off to pass on a working vacation and just take a real vacation instead. Compare the prices to the fact that you will be gone for at least four days. How much money could you have made if you had stayed home and worked those four days at local weddings and portrait jobs? Assuming that you are open to shooting more than one wedding per weekend, you could probably shoot at least two on a prime weekend. This would make far more money (after expenses) than a destination wedding, without the hassles and dangers of traveling. Combine that with the possibility that you will miss opportunities to contact people for other jobs while you are away. No matter how you price it, you can make more money by shooting a wedding within driving distance from your home than you can on a wedding that requires an airline flight.

If you want to travel to Hawaii for a vacation, instead of shooting a destination wedding, it would make more sense financially to stay home and work during that same amount of time, then put the money toward a real vacation. Then you won't have to deal with fussy brides and you can go wherever you want instead of having to stay near where they want you to be.

Two Reasons to Do Destination Weddings

The first and most common reason is the lure of getting out of your own town to see the world. Some people are content to be where they are, others are always curious to see what's on the other side of the hill no matter how good it is where they are right now. If you happen to fall into the latter category, destination weddings will certainly be attractive to you, and the fact that you will lose money is easily accepted.

The second reason to shoot a destination wedding is if you happen to live in either a remote area or an economically depressed area. For example, a good photographer in New York City could easily charge $6,000-plus for a day of shooting and might gross $10,000 after the couple purchases albums and prints. If that same photographer were to move to a small town in rural America, the number of $6,000 jobs within driving distance would not be enough to survive on. At this point, the price difference has nothing at all to do with the quality of the photographer. Luckily, we live in the age of the Internet, so if you know how to market your Web site, a bride in New York can find your business right in the comfort of her own home. She can also pay you and contact you to make all the necessary arrangements even if you happen to be off shooting a destination wedding in some remote place halfway around the planet. Thanks to the Internet, good photographers are no longer limited by geography. They can live and work anywhere they want.

How to Calculate a Fee

The following rates are based on arriving at the destination one extra day before the wedding. This extra day is a security against the times when you have to deal with getting stranded in the airport. Hopefully this won't happen, and you can spend the extra day scouting locations or just lounging on the beach. The total time necessary to complete a destination wedding includes one full day of traveling, the extra day, the wedding day, and the full day of the trip home. This makes each job a four-day affair at the bare minimum. Although prices listed here are estimated, they are based on my experience and they are typical for most locations. This information gives you some basic guidelines for figuring your own price.

A typical Destination Wedding fee should include:

✦ **$1000:** This covers the airline ticket including two hours to research and book the ticket. (Ticket prices vary widely depending on the season and the location. This arbitrary price is just provided as a sample rate).

✦ **$160:** Food at $40 per day for four days.

✦ **$140:** Car rental at $35 per day for four days.

✦ **$240:** Hotel at $80 per day for four days.

✦ **$400:** Fee for two travel days at $200 per day.

✦ **$150:** Fee for extra day.

The total for travel is approximately $2,090, plus the normal fee you would charge for a wedding at home.

The national average for wedding photography is $2,500 but very few "average" wedding photographers will be asked to travel unless they just happen to have some connections to the couple. Bearing that in mind, the price for a destination wedding should start at roughly $5,000 and go up from there.

If you happen to be just starting out in the wedding industry, I can tell you that your predecessors have worked long and hard to create a tradition of high pay in the wedding industry. You have an obligation to all wedding photographers to charge competitive rates. If your work is good, you will get plenty of jobs at a competitive rate. If your work is not attracting clients at a competitive rate, then you should think about changing your work, not your rates.

If you want to find out what the local going rate is, just call up a few of the more established photographers in your area and tell them you are calling to find out the rates so you don't run down prices. I'm sure they'll be glad to tell you what the price range is in your area.

Summary

Traveling to exotic destinations to photograph a wedding can be one of the most rewarding jobs you will ever encounter as a photographer. Of course, you have challenges presented by the hazards of transportation and health issues, but with a little preparation, the rewards far outweigh the difficulties.

✦ ✦ ✦

The Business of Digital Wedding Photography

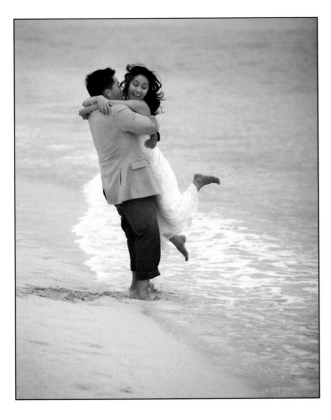

14
Creating Your
Own Workspace

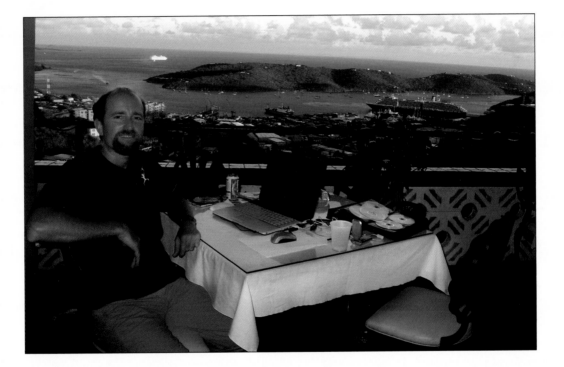

The modern digital wedding photographer has much freedom in the design of a working space. There is no requirement that you own or rent a studio space unless you also do other types of photography that require a studio. Many very successful wedding photographers operate out of a small office space or a spare bedroom in their home. Destination wedding photographers can even manage to run an entire business with no more than a laptop computer and a wireless connection. The days of elaborate studio and gallery setups are not gone; they've just become a choice.

By its very nature, wedding photography takes place on location. However, contrary to what you might imagine, the majority of a wedding photographer's job is not spent shooting pictures. In fact, the vast majority of a wedding photographer's workweek is spent sitting in front of a computer editing images, answering e-mail, talking on the phone, burning discs, creating albums, and so forth. The space needed to perform these tasks may be as small and unassuming as a spare bedroom without having any effect at all on the style or the quality of the final product. This chapter looks at options for creating the physical space where a wedding photographer works on a day-to-day basis, as well as the different types of equipment and software needed to run a successful photography business.

Three Workspace Options

In general, you have three options for the creation of the physical place where you work.

✦ You can create a studio with shooting space and office space.

✦ You can use a rented office space away from your home.

✦ You can create an office space in your home.

Each option has its benefits and drawbacks. The one you choose depends on the type of photography you want to do, where you live, what your home life is like, and to a certain extent, your personality.

Studio

The photo studio is primarily used by photographers who do a mixture of all sorts of photo jobs instead of specializing in wedding work. A studio photographer typically has a staff of at least one other person, which allows the photographer to concentrate on shooting. The workweek may involve shooting family portraits, high school seniors, model portfolios, babies, pets, and commercial work for various businesses around town. If shooting such a wide variety of subjects interests you, then owning or renting a studio space is the perfect choice. Of course, if you like to shoot in the studio, you will find an occasional bride that wants a studio portrait as well. If you can produce images similar to what brides see in fashion magazines, you may find that there is a lot interest in your studio work.

Of course, your studio space must also have an office space included, either in a separate room, or off to the side of the shooting space. The office portion of the studio does not differ substantially from what you might find in a home office.

Office

An office is a commercial space away from the home. There are many advantages to such a space:

✦ Clients don't come into your home.

✦ An office adds a sense of professionalism for visiting clients.

✦ If you have children, you may have to leave home in order to get any work done.

✦ An office separates work time from nonworking time so that when you are at home, you can completely forget about it.

Having an office away from home is much better for the workaholic types because it forces you to stop working and go home at some point. If the location is away from your home, you can't just walk back into the other room and keep working all night. This type of situation is perfect for those who want more separation between home life and work.

Figure 14-1 is a good example of an office in a commercial space. The space is not fancy but it is very functional, and it has all the necessary basic equipment needed to run a successful photography business. This particular office space could easily be in a home. Not shown in this image is another set of chairs and a small table on the other side of the room where client meetings take place.

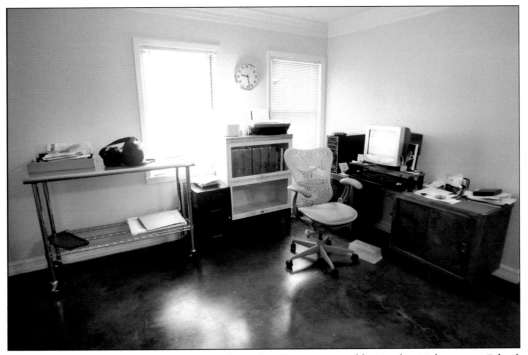

Figure 14-1: Shown here is a very clean and simple office setup used by Heather Mabry to run Eclectic Images at `http://x.eclecticimagesphotography.com`.

Home office

The home office is for the person with exactly the opposite views of work as the person with the away office. This type of work situation requires that you like having clients in your home, and you like working around the children, and even like having the ability to step into the office to get some work done after dinner. The difficulty of separating home life from work life is always present, but if you enjoy mixing work and regular life together into one way of living, then this just might be the perfect workspace for you.

With the home office, your children don't grow up wondering where Mommy or Daddy disappeared to every morning. Instead they know exactly what you do and how you make a living. As they get older, they may even take part in the family business by doing small jobs to help out.

Designing Your Space

The modern digital wedding photographer's office has several basic aspects. It has one or more computers, each with a comfortable chair and a high-quality monitor that presents true colors and is easy on the eyes. The office may also have a phone, fax, credit card swiper, DSL modem, office printer, and perhaps a large printer for making finished prints. This inventory is not large as far as businesses go. You can purchase the entire setup for well under $15,000.

Wall colors

The room itself, at least the parts of it that are behind your computer monitor, should be painted medium gray to cut down on any colorcasts that may be created by light bouncing off different colors of paint. Any color (other than white, black, or gray) on the wall that is immediately behind your computer monitor can influence your visual perception of the colors on your monitor, so as boring as it sounds, your wall colors really should be limited to white or some shade of gray.

Seating

Invest money in a high-quality chair for each person who works in your office. This one piece of equipment doesn't seem as glamorous as many of the digital toys, but you may find yourself working long hours at a photography business and a good chair allows you to maintain a comfortable posture with proper back support. Good posture can't be overemphasized; you need a chair that adjusts in height so that your legs can rest with feet on the floor and thighs horizontal to the floor. Your upper arms should hang straight down and your forearms should be parallel to the floor. Everything I've ever read says to keep your feet flat on the floor, but I've found that placing a small box or other object on the floor in front of my feet allows me to continually move my feet into different positions on the box and floor for some variety. Notice the small box beneath the desk in the picture of Heather Mabry's office (refer to Figure 14-1).

Lighting

Another facet to consider as you choose or create the layout in your office is the location of the windows and other sources of bright light. If you place your computers with a window behind them (in front of your face), you may at first think you've given yourself a great view of the neighborhood, but after a few minutes you quickly begin to experience eyestrain because your eyes are trying to adjust to see a relatively dark computer screen surrounded by a bright area. Another mistake is placing your computer facing directly away from a window or other bright light source. The light coming from behind you creates a glare on your screen that also contributes to eyestrain. The ideal situation would be, light gray walls with windows and lights to either side of the workstation.

Client Interviews

The only time a wedding photographer really needs a space more presentable than the average office is for meeting with clients. If you happen to be neat enough to have a presentable office space, then you can do interviews there, but most photographers don't keep the workspace quite that clean. Instead, some photographers choose to do interviews at a quiet public location, such as a coffee shop or rented meeting space. If the space is quiet and without a lot of distractions, clients generally find this completely acceptable.

One advantage of having interviews in your own office is that you can set up a very impressive system for displaying your images. Many photographers use digital projectors or large plasma-screen TVs to show off images with great results. You can use these displays both for showing your portfolio before the job and for showing images to generate sales after the job. Viewing on a large screen is very conducive to selling large prints. After all, when you've just seen your image projected at four feet by six feet, an 11-x-14-inch print looks pitifully small.

Digital projector

The digital projector (see Figure 14-2) is by far the most commonly used display type for anyone with a large showroom. You can set up a pull-down screen that is as large as four feet tall and eight feet wide for a very dramatic presentation. The drawbacks to digital projectors are that they can often be difficult or impossible to color calibrate, and they have a bulb that burns out after 300 to 500 hours. When the bulb burns out, replacing it may actually cost as much as $500. This drastically increases the expense of your display when you try to calculate how much it will cost to run it for several years. In the current market, a decent digital projector with a 6-x-8-foot screen will cost at least $3,000.

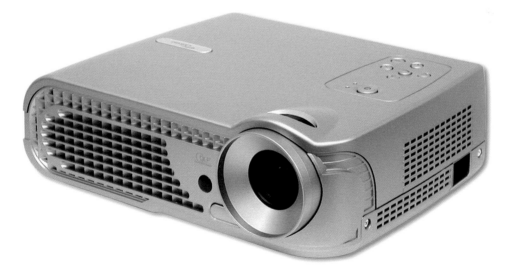

Figure 14-2: The digital projector is a very popular solution for showing large images to clients.

Plasma TV

The plasma-screen TV (see Figure 14-3) is a very attractive alternative for those with a medium- to small-sized showroom. Screen sizes range from 30 inches to over 50 inches. The advantages of plasma screens are that you can easily color calibrate them just as you would any computer monitor, and they are rated to have a life span of 30,000 hours without noticeable color shifts. This equates to 16.4 years of running it five hours per day. In the current market, a medium-sized 42-inch pro-quality plasma display and wall-mount bracket will cost roughly $3,000.

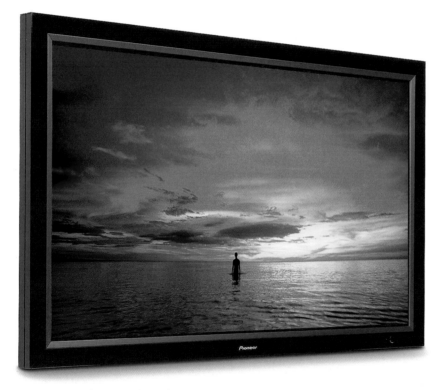

Figure 14-3: A plasma TV has a large viewing area with a very crisp, bright screen.

Cost comparison

If you compare how much it will cost to run the two displays for 30,000 hours, (assuming a bulb life of 400 hours and a cost of $200 each) the digital projector will require 75 bulb changes at a total cost of $18,000 for the projector and all the bulbs. The plasma display will cost only the original price of $3,000. In reality, neither of your displays is likely to last that long before you move on to something else. However, the cost savings with the plasma display are obviously far greater over time.

Music

With either of the above setups, you should also plan on purchasing a good surround sound speaker system. The difference between a show with music and the same show seen in silence is simply so great that you cannot afford to skimp on the music. Along with your speaker system you need a decent amplifier to power all the speakers. You can play the show and the music from your computer, but you need to run a cable from the speaker output on your computer to the input on your stereo amplifier because your computer does not supply any power to run speakers — the amplifier must supply the power for the speakers.

With your digital projector or plasma screen, you also have the option of creating your show in a DVD movie format that you can play in a normal DVD player or running the show directly off your computer. I recommend using the computer because a computer gives you the ability to create a color calibration profile, while a regular DVD player does not normally have this ability.

Setting the scene

Once all the physical aspects of a good visual and auditory presentation are in place, you will have treated only two of your client's senses to a wonderful treat. What about the other senses? If you try to provide something to make all of the five senses happy, your show will have much more impact. You've got sight and sound covered. Now you need to do something for touch, taste, and smell.

Providing a comfortable seating arrangement takes care of the touch. A nice aroma can be introduced with incense or flowers, although both of those run the risk of irritating someone with allergies. Some photographers have actually been known to bake cookies or bread, or put on a pot of good coffee just for the homey, warm feelings produced by such smells. The taste buds can also be treated with a glass of good wine, beer, coffee, or ice tea.

The viewing area needs special attention in the way you prepare the lighting. You need to be able to cut the lights down very low while the show is in progress. This allows the screen to show up better, and it also focuses your client's attention more on the screen. After the show is over, you need a bright white light source to shine down from above and behind the client so that he or she can view your album and print samples very clearly.

The portable interview

You may occasionally find that you are required to interview clients at a coffee shop or in the client's home. This requires either a selection of albums or a laptop for showing your images. I personally prefer the laptop for its portability and the ease of updating the slide show as you get new images from each new job. While a laptop screen is not anywhere near as impressive as a 40-inch plasma display, modern clients are generally technologically savvy people and they seem perfectly comfortable viewing images on a laptop.

It should be noted that the method of display does not override the quality of your photography. If your images are not stunning, showing them on a stunning display won't help much. However, if the image quality is there, a high-quality presentation definitely adds a whole new dimension to the viewing experience as well as the impression of your professionalism. If you want to sell large prints, showing your images on a large screen is the absolute best way to make it happen.

Computer Hardware

The job of a digital wedding photographer involves a lot of computer work. You manage your finances, create your Web site, surf the Internet, upload images to the lab, purchase new equipment, create client slide shows, manipulate images, print images, e-mail clients, edit new images, and burn images to CD or DVD. All of these jobs are done on the same computer, and often several of them happen at the same time. If you are starting out in the photography business and you don't have a computer system, you have a choice between a Mac and a PC. This section provides an overview of all the different computer parts, what they do, and what features are good for the specific jobs a digital wedding photographer does.

Choosing an operating system

PC or Mac — which is better? Processing speeds are currently very similar so there is no significant performance difference with either system. The choice is a bit like choosing between Canon and Nikon: Either tool works well in skilled hands. PCs still tend to have an edge when it comes to price and software availability with some programs not appearing for Mac until they have already been available to PC users for quite a long time. Very few software programs come out only for Mac, and Mac computers tend to cost considerably more for the same features and speed. Dollar for dollar, you tend to get a lot more features and performance from a PC.

Which system works best for you may depend more on the system you are with more familiar. In this case, the Canon-versus-Nikon analogy doesn't hold up at all. Most cameras function in basically the same way, so if you have experience with one, you can pretty much just pick up another and start using it right away. Not so with Mac and PC computers. The two types are so fundamentally different that even if you are an expert at one, you can't just sit down with the other and understand all the controls immediately.

Selecting your computer size

After you decide on PC or Mac, the next decision is to determine what size you should get. Computers come in three basic sizes: desktop, portable, and notebook. The desktop, often called a tower, is the large box size most commonly seen in office and studio use where you want the maximum feature set and maximum adaptability. By adaptability, I mean that the tower-style box has many slots where you can add and subtract parts, such as hard drives and controller cards to give the computer new features. Tower-style computer cases are designed with standard-sized spaces inside to accommodate all sorts of add-on parts.

Desktop

Desktop tower systems (see Figure 14-4) also have room for lots of fans. This is important because the fast processors in these systems generate a lot of heat. Each processor has a huge aluminum or copper heat dissipating block mounted right on top of it with a large fan blowing cool air over the block to cool it down. The ability to cool down the processor is a major advantage with the larger computer systems.

Figure 14-4: A desktop system offers the most flexibility, speed, and cost effectiveness for the digital photographer.

Portable

Laptop and portable computers are smaller and they generally come equipped with an LCD screen that folds down when not in use. These two smaller types of computers come in a range of sizes and weights. Those that weigh in at seven to 15 pounds are generally called portable, and while you can easily pick up and move a computer of this size around, you wouldn't want to carry it in your backpack all the time. The advantage of this size is that it is large enough to pack a lot of features, a fast processor, and a large screen. If you do only occasional portable interviews, this size computer would be just right.

Notebook

Notebook-size computers weigh in at two to seven pounds and they are the only truly portable computers. Notebooks are perfect for destination photographers and anyone else that travels a lot. These tiny computers (see Figure 14-5) pack an amazingly powerful computer system into a package that is only 1 to 2 inches thick with viewing screens that can range in size up to about 17 inches.

Figure 14-5: This system offers extreme portability, but it sacrifices a lot in speed, flexibility, and cost effectiveness.

Both the portable and the notebook sizes cost far more than the desktop models because you pay a premium for miniaturization. Portables and notebooks also offer fewer features and very limited options for adaptability compared to the larger desktop-sized computers. Smaller computers are also much more difficult to work on if they malfunction. Your local computer store can probably fix anything that goes wrong with a desktop, but if a laptop goes out, you most likely have to send it back to the manufacturer. About the only repairs or improvements that even the most computer-savvy person can do to a laptop is change the battery, the memory chips, and the hard drive. Each of these three components has an access door built in for easy replacement or repair. Everything else is buried deep inside the body of the computer.

Another drawback to laptops is that the processors need to be slower. If you try to put a fast processor into a laptop (and you can) you have to add a large fan that makes a large amount of noise. The fan also blows downward, which happens to be where your legs are if you're actually using your laptop as the name implies. This won't last long because your legs soon get uncomfortably hot, and your laptop is only good for tabletop use.

A good speed for laptop processors is 1.5 to 2 GHz. This is slow enough to allow the use of very quiet fans, and the heat buildup under the computer is minimal. These processor speeds are only about half

the speed of the current fastest processors on the market; however, if you add a gigabyte of RAM, you still have a computer that can function at a very comfortable pace—although not speedy by any means.

Most photographers get the greatest amount of use from the desktop style of computer. The only real reason to choose a laptop is for portability. If you do more than an occasional destination wedding, you will certainly be looking at a laptop. Otherwise, the desktop tower systems provide far more features and speed for the same amount of money.

RAM

RAM stands for Random Access Memory. This memory chip is where your computer temporarily stores small amounts of information that it is using. Each time you open a program; the code for that program is read into this memory and held there waiting for you to do something. When you close the program, the code is deleted from the RAM. It is important to note that RAM is different from your hard drive. The hard drive stores information permanently while the RAM only stores information while the electricity is on.

RAM is particularly important for photographers because every time you open an image, you read it into the RAM. If you open Photoshop, all of the code for the program is also read into the RAM. If you run a filter on the image, the processor chip makes changes to the image in the RAM. As you can start to see, much of what photographers do on their computers takes place between the processor and the RAM chips. Because of all this, the amount of RAM in your computer is extremely important in determining how fast your computer functions. RAM can be an extreme limitation to your computer if you don't have enough. For example, if you only have 32MB of RAM and you try to open a 50MB file, the computer is forced to use the hard drive for temporary storage of the file. Hard drives are much slower than RAM, so your computer is limited to the speed of the hard drive instead of the speed of the RAM.

What is a good amount of RAM for a photographer's computer? One gigabyte is a healthy starting point for the average photographer. Less than 500MB is a severe limitation for working with images, and you will notice an extreme jump in speed if you change from 500MB to 1GB. If you add more than 1GB of RAM, you generally start to see a less drastic improvement because the speed of the whole system is limited by other parts of the computer, such as the hard drive. In order to take advantage of 2 or more gigabytes of RAM, you need an extremely fast hard drive setup.

Hard drive speed

Computer hard drives are constantly improving. The storage capacity gets larger and the speeds get faster every day. If you want to create a fast computer system there are two features to look for: the speed of the drive itself and the system used to attach the drive to the computer.

Drive speed is the speed at which the disk drive spins the drive inside. Avoid drives that spin as slow as 5400 rpm and look for either 7200 rpm drives or the newer 10,000 rpm drives that are just now becoming available. The faster the drive spins, the faster it can read and write data.

All moderate to high-end computer systems being built today should be using Serial ATA for connecting the drive to the computer. Older connection systems, such as ATA/100 run roughly 30 times slower than Serial ATA.

Another method of increasing drive performance speed is to put two hard drives on Serial ATA connections and configure them to run as a RAID 0 array. RAID 0 uses both drives together as if they were just one large drive. The benefit of this system is that it divides the information in half and puts one half on

each drive. When that information needs to be accessed again, each drive only has to read half of the total. With the Serial ATA cables, the information can travel to, or from, both drives simultaneously. This essentially cuts in half the amount of time it takes for your hard drives to read or write an image file.

Drive space

Drive space is not a huge factor unless you want to store your images permanently on your hard drives. If you choose to do this, be aware that hard drives are made up of many moving parts and they will eventually die. You won't have to be in the photography business very long before you see it happen. When it happens to you, if you have your images backed up on an optical media, such as a DVD, you won't have to worry about losing valuable client images.

If you choose to use hard drives as your primary image storage method (and I don't recommend this) you can back up those images by having two sets of drives — one of which is stored in a fire safe or at another location. It is much safer to back up your image files and other important data on DVDs that are stored in a fire safe.

Storing the latest ten to 20 weddings on your drive is not a problem with hard drives in the 250-500GB range. One or two drives of this size can easily store an entire season's worth of images so that they are always within easy reach when you need to access them for print orders or album creation.

Drive connections

Internal connections of the Serial ATA type were discussed in the previous section, but what about external connection methods? All modern computers come equipped with at least two USB 2.0 connection ports where you can plug in a wire that attaches on the other end to an external hard drive enclosure. These external drives are *hot swappable*, which means that you can plug them in and unplug them without shutting down your computer. External drives can easily expand your storage capacity without limit. USB 2.0 is the preferred connection method for external drives; however, there are several other systems on the market. The older USB 1.1 connections are many times slower and should be avoided. FireWire is a very acceptable option that is only slightly slower than the USB 2.0 connection.

CD and DVD burner with software

Each workstation should come equipped with two optical drives. One drive is for burning DVDs and CDs while the other drive is for reading them. All drives that burn DVDs can also burn CDs so you really only need one drive for burning. The second drive is for reading only. The advantage of this two-drive system is that read-only drives are often several times faster than the burning drives. The read-only drives are used as the primary drive for looking at the discs, and the slower, burning drives are used to create new discs.

The newest DVD technology that all photographers should be taking advantage of is dual-layer DVD. This type of disc looks the same as a normal DVD and it still plays in all standard DVD readers and computers, but this new burning technology can store roughly 8GB of data on one disc, compared to the 4.7GB you can store on a normal DVD.

Graphics card

The use of a high-end graphics card greatly speeds up the process of displaying images on your monitor. If your computer has no graphics card, the main processor chip runs your monitor in addition to all of its other jobs. This creates a noticeable delay when you scroll through the images in a browsing program or when you edit images in Photoshop. You can take some pressure off your main processing chip by adding a graphics card with at least 128MB of built-in RAM. What this means in low-tech language is that the graphics card runs the monitor while the main processor chip is left free to work on other things, such as generating the thumbnails you need to look at while editing images.

Networking your computers

Any photographer with more than one computer workstation absolutely must set up a network between them. Having a network enables you to access images or anything else from any computer on the network. For example, if one person is editing images on computer A and you need to print a document on the printer that happens to be attached to computer B, all you have to do is send your document through the network to the printer without ever disturbing the other person using that computer. Another example is while a new set of images is being edited on computer A, a person working on computer B can browse those same images, open (directly onto computer B) the ones that need color correction or artwork, and then save them back through the network to the hard drive on computer A.

The physical method you use to attach the computers together can be either a cable or a wireless connection. With wireless, each computer needs a transmitter/receiver card installed. If you choose a wireless connection, just be aware of the fact that the wireless signal travels quite a bit farther than the walls of your home or office. If you fail to properly set up security features, a stranger can pick up the signal and log on to your network without your permission.

It is very standard for all PCs and Macs to come equipped with the connection ports for networking cables. You can connect these ports from the computer directly to a *hub*, which is basically a small box with several network cable plugs. Each computer is connected to the hub, and the hub allows the signals to travel back and forth between all of your computers. Your DSL modem may function as a hub if it comes equipped with several network cable connections. A DSL modem can also function as a hub if it has an antenna for wireless broadcast. If you have a large business with many computers, you can purchase a hub with many cable connections. Setting up a network is a topic that deserves a book all its own, and in fact there are many. You can either read up on the topic or simply hire a computer technician to help you with the setup.

Monitors

In the past few years, LCD monitors have quickly come down in price and become the standard in the photographic industry, replacing the larger CRT monitors. Bright colors and sharp, flicker-free text make LCD screens a perfect match for digital photographers who spend large amounts of time staring at the screen.

Most computer monitors display the sRGB color space, but the newest generations of LCD monitors are capable of producing true Adobe RGB colors. One company, Eizo, is leading the way with this new technology. This company already has several monitors that display the full range of colors in the Adobe RGB color space, and they can also be set to view in CMYK or sRGB. This will hopefully become standard in the near future.

There is no single monitor on the market that photographers agree is the best. However, there are several monitor companies that seem to show up in photographer's offices more often than others. This is a very nonscientific listing of the most common brands.

```
www.eizo.com

www.apple.com

www.sony.com

www.lacie.com

www.viewsonic.com

www.hp.com

www.dell.com
```

Calibrating your monitor

Every single monitor that comes off the assembly line is an individual. It has image characteristics that are somewhat like its siblings, but not exactly so. Somehow the combinations of parts and small differences in alignment and how tight the bolts are and a million other tiny factors that are slight production variables, add up to create slightly different color-producing abilities on each monitor.

To neutralize these differences and set every monitor to a standard, you must calibrate the monitor. Not only that, but you must repeat the calibration at least every few months to correct changes that occur as the monitor ages.

Calibrating your monitor is a reasonably simple process that starts with the purchase of a calibration kit. The kits are all on the expensive side, so if you are a small studio or just starting out, you might try sharing a calibration kit with several other photographers in your area. After you have the kit, you need to install a software program that walks you through the various steps required to calibrate your monitor. Most systems provide a sensor that you place on your monitor while the software causes the monitor to produce various colors under the sensor. As the process ends, the software compares the colors the monitor actually produced with the colors it should have produced, and a *profile* is created that corrects the monitor's original colors and causes the monitor to produce perfectly standardized colors instead.

Color profiles

A profile is a set of instructions that a calibration device creates to correct the inconsistencies in a device and make it produce standardized colors. Profiles can be created for monitors, printers, cameras, scanners — anything that produces color.

Monitor calibration kits

The following companies produce kits, which usually consist of a sensor and software CD.

✦ Monaco Optix at `www.monacosys.com`.

✦ ColorVison at `www.colorvision.com` has two versions of calibration kit. PhotoCal is the starter version and OptiCal is more for the professional.

✦ LaCie BlueEye Vision at `www.lacie.com`.

✦ GretagMacBeth at `www.gretagmacbeth.com` offers two calibration kits: the Eye-One and the Eye-One Pro.

✦ The Sony Artisan at `www.sony.com` is a top-notch monitor that comes with a built-in calibration feature and sensor. The system has many features not offered by the others, such as creating different contrast profiles for different papers that you use for printing your images. This system also has a self-test that lets you know when it needs to be calibrated again.

Adobe Gamma monitor profile

While Adobe does provide a method of profiling your monitor as a standard part of the Photoshop package, I don't recommend using this feature. The reason being that this sort of profile is based on your own personal ability to determine what a neutral gray is and then match several other options visually. This system simply cannot compare to the machine measurements that happen with a real color calibration kit, although it works reasonably well if you can't yet afford to get one of the more expensive kits.

Office Printer

An office printer need not be anything fancy. Its main job is printing documents, and many models from HP and Epson suffice. However, for a small amount of extra cash you can get a few extra features that can be extremely useful.

Direct printing on DVDs and CDs is an option for some low-end printers, and they do an absolutely amazing job. The software provided is easy to use, and it enables you to create beautiful custom discs for each job. It's not recommend that you use stick-on labels on the surface of the discs. DVDs do not tolerate the imbalanced spin this causes, and the adhesive can cause degradation of the discs over time.

Fire-Proof Safe

At least one fire-proof safe (see Figure 14-6) should be an essential part of every digital photographer's office. In it, you can store original image discs, portable hard drives, client contact information, and so forth. In theory, a fire safe saves your discs and other important items in the event of a fire. Hopefully, you'll never have to test that theory.

Other options include safe deposit boxes and online storage; however, both of these options require a considerable amount of effort on your part and as such, they are less likely to be used on a daily basis. The fire safe is always easily accessible, which makes it much more likely that you and your staff will be using it if a disaster actually does take place.

Figure 14-6: A fire-proof safe makes the perfect vault for storing your backup DVDs or portable hard drives to prevent loss in case of fire or theft.

Essential Software

The digital wedding photographer must perform several basic jobs on the computer. For each job, there are often several different software options that range in price and complexity. The following list covers the software needed for the major tasks of a digital wedding photographer.

✦ **Image manipulation:** Photoshop, Photoshop Elements, or ACDSee Pro

✦ **Image browsing and organization:** ACDSee Pro, Breeze Browser, or iView Media Pro

✦ **Downloading flash cards:** ACDSee Pro or Breeze Downloader Pro

✦ **Make slide shows in the EXE format, which cannot be printed by the client:** Pix to EXE or ProShow Gold/Producer

✦ **Create DVD slide shows:** Proshow Gold (or the more expensive Producer version)

- **General administrative tasks:** Microsoft Word, Outlook, and Excel
- **Accounting:** QuickBooks
- **Uploading and downloading large files over the Internet:** WS FTP
- **Web browsing:** Firefox, Netscape, or Internet Explorer
- **Creating PDF files:** Adobe Acrobat
- **Web site creation:** Adobe Dreamweaver

Internet Service

Before you can log on to the Internet, you need to pay for the service of an Internet service provider or ISP. This is a company in your area that you pay $15 to $20 per month for your connection to the Internet. Usually this service comes with free e-mail and a free space where you can create a small personal Web site. If you have your ISP host your business Web site, the total price will usually start at about $40 per month.

If DSL is available in your area, adding that to your normal Internet service greatly improves your Web surfing experience and is vital if you want to use an online print service that enables you to send images over the Internet. The ISP often changes your connection to DSL for free; however, the phone company then charges you a monthly fee to use DSL.

If you do go with DSL, you must purchase a DSL modem that connects to the phone line in your office. DSL operates at a completely different frequency from phone conversations so you can use your DSL service to surf the net while talking on the phone at the same time.

DSL modems can be purchased with a wireless feature for only a few dollars more. If you have a laptop computer or computers in distant parts of your office, using the wireless feature may be far easier than running wires, although wire connections allow faster transmission times.

Domain registrar

A domain registrar is a company that helps you to register the domain name for your business. You can find a listing of domain registrars at www.internic.net. You may find it easier to have your Web site hosting company to register the name for you. Most Web site hosting companies do this for free or for a small fee if you host your site with them.

Web site host

The Web site host is the place (usually a company) where your Web site resides on a computer that is hooked directly to the Internet. This computer runs constantly so that your Web site can be accessed at any hour of the day or night.

As soon as you sign up for an account with a Web site hosting service, you get a password that allows you to log on and load your Web site onto the host's computers. Using this login information, you can easily reconnect at any time to make changes to your Web site.

The Web site host often has software that enables you to manage many features of your Web site as well as look at statistics that tell you how many people have looked at your site, where each of them comes from, what search terms they used to find you, what time they visited, how long they stayed, which pages they looked at, and so forth. This feature is extremely valuable for assessing how your clients are finding you. These statistics tell you what aspects of your marketing plan are working and which ones you need to improve.

You can find updated details about my favorite hosting companies on my Web site at `www.aperture photographics.com`.

Your Web Site

If you want to compete with the masses of other photographers out there these days, you need to spend a lot of time and effort building and optimizing your Web site. When building it, consider both the needs of your customers who need to find information and pictures and also the search engines that determine whether or not your customers can find you. Unfortunately, the Internet functions in a very different way from, say, a Yellow Pages ad. The two are similar in that they both have information about you, but the phone book shows listings for anyone that can afford to pay, while the Internet shows listings based on how important other businesses think you are. This is a fundamental difference that makes the Internet a very challenging and competitive place to market yourself.

Do it yourself or hire someone

Many photographers simply hire a Web site designer to create a Web site for them. I think this is a huge mistake because it takes the creativity and the flexibility out of your hands. More than anything else, the disadvantage of having someone else create your site is that you have to hire him or her again every time you want to make a change. That means every time you want to add a new service or update a price, you have to call your Web site designer and tell him or her about the change and then wait for the designer to schedule it and make it happen. Alternatively, if you spend a few days learning to work on your own Web site, you can make a change in a matter of minutes. The time it takes you to learn these skills will be repaid many times over in the amount you save in designer fees and the business you can generate from a good Web site.

SEO

Another reason for not hiring a Web site designer is that most of them are graphic designers who often have little or no idea how to design for the search engines. This is called Search Engine Optimization (SEO), and it is, quite frankly, more important than designing the site to please your client. Of course, you need to please your clients with an attractive site that functions well, but the beauty of your site is meaningless if nobody can find it. To learn more about SEO, simply type it in as a search term on the Internet, and you will find a huge amount of information on the topic.

On my Web site, I also have a section for photographers in which I share the secrets I've discovered about designing your Web site to please the search engines. These techniques have helped put me right at the top for searches on the destination wedding locations I choose to target.

Construction phase

The best way to get ideas for your own Web site is, of course, to check out what your competition is doing. If nothing else, you may learn a lot about what you don't want to do with your own Web site. As you browse through your competitors' sites, make notes and sketches for features you like about the way each site is designed. Later, you can use the ideas you collect to sketch out your own site.

Building a Web site is a bit like building a house. With a house, you don't just buy a bunch of boards and start hammering them all together. You have to start with a plan. Web sites are built the same way; you gather your ideas, sketch out your site on paper, and then start putting it all together. The design phase is by far the most difficult and also the part on which you should spend the most time. If you happen to be a great home decorator, then you will probably enjoy doing the design on your Web site as well, but if you happen to be the type that would hire a decorator for your home, then you could probably benefit from similar help with your Web site. This is where a graphic design artist can really make you look good. This person doesn't have to actually build your site, he or she can handle details such as choosing colors, picking and making graphic elements such as buttons, choosing fonts, and creating background textures. You can then take these parts and put them together into a Web site.

Make it client friendly

Building a client-friendly Web site can be quite a challenge. You have to balance your need to lead clients through all the information on your site without making them feel like they've left your site when they view a new page. Each page should match the style of the others and have an easily understood way of navigating to all the other parts of the site.

The physical structure of the site has a lot to do with the way your clients can move around in it. For example, if your site is based on single pages, when clients click a link, they get transported to a new page. A slightly more complex layout is to use a framed Web site, as in Figure 14-7. This creates parts of the page that don't move while using one section or *frame* to load the new pages each time a link is clicked. Many sites use this format, but the search engines have a harder time finding your pages if you use frames, so you have to make a site map with links that the search engines can follow to each of your pages. Check my Web site for more information on this.

What information to include

You can use your Web site as far more than a portfolio. You can also use it to educate your clients by including information about how photographers work, how to schedule the time for photography, how to decorate the wedding site, and basically anything else you can think of that a bride may want to know about wedding photography. If you find yourself telling each bride the same thing over and over and over, why not take a few minutes to craft your answer into some well-written text and place it in a new page on your Web site? Most brides that are contemplating hiring you will spend however long it takes to read every single word on your Web site.

One of the most helpful jobs that a good Web site can perform for you is to qualify potential clients. By putting details such as prices, contracts, and other information on your site, you won't have to answer phone calls from people asking, "How much do you charge?" or "What kinds of things are in your packages?" All of these questions can be answered by your Web site so that you only talk to clients that can afford your prices and who like your style of photography. This saves you a tremendous amount of time.

Figure 14-7: The top and left sides of this Web site are fixed while the bottom-right side changes every time a visitor clicks a link. This style is called a framed Web site. The white lines (which are not part of the Web site) indicate where the frames meet.

Some photographers don't put pricing information on their site because they believe that they can occasionally convince someone to purchase their services even though that person might not otherwise think they could afford it. In my experience, the opposite is true. If someone wants your services bad enough, he or she finds a way to afford it even if it means cutting back on some other part of the wedding to get you. If there's a will, there's a way.

Software for creating the site

The most commonly used Web site creation programs are:

✦ **Adobe (was Macromedia) Dreamweaver:** www.adobe.com (very powerful, $400)

✦ **Coffee Cup:** www.coffeecup.com (rated very highly, $50)

✦ **Microsoft FrontPage:** www.microsoft.com ($170)

✦ **Web Express:** www.mvd.com (full featured, $60)

Featured Photographers: Anne and Bill Holland

www.hollandphotoarts.com

Bill and Anne operate Holland Photo Arts, a successful digital wedding business in Charlottesville, Virginia. Bill was kind enough to share the details of his home-office setup to provide a little peek behind the curtain, so to speak, in this family-owned business.

Office space

We work out of our home. My office is in our basement, which is also a partial living area, but it enables me to largely separate work and personal environments. Anne's office is in a recently completed addition to our home, which she painted just the way she wanted it — hot pink! This new space gives her a great view of the back yard and her own dedicated office space with lots of storage capability.

While it's extraordinarily convenient having a ten-second commute, part of our business has involved learning how to balance our work life with our personal lives. In the early years, we worked constantly with hardly a day off. Now we're taking a little more time off, but it's difficult to do when your computer is sitting right there, beckoning for attention. We spend a lot of time communicating via e-mail with our clients, so it makes sense for us to maintain office hours to aid with the balance.

Computers

We're an all-PC shop. We both had extensive PC experience prior to opening our business, so it made sense to just stick with what we knew. Starting a business has enough of a learning curve without having to learn a new computer system on top of that.

Anne is set up with a 17-inch HP laptop with a CD/DVD burner that's sadly not all that reliable, so we'll likely replace it with a 17-inch Dell laptop. Our entire house is equipped with 802.11g wireless, but even the laptop is wired to the network with cables for increased data transfer speed when moving images back and forth. I use a Dell workstation, as do our production assistants. The two assistants are generally not here at the same time, so they share a machine. We use a mix of LCD and CRT monitors that we calibrate with a ColorVision Spyder.

We have two Dell PowerEdge servers that hold our wedding images. Each server contains four 250GB SATA (Serial ATA) internal drives and are set up in a RAID array, which copies the exact same information onto both drives at the same time. Each of these computers has an effective capacity of 500GB — perfect for storing a year's worth of wedding images. We chose Dell servers for their reliability and Dell's service.

Printers

We have a black-and-white laser printer, an Epson 1280 for general color printing, and an Epson R1800 for printing miscellaneous small images as well as CD and DVD labels.

Software

Each computer is outfitted with Microsoft Office Small Business Edition, Photoshop CS2, and Firefox. We prefer Firefox to Internet Explorer due to its usability and security features. We use Adobe Camera Raw for our RAW image adjustments and Adobe Bridge for editing our take from each wedding. We also use Breeze Systems Downloader Pro for downloading and renaming all files from the Epson P2000 image tank (a portable storage device) after each wedding.

Continued

Continued

Anne and I each have the latest version of Photojunction (album design software) installed on our machines. She is the primary album designer, and after she's finished with a design, I export it to layered PSD files so that I can make any necessary adjustments. Our production assistants do basic image corrections — dodging and burning, blemish removal, and so forth — before making the initial proofs. While the use of Photojunction is required for Queensberry albums, Anne also uses it for our Cypress albums in order to maintain the speed and consistency this program offers.

We use Nero for CD and DVD burning. Taiyo Yuden DVDs are the best and most reliable we've found. We deliver the high-resolution images on these DVDs, too. Each disc set contains one full set of DNG (digital negative) files and one full set of JPEG files from the wedding. We send the DNG files because they are the only RAW format whose specification is open to the public, and it's conceivable to us that somewhere down the road labs will start being able to process and print from these RAW images. So providing DNG files may allow our clients to print very high-quality images long after we've closed up shop and retired to a remote Caribbean island.

Connectivity and Web site

We use DSL for our Internet connection and a firewall to isolate our computers from unwanted visitors.

Our Web site is hosted with a company named Westhost, as we don't have the security expertise or the bandwidth to effectively host our own Web site. Our current Web site design and all prior designs were created by me (I was a professional Web designer in a prior life). You can check out our Web site at `www.hol-landphotoarts.com`

Summary

Having a workspace of your own is essential to every digital wedding photographer. Depending on the type of business you do and your personality type, you may want anything from a huge commercial studio space to a small office in a spare bedroom. Either one works just fine, and neither of them has the slightest effect on the creativity or the quality of the images you can produce.

This chapter gave a brief overview of the types of locations and office equipment you need to create a full-featured digital wedding business capable of handling image processing and client contacts.

✦ ✦ ✦

15

Working in a Digital Studio

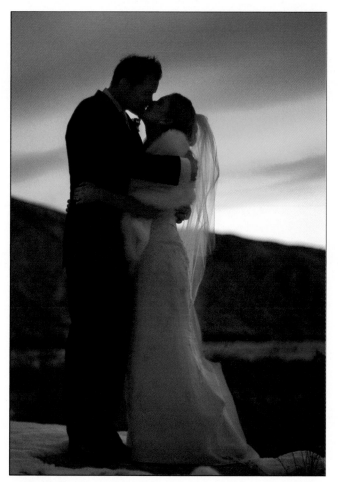

© Amy Lizotten

The digital wedding photographer spends the vast majority of the total working hours sitting in front of a computer in a digital studio. This is a rewarding and sometimes tedious element of digital photography. Daily tasks range from downloading and editing images from the most recent shoot, to

cropping, correcting, and touching up the images in Photoshop. This chapter takes a much deeper look at the digital wedding workflow that was introduced in Chapter 4.

Transferring Images from Camera to Computer

After a full weekend of shooting weddings, you suddenly find yourself faced with the prospect of sorting through all the images, perhaps thousands of them, and putting them into some form for final use. Getting them from the CompactFlash cards to your computer is a delicate task that occasionally malfunctions. This section discusses the safest techniques to use when downloading, as well as some solutions for times when something does go wrong.

You can find many types of media card readers, such as those shown in Figure 15-1. When you plug your memory card into the card reader, you should not try to view, sort, delete, rename, or do anything else to the images while they are still on the memory card. Remember, this point in time is very delicate because you do not yet have a second copy to use as a backup. The *only* action you should do now is simply select the entire set of images, and then drag and drop them into the destination folder on your hard drive.

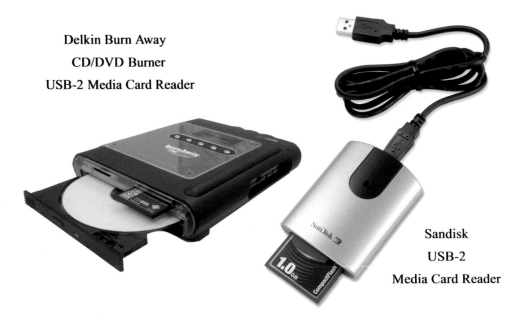

Delkin Burn Away
CD/DVD Burner
USB-2 Media Card Reader

Sandisk
USB-2
Media Card Reader

Figure 15-1: Media card readers come in many shapes and sizes.

An even better way to transfer the images is to use a downloader program that is designed specifically for the task of moving images from your memory card to the folder of your choice on the hard drive. Photoshop Elements, Breeze Browser, and ACDSee all have excellent companion programs that perform this function. Downloader programs also have many renaming options as well as options for changing all images from 72 dpi to 300 dpi, assigning camera profiles during download, rotating during download, and

so on. Many camera manufacturers include simple downloaders with the software that comes with each new camera. Using such a downloader program lessens the chances of causing any sort of file corruption problems.

At the beginning of this section, I mentioned that you shouldn't do any action to the CompactFlash card before downloading. Now, at the end, I'm listing off things that the downloaders can do to the images. This is not a contradiction. The difference is that the downloader program doesn't change the images on the CompactFlash card. It simply reads the image from the CompactFlash card into the computer's RAM and then performs the changes in the RAM before it writes the image to the computer's hard drive. This is very different from attempting to actually change the images on the CompactFlash card, and in my experience, it does not cause problems.

The following are some points to remember about downloading:

✦ Never set your downloading software to delete the images automatically as they are downloaded. Leave the images on your memory card until you have to format the cards just before the next job.

✦ Never interrupt the download process or turn off the power on the camera or computer until the download is complete.

✦ Always check the thumbnails on every image before you consider the downloading process to be successful. Occasionally you encounter problems with the download process that necessitate re-downloading the images from the memory card.

✦ Create a backup set immediately after placing the images on your computer and *before* you start the editing process.

Download problems

One major topic of concern to all digital photographers is the possibility of having a download that doesn't work for some reason. Perhaps the cord wasn't plugged in all the way or the software just got things wrong. Whatever the reason, the result is that you get either nothing or a list of files that show data but won't open in any image editor. Sometimes, as in Figure 15-2, you can even get an image that has missing pieces.

Images don't always download properly. This doesn't happen very often but it does happen to me at least once or twice per year, and all it takes is once to get you in big trouble. The screenshot in Figure 15-3 is from a download that didn't work. The problem started after 981 images downloaded correctly in a series of about 1,200. You can see the thumbnail on the left screen and all the metadata from that image displayed just above it. This was the last correctly downloaded image. On the right screen, you can see that I've clicked on a blank thumbnail. The file does have data, as you can see from the 1,132K of space it takes up. However, there is no metadata and no image. These files would not open in any image browser or editor.

I have personally encountered several similar problems and I've heard every experienced photographer I know talk about downloading problems he or she has encountered. Considering all this, the only prudent course of action is to always have enough memory cards to shoot an entire job without having to format the cards and reuse them in the field. Even if you are able to use some sort of data storage device or portable DVD burner, you never really know if the download worked until you get home; and if it didn't work, you had better hope that you still have the memory cards to fall back on. If you have enough memory cards to shoot the whole event without formatting and reusing any cards, you can relax with the knowledge that if there is ever a mistake in the process of downloading to your computer, you can just go back to the memory cards and try the download again.

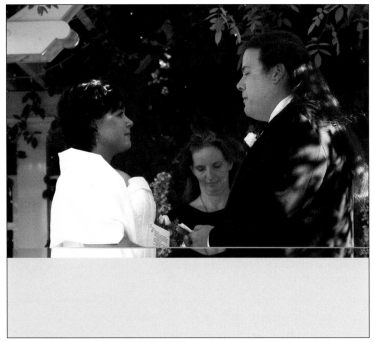

Figure 15-2: Only the top half of this image downloaded correctly.

Figure 15-3: Occasionally you get images that show a data size, but the computer can't recognize the data as an image.

After the images are safely on your computer, let your image browsing software (ACDSee, Adobe Bridge, Breeze Browser, and so on) go through and make thumbnails of each image. Next, you should personally glance through all of the thumbnails to make sure they are all whole. If a thumbnail can be made, you know the image is there. The final step in the process is to make a backup copy of the entire set on DVD or by copying the set to a second hard drive. After that is done, you can safely format your memory cards in preparation for the next job.

Although there are occasional problems with the process of downloading from memory card to computer, it is very rare for images to be corrupted while still in the camera. Corruption of the memory card itself is usually the result of placing it in a card reader and trying to access the images on a computer. You can also cause problems by putting a memory card on one camera and then switching it to another brand of camera. If you format the card before switching there won't be any problem, but each camera has its own file addressing system, and occasionally one will override the other.

If you do encounter a corrupted memory card, the following software companies sell programs that may be able to bail you out:

www.datarescue.com

www.artplus.hr

www.softwareshelf.com

www.pcinspector.de

www.photosrecovery.com

www.prosofteng.com

www.imagerecall.com

Memory card problems usually occur because there was a problem with what I call the file address. In simplified terms, each memory card has a table that contains the directions to where each file is located — somewhat like your street address. If there is a problem with the table, then some or all of the files may not be visible. That doesn't mean that the files aren't there; it just means they can't be found. Programs by companies such as DataRescue can analyze the memory card and look for the missing table information. If that can't be found, the program searches for data groups that it somehow recognizes as being a single image. The software usually finds every image that was on the card. You can even use this software after you've formatted the card in the camera because all the camera does when it formats is delete the address table. After the camera formats, all the images are still right where they were, but without the table, so your camera thinks the memory card is empty and it just starts writing new images over the old ones. When you run DataRescue, you get the most recent images you just shot, plus any remaining images from previous uses that haven't been written over yet.

Don't format in the computer

Computers have more options for formatting than your camera does. This can cause problems if you try to format a memory card in a computer. For example, many cameras can only read discs formatted with a setup called FAT 32. If you format in the computer, you have the option of using FAT 32, FAT 16, or even NTFS formats. The wrong format usually makes the memory card completely unrecognizable in your camera. Your camera may not even notice that it is there, or it may give a strange message such as "file is locked." You probably won't even be able to reformat the disc in the camera until you first reformat it in the computer — this time using the right format type for your camera. I've never personally encountered

any problems with erasing files on a memory card, but I still think it is a mistake to do anything to a memory card in the computer. When you need a clean memory card, simply popping it in the camera is always going to be the safest way to go.

Editing, Selecting, and Deleting Images

After the images are all downloaded to your computer and backed up, you can safely start the process of editing out the bad ones and sorting the keepers into different categories. Several programs on the market can help you with this task. Figure 15-4 shows the main screen of ACDSee Pro Photo Manager.

Figure 15-4: ACDSee Pro is one of many programs used for "Digital Asset Management."

DAM software

Digital Asset Management is a group of computer programs that that are used to organize large libraries of images. These programs can perform a multitude of tasks including enhancing, searching, categorizing, rating, tagging, naming, rotating, and so on.

The four image-editing programs that seem to have captured the most attention among professional photographers are ACDSee Pro, Adobe's Lightroom, Apple's Aperture, and BreezeBrowser Pro. These programs enable you to do far more than the simple task of editing out bad images:

 www.breezesys.com

 www.acdsystems.com

 www.apple.com

 www.adobe.com

All four are very powerful programs that work with every image type you can imagine, and all have systems for tagging images as you edit them. My own personal favorite is ACDSee in its various versions; the new Pro version has incorporated more image-editing features, including a very powerful RAW file converter, making the choice even easier. ACDSee Pro also gets top marks for its ability to create thumbnails and scroll through full-size images extremely fast. To be honest, all four programs work incredibly well, and you won't be disappointed with the performance you get from any of them.

The editing process

As you begin the process of editing out the bad shots, you have several options for how to proceed with the task. The obvious part is that you click the bad images and delete them. However, as you go through your image set, you should consider other uses for the images and prepare them for these tasks as well. For example, if you decide you want to make a DVD slideshow, you'll need to pull out the best 100–300 images from the entire set. This can be accomplished by marking or "tagging" the good images at the same time as you look through and delete the bad ones. Having the best images tagged also comes in handy if you want to make Web slideshows or load images to an online storefront for print sales. Each time you need to use the "best" group that you made when you tagged them, you can simply sort the entire set by the tagged rating, and all of your tagged images are instantly grouped together.

In ACDSee, the process of tagging images is as simple as clicking an image and then clicking Ctrl+(1 through 5) with Ctrl+1 being the best, and Ctrl+5 being the worst. You can tag any image with a ranking tag of 1–5 depending on how good you think it is and then sort according to rank. This puts all your favorites at the top and your least favorites towards the bottom.

Whatever software program you choose for the job, the basic process here is to edit out the bad images. Depending on what sort of final products you produce, you may need to edit more carefully or hardly at all. For example, if you sell prints and albums without giving away the negatives (digital files in this case), you really don't need to edit out any bad images because the client will never see them anyway. Instead, you would tag the best images and simply ignore the rest. This is a much simpler way to edit than trying to delete all the bad images. Something about the psychology of deleting files makes it much harder to do, and much more time consuming than simply selecting your favorites (with a tag) and dragging them out to a new folder.

Select your best

If your business model involves giving your client the original images, then you should spend a lot more time editing. As you edit, bear in mind the old adage, "What they don't know, won't hurt them." In other words, if you delete an image, your client won't be upset because they won't know that it ever existed in the first place. If you choose to include an image, you better feel confident that it has some redeeming quality that is worthy of keeping it in the set.

Your clients are usually not experienced at viewing and editing images. As such, they look at your images and make judgments about your professionalism and your artistic ability. For example, say you took 1,000 images at a wedding. Of those, you have 500 decent images, 150 really impressive ones, 10 superb ones, and two that are absolutely breathtaking. If you give your clients all 1,000, including the good, the bad, and the ugly, they'll probably think you're the worst photographer in the world. If you only give them 150, they will certainly be wowed at the first viewing, but after they have a while to think about it, they'll probably start to wonder what you were doing all day. If you give them 500–800 images with a folder of 150 labeled "favorites," you're much more likely to make them happy.

I once had a MOB (mother of the bride) come to me several months after the wedding complaining about how much I charged her daughter. She said in a New York accent, "Ya took 200 picshas of the bride but ya didn't get a single shot o' my sista Karen that came all the way from Florida. Look at this —" she pointed out — "ya got ten shots o' the bride puttin' on 'er shoes!" Then she pulled four 5x7s out of a folder and threw them down on the table. "And look at these!" she exclaimed. "You call yourself a photographa!? I want my money back!"

I have to admit it, she picked out four of the most awful shots I had ever seen and I have no idea how they slipped through my editing process, but there they were! I didn't give her money back because I know that we actually did do a great job despite those four images. However, I learned a few important lessons from this encounter. One is that she was so upset by the four bad ones that she couldn't see anything else. The second is that she could look at ten shots of the bride putting on her shoes, and it was so overwhelming for her that she couldn't see the really good one. I should have picked it out for her and deleted most of the rest.

I always include many generic images that show off the grounds and just a general overview of what was going on. However, I would never purposefully give a client a blurry or poorly exposed image unless it has some other serious redeeming qualities. Sometimes a little blur can impart a really artistic feel, or it can convey the motion that was actually occurring in the scene. Of course, you should keep these in. Some of my favorite shots came about through serendipitous mistakes that accidentally created a beautiful image. In general, though, I recommend deleting any images of questionable technical quality. The image in Figure 15-5 was created when I accidentally left the camera on Aperture Priority mode in a very dark area, and the shutter stayed open for about two seconds before I realized what was happening and clamped my hand over the front of the lens.

You can make your clients' viewing a bit easier by categorizing the images into the basic parts of the wedding day:

✦ Getting dressed

✦ Ceremony

✦ Portraits

✦ Family groups

✦ Reception

When your clients want to view images or order prints, it's much easier for them to find the particular image they want if they don't have to sort through the entire set to find it.

Figure 15-5: Mistakes happen. Sometimes they end up looking better than what you would have gotten if you had taken the shot correctly.

Renaming image files

Depending on whether you keep the original images or provide them to your clients on disc, you may decide to renumber the images to sequential numbers. Many photographers integrate complex naming formats that contain part of the client's name or the wedding date, as well as the sequential number. For example, image `220506gj 0001.jpg` tells you the date the image was taken, 22/05/06 (day/month/year), the initials of the photographer, and the sequential number. If you plan on supplying images to your clients on a DVD disc, you should probably keep things simple by using only a sequential number such as `0035.jpg`. Renumbering requires that you make a copy of the final image discs for both the client and yourself so you both have the same image numbers to deal with when prints are ordered.

Many programs have a batch-renaming feature, but ACDSee has a very powerful system that enables you to configure your filenames any way you can imagine. You can also add to the metadata in the file. This allows you to embed notes, copyright information, shoot details, contract details, or any other text you like — right into the image itself.

Make sure that you rename your files *after* editing, and *before* you create your final image disc set. This erases the fact that there are missing images. If you kept the original file numbers, your clients could see the missing numbers in the sequence, and they would almost certainly ask you what happened to the rest of the files.

Archival Storage

Now that you have everything edited, it's time to make a backup of the final image set on a CD or DVD. This backup contains only the "keepers" and any new images you may have created by changing the originals in Photoshop or some other image-editing software. The images you deleted in the editing phase are not part of this image set.

You have many ways to go about making this image set, but my favorite is still the DVD. Because it takes roughly six CDs to equal the storage space of one DVD, CDs are simply not a practical storage medium. The additional man-hours it takes to burn so many discs far outweighs the savings you get on the cheaper discs.

DVD is by far the simplest and most economical format for long-term storage of your images; and now that dual layer discs are available, you can easily archive an entire wedding on one disc, even if you had two photographers. You need a special type of DVD drive to create dual-layer discs, but your clients can still view them on any normal DVD drive.

Are DVDs archival? Most manufacturers claim at least ten years even on the cheapest models of discs. If you sell image rights to your customers so that they then own the images, you won't need to worry about your own copy being archival — it just needs to last a couple of years for backup purposes. However, if you are selling prints and your clients will not have access to the original images, that makes you the sole responsible person. If the bride comes back ten years from now with a print order, will you still be able to read that disc? If you're concerned about this, I recommend that you do some research on archival discs. Manufacturers are just now addressing the archival ability of a DVD, so the most current information available will be old news by the time this book is published. New studies are recommending that you not use stick-on labels because the adhesive is not archival and will eventually contribute to the decay of the disc. When I first tried to use stick-on labels, my own computer could read the disc just fine but my clients called and complained that the disc was empty. Apparently, the stick-on type label creates enough wobble that many DVD drives can't read the information at all until the label is removed.

Gold discs, such as the one in Figure 15-6, which actually have a coating of 24-karat gold, are performing very well in accelerated aging tests. Claims of a 100-year lifespan are not uncommon for this type of disc. Gold is an inert element that is highly resistant to the damaging effects of oxidation, which cause the rapid decay of many other discs. Currently, gold discs are sold by several manufacturers at a cost of less than $3 per disc — not a big amount for that much peace of mind. The only catch is that an accelerated age test is not going to exactly duplicate what a real disc may go through in 100 years of being passed around, dropped, played in various devices, and "stored" in grandma's attic. Right now, the only alternative to using gold discs is to copy your important discs to new discs every four to five years.

If you provide image discs to your clients, you should alert them to the possibility that the discs may degrade over time, so they should be duplicated onto a new disc every four or five years.

Figure 15-6: 24K Gold CDs and DVDs are currently the only archival choice on the market.

Image Manipulation

Image manipulation programs offer an incredibly complex and powerful set of tools that every digital wedding photographer needs to master. Photoshop is, of course, *the* program of choice for the digital imaging professional. However, it should be mentioned that there are many less expensive programs that perform the basic functions that are required by the digital wedding photographer — although without the depth of tools and abilities contained in the Photoshop software. ACDSee Pro and Photoshop Elements are two of the more powerful and cost-effective programs available. Apple's Aperture and Adobe's Lightroom are two newer software offerings that have a lot of digital image manipulation abilities — especially if you shoot in the RAW format.

There are many fine books on the subject of image manipulation, but this particular book is by no means a complete tutorial. However, several techniques described here are absolutely essential to the daily working of a digital photographer.

Levels

Many images come out of the camera looking rather flat and dull. A very simple recipe for adding some sparkle back into an image is to open it in Photoshop and adjust the Levels. Figures 15-7 through 15-10 illustrate the following steps.

To adjust the levels in an image, open the image in Photoshop and then click the New Adjustment Layer icon (on the Layers palette) and choose Levels. This type of adjustment layer enables you to adjust each color channel separately. Just click the drop-down menu and choose red, green, or blue. A dialog box pops up with three small triangles below a histogram. Leave the middle and left-hand sliders where they are, but move the right-hand slider to the left until it is under the spot where the data begins.

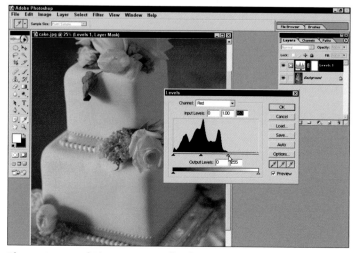

Figure 15-7 and Figure 15-8: Adjusting each color channel creates a very odd look when you first start.

Do the same thing for the red, green, and blue channels. As you begin this process, the image takes on a strange color tone, but it should go back to normal as you adjust the last of the three color channels. Some further adjustment of the sliders may be needed if there is still a color cast after you get done with all three channels. Adjusting the levels is perhaps the most common, and as such, the most valuable adjustment you need to learn in Photoshop.

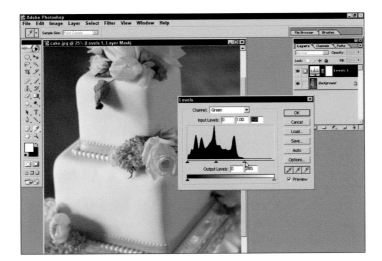

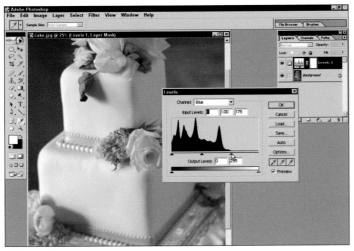

Figure 15-9 and Figure 15-10: As you adjust the third slider, your
image should come back to life. This simple adjustment often creates
a dramatic improvement over the original image.

Brighten a dark image with screen mode

Perhaps the second most common Photoshop adjustment you need to make is to brighten an image
that is a bit too dark. To do this, start by opening an image and then click the image layer in the Layers
palette. Drag the layer to the Duplicate Layer icon (next to the trash can).

Now you have two identical layers, each containing a copy of the image. Click the upper one to select it. Now click the drop-down menu at the top of the Layers palette that contains a list of different blending modes and choose the screen option seen in Figure 15-11. This brightens all the tonal values in the image at the same time without causing any color casts.

If the newly brightened image is a bit too bright overall, simply move the Opacity slider (the box just to the right of the blending modes) to adjust the opacity down until you get the desired amount of brightness. Figure 15-11 shows an image that needed a little brightening in the foreground, but I didn't want the background to get brighter, too. By adding a mask to the layer, I was able to paint on the mask to hide and reveal the effect of that layer.

Painting on the layer mask allows you to hide and reveal different parts of the image.

Clicking here adds a layer mask.

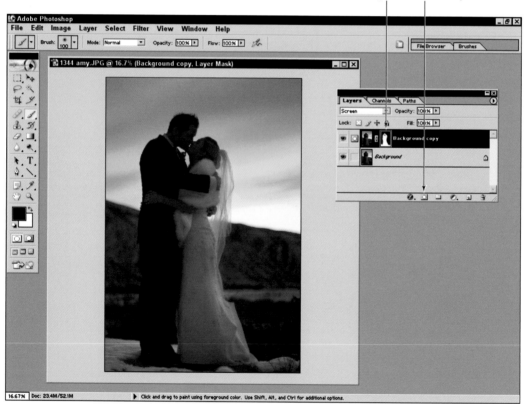

Figure 15-11: Setting the upper layer to Screen mode lightens an image without creating any color casts or changing the contrast. Adding a mask enables you to control what parts of the image get brightened.

Sharpening

Unfortunately, no amount of sharpening will fix a blurry image. However, all digital images, whether they come from a camera or scanner, will appear a little soft-looking in the original form. Once you apply the proper amount of sharpening, the softness disappears and the image appears bright and crisp. While it is possible to set your camera to do some sharpening, the preferred method is to turn off camera sharpening and do the job yourself after the image is manipulated and resized to the proper dimensions for printing or other final use. Proper sharpening technique is essential to your work as a digital photographer, but knowing when to sharpen, and when not to sharpen, is even more important.

General sharpening guidelines include:

✦ Never sharpen an original image. Always save it without sharpening.

✦ Sharpen only after the image has been sized and cropped to the final dimensions.

✦ Sharpening is the very last step before printing the image.

✦ If a sharpened image is needed for use at a different size, start over from the original unsharpened version.

✦ After sharpening, save the sharp version with a new name so that it does not replace the original.

There is no single formula for sharpening an image because the amount of sharpening needed is dependent on the size of the image. A large image destined for a 16 x 20 print needs sharpening adjustments that would completely destroy a small image that has been sized for your Web site.

The most basic sharpening technique is to open an image and click Filter ➪ Sharpen ➪ Unsharp Mask. This opens the Sharpen dialog box where you can adjust three different controls. Figure 15-12 shows the approximate settings that result in a well-sharpened image from a modern digital camera. Notice that the sharpening dialog is viewed at 100%. This is very important. You won't get a good idea for what your sharpening is going to look like unless you view your work at 100%.

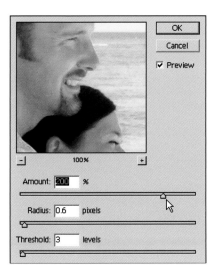

Figure 15-12: This image shows the approximate settings that result in a well-sharpened image from a modern digital camera.

In the two examples in Figure 15-13, I magnified the view to 200% so that the effects of correct sharpening and excessive sharpening can be compared. The image on the right has been oversharpened. The effects of oversharpening are easily seen in places where sharp black lines meet light toned areas (see arrows). Sharpening works by finding these lines between light and dark areas and emphasizing them. A small amount of this effect serves to create the impression of sharpness, while an overdose creates a white halo where light and dark objects meet.

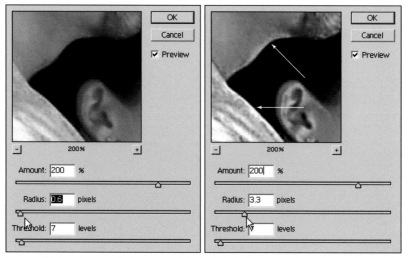

Figure 15-13: A white halo around dark objects is a sure sign of oversharpening.

The settings in Figure 15-12 are a good starting point for the average digital camera image. However, sharpening should be fine-tuned visually, by adjusting the sliders while watching (at 100% magnification) for the white halo, which is the telltale sign of over sharpening.

Summary

Learning the ins and outs of working in a digital studio can be a complex process to say the least. Downloading images is a regular part of your daily job. The tips in this chapter and the list of rescue software will help you to prevent disasters with corrupted media cards and recover from the disasters if they do occur.

The physical process of downloading images, editing out the bad ones, and organizing the "keepers" flows much more smoothly with the tips and software suggestions covered in this chapter.

Learning to use Photoshop or other image manipulation software may take some time, but with the few techniques covered in this chapter, you have the ability to accomplish a few of the most basic tasks necessary for processing digital images.

✦ ✦ ✦

CHAPTER

16
Creating the
Finished Product

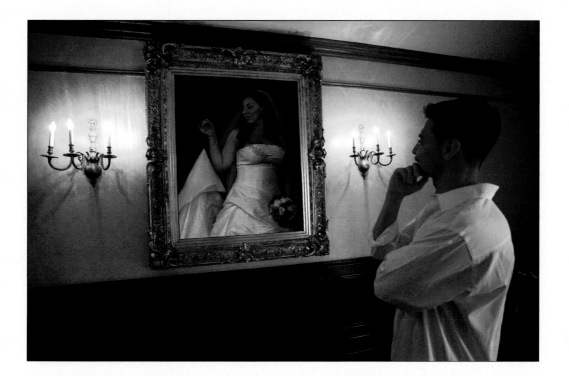

The digital age has created an explosion of products that you can offer to your wedding clients. The choices are so numerous that the job of narrowing down to the best offerings is a very difficult and time-consuming task.

This chapter looks at the various ways you can deliver products to your clients, from online print sales, albums, data DVD, DVD slide shows, and more.

The finished products you offer determines how your clients experience the images they commissioned you to create. Do they look at albums, computer slide shows, DVD movies that play on the TV, or framed prints? Depending on how your business works, you may choose to offer all or none of these items. Some photographers only do the photography service, while others rely on the aftermarket sales to generate a significant portion of the total sale. Many combine a selection of offerings into a package.

Different packages with different combinations of items assure that you have some offering that appeals to almost everyone, both in terms of budget and in the type of items for which the client is looking.

If you are starting out in the wedding photography business or considering the possibility of doing so, this chapter provides a quick overview of the various products you may want to offer to your clients. Along with each product is a discussion of how that product has traditionally been marketed and sold, as well as a look at where that type of product may be headed in the future.

Print Options

Whether you choose to sell your images or just make them for your own enjoyment, you will eventually want to get some paper prints made. You have basically two ways to go about this: print your own or find a lab to print them for you. Either way can produce excellent results, although as you may imagine, it takes a lot more work, research, and practice to learn how to print your own. If you decide to go with a lab, you simply drop off a CD with your images on it. The lab does all the work, and has done the research and has the practice it takes to learn how to make good prints.

The proofing process

In general, there are two types of prints that are offered by photographers — finished prints and proof prints. The term *finished prints* is pretty self-explanatory. These are the highest quality prints that you sell to your clients with the expectation that they will be framed or placed in albums. The other type of print is called a *proof print*. Proof prints, or *proofs* as they are often called, were originally printed on a type of paper that allowed the image to fade away after a period of only a few weeks. This allows the photographer to provide a small copy of the image to a client so that the client could see what was there. The client then must purchase a finished print if he or she wants something to keep. The point was simply to provide some *proof* of what the image would look like.

Paper proofs

Modern paper proofs are generally 3 inches x 5 inches to 4 inches x 6 inches in size, and they are generally not retouched unless you anticipate large sales from a small number of images. Unfortunately, nobody has figured out a way to make modern proofs fade out.

The tradition of providing proof prints survived without question right up to the invention of the personal scanner. Now, almost everyone owns — or knows someone who owns — a personal scanner capable of copying even a small print at high enough resolution that the print can be reproduced at a much larger size, thus denying the photographer a sale. In the case of a family portrait where the income is generated almost exclusively from the sale of prints, this can result in the loss of thousands of dollars for the photographer. The past few years have seen a huge fuss over this issue in the photographic world. Many efforts have been made to educate clients about a photographer's rights, but it seems you can't change human nature. The reality is that stopping them from copying paper proofs is a bit like trying to stop the rain.

Digital proofing

There are currently many digital alternatives to the paper proof. The most common are CD proofing, in-person digital presentation by the photographer, and Web-based proofing in an online storefront. All three options have very specific instances when they would be the most obvious choice to use. For example, if your clients can come in to your office for a personal presentation, that would be first choice. If your clients are far away and there are only a few of them, such as for a family portrait, then mailing a

CD is the logical choice. If there are many clients, such as at a wedding, and they all live in distant places throughout the world, then online viewing is the logical choice.

Presentation in your studio/office is the most effective method of showing images to a client. With this method, you can control the environment to make sure that the clients get the maximum emotional impact on the first viewing. Many photographers have a dedicated viewing setup that sometimes even resembles a small movie theatre. Comfortable seats, a large, high-resolution screen, a little wine or champagne, and a selection of beautiful music played on a high-quality stereo system can all add a tremendous emotional impact to the slide show. If you display in your own setup, you don't have to worry about whether or not your clients might be viewing your beautiful images on an uncalibrated 14-inch monitor that only displays 256 colors.

Digital projectors are very popular for this sort of viewing, but make sure to get one with a decent resolution of at least 1024 x 768. Anything less than this and you won't be happy with the way it shows still images. Stills are much more demanding than a video when it comes to digital display, so a low-end projector that may do fine with video may not do well with a slide show of still images. Plasma displays are more expensive, but they're also capable of much better color and resolution that looks absolutely stunning with still images.

If your clients happen to be a long distance away, you can either set up an online viewing system to show off your images, or you can send them a CD with a digital slide show. There are several companies that produce excellent software for digital slide shows, but for the purpose of viewing images to select for printing, I've found nothing that beats a program called FlipAlbum (`www.flipalbum.com`). The features I find most valuable about this program are:

✦ Files are embedded into a (.exe) program and can't be extracted for printing.

✦ Users can skip backward and forward at will to view and compare different images.

✦ The view resembles a book with a cover, a table of contents, and pages that flip when you click them.

✦ Music can be added very easily.

✦ You can set an expiration date after which the show no longer works.

✦ You can also place several different FlipAlbums on one disc. This is great for putting a portfolio on the same disc as a client's images.

✦ The only drawback is that this is a PC-only program; it does not play on a Mac.

When you use a system such as FlipAlbum, or online viewing, you have no control over what sort of monitor your clients use. A bad monitor can certainly not help, and depending on how bad it is, it may cut out a significant portion of your sales. You would be well advised to ask some questions about the computer and monitor that will be used before trusting your clients with something like this unless you absolutely have no choice. You might also send a little disclaimer advising them that the finished prints will look far better than what they look like on the average computer monitor.

Getting Paper Prints

There are two basic options for producing paper prints: print your own or purchase prints from a lab. Both methods have advantages and disadvantages. The method you choose may be dictated by your level of skill and interest in learning all the technology that goes into printing your own prints. If you don't want to add all that work on top of being a beginner in the business (which has a huge learning curve of its own), you may be wise to go with a photo lab in the early stages of your wedding photography career.

Purchasing from a lab

Most beginning photographers are far better off using the expert printing service of a professional lab instead of trying to print their own prints. Not only does this save you the time and expense of learning how to make your own prints, but a professional lab can produce consistently better-quality images than what most beginning photographers can hope to get from their own printer — at least within the first few months.

Finding a lab can be as simple as looking in the phone book to see what is in your area. Working with a local lab when you first start out can be extremely helpful. The technicians at a small lab will be much more willing to walk you through any difficulties than would an employee working at a big national lab that is more accustomed to dealing with seasoned professional photographers.

Also, many professional labs are happy to work with you even if you are out of the area. If you have an Internet connection, you have the ability to send your images to any lab in the world and get finished prints in the mail a few days later. To find a current listing of professional labs, simply scan the ads in a few photography magazines.

Printing your own prints

Photographers have a long history of making their own prints. In the past, this was often done in a darkroom, which was considered a standard part of every photography business. Many professionals and amateurs alike converted basements, bathrooms, and even closets into a darkroom where they spent countless hours bathed in the dim red light surrounded by an intoxicating swirl of odors from the various chemicals they used. Waiting in the dark, they watched patiently until, as if by magic, an image slowly materialized on the surface of a blank sheet of paper.

Today the prospect of printing your own prints is thankfully much different. The digital revolution has made the process easier and much less hazardous to your health. In the current market, you can purchase a photographic-quality printer for under $1,000 that will rival or exceed the quality and longevity of prints that were produced in the average darkroom. For those of us that actually experienced working in a darkroom, the advantages of producing digital prints are practically uncountable. For the new photographer, there is a different type of darkroom to be concerned with — the digital darkroom.

Printers

The only tools you need to get started producing professional-quality paper prints are a calibrated monitor (which you should already have), some paper to print on, and a printer. The most common companies that produce printers for photographers are Epson, HP, and Canon. Epson produces two basic lines of printers, which are divided based on the type of ink they use. One line of printers uses dye-based ink, which has wonderful colors, but a shorter lifespan. The other line of printers uses pigment inks, which still have extremely good colors, and they also have an extremely long lifespan that will easily outlive standard color photographic printing papers. The actual predicted lifespan varies widely depending on the type of paper and ink you use.

The Epson Stylus Photo series of printers is the perfect choice for a small studio with low-volume printing needs. These amazing little printers offer eight-color UltraChrome K3 Ink for archival prints. Eight separate color cartridges combine to create an extremely smooth graduation between tones. The highlights are so smooth that you really can't tell it was printed on an inkjet unless you get out a magnifying glass to look for the dots. If you need larger prints, check out the Epson Stylus Pro series of printers, which uses the same K3 ink set on papers up to 44 inches wide.

Printer color calibration

The bad news is that printer calibration is significantly more expensive than monitor calibration, and you have to do it for each and every type of paper you want to print on. The good news is that you don't have to do it at all because there are companies that can do it for you—for a fee, of course. The fee is usually around $100 per paper type. If you don't use a lot of different paper types, this may be a great way to go. To use this service, you download a test file, print it on your own printer, and mail it off to be tested. After your test print is profiled, the profile is e-mailed to you along with instructions on how to install it in your own system. One of the largest companies supplying this service is `www.drycreekphoto.com`.

Some companies also compile libraries of pre-made profiles for certain popular printer and paper combinations. If they happen to have your printer/paper combination listed, you simply pay a fee (usually $25-$50), and you can download that profile. The only problem with this system is that every printer is slightly different from every other printer made; just like with monitors, each one is an individual. Printers are fairly consistent from one to the next, but there are small differences that will not be accounted for if you purchase a pre-made color profile. To find a library of pre-made profiles, look at `www.inkjetmall.com`.

If you want to have the flexibility and control of calibrating a new paper any time you like, there are several options on the market. Two of the best are the Colorvision Spyder and the more expensive GretagMacbeth Eye-one Pro.

These are the same calibration kits that work on monitors, but they have an add-on program that works to calibrate your printer as well. Frequently, this portion of the kit costs a substantial amount of money because it includes a completely different sort of hardware called a colorimeter, along with the additional software to run it. To start the printer calibration process, you simply print out a test page from a digital file supplied with the calibration kit. The test file has many small color squares, each one a different color. After you print the test page, the colorimeter is used to read the colors produced, and a profile is created that balances out any imperfections in the color. It is essential that you repeat the process for each type of paper you use because every paper/ink combination is completely different.

Bulk ink systems

Bulk ink systems, such as the one in Figure 16-1, can be very beneficial to the photographer who wants to make large quantities of prints. A bulk ink system consists of a set of bottles where the ink is stored, along with tubes to feed the ink from the bottles to a new set of ink cartridges that are specially modified with a new digital chip to tell the computer that the ink is always full. Normally, when you print a certain number of prints, the digital chip on each ink cartridge tells the computer that the cartridge is empty and you have to put in a new cartridge before you can proceed. This doesn't happen with a bulk ink system. You simply keep an eye on the ink in the bottles and refill them when necessary. The cost of a bulk ink system is roughly equivalent to the price of ten ink cartridge sets. However, even the smallest bottles of ink you can get with such a system have more ink in them than ten regular cartridges, so the system pays for itself almost immediately, and it saves you considerable amounts of money thereafter. To find a bulk ink system for your printer, look at `www.inkjetart.com` and `www.inkjetmall.com`.

Paper choices

You have so many choices for papers to print on that the selection is a bit bewildering. You can find many places to look online for information about the various paper choices, but my favorite is `www.inkjetart.com`. This Web site provides tests and comparisons of the various papers as well as other supplies for inkjet printing. Another great source for paper and printing supplies is `www.inkjetmall.com`. Both of these companies offer packs of sample pages so that you can print out tests on a lot of different papers without making a large investment in any single paper type.

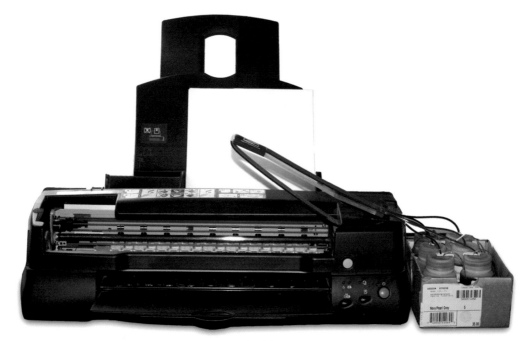

Figure 16-1: Bulk ink systems can save a considerable amount of money if you plan on printing more than just a few prints a month.

A few of the many companies that produce inkjet printing papers include:

✦ www.hawkmtnartpapers.com

✦ www.crane.com

✦ www.epson.com

✦ www.hahnemuehle.com

✦ www.lexjet.com

✦ www.moabpaper.com

✦ www.ilford.com

Online proofing and print sales

Many companies can set you up with an account and allow you to post your images online in the form of a storefront. This is very different from just placing them on your Web site, although as you can see in Figure 16-2, it may look as if it is part of your Web site. With an online storefront, you set up whatever sizes and prices you want to offer to your clients. Clients can then view the images and purchase whatever they want, all in the privacy of their own homes and from anywhere in the world.

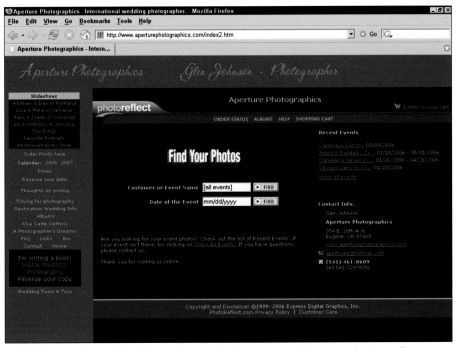

Figure 16-2: Labtricity provides software that integrates with your Web site and connects you directly to a pro lab.

The company that you work with makes the prints (some give you the option of printing them yourself) and then either mails the prints directly to you or directly to the client. This same company also acts as a credit card processor for the orders. At the end of the month, you get a check for all your orders. Of course, the companies that offer this service also charge fees for running the online storefront, processing the credit cards, and printing the prints.

There are two basic types of online labs: those that keep the images on their computers, and those that allow you to keep the images on your computer. If they keep the images, you have several drawbacks, the largest being that you have no control over the images after you send them off to the company. On the surface, this may sound like quite a relief because they take over all the work and you are done with it. However, it means that you have to retouch every single image before you upload it because after you send your images off, you no longer have control of them.

If you use a service that allows you to keep the images on your own computer, then you can wait until you actually get an order before you do any major retouching. This is perfect for those who want to upload a lot of images without spending the time it takes to make them all perfect before you even know if there will be anyone interested in purchasing them.

Online Storefront Providers

It seems like there are new online service providers popping up every day. The list of features they provide is also growing every day. Many providers now offer all sorts of custom printing options and even albums that you or your clients can assemble through the online system. The following companies offer online storefront services to professional photographers. This list covers only a few of the major players and is by no means a complete listing of all the companies out there that offer online storefront services.

Labtricity.com

The Labtricity Publisher software can be downloaded for free at www.labtricity.com. This program allows you to customize the appearance of the storefront and integrate it into your current Web site (refer to Figure 16-2). You can choose to set passwords for each client, and you can also set a date when each customer gallery expires. First, you choose a lab to work with, then you choose how much you want to charge and what sizes of prints you want to offer. The software that controls all of this resides on your own computer, so you can open it up and see all your orders right there.

When an order comes in, you get an e-mail notification summarizing the order and then when you open the Labtricity program, the order pops up and enables you to scroll through the images, color correcting, cropping, and generally making sure the order is ready to go. The Labtricity interface page lets you make all sorts of adjustments to each image before it goes out. When you're satisfied that all is in order, you click Send and the images go straight to the lab over your Internet connection.

The Labtricity software doesn't actually change your image files. Instead, it uploads the original file along with the instructions for all the edits you make. The great thing about this is that if your client orders several different print sizes from one image file, you only have to upload the file once and all the changes are done on the other end just before the printing takes place.

Perhaps the best feature of Labtricity is that it allows you to choose the lab that makes the prints from among a large selection of national labs. If you eventually decide you are unhappy with the lab you've chosen, you can keep the same software and just switch to a new lab. Labtricity Publisher is the free version of this software but the same company has several other versions that cost money but also offer a lot more features.

Pictage.com

Pictage is easily the most well known of all the online storefront offerings available today. With Pictage, you send in the high-resolution digital files (via FTP, or mailing a DVD), edit the event page, release the event to the client, and then order proof products. Pictage announces the site to your customers and handles all orders from that point on.

If the bride wants an album, you can build the album layout right on the Pictage site and then make it available for the bride to view and approve. Upon your approval, Pictage prints and binds the album and ships it either to you or directly to the bride.

As a customer, Pictage gives you options for different printing papers, toning options, border options, and so on.

As the photographer, you can get proof prints, art prints, custom prints, proof CDs, hard-bound proof books, albums, and so on. Pictage also provides educational materials designed to help you market the service to your clients. These materials range from low-cost advertising prints that you can give out to prospective clients to instructional DVDs that show you how to make the best of the services Pictage offers.

The Pictage service currently costs $50, $100, or $150 per month depending on the amount of images you want to upload.

After using the Pictage system for one year, my main critique is that the billing system is so confusing that I had no idea what was going on at the end of the month. Perhaps an accountant could make sense of it, but I wasn't able to decipher it even after calling to get help. The print quality was always good and shipping was speedy. Lab costs seemed a bit on the high side, but as I mentioned, the bills were so confusing that I was never sure how much I was paying for lab services. The upload fees and the time it takes to upload files are a definite drawback for photojournalistic-style shooters who shoot a lot of images.

Printroom.com

Printroom is another online storefront service provider that offers a tremendous amount of flexibility to the photographer (see Figure 16-3). The following are some of the major advantages of Printroom that are not offered by most other online services:

✦ Personalized Studio home page with your own business logo produced from a variety of templates, or you can send in your own HTML coding for a completely custom storefront design.

✦ 300MB of online storage space to host multiple galleries within each studio with no time limit for image display in each gallery and no charge per image upload, event, or gallery display. Extra storage space only costs $20 per 100MB, and this is a one-time fee.

✦ Ability to choose print sizes and products to offer, and to set your own price for each print size and product offered. In addition, you have the flexibility to set different prices for the same print size or product offered in different galleries.

✦ Ability to offer promotions or volume discounts to customers. You can design your own promotion campaigns such as "Get a 20 percent discount when purchasing $100 or more" or "Buy one 8 x 12 and get one 4 x 6 free".

✦ Ability to bundle different print sizes and/or gifts into packages and to set your own package pricing. You can combine up to four different print sizes/products of your choosing and make available up to ten different packages for your customers to choose from.

✦ Ability to offer free prints and to pre-sell photos at an event for online redemption by giving customers a "Photo Pass" with a unique redemption code.

✦ Online sales reports show business transactions in real time. You can access your online account 24 hours a day to check your sales summary report, as well as the detailed names and shipping addresses of your customers. Sale is recorded and the online report is updated upon the shipment of each order. You are also able to follow an order through the print process.

✦ A variety of gift items including T-shirts, coffee mugs, mouse pads, puzzles, coaster sets, refrigerator magnets, key tags, buttons, trading cards, and luggage tags.

✦ Ability to sell digital files either for personal or editorial use. Client can download the file immediately after purchase.

✦ Annual membership fee of $99 payable up front with a 30-day money-back guarantee. If the annual sales for the current year exceed $3,000, the fee is waived for the following year. Transaction Fee: 13 percent of total sales; not charged on taxes, and shipping and handling fees. There is also a 3 percent payment processing fee (credit cards, checks, or money orders). Order fulfillment costs: you pay standard Printroom.com prices for all items that are ordered by customers and fulfilled by Printroom.

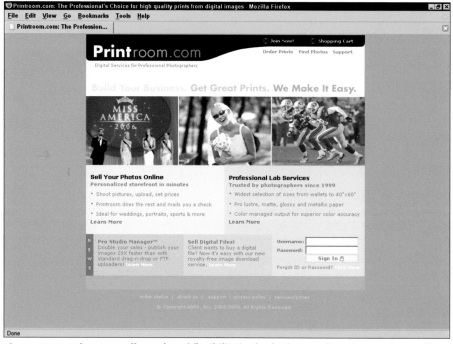

Figure 16-3: Printroom offers a lot of flexibility in the look as well as the products offered.

IntoTheDarkroom.com

This innovative software company has created a whole new approach to the online storefront concept. Instead of having a big company that controls the online experience and all the sales, this software makes it simple for you to be in complete control of managing your own online storefront.

Once the software is set up, you simply resize a batch of images to 600 x 400 pixels and upload them to a folder on your Web site. The Darkroom software, which resides on your server, uses Flash 8 technology to pull the images into the storefront and run them as a slide show complete with music (see Figure 16-4). The music is simply uploaded into the same folder in the MP3 format. This is the ultimate in simplicity.

When clients get tired of watching the slide show, they click "View images and order prints", which takes them to a similar interface with a long Favorites tray on the bottom. When a thumbnail is clicked, it automatically moves the image to the Favorites tray. Once all the favorites are selected, the client clicks Place Order, which takes him or her to a form to choose the sizes and quantity for each print ordered. When the order is complete, it is sent as an e-mail, and you can either send out the files for printing to your own lab, or you can print them yourself.

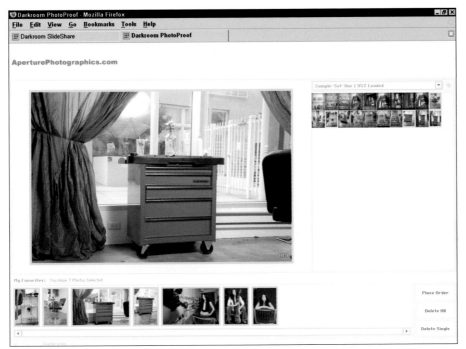

Figure 16-4: With Darkroom you own the software, so you have complete control over your online storefront.

The major benefits of the Darkroom software include:

✦ You own the software so there are no fees for using it after the initial purchase, nor are there any upload fees or limits to the amount of hard drive space you can use.

✦ Client purchases go through your normal credit card or PayPal accounts. Clients can also pay with personal checks.

✦ You can easily integrate it to look similar to the rest of your Web site.

✦ Branded with your logo.

✦ Innovative Flash interface that loads much faster than a normal HTML interface.

✦ The software lives on your server so it is much faster than most online labs that are serving images to hundreds of viewers at any one moment.

✦ Very easy to make new galleries by simply resizing a folder full of images and then uploading it to your Web site.

The downsides to this software are that it takes a bit more work on your part to fill the orders, charge the credit cards, package the prints, and ship them out.

Set an expiration date

No matter what company you choose to go with for your online storefront, setting an expiration date for each online gallery is always an extremely important aspect of your success. A lot of psychology goes into pricing and selling wedding images, and one of the worst mistakes you can make is to give your clients a long time to order. This is true of all types of photography but especially so with weddings. When a wedding is over, it's over! Everyone quickly gets back into normal life where a million distractions soon cause them to forget all about the wedding. The guests will forget within a week or two, and the couple will follow a few weeks later. If you don't get any sales immediately, you might as well forget it. If you leave the images online for only one or two months, you create a sense of urgency, and your clients will have to act right away or not at all. If you give them a chance to procrastinate, they will. If they procrastinate anyway and pass the expiration date, you can charge a hefty fee to reload the online gallery.

Onsite Client Orders

You can also use programs like Labtricity for client ordering sessions. For example, say a customer came in for a portrait session earlier, and now you have him or her back for a viewing and print ordering session. You sit down at a computer and show the images in a slide show format, after which you go back and take orders. Labtricity runs the slide show and enables you to make quick image adjustments right there while the client is watching. As the order builds up, the client can see which images have been ordered, what sizes, and how much it will cost. After the order is finished, the software prints out a customer receipt, which contains thumbnails of each image in the order, as well as size, quantity, price, and other information. As you create the order, the software calculates the total charged and records everything where you can easily view it later. After the client leaves, you can do final retouching and then press Send. A few days later (usually very few), the prints arrive in the mail. If you've been using a local lab for your prints, you might be surprised to find that using an online lab can drastically cut down on the amount of time you spend driving back and forth to the lab every day without adding a significant delay in order processing time.

The Data DVD or CD as a Finished Product

If you decide to provide images to your clients on DVD, you will want to produce something nicer than just a disc with the names scribbled on it. Such a presentation obviously doesn't create a very professional image for your business.

You may want to take a look at the various models of printers that are capable of printing directly on the surface of special discs that have a white inkjet-compatible coating on the top surface. These printers can do double duty by printing on normal office paper and photographic papers as well. To print directly on a disc, you place the disc in a special tray that slides into the printer from the front and moves the disc under the printing heads inside the printer. Epson makes several models that print beautiful colors directly on the disc. Epson printers also come with software that makes it very easy to design the layout and get it to match up with the disc. Figure 16-5 shows some sample layouts created with the software that comes with an Epson R200 printer that sells for under $200.

Specify Home Use Rights

When you provide a set of images to a client, you need to make it very clear that you still own the copyright. In legal terms, you are providing *Home Use Rights*, which means that a client can use the images for personal, nontransferable, and noncommercial uses. When you give this type of right to the client, you still retain the copyright to the images.

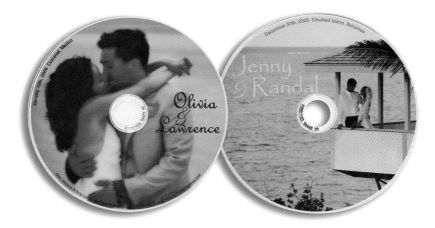

Figure 16-5: Examples of disc labels created with Epson software and an Epson R200 printer.

The following is a sample of what you might say on your contract to spell out these rights.

"This contract includes "Home Use Rights," which means that you can use the images for personal, non-transferable, and noncommercial uses. You may make as many prints as you like for yourself or to give away as gifts. You may copy the disc to facilitate storing a backup in a separate location, but you may not give out copies of the disc to any person outside your immediate family. You are personally liable for communicating the limitations of this contract to any person who receives a disc copy, and you are personally liable for any illegal uses that arise from the distribution of disc copies. You may not sell the image files or prints produced from the files whether in original form or after any amount of alteration. Other persons may not use the image files as a basis for the creation of any artworks if that artwork is to be used for any commercial purpose. The images may not be released or transferred to any other person or company, whether for profit or as a gift. The images may not be used in any commercial media, for any purpose whatsoever. If you have a question about any specific usage, please contact the photographer to ask for clarification before proceeding with such use."

Other files to include on the disc set

If you want to ensure that your clients have the best experience possible with these images, you may want to spend some time compili ng a folder of additional items that you include on every disc set you send out. Some of the items I like to include are:

✦ Instructions for finding a good print lab and how to work with the lab to get the best prints possible.

✦ Free software for viewing and editing images including a link to Adobe Photoshop Album Starter Edition. This is a great program that allows browsing of the images and some very simple tools for image editing.

✦ A price list for other services you offer, such as albums, custom prints, slide shows, custom image retouching, and so forth, along with some small samples of each of these types of work.

✦ Information about other types of work you do, such as family portraits or commercial work. This keeps you hooked in with the entire family of each wedding client so they know whom to come to when they have other photographic needs.

The Shoot-and-Burn Photography Model

Many wedding photographers that operate a one-man show sort of business soon find that they can make a lot more profit shooting pictures than they can from selling 4 x 6's and 5 x 7's to grandma. This is not true of portrait photography, where the clients are more willing to spend large sums of money on single images, and it certainly isn't true for a large studio where there is a staff that can do all the print order tracking and processing. However, for the smaller business, it may make sense to charge a higher fee up front to compensate for the loss in print sales, and then just give your clients the image files on DVD so they can make their own small prints.

This business model causes extreme concern to many established wedding photographers who see this as "the death of the wedding photography industry." They call this practice the "shoot-and-burn" business model and it has become fairly common to hear photographers complaining about how shoot-and-burn photographers are running down the industry by giving away their services at such a low cost.

In reality, the business model is not the problem. The problem is that some photographers give away their services at a low cost. This can happen with any business model, and the shoot-and-burn business model is no exception. However, there is no requirement that you have to give away your services in order to use this business model, and I am the first to encourage you to research prices in your area to make sure that you stay competitive according to your skill level and the quality of the work you produce.

In order to understand how the shoot-and-burn model can work to create a healthy profit for the smallest businesses, I offer the two comparisons that follow. For the purposes of comparison, imagine a photographer that is actually worth the national average price of $2,500 for the wedding photography service — not including prints or albums.

Standard photography studio with staff

This photographer charges $2,500 for the photography service. After the wedding, the bride meets with the photographer and views the images, then orders $500 in loose prints and a $2,000 album. The photographer spends an hour with the ordering session, and then staff members process the order for a total of about three more hours including trips to the lab. Net income from the print order totals roughly $250 after labor and lab fees. The album generates roughly $1,000 in net profit after labor, lab fees, and binding fees.

To offer a fair comparison of these two pricing models, you must look at all the elements that go into a print sale for a studio with a staff that works on these sales. For example, compared to running a business out of a small office, you also need to consider the following:

✦ Rent and utilities on a large place of business.

✦ Payroll for employees.

✦ An accountant to calculate payroll and keep you up on all the taxes and other government regulations you have to comply with when you have employees.

✦ Training employees on print order workflow.

✦ Training employees on sales techniques.

✦ Each order requires time to arrange and present the sales presentation, send orders to the lab, track the orders as they return from the lab, return unacceptable prints to the lab, track the returns again until the order is complete, contact clients and arrange a pickup time, and package the order for delivery.

✦ On top of that, you must deal with interpersonal relationships and the occasional hiring and firing of new staff, at which time you also have to go back through the training process again.

As you can see, the prospect of growing from a one-man-show into a studio with staff is enough to make many solo wedding photographers cringe.

The shoot-and-burn business model

This photographer charges $3,000 for the same photography service and encourages clients who are comparison shopping to consider the option of owning the images and making all the prints they want for the rest of their lives at the prices offered by the local lab, versus having to go back to the photographer and pay higher prices to get prints. If the client wants to order very many prints at all, the difference in price quickly disappears.

After the wedding, the bride meets with the photographer and views a selection of the best images in a slide show. After the show she picks up a nice little boxed set containing DVDs of the original image files in JPEG format. At that time, she also talks with the photographer about albums and looks at samples before deciding to purchase a $2,000 album.

As you can see, the shoot-and-burn photographer is not going out of business. In fact, the business is booming because this photographer has found a way to give the clients what they want (the image files), while getting the same amount of profit for less work.

After the wedding is over, the shoot-and-burn photographer can still sell albums, DVD slide shows, and custom prints because the labor for these items can be farmed out to the labs that produce the products without much effort on the part of the photographer. This allows the photographer to offer only services that can be performed with a minimum amount of personal effort and at a large profit margin. It also frees the photographer to do what he or she does best — take pictures.

The bad reputation that the shoot-and-burn photographer is currently getting is misplaced in my opinion. The real problem is that some photographers undercharge for their work. This is not a new problem; in fact, it has always existed and it always will. I don't think good photographers should worry about cheap wedding photographers because the clients that you want to work for are not looking for cheap. They look for the highest quality they can get with the amount of money they have, and contrary to popular belief, cheap is not a quality most clients want in their wedding photography. Think about this: Even poor people buy gold rings with real diamonds when they get married, and you can bet many of them feel the same about the photography — they want the best, not the cheapest.

Albums

Albums have traditionally been the single most common method of displaying wedding images. Digital technology has brought about a few changes to the album market, but the popularity of albums still reigns supreme. Companies that offer traditional albums with matted or flush-mount pages include www.zookbinders.com and www.caprialbum.com.

Modern digitally printed albums have a much sleeker look with thinner pages and no need for the traditional mats that framed images in the past. The ability to produce a page with multiple images and text all blended into a single print has created a lot of excitement among clients and photographers alike. The beauty and uniqueness of these products is so far beyond what was available in the days of film that I think it's safe to say that high-priced wedding albums have never been easier to sell.

Some companies call these page layouts *magazine style* because you can use text and images pretty much any way you like. The pages of these digitally printed albums no longer have bulky mats around the edge; instead, the print is the page. Many companies now offer pages that have only a very tiny crack down the middle so that when opened, the pages appear as a single giant layout.

With the skilled touch of a good graphic designer, each page has a layout that looks like it could have come straight from the pages of a coffee table art book or even a fashion magazine. The design styles are very modern, and the albums themselves are actually real hard-bound books. The pages are often printed on thick watercolor papers with long-lasting inkjet printers, before being assembled with traditional bookbinding methods.

The Design Stage

Many photographers design and build the album page layouts themselves. Others hire skilled Photoshop users to do the task on salary. Still others farm out the task to a skilled graphic design artist. Several album companies, including White Glove (`www.wgbooks.com`) and GraphiStudios (`www.graphistudios.com`), offer a complete service including graphic design, sending out customer proofs, printing, and binding (see Figures 16-6 and 16-7).

Zoho Design (`www.zohodesigns.com`) offers high-quality digital layout services at a very reasonable rate. Zoho Design (see Figure 16-8) gives you the option of taking the finished files and getting the printing and binding done yourself, or letting them take care of the whole package. White Glove allows you the choice of either printing the pages on your own inkjet printer or allowing them to do everything from the initial digital layout, to the printing, and finally the bookbinding.

JonesBook (`www.jonesbook.com`) offers custom printing and traditional style bookbinding (see Figure 16-9). Asukabook (`http://asukabook.com`) offers custom graphic design services as well as finished books that are beautifully printed on normal book-weight paper and then bound in several choices of hardback or soft-back bindings (see Figure 16-10).

Figure 16-6: White Glove gives you the option of printing your own album pages, or their full-service design, print, and binding services.

Figure 16-7: GraphiStudios offers the full range of design, printing, and binding services with a large assortment of different cover styles and paper choices.

Figure 16-8: Zoho Design offers professional graphic design for your album layouts.

Figure 16-9: JonesBook does the digital printing with Epson pigment ink printers and then binds the pages with traditional bookbinding techniques for an extremely elegant book.

Figure 16-10: Asukabook prints your digital files right on the page.

No matter which route you choose to get your digital albums, you should have no difficulty selling them. Even though the prices start at about $1,000 and go way up from there, the beauty and uniqueness of these books make them a highly sought after item among brides.

DVD Movies

Putting your images together in the form of a DVD movie used to be quite a difficult task that involved the use of a very complicated linear video-editing program such as Avid or Adobe Premier. Thankfully, the second generation of video slide-show software is much less complicated to learn. Photodex Proshow Gold (see Figure 16-11) is the one program that really stands out from the crowd. With Proshow Gold, you can do all the standard slide-show features; such as add music, select transitions, set transition times and image times, and so forth. The surprising part is that with Proshow Gold, the standard effects are just the tip of the iceberg. You can make your image zoom in or slowly pan across a wide scene, and you can create layers with text and other images appearing and disappearing for unlimited creative effects. This software enables you to express your creativity in ways you never even imagined. If you want to create presentations that truly WOW your viewers, this is the tool for you!

Figure 16-11: Photodex Proshow Gold creates DVD movies, slide shows, and screensavers with an unbelievable level of creative control.

If you want an excellent program, capable of producing the standard slide show with two tracks of music, still images, and video, then you need look no farther than ACDSee Pro. I was shocked to see how many features this new version of ACDSee has packed into a very easy-to-learn video creation package that enables you to output to video CD or DVD formats. ACDSee also outputs your slide-show file to the Macromedia Flash (.swf) format, which you can put on your Web site for prospective clients to view over the Internet. This is very valuable to the wedding photographer who uses the Internet to exhibit portfolios with large numbers of images.

Computer Slide Shows

Once again, Proshow Gold, ProShow Producer, and ACDSee top the list for programs that can create computer slide shows and screensavers for PC. With ACDSee, you can simply click a folder that contains your favorite images and then press Ctrl+S to start a slide show running according to the presets you specify. The ability to run a quick show such as this is invaluable when you want to show off a bunch of images to clients or friends.

Summary

The digital age is teeming with new and unusual products that you can offer your clients, and the list continues to grow every day. The only way to keep up is to read photo magazines where each new product is eventually featured.

Whether you keep your images and sell prints in a traditional fashion or charge more up front and give the images on a disc, both business models can benefit from increased sales and by offering custom albums, custom prints, DVD slide shows, and other aftermarket products. Both business styles can also tap into previously untouchable clients by selling prints to distant friends and relatives through an online storefront.

✦ ✦ ✦

Index

Continued

Continued

Continued